Jackson Pollock

Interviews, Articles, and Reviews

Edited by Pepe Karmel

The Museum of Modern Art, New York

Distributed by Harry N. Abrams, Inc., New York

Published in conjunction with the exhibition Jackson Pollock, organized by Kirk Varnedoe, Chief Curator, with Pepe Karmel, Adjunct Assistant Curator, Department of Painting and Sculpture, The Museum of Modern Art, New York, November 1, 1998 to February 2, 1999.

This exhibition was made possible by Bank of America. ■ Generous support was provided by The Henry Luce Foundation, Inc. ■ The reconstruction of Pollock's studio was made possible by EXOR America (Agnelli Group). ■ The Museum gratefully acknowledges the support of the Eugene V. and Clare E. Thaw Charitable Trust and an anonymous donor. ■ Additional funding was provided by TDI. ■ An indemnity for the exhibition was granted by the Federal Council on the Arts and the Humanities. ■ This publication is made possible through the generosity of The David Geffen Foundation.

Produced by the Department of Publications, The Museum of Modern Art, New York ■ Edited by Jasmine Moorhead ■ Designed by Steven Schoenfelder, New York ■ Production by Christina Grillo ■ Printed and bound by Poligrafiche Bolis SpA, Azzano San Paolo, Italy ■ This book was set in Font Bureau Eagle and Adobe Stone Serif. ■ Copyright © 1999 The Museum of Modern Art, New York

Library of Congress Catalogue Card Number: 99-075246 ■ ISBN: 0-87070-037-5 (MoMA, T&H) ■ ISBN: 0-8109-6212-8 (Harry N. Abrams)

Published by The Museum of Modern Art, 11 West 53 Street, New York, New York 10019 ■ Distributed in the United States and Canada by Harry N. Abrams, Inc. New York ■ Distributed outside the United States and Canada by Thames & Hudson, Ltd, London ■ Printed in Italy

Cover: *One: Number 31, 1950* (detail). 1950. Oil and enamel paint on canvas, 8 ft. 10 in. x 17 ft. 5⅝ in. (269.5 x 530.8 cm). The Museum of Modern Art, New York. Sidney and Harriet Janis Collection Fund (by exchange) © 1999 Pollock-Krasner Foundation/Artists Rights Society (ARS), New York

Contents

This publication is made possible through the generosity of
The David Geffen Foundation.

Introduction

Pepe Karmel

One of the great pleasures of researching an exhibition is discovering how much you don't know. Like most art historians, I used to think that Clement Greenberg had more or less single-handedly discovered Jackson Pollock, and that the critical history of Pollock's work therefore consisted of a list of disciples and dissenters from that grandly named dogma "Greenbergian formalism." But as Kirk Varnedoe and I dove into preparations for The Museum of Modern Art's 1998 exhibition *Jackson Pollock*, reading through stacks of photocopied articles, it gradually became apparent that Pollock's critical history was more complex and more interesting than this cliché suggested.

We realized, for instance, that there had been a distinct shift, around 1960, in the way that critics understood Pollock's development as an artist. What had appeared to observers of the 1940s and 50s as a relatively seamless evolution was now broken into three distinct phases: the early work, the "classic" drip paintings, and the late work.[1] Although Pollock's early work had been widely acclaimed when first exhibited, it was now downgraded to a mere prelude to the years 1947–50. Similarly, the later phase, which had seemed to many contemporary critics to represent an advance beyond the drip paintings, came to be seen as a dramatic falling-off. Although it became generally agreed that there was something revolutionary about Pollock's drip paintings of 1947–50—a profoundly radical quality absent from his earlier and later work—this quality proved surprisingly difficult to define. Pollock criticism since 1960 consists of a series of attempts to answer this question.

The goal of this anthology is double: to trace the changing interpretations of Pollock's work and to gather together the statements by Pollock and by his wife, the artist Lee Krasner, that form the essential points of reference for all discussions of his working method. The exigencies of publication have, alas, imposed severe limitations on what can be included here. To keep this book affordable for students and the broader art community, we have had to omit all illustrations. I hope that readers will be able to consult our exhibition catalogue, which provides an extensive overview of Pollock's work, reproduced in color.

This book includes only texts that are specifically about Pollock; it thus excludes numerous important essays about Abstract Expressionism in general.[2] It is being published in tandem with a companion volume, *Jackson Pollock: New Approaches*; writers and approaches represented in that volume—such as T. J. Clark on Pollock and social history and Rosalind Krauss on the *informe*—are therefore not reproduced here. Several important texts by scholars such as Michael Leja, E. A. Carmean, and Francis V. O'Connor are also missing, either because they are easily available elsewhere, or because they depend on visual analysis which would be hard to follow without illustrations.[3] Finally, this volume is (with one exception) limited to texts published in the United States; the British and European responses to Pollock are, however, discussed by Jeremy Lewison in *Jackson Pollock: New Approaches*.

Early reviewers were impressed with the expressive violence of Pollock's paint handling, although they often found his symbolism baffling. Beyond this emphasis, four issues dominated the Pollock criticism of the 1940s and 50s: the status of easel painting, decoration, chaos, and action.

Almost from the outset, critics related Pollock's work to the ongoing rivalry between easel painting and the mural. An anonymous reviewer in the May 1946 issue of *Art News* (p. 55) noted that Pollock had developed a new "simplified" manner of placing larger shapes against "flat, monochrome backgrounds," and commented that this was "a logical development in Pollock's attempt to create a new, abstract, mural style." Similarly, Greenberg observed in January 1948 that "Greenwich Village" artists were enlarging Henri Matisse's "simplified compositional schemes" in order to arrive at a "larger-scale easel art," which would spread over the wall like a mural but remain distinct from it.[4]

Three months later, in "The Crisis of the Easel Picture," Greenberg again wrote that advanced art was "destroying" the easel picture. This time, however, he said that the elimination of "fictive depth" was being accomplished not by the placement of simplified shapes on a flat background, but by the development of a "'decentralized,'" "polyphonic," "all-over" composition consisting of similar elements repeated across the canvas. Greenberg cited as examples recent work by Pollock, Jean Dubuffet, Joaquín Torres-García, Mark Tobey, Janet Sobel, and others—artists who were working, at this moment, at relatively small scale. Not a word here about mural painting.[5]

Greenberg compared these new allover compositions to "wallpaper patterns"—a term he had already used in his review of Pollock's first exhibition of drip paintings (p. 59). He was not the only critic to feel ambivalent about the similarity between allover painting and decorative design. In "A *Life* Round Table on Modern Art," published in October 1948, Leigh Ashton, director of the Victoria and Albert Museum commented that Pollock's *Cathedral* "would make a

most enchanting printed silk," and Theodore Greene, a Yale philosophy professor, said that it seemed a "pleasant design for a necktie."[6] Later, in 1952, art critic Harold Rosenberg would make a notorious reference to "apocalyptic wallpaper."[7]

As *Life* and *Time* magazines brought Pollock to the attention of a broader audience, the grounds for criticism changed. His pictures were now condemned as chaotic rather than decorative (p. 70). A new generation of critics tacitly accepted this description, but defended the seeming chaos as the evocative record of the "ritual dance" by which the work was created, with the rhythms of Pollock's movements determining the destination of the dripped and poured paint (p. 77). Though unnamed, Pollock was clearly a model for Rosenberg's 1952 portrait of "The American Action Painters," with its famous pronouncement that "At a certain moment the canvas began to appear to one American painter after another as an arena in which to act. . . . What was to go on the canvas was not a picture but an event."[8]

After Pollock's untimely death in 1956, critics began to focus less on the man and more on the pictures, struggling to define his achievement in aesthetic rather than existential terms. The battle lines were drawn with Greenberg's 1960 lecture "Modernist Painting," a formalist manifesto.[9] Pollock was not mentioned in this lecture, so it was left to a younger critic, Michael Fried, to deploy Greenberg's theories as a means of identifying what was truly revolutionary in the drip paintings.[10] A 1965 essay by Fried titled "Jackson Pollock" (pp. 97–103) was followed in 1967 by William Rubin's "Jackson Pollock and the Modern Tradition" (pp. 118–75), which imbedded the formalist interpretation within a rich historical narrative. These essays by Greenberg, Fried, and Rubin have remained central to Pollock criticism for over thirty years, providing a powerful, coherent reading for subsequent critics to react against.[11]

The Minimalists came first, rejecting both the ideas of "diaristic gesture" and "optical style."[12] Instead, they praised Pollock's ability to make process apparent in his finished paintings. The so-called opticality of the paintings, Robert Morris argued, resulted from "the properties of fluidity and a more or less absorptive ground," not from any grand theory about art.[13] Similarly, Robert Smithson reduced Greenberg's theoretical arguments to a matter of personal taste, arguing that the "wet" mind of the critic enjoyed "'pools and stains' of paint . . . melting, dissolving, soaking surfaces."[14] Pollock had a valuable lesson to teach, not about pure painting, but about the impersonal poetry of materials.

Parker Tyler had suggested a mythological dimension to Pollock's work as early as 1950 (pp. 65–67), and in 1961 Robert Rosenblum linked Pollock to a tradition of "The Abstract Sublime."[15] But the mythological reading of Pollock's work really took off in the 1970s, jump-started by the disclosure of a group of almost seventy drawings that he had executed in 1939–40 while in Jungian analysis. Scholars turned to these drawings in the hope that they would serve as

a kind of Rosetta Stone for the interpretation of Pollock's work. (See, for example, Elizabeth Langhorne's essay, pp. 202–19.) But Pollock's symbolism proved difficult to pin down, and interest in this approach dimmed after it was subjected to a blistering critique by William Rubin (pp. 220–61).

The Pollock criticism of the 1990s has been remarkable for its diversity. Social, biographical, and formal interpretations have coexisted with psychological and philosophical analyses drawing on gender theory, psychoanalysis, and dissident Surrealism. Opulent and austere, dense and ethereal, hauntingly suggestive and chastely matter-of-fact, Pollock's work seems to present an inexhaustible challenge to scholars—past, present, and (no doubt) future.

Notes

1. It has often been argued that "drip" is a misnomer, and that Pollock's works of 1947–50 should be referred to instead as "poured" paintings. According to the dictionary, "drip" connotes a sequence of separate drops, while "pour" suggests a continuous flow. To this extent, "pour" would indeed seem more appropriate. On the other hand, "pour" suggests that the fluid in question is being poured from a container, which is not the case, since Pollock released his paint from heavily loaded sticks or brushes. Since Pollock himself described his technique as "dripping fluid paint" (see p. 18 of this volume), I prefer to retain the conventional usage "drip." Other critics disagree.

2. Along with other general criticism of Abstract Expressionism, the numerous texts arguing that Pollock served as as an unwitting tool of Cold War propaganda are not represented here since they are concerned with the uses of his work rather than the work itself. See especially Max Kozloff, "American Painting during the Cold War," *Artforum* 11, no. 9 (May 1973): 43–54; Eva Cockcroft, "Abstract Expressionism, Weapon of the Cold War," *Artforum* 12, no. 10 (June 1974): 39–41; Serge Guilbaut, *How New York Stole the Idea of Modern Art: Abstract Expressionism, Freedom, and the Cold War* (Chicago: at the University Press, 1983); and Michael Kimmelman, "Revisiting the Revisionists: The Modern, Its Critics, and the Cold War," in *The Museum of Modern Art at Mid-Century: At Home and Abroad; Studies in Modern Art* 4 (New York: The Museum of Modern Art, 1994), pp. 38–55.

3. See especially Michael Leja, *Reframing Abstract Expressionism: Subjectivity and Painting in the 1940s* (New Haven: Yale University Press, 1993); E. A. Carmean Jr., "Jackson Pollock: Classic Paintings of 1950," in *American Art at Mid-Century—The Subjects of the Artist*, exh. cat. (National Gallery of Art, Washington, D.C., 1978), pp. 127–53; and Francis V. O'Connor, *The Black Pourings, 1951–1953*, exh. cat. (Boston: Institute of Contemporary Art, 1980).

4. Clement Greenberg, "The Situation at the Moment," *Partisan Review* 15, no. 1 (January 1948): 83; reprinted in in *Arrogant Purpose, 1945–1949*, vol. 2 of *Clement Greenberg: The Collected Essays and Criticism*, ed. John O'Brian (Chicago: at the University Press, 1986), pp. 194–95.

5. Clement Greenberg, "The Crisis of the Easel Picture," *Partisan Review* 15, no. 4 (April 1948): 481–84; reprinted in O'Brian, vol. 2, pp. 221–25.

6. "A *Life* Round Table on Modern Art," *Life* 25, no. 15 (October 11, 1948), p. 62.

7. Harold Rosenberg, "The American Action Painters," *Art News* 51, no. 8 (December 1952): 49; reprinted in Rosenberg, *The Tradition of the New* (Chicago: at the University Press, 1982), p. 34.

8. Rosenberg, "The American Action Painters," p. 22.

9. Greenberg, "Modernist Painting," 1960, in *Modernism with a Vengeance, 1957–1969*, vol. 4 of *Clement Greenberg: The Collected Essays and Criticism*, ed. John O'Brian (Chicago: at the University Press, 1993), p. 86. The logic of "Modernist Painting" is adumbrated in Greenberg's 1940 essay "Towards a Newer Laocoön," but it did not form the exclusive basis of his critical practice in the 1940s or 50s. The battle with Rosenberg and his followers came to a climax in Greenberg's 1962 essay, "How Art Writing Earns Its Bad Name," reprinted in O'Brien, vol. 4, pp. 135–44.

10. In "An Introduction to My Art Criticism," in *Art and Objecthood* (Chicago: at the University Press, 1998), pp. 16–23, Fried reevaluates his own relation to Greenberg and explores the assumptions underlying his criticism of the 1960s.

11. I have tried to suggest my own formalist but non-Greenbergian reading of Pollock in "A Sum of Destructions," published in *Jackson Pollock: New Approaches* (New York: The Museum of Modern Art, 1999).

12. For "diaristic gesture," see Allan Kaprow, "The Legacy of Jackson Pollock," 1958, pp. 84–89 of this volume. For "optical style," see Michael Fried, "Jackson Pollock," 1967, pp. 97–103 of this volume.

13. Robert Morris, "Anti Form," *Artforum* 6, no. 8 (April 1968): 34–35. Similarly, Donald Judd commented: "The dripped paint in most of Pollock's paintings is dripped paint. It's that sensation, completely immediate and specific." ("Jackson Pollock," April 1967, p. 116 of this volume.)

14. Robert Smithson, "A Sedimentation of the Mind: Earth Projects," *Artforum* 7, no. 1 (September 1968): 49. The implicit reference to Greenberg is underscored by Smithson's description of a "critic with a dank brain" who "would prefer to see art in a dewy green setting—say the hills of Vermont," where Greenberg was the patron saint of the Bennington College art department.

15. Robert Rosenblum, "The Abstract Sublime," *Art News* 59, no. 10 (February 1961): 39–41, 56–57.

Note

Except where indicated, the texts in this volume have been reprinted as they appeared in their original place of publication. Obvious spelling errors have been corrected. Footnotes, even where they refer to other texts in this volume, have not been changed or updated, except to make them consistent within each essay. It has not been possible to reproduce the illustrations that originally accompanied these texts. Where a work by Pollock is referred to by title alone, it can generally be found in *Jackson Pollock*, the catalogue of 1998 exhibition at The Museum of Modern Art. References to numbered text figures have been replaced either by the name of the painting in question or (in the case of untitled works) by the number assigned the work in Francis V. O'Connor's and Eugene V. Thaw's *Jackson Pollock: A Catalogue Raisonné of Paintings, Drawings, and Other Works* [hereafter "OT"].

Accessing the Bibliography

Begin at the Museum's Web site at www.moma.org. From the Museum's home page, go to "Research Resources," and then to "DADABASE." Choose the option to "Search the Catalog." Then search by subject for "Jackson Pollock." The bibliography should appear under its own heading.

Artist's Statements and Interviews

Pollock's first solo exhibition opened at Peggy Guggenheim's gallery, Art of This Century, *on November 9, 1943. Soon thereafter, he was asked to contribute a statement to the Los Angeles journal* Arts and Architecture. *The anonymous interviewer was probably the painter Robert Motherwell.*

Anon. "Jackson Pollock: A Questionnaire." *Arts and Architecture*
(LOS ANGELES) 61, NO. 2 (FEBRUARY 1944): 14. © THE POLLOCK-KRASNER FOUNDATION, INC.

Where were you born?
Cody, Wyoming, in January, 1912. My ancestors were Scotch and Irish.

Have you traveled any?
I've knocked around some in California, some in Arizona. Never been to Europe.

Would you like to go abroad?
No. I don't see why the problems of modern painting can't be solved as well here as elsewhere.

Where did you study?
At the Art Students League, here in New York. I began when I was seventeen. Studied with Benton, at the League, for two years.

How did your study with Thomas Benton affect your work, which differs so radically from his?
My work with Benton was important as something against which to react very strongly, later on; in this, it was better to have worked with him than with a less resistant personality who would have provided a much less strong opposition. At the same time, Benton introduced me to Renaissance art.

Why do you prefer living here in New York to your native West?
Living is keener, more demanding, more intense and expansive in New York than in the West; the stimulating influences are more numerous and rewarding. At the same time, I have a definite feeling for the West: the vast horizontality of the land, for instance; here only the Atlantic ocean gives you that.

Has being a Westerner affected your work?
I have always been very impressed with the plastic qualities of American Indian art. The Indians have the true painter's approach in their capacity to get hold of appropriate images, and in their understanding of what constitutes painterly

subject-matter. Their color is essentially Western, their vision has the basic universality of all real art. Some people find references to American Indian art and calligraphy in parts of my pictures. That wasn't intentional; probably was the result of early memories and enthusiasms.

Do you consider technique to be important in art?
Yes and no. Craftsmanship is essential to the artist. He needs it just as he needs brushes, pigments, and a surface to paint on.

Do you find it important that many famous modern European artists are living in this country?
Yes. I accept the fact that the important painting of the last hundred years was done in France. American painters have generally missed the point of modern painting from beginning to end. (The only American master who interests me is Ryder.) Thus the fact that good European moderns are now here is very important, for they bring with them an understanding of the problems of modern painting. I am particularly impressed with their concept of the source of art being the unconscious. This idea interests me more than these specific painters do, for the two artists I admire most, Picasso and Miró, are still abroad.

Do you think there can be a purely American art?
The idea of an isolated American painting, so popular in this country during the 'thirties seems absurd to me, just as the idea of creating a purely American mathematics or physics would seem absurd. . . . And in another sense, the problem doesn't exist at all; or, if it did, would solve itself: An American is an American and his painting would naturally be qualified by that fact, whether he wills it or not. But the basic problems of contemporary painting are independent of any one country.

In the spring of 1947, Pollock's 1943–44 Mural, *painted for Peggy Guggenheim's townhouse, was included in The Museum of Modern Art's exhibition* Large-Scale Modern Paintings, *along with works by Pablo Picasso, Henri Matisse, Fernand Léger, Joan Miró, Pierre Bonnard, Marc Chagall, Max Beckmann, and David Alfaro Siqueiros. The tension between easel painting and mural painting was very much in the air, discussed, for instance, in an anonymous 1946 review of Pollock's work (p. 55, below) and in Clement Greenberg's 1948 essay "The Situation at the Moment." Indeed, Greenberg's influence seems visible in the following statement, which Pollock wrote as part of his application for a grant from the Guggenheim Foundation. As it happened, Pollock did not receive the grant, and it was three years before he returned to working at a mural scale.*

Jackson Pollock. Application for Guggenheim Fellowship
1947. © THE POLLOCK-KRASNER FOUNDATION, INC.

I intend to paint large movable pictures which will function between the easel and mural. I have a set a precedent in this genre in a large painting for Miss Peggy Guggenheim which was installed in her house and was later shown in the "Large-Scale Paintings" show at the Museum of Modern Art. It is at present on loan at Yale University.

I believe the easel picture to be a dying form, and the tendency of modern feeling is towards the wall picture or mural. I believe the time is not yet ripe for a *full* transition from easel to mural. The pictures I contemplate painting would constitute a halfway state, and an attempt to point out the direction of the future, without arriving there completely.

Pollock contributed this statement to the first (and last) issue of Possibilities, *a small magazine edited by Robert Motherwell and Harold Rosenberg. It was accompanied by illustrations of paintings Pollock had done in 1944–46, but did not include any of the "drip" paintings he had begun making in 1947. Pollock's oft-quoted description of his working technique seems to apply, however, to both his new and old work.*

Jackson Pollock. "My Painting." *Possibilities*
(NEW YORK) I (WINTER 1947–48): 78–83. © THE POLLOCK-KRASNER FOUNDATION, INC.

My painting does not come from the easel. I hardly ever stretch my canvas before painting. I prefer to tack the unstretched canvas to the hard wall or the floor. I need the resistance of a hard surface. On the floor I am more at ease. I feel nearer, more a part of the painting, since this way I can walk around it, work from the four sides and literally be *in* the painting. This is akin to the method of the Indian sand painters of the West.

I continue to get further away from the usual painter's tools such as easel, palette, brushes, etc. I prefer sticks, trowels, knives and dripping fluid paint or a heavy impasto with sand, broken glass and other foreign matter added.

When I am *in* my painting, I'm not aware of what I'm doing. It is only after a sort of "get acquainted" period that I see what I have been about. I have no fears about making changes, destroying the image, etc., because the painting has a life of its own. I try to let it come through. It is only when I lose contact with the painting that the result is a mess. Otherwise there is pure harmony, an easy give and take, and the painting comes out well.

Berton Roueché, a gifted New Yorker *writer, was an East Hampton neighbor of Pollock's. Even after* Life *magazine's 1949 feature on the artist (pp. 63–64), it was only with some difficulty that Roueché persuaded his editor to let him publish this brief interview with Pollock and Krasner.*

Berton Roueché. "Unframed Space." *The New Yorker*
26, NO. 24 (AUGUST 5, 1950): 16. © 1950 BERTON ROUECHÉ. REPRINTED BY PERMISSION. ALL RIGHTS RESERVED.

We improved a shining weekend on eastern Long Island by paying a call on Jackson Pollock—an uncommonly abstract abstractionist and one of seven American painters whose work was tapped for inclusion in the Twenty-fifth International Biennial Exhibition of Figurative Arts, now triumphantly under way in Venice—at his home, a big, gaunt, white clapboard, Ulysses S. Grant-period structure in the fishing hamlet of The Springs. Pollock, a bald, rugged, somewhat puzzled-looking man of thirty-eight, received us in the kitchen, where he was breakfasting on a cigarette and a cup of coffee and drowsily watching his wife, the former Lee Krasner, a slim, auburn-haired young woman who also is an artist, as she bent over a hot stove, making currant jelly. Waving us to a chair in the shade of a huge potted palm, he remarked with satisfaction that he had been up and about for almost half an hour. It was then around 11:30 A.M. "I've got the old Eighth Street habit of sleeping all day and working all night pretty well licked," he said. "So has Lee. We had to, or lose the respect of the neighbors. I can't deny, though, that it's taken a little while. When'd we come out here, Lee?" Mrs. Pollock laughed merrily. "Just a little while ago," she replied. "In the fall of 1945."

"It's marvellous the way Lee's adjusted herself," Pollock said. "She's a native New Yorker, but she's turned into a hell of a good gardener, and she's always up by nine. Ten at the latest. I'm way behind her in orientation. And the funny thing is I grew up in the country. Real country—Wyoming, Arizona, northern and southern California. I was born in Wyoming. My father had a farm near Cody.

By the time I was fourteen, I was milking a dozen cows twice a day." "Jackson's work is full of the West," Mrs. Pollock said. "That's what gives it that feeling of spaciousness. It's what makes it so American." Pollock confirmed this with a reflective scowl, and went on to say that at seventeen, an aptitude for painting having suddenly revealed itself to him in a Los Angeles high school, he at once wound up his academic affairs there and headed East. "I spent two years at the Art Students League," he said. "Tom Benton was teaching there then, and he did a lot for me. He gave me the only formal instruction I ever had, he introduced me to Renaissance art, and he got me a job in the League cafeteria. I'm damn grateful to Tom. He drove his kind of realism at me so hard I bounced right into non-objective painting. I'm also grateful to the W.P.A., for keeping me alive during the thirties, and to Peggy Guggenheim. Peggy gave me my first show, in 1943: She gave me two more, and then she took off for Europe, and Lee and I came out here. We wanted to get away from the wear and tear. Besides, I had an underneath confidence that I could begin to live on my painting. I'd had some wonderful notices. Also, somebody had bought one of my pictures. We lived a year on that picture, and a few clams I dug out of the bay with my toes. Since then things have been a little easier." Mrs. Pollock smiled. "Quite a little," she said. "Jackson showed thirty pictures last fall and sold all but five. And his collectors are nibbling at those." Pollock grunted. "Be nice if it lasts," he said.

We asked Pollock for a peep at his work. He shrugged, rose, and led us into a twenty-five-by-fifty-foot living room furnished with massive Italianate tables and chairs and hung with spacious pictures, all of which bore an offhand resemblance to tangles of multicolored ribbon. "Help yourself," he said, halting at a safe distance from an abstraction that occupied most of an end wall. It was a handsome, arresting job, a rust-red background laced with skeins of white, black, and yellow and we said so. "What's it called?" we asked. "I've forgotten," he said, and glanced inquiringly at his wife, who had followed us in. "'Number Two, 1949,' I think," she said. "Jackson used to give his pictures conventional titles: 'Eyes in the Heat' and 'The Blue Unconscious' and so on but now he simply numbers them. Numbers are neutral. They make people look at a picture for what it is— pure painting." "I decided to stop adding to the confusion," Pollock said. "Abstract painting is abstract. It confronts you. There was a reviewer a while back who wrote that my pictures didn't have any beginning or any end. He didn't mean it as a compliment, but it was. It was a fine compliment. Only he didn't know it." "That's exactly what Jackson's work is," Mrs. Pollock said. "Sort of unframed space."

Jackson Pollock. Interview with William Wright.

THE SPRINGS, LONG ISLAND, NEW YORK, LATE 1950. BROADCAST ON RADIO STATION WERI, WESTERLY, RHODE ISLAND, 1951. © THE POLLOCK-KRASNER FOUNDATION, INC.

ww: *Mr. Pollock, in your opinion, what is the meaning of modern art?*

JP: Modern art to me is nothing more than the expression of contemporary aims of the age that we're living in.

ww: *Did the classical artist have any means of expressing their age?*

JP: Yes, they did it very well. All cultures have had means and techniques of expressing their immediate aims—the Chinese, the Renaissance, all cultures. The thing that interests me is that today painters do not have to go to a subject matter outside of themselves. Most modern painters work from a different source. They work from within.

ww: *Would you say that the modern artist has more or less isolated the quality which made the classical works of art valuable, that he's isolated it and uses it in a purer form?*

JP: Ah—the good ones have, yes.

ww: *Mr. Pollock, there's been a good deal of controversy and a great many comments have been made regarding your method of painting. Is there something you'd like to tell us about that?*

JP: My opinion is that new needs need new techniques. And the modern artists have found new ways and new means of making their statements. It seems to me that the modern painter cannot express this age, the airplane, the atom bomb, the radio, in the old forms of the Renaissance or of any other past culture. Each age finds its own technique.

ww: *Which would also mean that the layman and the critic would have to develop their ability to interpret the new techniques.*

JP: Yes—that always somehow follows. I mean, the strangeness will wear off and I think we will discover the deeper meanings in modern art.

ww: *I suppose every time you are approached by a layman they ask you how they should look at a Pollock painting, or any other modern painting—what they look for—how do they learn to appreciate modern art?*

JP: I think they should not look for, but look passively—and try to receive what the painting has to offer and not bring a subject matter or preconceived idea of what they are to be looking for.

ww: *Would it be true to say that the artist is painting from the unconscious, and the— canvas must act as the unconscious of the person who views it?*

JP: The unconscious is a very important side of modern art and I think the unconscious drives do mean a lot in looking at paintings.

ww: *Then deliberately looking for any known meaning or object in an abstract painting would distract you immediately from ever appreciating it as you should?*

JP: I think it should be enjoyed just as music is enjoyed—after a while you may like it or you may not. But—it doesn't seem to be too serious. I like some flowers and others, other flowers I don't like. I think at least it gives—I think at least give it a chance.

WW: *Well, I think you have to give anything that sort of chance. A person isn't born to like good music, they have to listen to it and gradually develop an understanding of it or liking for it. If modern painting works the same way—a person would have to subject himself to it over a period of time in order to be able to appreciate it.*

JP: I think that might help, certainly.

WW: *Mr. Pollock, the classical artists had a world to express and they did so by representing the objects in that world. Why doesn't the modern artist do the same thing?*

JP: H'm—the modern artist is living in a mechanical age and we have a mechanical means of representing objects in nature such as the camera and photograph. The modern artist, it seems to me, is working and expressing an inner world—in other words—expressing the energy, the motion, and other inner forces.

WW: *Would it be possible to say that the classical artist expressed his world by representing the objects, whereas the modern artist expresses his world by representing the* effects *the objects have upon him?*

JP: Yes, the modern artist is working with space and time, and expressing his feelings rather than illustrating.

WW: *Well, Mr. Pollock, can you tell us how modern art came into being?*

JP: It didn't drop out of the blue; it's a part of a long tradition dating back with Cézanne, up through the cubists, the post-cubists, to the painting being done today.

WW: *Then, it's definitely a product of evolution?*

JP: Yes.

WW: *Shall we go to this method question that so many people today think is important? Can you tell us how you developed your method of painting, and why you paint as you do?*

JP: Well, method is, it seems to me, a natural growth out of a need, and from a need the modern artist has found new ways of expressing the world about him. I happen to find ways that are different from the usual techniques of painting, which seems a little strange at the moment, but I don't think there's anything very different about it. I paint on the floor and this isn't unusual—the Orientals did that.

WW: *How do you go about getting the paint on the canvas? I understand you don't use brushes or anything of that sort, do you?*

JP: Most of the paint I use is a liquid, flowing kind of paint. The brushes I use are used more as sticks rather than brushes—the brush doesn't touch the surface of the canvas, it's just above.

WW: *Would it be possible for you to explain the advantage of using a stick with paint—liquid paint rather than a brush on canvas?*

JP: Well, I'm able to be more free and to have greater freedom and move about the canvas, with greater ease.

WW: *Well, isn't it more difficult to control than a brush? I mean, isn't there more a possibility of getting too much paint or splattering or any number of things? Using a brush, you put the paint right where you want it and you know exactly what it's going to look like.*

JP: No, I don't think so. I don't—ah—with experience—it seems to be possible to control the flow of the paint, to a great extent, and I don't use—I don't use the accident—'cause I deny the accident.

WW: *I believe it was Freud who said there's no such thing as an accident. Is that what you mean?*

JP: I suppose that's generally what I mean.

WW: *Then, you don't actually have a preconceived image of a canvas in your mind?*

JP: Well, not exactly—no—because it hasn't been created, you see. Something new—it's quite different from working, say, from a still life where you set up objects and work directly from them. I do have a general notion of what I'm about and what the results will be.

WW: *That does away, entirely, with all preliminary sketches?*

JP: Yes, I approach painting in the same sense as one approaches drawing; that is, it's direct. I don't work from drawings, I don't make sketches and drawings and color sketches into a final painting. Painting, I think, today—the more immediate, the more direct—the greater the possibilities of making a direct—of making a statement.

WW: *Well, actually every one of your paintings, your finished canvases, is an absolute original.*

JP: Well—yes—they're all direct painting. There is only one.

WW: *Well, now, Mr. Pollock, would you care to comment on modern painting as a whole? What is your feeling about your contemporaries?*

JP: Well, painting today certainly seems very vibrant, very alive, very exciting. Five or six of my contemporaries around New York are doing very vital work, and the direction that painting seems to be taking here—is—away from the easel—into some sort, some kind of wall—wall painting.

WW: *I believe some of your canvases are of very unusual dimensions, isn't that true?*

JP: Well, yes, they're an impractical size—9 x 18 feet. But I enjoy working big and—whenever I have a chance, I do it whether it's practical or not.

WW: *Can you explain why you enjoy working on a large canvas more than on a small one?*

JP: Well, not really. I'm just more at ease in a big area than I am on something 2x2; I feel more at home in a big area.

WW: *You say "in a big area." Are you actually on the canvas while you're painting?*

JP: Very little. I do step into the canvas occasionally—that is, working from the four sides I don't have to get into the canvas too much.

WW: *I notice over in the corner you have something done on plate glass. Can you tell us something about that?*

JP: Well, that's something new for me. That's the first thing I've done on glass and I find it very exciting. I think the possibilities of using painting on glass in modern architecture—in modern construction—terrific.

WW: *Well, does the one on glass differ in any other way from your usual technique?*

JP: It's pretty generally the same. In this particular piece I've used colored glass sheets and plaster slabs and beach stones and odds and ends of that sort. Generally it's pretty much the same as all of my paintings.

WW: *Well, in the event that you do more of these for modern buildings, would you continue to use various objects?*

JP: I think so, yes. The possibilities, it seems to me are endless, what one can do with glass. It seems to me a medium that's very much related to contemporary painting.

WW: *Mr. Pollock, isn't it true that your method of painting, your technique, is important and interesting only because of what you accomplish by it?*

JP: I hope so. Naturally, the result is the thing—and—it doesn't make much difference how the paint is put on as long as something has been said. Technique is just a means of arriving at a statement.

Francis V. O'Connor dates these handwritten statements, found among Pollock's papers, to late 1950, after the recording of the Wright interview.

Jackson Pollock. Handwritten statement.
UNDATED. © THE POLLOCK-KRASNER FOUNDATION, INC.

No Sketches

acceptance of

what I do—.

Experience of our age in terms

of painting—not an illustration of—

(but *the equivalent.*)

Concentrated

fluid

Jackson Pollock. Handwritten statement.
UNDATED. © THE POLLOCK-KRASNER FOUNDATION, INC.

Technic is the result of a need ————

new needs demand new technics ——————

total control ———— denial of

the accident ——————————

States of order ————

organic intensity ————

energy and motion

made visible ——————

memories arrested in space,

human needs and motives ——————

acceptance ————

Jackson Pollock

Interviews with Lee Krasner

Beginning in 1967, Pollock's widow, the painter Lee Krasner, gave a series of remarkable interviews discussing Pollock's development as an artist, his working process, and the tensions in his life. Krasner's artistic and intellectual insights illuminate not only Pollock's career, but an entire era in American art.

Bruce Glaser. "Jackson Pollock: An Interview with Lee Krasner." *Arts Magazine* 41, NO. 6 (APRIL 1967): 36–39.

Lee Krasner's painting career spans a period of about thirty-five years, yet for the last twenty, her most vital years, she has not been accorded her due as a painter. This was not because she lacked in her capacity as an artist, as her continued and serious development during this time clearly indicates. Her inclusion in numerous important group exhibitions since 1940, her six one-man shows at several of New York's leading galleries and her large, retrospective exhibition at the White-chapel Gallery in London in 1965, were a recognition of her place in the avant-garde of American art and an opportunity for the more knowledgeable members of the art world to affirm her position. Although these accomplishments were based on a solid body of work, a less serious minded public preferred their fascination for her first as Jackson Pollock's wife (1945–56) and then, as heir to his properties, as an ostensibly powerful manipulator of art prices and politics.

Miss Krasner's identity as a serious painter was unquestioned by Pollock when he became acquainted with her in 1942, during the course of their participation in an exhibition called, "French and American Painting." The exhibit was arranged to compare contemporary artists on both sides of the Atlantic, but also to convey the unpopular idea that American artists could hold their own in the context of the modern European masters. The show, organized by John Graham and held at the McMillen Gallery, included works by Matisse and Picasso, and other French painters along with a group of paintings by comparatively unknown Americans, including Stuart Davis and Gorky (as well as Pollock and Krasner) whom Graham considered the important members of the younger generation of abstract artists.

The possibility of a proper assessment of Miss Krasner's work after that seems to have dissipated as she became closely associated with the powerful personality of Pollock. Nevertheless, her work retained its independence and was remarked upon for its quality by the more discerning critics. A case in point is the group of intricate, tightly-knit 'hieroglyphic paintings' from between 1946

and 1950, which are not clearly related to her husband's generally more open, looser-flowing compositions of that period. But it was only recently in London, away from the habit of insidious associations prevalent in the New York art world, on the occasion of her retrospective exhibition, that her work was able to gain independent recognition from a very responsive public as well as from the experts.

In the following interview with Miss Krasner I focused on her recollections of the artistic milieu of the late 'thirties and the early 'forties, the period leading up to the maturation of American painting into a world-wide influence. As such, this inquiry outlines a part of the background of the New American Painting of which Lee Krasner is an integral part. The interview was originally broadcast over WBAI-FM, New York, and appears here in a revised and edited form.

GLASER: *The American 'art scene' in the 1930's and 1940's must have been quite different from the years that followed the advent of the so-called culture explosion. In contrast to the New York art world today, where a mass public responds immediately to the latest styles of contemporary painting, would it be fair to characterize that time as an 'Age of Innocence'?*

KRASNER: I am certainly aware of the difference between that time and today, but I am not so sure it was an 'Age of Innocence' for the artists, as we were conscious of the directions that painting was taking.

In the late 1930's the 'art scene' consisted of a rather intimate group of painters and their friends. I don't mean that we saw each other steadily, but one knew who was painting and what their work was about. We didn't know this through galleries since almost none of us had anywhere we could show and the galleries weren't interested in showing our kind of painting. There were some dealers who were interested in avant-garde art, but they were generally involved with its European manifestations. For most of us, our knowledge of what was happening here came from one another. We would meet at a bar or we might visit each other's studio from time to time and talk. Now, with us, as with the dealers, the focus was on French painting. We felt that what was contemporary and alive was happening in Paris and we looked forward to publications from there because not much of the work was being shown. We kept aware of the painting from abroad and were very much involved in it and developed from it, eventually achieving our independence and our own reputations.

GLASER: *Who did see your work then, in the early days?*

KRASNER: Many of us were members of a group called the American Abstract Artists which we formed to exhibit our works once a year. As the title implies, we were oriented to abstract art, but not all the abstract artists were members. We would rent a place, put a show together ourselves and then try to interest people in coming to see it. However, a very few people actually bought our paintings. The public, critical and museum response to American painting was direct-

ed almost entirely toward the regional schools and social realist painting.

GLASER: *Was there anyone in your group of painters who was very highly regarded or looked up to as an influence at that time?*

KRASNER: We were aware of what others were doing but there was no special regard for any one artist. I was very aware of what Gorky, Stuart Davis, John Graham and De Kooning, among others, were doing. I didn't know Pollock at this point. I didn't get to see his work until 1942 when we both participated in a show at the McMillen Gallery.

GLASER: *What was the significance of the Works Progress Administration (WPA) labor relief program to the artists? Didn't it provide an opportunity for you to meet other artists and also to have your work seen by the public at large?*

KRASNER: The Federal Arts Project of the WPA not only offered an opportunity for artists to meet, but more important, it provided a livelihood. This was, of course, during the Depression and a great many artists were dependent on the WPA. That it made it possible for them to survive and continue painting seems to me its most significant aspect, even if it had some bad ones. An organization as large as this one was, with its complex administration, would naturally get wound up in its own red tape. For example, in order to get a work of art for some public building, somebody from the public had to say we want a painting of a certain kind. Unfortunately, art doesn't work well when subjected to democratic processes. Predictably, the abstract artists were not much in demand.

GLASER: *Didn't the abstract artists reflect a strong political awareness in spite of their avoidance of representational styles that could be used to promote their views?*

KRASNER: Yes, many of us took part in demonstrations and sit-down strikes. In fact, I was arrested many times myself. But as far as I can see this had no connection with my painting. My experience with Leftist movements in the late 1930's made me move as far away from them as possible because they were emphasizing the most banal, provincial art. They weren't interested in an independent and experimental art, but rather linked it to their economic and political programs. Eventually the Communist Party moved into the Artists' Union, which had been formed to protect the rights of the artists on the WPA, and started to take over. Then I decided it was time to leave. The trouble was that the union didn't meet to discuss any problems in painting, though occasionally they would put on some sort of exhibition. Their primary emphasis under the domination of the Communist Party was a quest for political power and influence. To me, and to the painters I was associated with, the more important thing was French painting and not the social realism and the picture of the Depression that they were interested in, even if it was going on right under our noses. Painting is not to be confused with illustration.

GLASER: *Who were the French painters you were most interested in?*

KRASNER: Matisse and Picasso. Of course, one was aware of other artists working

in France, but they were the two dominant figures and one thought of Paris as the place from which the vitality and the living force of painting emanated. When many of the European artists, such as Mondrian, Matta, Chagall, Léger, Lipchitz, and others, came to New York as refugees at the beginning of World War II, we were highly conscious of their presence and very pleased and excited that they were here. I remember the American Abstract Artists invited Léger and Mondrian to take part in one of our exhibitions. But for me, the two artists I was most interested in were still in Paris. It was not the physical presence of the painters that mattered, but their work.

GLASER: *What was Jackson Pollock's effect at this time, and what was his relationship to European painting?*

KRASNER: Jackson Pollock was an enormous factor as he exploded. He popped the lid, so to speak. His painting shifted the focus of attention from French painting to what was happening here. I think this change could be indicated by an incident I recall that took place between Hofmann, who was a leading exponent of Cubism, and Pollock. I brought Hofmann up to meet Pollock for the first time and Hofmann said, after looking at his work, "You do not work from nature." Pollock's answer was, "I am nature." I think this statement articulates an important difference between French painting and what followed. It breaks once and for all the concept that was still more or less present in Cubist derived painting, that one sits and observes nature that is out there. Rather, it claims a oneness.

GLASER: *Some of the criticism and analysis of Pollock's paintings emphasizes the role of spontaneity or the 'automatic' quality of his working process. One has the feeling from these descriptions that he had little consciousness of intention and that he made his paintings as if he were caught up in some sort of emotional outpouring or rhapsodic transport. From what you knew of him, do you think this is an accurate description of the way he painted?*

KRASNER: The way you describe it, and I don't know where you read this, it sounds like a piece of intellectual snobbery of the lowest order. I go on the assumption that the serious artist is a highly sensitive, intellectual and aware human being, and when he or she 'pours it out' it isn't just a lot of gushy, dirty emotion. It is a total of the experiences which have to do with being a painter and an aware human being. The painter's way of expressing himself is through painting not through verbal ideas, but that doesn't preclude the presence of highly intellectual concepts. The painter is not involved in a battle with the intellect.

GLASER: *What kind of changes occurred in the New York art world after World War II, in the late 1940's?*

KRASNER: Many exciting things were happening here and a larger group of people began to respond to them. Galleries were beginning to show the work, some new schools started up and more magazines and articles about what we were

doing appeared. Eventually the recognition became international.

One of the things that might have influenced the public attitude about the New American Painting was the publication of several pages of full-color reproductions of Pollock's work in *Life* magazine in 1949. It was the first instance of a mass circulation magazine reaching a public very innocent about modern art and telling them, in a featured article, about the significance of what was happening here. The article's title was, "Jackson Pollock, Is He the Greatest Living Painter in the United States?", and I believe the question was stated as a result of Clement Greenberg's proposal of that idea when he was reviewing for the *Nation*. Greenberg was one of the few critics who spoke specifically for Pollock at the time Pollock was painting. There wasn't the solid front for the new artists, among writers and the art magazines, that one imagines. *Art News*, among other publications, hardly mentioned Pollock. Review after review of one major show after another consisted of just a few lines, a little blurb. So the article in *Life* was all the more extraordinary.

The museums didn't show much more conviction. The *She-Wolf*, a painting that was in Jackson's first exhibition in 1943, at Peggy Guggenheim's Art of This Century Gallery, was reserved for purchase by the Museum of Modern Art, but they felt that the price of $650 was too high for them. Only a short time later, after James Johnson Sweeney wrote an article called "Five American Painters" for *Harper's Bazaar*, that included a half-page color reproduction of the painting, did the museum get the $650 to buy it. Sweeney also was one of Pollock's early supporters and he introduced his first show.

GLASER: *When did the public show its commitment by actually buying his paintings?*

KRASNER: I really don't know. It happened so fast that I haven't been able to figure it out. For instance, the painting *Blue Poles*, which was painted in 1953, and shown at the Sidney Janis Gallery within a year or two after that, was purchased from the gallery for $6,500. In 1957, it was included in the Jackson Pollock exhibition that was sponsored by the Museum of Modern Art and circulated in Europe. The show was planned before Jackson's death in the automobile accident in 1956, and so the show became a memorial. Now the man who owned the painting put it up for sale and it was purchased in Europe for $35,000. It seems as if the show's tour through Europe had something to do with the rise in price, and in effect European approval was still very important.

GLASER: *How do you feel about the often expressed notion that Abstract Expressionism is over with, and what is your feeling about the work of the younger painters?*

KRASNER: The idea that Abstract Expressionism is finished and dead has more to do with public relations than with art. It arises from the consumer's need to always have something new. In spite of the pressures in this country to keep up with the new, I think there is some very good painting being done today. The trouble is that one sees a commercialism that is shocking. As I said before, artists

exhibit soon after leaving their art schools and they have little difficulty selling their work. The galleries are fighting for them. But of course, you can't get art the way you pick apples off a tree. In a situation like this the serious young painters who have not joined the bandwagon need encouragement and support because they are doing the most vital and interesting work.

Francine du Plessix and Cleve Gray. Interview with Lee Krasner in "Who Was Jackson Pollock?" *Art in America*

55, NO. 3 (MAY–JUNE 1967): 48–51. ORIGINALLY PUBLISHED IN ART IN AMERICA, BRANT PUBLI-CATIONS, INC., MAY/JUNE 1967.

In a letter of 1929 written from Los Angeles, where Jackson was in Manual Arts High School, he told his brother Sandy, "People terrify and bore me."

Jackson faced his problems. You ask about his drinking. The drinking was something we faced all the time; wouldn't I be foolish if I didn't talk about it? No one was more conscious about it than he was. Jackson tried everything to stop drinking—medical treatments, analysis, chemistry, everything available. In the late 1940s he went to a Dr. Heller, a general practitioner who had never treated an alcoholic. He was the first man who was really able to help Jackson stop drinking. From 1948 to 1950 Jackson did not touch alcohol. I often asked him what Dr. Heller did, when he saw him every week at the East Hampton Medical Clinic. Apparently they just talked. Once when I asked him about Dr. Heller, Jackson said to me, "He is an honest man, I can believe him." Do you realize what that means? "He is an honest man, I can believe him."

He never drank while he worked. You know, he worked in cycles. There would be long stretches of work and then times when he did not work. He drank before and after these work cycles. In 1950 Dr. Heller got killed in an automobile accident—just like Jackson—and when Jackson took to drink again later that year there was no Heller to go to.

I remember the day I went to his studio for the first time. It was late '41. I went because we had both been invited by John Graham to show in the Mc-Millen Gallery in January '42. I wanted to meet this artist I had never heard about. Actually we had met about four years before and had danced together at an Artists' Union party. But I had forgotten about that first meeting. When he was invited to the McMillen show I was astonished because I thought I knew all the abstract artists in New York. You know, in those days one knew everyone. Well, I was in a rage at myself, simply furious because here was a name that I hadn't heard of. All the more furious because he was living on Eighth Street and I was on Ninth, just one block away. He and his brother Sandy and Sandy's wife had the top floor; each had half. As I came in, Sandy was standing at the top of

the stairs; I asked for Jackson Pollock, and he said, "You can try knocking over there, but I don't know if he's in." I later found out from Sandy that it was most unusual for Jackson to answer. When I knocked, he opened. I introduced myself and said we were both showing in the same show. I walked right in.

What did I think? I was overwhelmed, bowled over, that's all. I saw all those marvelous paintings. I felt as if the floor was sinking when I saw those paintings. How could there be a painter like that that I didn't know about? I must have made several remarks on how I felt about the paintings. I remember remarking on one, and he said, "Oh, I'm not sure I'm finished with that one." I said, "Don't touch it!" Of course I don't know whether he did or not.

He was not a big man, but he gave the impression of being big. About five-foot-eleven—average—big-boned, heavy. His hands were fantastic, powerful hands. I wish there were photographs of his hands. All told, he was physically powerful. And this ran through from the first time I met him until the day he died, when there had been quite a change in his appearance.

He was not in the war at the time I met him because he had been classified 4-F. He had spent six months at Bloomingdale's, a White Plains, New York, hospital for treatment of psychiatric cases, when he was about eighteen. And the alcoholic problem had been with him most of his life. One morning before we were married Sandy knocked on my door and asked "Did Jackson spend the night here last night?" I answered, "No, why?" "Because he's in Bellevue Hospital and our mother has arrived in New York. Will you go with me and get him?" We went and there he was in the Bellevue ward. He looked awful. He had been drinking for days. I said to him, "Is this the best hotel you can find?" At Sandy's suggestion I took him back to my place and fed him milk and eggs to be in shape for dinner that night with Mother. We went together. It was my first meeting with Mother. I was overpowered with her cooking, I had never seen such a spread as she put on. She had cooked all the dinner, baked the bread, the abundance of it was fabulous. I thought Mama was terrific. Later I said to Jackson, "You're off your rocker, she's sweet, nice." It took a long time for me to realize why there was a problem between Jackson and his mother. You see, at that time I never connected the episode of Jackson's drinking with his mother's arrival. And around then Stella (Jackson's mother) moved out to Connecticut with Sandy and his family so we didn't really see that much of her. I hadn't yet seen anything of the dominating mother.

When we were married Jackson wanted a church wedding; not me. *He* wanted it and we had it. Jackson's mother, in fact all the family, was anti-religious—that's a fact. Violently anti-religious. I felt that Jackson, from many things he did and said, felt a great loss there. He was tending more and more to religion. I felt that went back to his family's lack of it. You know in his teens he used to listen to Krishnamurti's lectures.

If I conjure up the gentle part of Jackson, that was one part. But there was the other part, the other extreme, the angry man. Both of them existed in extremes. But Jackson's violence was all verbal. There never was any physical violence. He would just use more four-letter words than usual. Or he would take it out on the furniture. One night we were having ten or twelve people for dinner. Jackson and Hans Namuth were at one end of the table. I don't know what the argument was about, but I heard loud voices and suddenly Jackson overturned the whole table with twelve roast beef dinners. It was a mess. I said, "Coffee will be served in the living room." Everyone filed out and Jackson went off without any trouble. Jeffrey Potter and I cleaned up.

I will tell you a story about de Kooning. Jackson and he were standing at the Cedar Bar, drinking. They started to argue and de Kooning punched him. There was a crowd around them and some of the fellows tried to egg Jackson on to hit de Kooning back. Jackson turned to them and said: "What? Me? Hit an artist?" He was *not* violent. Angry, yes. Bitter, yes. Impatient, yes. Not violent.

This is how we got to live in Springs: We had friends, the Kadishes, who rented a house out there in the summer of '45. They invited us to spend a weekend with them. Jackson loved city life. I was the one who had an aspiration to live in the country. At the end of that weekend I said to Jackson: "How about us looking for a place to rent and moving out there for one winter? We can rent that house we saw for forty dollars, and sublet our own place." He thought it was a terrible idea. But I remember when we got back to Eighth Street he spent three days stretched out on the couch just thinking. Then on Friday he leaped up and said, "Lee, we're going to buy a house in Springs and move out!" Well of course we didn't even have the forty dollars to pay rent, not to speak of *buying* a house, so I said, "Jackson, have you gone out of your mind?" His answer was: "Lee, you're always the one who's saying I shouldn't let myself worry about the money; we'll just go ahead and do it." We went back to Springs. The house we wanted had just been sold, so we asked the agent to see what else there was. He showed us a place we liked. The price was $5,000. We could get a $3,000 mortgage and had to raise $2,000 in cash. I went to Peggy Guggenheim, but she wouldn't consider a loan and said sarcastically, "Why don't you go ask Sam Kootz?" I went to see Kootz, and he agreed to lend us the money but only with the understanding that Jackson would come over to his gallery; he had heard that Peggy was closing her gallery. When I got back to Peggy's and told her what Kootz had said, she exploded. "How could you do such a thing and with Kootz of all people! Over my dead body you'll go to Kootz!" I said, "But Peggy, it was your idea to ask Kootz." Well, we eventually reached an agreement by means of which Peggy lent us the $2,000. She did this by raising Jackson's monthly fee to $300, deducting $50 a month to repay the loan and having rights to all of Jackson's output for the next two years. This, incidentally, was the agreement that gave rise to her

recent lawsuit against me.

I think that living in Springs allowed Jackson to work. He needed the peace and quiet of country life. It enabled him to work.

The first two years we lived in Springs we had no car. You know, before I met him, there was an existence of dire poverty, about as bad as it can be. This was sometime between the time he arrived in New York and when he got on W.P.A. In the deep Depression he used to get a meal for five cents. I know that when he lived with Sandy he had to work as a janitor in the Little Red School-house in The Village. Later Jackson got a Model A Ford, but in the beginning we had to bicycle to do all the errands; that would take a good part of the day.

He always slept very late. Drinking or not, he never got up in the morning. He could sleep twelve, fourteen hours, around the clock. We'd always talk about his insane guilt about sleeping late. Morning was my best time for work, so I would be in my studio when I heard him stirring around. I would go back, and while he had his breakfast I had my lunch. His breakfast would not set him up and make him bolt from the table like most people. He would sit over that damn cup of coffee for two hours. By that time it was afternoon. He'd get off and work until it was dark. There were no lights in his studio. When the days were short he could only work for a few hours, but what he managed to do in those few hours was incredible. We had an agreement that neither of us would go into the other's studio without being asked. Occasionally, it was something like once a week, he would say, "I have something to show you." I would always be aston-ished by the amount of work that he had accomplished. In discussing the paint-ings, he would ask, "Does it work?" Or in looking at mine, he would comment, "It works" or "It doesn't work." He may have been the first artist to have used the word "work" in that sense. There was no heat in his studio either, but he would manage in winter if he wanted to; he would get dressed up in an outfit the like of which you've never seen.

He often said, "Painting is no problem; the problem is what to do when you're not painting."

In the afternoon, if he wasn't working, we might bicycle to town. Or when we had a car, he would drive me to town and wait in the car for me while I shopped. When he was working, he would go to town when the light gave out and get a few cartons of beer to bring home. Of course, during those two years (1948 and 1949) he was on the wagon. He didn't touch beer either. We would often drive out in the old Model A and get out and walk. Or we would sit on the stoop for hours gazing into the landscape without exchanging a word. We rarely had art talk, sometimes shop talk, like who's going to what gallery.

One thing I will say about Pollock; the one time I saw temperament in him was when he baked an apple pie. Or when he tried to take a photograph. He never showed any artistic temperament. He loved to bake. I did the cooking but

he did the baking when he felt like it. He was very fastidious about his baking—marvelous bread and pies. He also made a great spaghetti sauce.

He loved machinery, so he got a lawn mower. We made an agreement about the garden when he said, "I'll dig it and set it out if you'll water and weed." He took great pride in the house. One of the reasons for our move to Springs was that Jackson wanted to do sculpture. You know, it was his original interest in high school and art school. He often said, "One of these days I'll get back to sculpture." There was a large junk pile of iron in the backyard he expected to use.

He would get into grooves of listening to his jazz records—not just for days—day and night, day and night for three days running until you thought you would climb the roof! The house would *shake*. Jazz? He thought it was the only other really creative thing happening in this country. He had a passion for music. He had trouble carrying a tune, and although he loved to dance he was an awkward dancer. He told me that when he was a boy he bought himself a violin expecting to play it immediately. When he couldn't get the sound he wanted out of it, he smashed it in a rage.

He was secure in his work. In *that* he was sure of himself. But I can't say he was a happy man. There were times when he was happy, of course; he loved his house, he loved to fool in his garden, he loved to go out and look at the dunes, the gulls. He would talk for hours to Dan Miller, the grocery store owner. He would drink with the plumber, Dick Talmadge, or the electrician, Elwyn Harris. Once they came into New York to see one of his exhibitions.

It is a myth that he wasn't verbal. He could be hideously verbal when he wanted to be. Ask the people he really talked to: Tony Smith and me. He was lucid, intelligent; it was simply that he didn't want to talk art. If he was quiet, it was because he didn't believe in talking, he believed in *doing*.

There is a story about Hans Hofmann related to this. It was terribly embarrassing to me, because I brought Hofmann to see Pollock. Hofmann, being a teacher, spent all the time talking about art. Finally Pollock couldn't stand it any longer and said, "Your theories don't interest me. Put up or shut up! Let's see your work." He had a fanatical conviction that the *work* would do it, not any outside periphery like *talk*.

There is so much stupid myth about Pollock, I can't stand it!

There is the myth of suicide. There is no truth in this. It was an automobile accident like many others. That was a dangerous part of the road; just a while before, I myself skidded on that part of the road. The state highway department had to fix it soon after Jackson's death. That speaks for itself.

I'm bored with these myths. Jackson was damn decent to his friends no matter what the situation was. He saw few people; he didn't have a lot of friends. He was not interested in contemporary artists' work—except for a few—but, as it turned out, most of the people he saw had a connection with the arts. Among

those who recognized Pollock's work, John Graham preceded everybody. One night when we were walking with John, we saw a little man with a long overcoat; it was Frederick Kiesler. John introduced Pollock by saying: "I want you to meet the greatest painter in America." Kiesler bowed low to the ground, and as he came up he asked, "North or South America?" Jim Sweeney was the first to go into print for Pollock; he introduced Pollock's first show. It was a fine introduction, but in it he called Jackson "undisciplined." Jackson got furious. Oh, he was angry, really mad, and he painted a picture, *Search for a Symbol*, just to show how disciplined he was. He brought the wet painting to the gallery where he was meeting Jim Sweeney and said, "I want you to see a really disciplined painting."

Herbert and Mercedes Matter brought Sandy Calder to see Jackson in '42. After looking at the paintings, Sandy said, "They're all so *dense*." He meant that there was no space in them. Jackson answered, "Oh you want to see one less dense, one with open space?" And he went back for a painting and came out with the densest of all. That's the way he could be. But he had deep understanding of his friends. One day I asked him, "Why is Jim Brooks so terrified of you when you are drunk?" Jackson explained sympathetically to me why Jim might be reacting that way. When I would speak to him about my own troubles with his drinking, he would say, "Yes, I know it's rough on you. But I can't say I'll stop, because you know I'm trying to. Try to think of it as a storm. It'll soon be over."

B. H. Friedman. "An Interview with Lee Krasner Pollock." In *Jackson Pollock: Black and White*, exh. cat.
NEW YORK: MARLBOROUGH-GERSON GALLERY, 1969, PP. 7–10. REPRINTED BY PERMISSION OF B. H. FRIEDMAN.

BHF: *In 1951, when Jackson had his black-and-white show at Betty Parsons', many of us were surprised, even shocked, not only by the lack of color, its seeming denial, but by the return in some of these paintings to figurative work. We, on the outside, had watched his development as an abstractionist and as a very original colorist, but did you experience the same sense of shock? Or, being closer to him and the work, had you seen or felt these paintings coming?*

LKP: Well, of course, I had one advantage that very few others had—I was familiar with his notebooks and drawings, a great body of work that most people didn't see until years later, after Jackson's death. I'm not talking about drawings he did as a student of Benton, but just after that, when he began to break free, about in the mid-'thirties. For me, all of Jackson's work grows from this period; I see no more sharp breaks, but rather a continuing development of the same themes and obsessions. The 1951 show seemed like

monumental drawing, or maybe painting with the immediacy of drawing—
some new category. . . . There's one other advantage I had: I saw his paint-
ings evolve. Many of them, many of the most abstract, began with more or
less recognizable imagery—heads, parts of the body, fantastic creatures.
Once I asked Jackson why he didn't stop the painting when a given image
was exposed. He said, 'I choose to veil the imagery'. Well, that was that
painting. With the black-and-whites he chose mostly to expose the imagery.
I can't say why. I wonder if he could have.

BHF: *Then, do you consider these paintings more 'naked' than his earlier work?*

LKP: No, no more naked than some of those early drawings—or paintings like
Male and Female or *Easter and the Totem*. They come out of the same sub-
conscious, the same man's eroticism, joy, pain. . . Some of the black-and-
whites are very open, ecstatic, lyrical; others are more closed and hidden,
dark, even oppressive, just as with the paintings in color.

BHF: *In the 1950 show there seems to have been something like a primitive* horror vacui:
the entire canvas needing to be filled—except for Number 32. *In that painting, as
in the 1951 black-and-whites, there's an acceptance of empty space, negative space,
the void. The voids read positively. Do you think the 1951 show came out of that
one monumental black-and-white in the '50 show?*

LKP: After the '50 show, what do you do next? He couldn't have gone further
doing the same thing.

BHF: *Jackson spoke about liking the resistance of the hard surface of the floor when he
painted. Perhaps, in a sense, limiting himself to black-and-white may have been
another form of self-imposed resistance?*

LKP: I haven't a clue as to what swung him exclusively into black-and-white at
that point—besides the drawings, he did some black-and-white paintings of
considerable size earlier—but it was certainly a fully conscious decision.
There were no external causes, no shortage of color or anything like that.

BHF: *He very much admired* Guernica *and the studies for it; was he maybe responding
to that, reacting to it?*

LKP: If so, it was an awfully slow burn—say, twenty years. But there's no question
that he admired Picasso and at the same time competed with him, wanted
to go past him. Even before we lived in East Hampton, I remember one time
I heard something fall and then Jackson yelling, 'God damn it, that guy
missed nothing!' I went to see what had happened. Jackson was sitting, star-
ing; and on the floor, where he had thrown it, was a book of Picasso's work
. . . Jackson experienced extremes of insecurity and confidence. You only
have to see the film of him making his painting on glass (*Number 29*, 1950)
to know how sure he was of himself: the way he wipes out the first start and
begins over. But there were other times when he was just as unsure. A little
later, in front of a very good painting—not a black-and-white—he asked me,

'Is this a painting?' Not is this a good painting, or a bad one, but *a painting!* The degree of doubt was unbelievable at times. And then, again, at other times he knew the painter he was. It's no wonder he had doubts. At the opening of the black-and-white show one of the New York dealers, supposedly in the know, told him, 'Good show, Jackson, but could you do it in color?' A few weeks later another dealer said to me, 'It's all right, Lee, we've accepted it'. The arrogance, the blindness was killing. And, as you see, not only from the outside world, but the art world itself.

BHF: *What about the imagery? Did Jackson ever talk about it?*

LKP: I only heard him do that once. Lillian Kiesler and Alice Hodges were visiting and we were looking at *Portrait and a Dream*. (This is a diptych of 1953, in which the left panel is black-and-white, abstractly suggestive of two anthropomorphic figures, and the right—gray, orange, and yellow—is clearly a man's head, probably a self-portrait.) In response to their questions, Jackson talked for a long time about the left section. He spoke freely and brilliantly. I wish I had had a tape-recorder. The only thing I remember was that he described the upper right-hand corner of the left panel as 'the dark side of the moon'.

BHF: *Several writers have connected the black-and-white paintings, and some of the colored ones also, with the feel of the East Hampton landscape, particularly in winter: the look of bare trees against the sky and flat land moving out toward the sea.*

LKP: Jackson was pretty explicit about that in the *Arts & Architecture* questionnaire. ('. . . I have a definite feeling for the West: the vast horizontality of the land, for instance; here only the Atlantic Ocean gives you that.') Then (1944) he emphasized the West, but by the time of the black-and-white show, after living in Springs for six years, I think he would have given just as much emphasis to this Eastern Long Island landscape—and seascape. They were part of his consciousness: the horizontality he speaks of, and the sense of endless space, and the freedom. . . . The only time I heard him use the word 'landscape' in connection with his own work was one morning before going to the studio, when he said, 'I saw a landscape the likes of which no human being could have seen'.

BHF: *I guess he was talking about a sort of visionary landscape.*

LKP: Yes, but in Jackson's case I feel that what the world calls 'visionary' and 'real' were not as separated as they are for most people.

BHF: *Maybe Jackson lived in a visionary landscape all the time. . . . Can you say something about how these paintings were made, the physical procedure?*

LKP: Yes, there I'm on safer ground. Jackson used rolls of cotton duck, just as he had intermittently since the early 'forties. All the major black-and-white paintings were on unprimed duck. He would order remnants, bolts of canvas anywhere from five to nine feet high, having maybe fifty or a hundred yards left on them—commercial duck, used for ships and upholstery, from

John Boyle down on Duane Street. He'd roll a stretch of this out on the studio floor, maybe twenty feet, so the weight of the canvas would hold it down—it didn't have to be tacked. Then typically he'd size it with a coat or two of 'Rivit' glue to preserve the canvas and to give it a harder surface. Or sometimes, with the black-and-white paintings, he would size them after they were completed, to seal them. The 'Rivit' came from Behlen and Brother on Christopher Street. Like Boyle's, it's not an art-supplier. The paint Jackson used for the black-and-whites was commercial too—mostly black industrial enamel, Duco or Davoe & Reynolds. There was some brown enamel in a couple of the paintings. So his 'palette' was typically a can or two of this enamel, thinned to the point he wanted it, standing on the floor beside the rolled-out canvas. Then, using sticks, and hardened or worn-out brushes (which were in effect like sticks), and basting syringes, he'd begin. His control was amazing. Using a stick was difficult enough, but the basting syringe was like a giant fountain pen. With it he had to control the flow of ink as well as his gesture. He used to buy those syringes by the dozen. . . . With the larger black-and-whites he'd either finish one and cut it off the roll of canvas, or cut it off in advance and then work on it. But with the smaller ones he'd often do several on a large strip of canvas and then cut that strip from the roll to make more working space and to study it. Sometimes he'd ask, 'Should I cut it here? Should this be the bottom?' He'd have long sessions of cutting and editing, some of which I was in on, but the final decisions were always his. Working around the canvas—in 'the arena' as he called it—there really was no absolute top or bottom. And leaving space between paintings, there was no absolute 'frame' the way there is working on a pre-stretched canvas. Those were difficult sessions. His signing the canvases was even worse. I'd think everything was settled—tops, bottoms, margins—and then he'd have last-minute thoughts and doubts. He hated signing. There's something so final about a signature. . . . Sometimes, as you know, he'd decide to treat two or more successive panels as one painting, as a diptych, or triptych, or whatever. *Portrait and a Dream* is a good example. And, do you know, the same dealer who told me Jackson's black-and-whites were *accepted*, asked him now, two years later, why he didn't cut *Portrait and a Dream* in half!

Barbara Rose. "Jackson Pollock at Work: An Interview with Lee Krasner." *Partisan Review* 47, NO. 1 (1980): 82–92. REPRINTED BY PERMISSION OF BARBARA ROSE.

As Jackson Pollock's paintings are slowly beginning to be understood as works of art belonging to a tradition of modernist painting, as opposed to scandalous personal acts that created the Pollock myth, any information regarding Pollock's own intention and methods becomes critical in defining the actual historical context within which the unprecedented masterpieces—the mural-sized, so-called "drip" paintings he began in 1947—were created. In the following interview with Pollock's widow, painter Lee Krasner, the circumstances leading up to Pollock's discovery of a new style that involved pouring diluted paint onto an unstretched piece of canvas on the floor, rather than applying paint to the conventional stretched painting on the easel or wall, are clarified. The interview, inspired by the forthcoming publication of Hans Namuth's celebrated action photographs in a book called *Pollock Painting*, reveals Krasner's intimate relationship as a colleague with her husband whose principal champion and greatest supporter she was.

Recent interest in Krasner's own career as a pioneer Abstract Expressionist, overshadowed by Pollock's celebrity, has raised the question of why her reputation suffered in relation to those of her male contemporaries. The interview makes it clear for the first time why Krasner was prohibited from painting the big pictures that were essential to the creation of the major reputations of the New York School until after Pollock's death in 1956. For, although she was an abstract artist earlier than any of the first generation New York School painters, except Reinhardt and Gorky (she was painting abstractly while her teacher Hans Hofmann was still a figurative artist), her development as a painter of large-scale, monumental works was artificially postponed as the result of the primacy both she and Pollock gave to his career. Pollock's large "drip" paintings date from the move of his studio from the bedroom in the house the couple purchased in 1945, when they moved from Greenwich Village to Springs, East Hampton, to the barn behind the house which became his studio in 1947. He had already been painting on the floor in the bedroom, but the move into the barn permitted the kind of physical freedom documented in Namuth's photographs and the film made in fall 1950.

With Pollock painting in the barn, Krasner finally had a studio of her own. (She had been working in the living room.) The "little image" series, her own version of all-over painting done with a conventional brush technique on easel-sized canvases, was done in this small bedroom in the late forties. After Pollock's death in 1956, Krasner began using the barn as her studio, working on a very large scale, although she never painted on the floor as Pollock had. Her memories

of life in Springs, during the most productive decade of Pollock's life, add to our understanding of Pollock's central role in the history of the New York School, as well as the nature of their relationship as two working professionals.

Barbara Rose: *When did Pollock begin to use the Springs studio?*

Lee Krasner: We moved out there in November 1945. Pollock started to work in the bedroom upstairs in the house because the barn, which later became the studio, was a mess, filled with lots of rough iron things and some farm implements. Mr. Quinn, the former owner of the house, had something to do with the town roads, so there were all kinds of things in there. You could barely get in, so it was a matter of clearing it out. And that would take time, so he started to work in the house. Pollock's 1946 show was painted in one of the bedrooms upstairs in the house. He painted *The Key* in the bedroom. I remember because it was in the '46 show.

As you know, Pollock painted on the floor: *The Key* took up the whole space on the bedroom floor. He could barely walk around it. The move into the studio had to follow that, because in addition to clearing the barn out, we also moved it, to the site it's on now. (It was directly behind the house and cut off our whole view.) The next show he has is in 1949—in fact, he had two shows in '49, so it must have been between 1947 and 1949 that the building was cleared out and moved, and he began to work in the bigger studio in the barn.

Barbara Rose: *Was there a change in scale because of Pollock's move of his studio from the bedroom to the barn?*

Lee Krasner: Surely, since his 1950 show had some big paintings. It had *One, Autumn Rhythm* hanging opposite it, *Lavender Mist*, plus the big black and white painting in Düsseldorf, the Muriel Newman painting in Chicago, which is about the size of *Lavender Mist*, plus some other big paintings. However, I want to point out that before we moved out to Springs, when we were living on Eighth Street in the Village, Peggy Guggenheim commissioned the mural for her apartment, which is the largest painting Pollock ever painted. That was in 1943. Incidentally, that's not painted on the floor. Pollock didn't always paint on the floor, although he painted a great deal on the floor. For that mural, we had to rip out a wall and carry out the plaster in buckets every night. We weren't supposed to live in the building, which we rented from Sailor's Snug Harbor. At any rate, we needed to create a wall large enough to hold the mural, so we broke down a partition between two rooms. That created a wall long enough for him to get that big mural painting on.

Barbara Rose: *Was that Peggy Guggenheim's dimensions or Pollock's?*

Lee Krasner: The mural was a commission from Peggy of a fixed dimension to fit into the hallway, I believe. She specified the dimension.

Barbara Rose: *Can you be more specific about the date Pollock began painting in the barn?*

Lee Krasner: In 1949 he had two exhibitions. Those paintings were done in the barn, so I would say the move took place probably in 1947. When he took the barn, I took the bedroom as my studio. I do know that my mosaic table was done in 1947, before I got the bedroom. (I was working in the living room.) I remember I moved into the bedroom after the mosaic table was done. It was probably in 1947, not long after Pollock had his 1946 show.

Barbara Rose: *The first "drip" paintings were made in 1947. Do you think moving into the barn had anything to do with greater physical freedom?*

Lee Krasner: It would be very convenient to think along those lines, but I don't believe that was it. Pollock had a lot more space on Eighth Street. He wasn't confined to one tiny little room. I think the increase in size has more to do with the fundamental aspects of why he did what he did. He certainly needed the physical space to work as he did, but I think he would have found the physical space whenever he was ready to paint with large gestures.

Barbara Rose: *Do you remember how and why Pollock started the "drip" paintings? Did he speak of experimenting with a new technique?*

Lee Krasner: I am always rather astonished when I read of a given date. I actually cannot remember when I first saw them.

Barbara Rose: *Was there a perception that he was entering a new area?*

Lee Krasner: There was certainly a sense of "I never saw this before." There is that feeling. But with Pollock one had a lot of that surprise to deal with.

Barbara Rose: *Did he have a sense of how important the "drip" paintings were at the time?*

Lee Krasner: I can only surmise that; I cannot quote him. I have a feeling that he was aware of their importance.

Barbara Rose: *When was the first time you recall seeing him paint on the floor?*

Lee Krasner: He didn't do it when we lived on Eighth Street in New York. But, I remember *The Key* on the floor in the bedroom in 1946. I can't remember him working on the floor in New York, so he must have begun in Springs. I don't have the remotest idea of why he wanted to work on the floor.

Barbara Rose: *Was there any precedent?*

Lee Krasner: The only thing I remember hearing was that he had seen the Indian sand painters working on the ground. As you know, Pollock didn't verbalize at all times. He kept things pretty much to himself; occasionally he said something. I only remember hearing about the Indian sand paintings from him in terms of a precedent for working on the ground.

Barbara Rose: *Yet formalist critics discount the Indian influence in order to make him a thoroughly European artist.*

Lee Krasner: Of course he was very aware of European art, but what he identified with was about as American as apple pie. His stories about the Indians—and he made many trips to the West—were not European in any sense. In finding this flow of paint, this thrust of paint, this aerial form which then landed—his so-

called breakthrough—he could merge many traditions of art. You recall he had said in a '44 interview that here in the East, only the Atlantic gave him a sense of space that he was accustomed to. He did work with his father, who was a surveyor, in the Grand Canyon, so he really had a sense of physical space. In finding this technique of expressing what he expressed, he merged many things out of his American background—which does not disconnect him from tradition and his knowledge of European painting. His art was a synthesis.

Barbara Rose: *Was the barn heated at this time?*

Lee Krasner: The barn was not heated at that time. In some early photographs you can literally see between the boards, which means it wasn't insulated or heated. And that means seasonal work.

Barbara Rose: *So he didn't work in the winter?*

Lee Krasner: No, not dead, dead winter, until later on. At one point he got one of those terrible kerosene stoves, and if he was working he could ignite it, which terrified me. A little wooden barn, full of pigment and all sorts of flammable stuff, heated by one of those kerosene potbellies. You know, with a chimney and a big kerosene container on the bottom. Very frightening.

Barbara Rose: *When he didn't paint, did he draw?*

Lee Krasner: Not necessarily. He really worked in cycles. When he was working, the weather didn't especially stop him. He would put layers and layers of clothing on and would ignite that kerosene thing and work. But there were some months, about four or five months of the year when it was bitter, bitter cold out there, when you really couldn't work. Otherwise, he could manage somehow or other. He did an enormous amount of work considering that there was no heat in the barn.

Barbara Rose: *Did you feel that temperamentally the seasons had an effect on him out there?*

Lee Krasner: At the time I wasn't aware of it as such. Certainly his relationship to nature was intense. For example, the moon had a tremendous effect on him, and he liked gardening. Just walking on the beach in the wintertime, with snow on the sand was exciting. He identified very strongly with nature.

Barbara Rose: *What do you mean by the moon having an effect on him?*

Lee Krasner: He painted a series of moon pictures, and spoke about it often. This is one of the things we had in common, because the moon had quite an effect on me, too. It made me feel more emotional, more intense—it would build a momentum of some sort for me. He spoke of the moon quite often. He referred to *Portrait in a Dream* as the "dark side of the moon." There was a whole series of moon paintings—*Moon Woman, Mad Moon Woman, Moon Woman Cuts the Circle.*

Barbara Rose: *Do you know where his knowledge of mythology came from?*

Lee Krasner: I think his interest in myth originally stems from one of his high school teachers in California. I can't remember the man's name, but he was

interested in Eastern philosophy. He introduced him to Eastern philosophy, and consequently he attended lectures by Krishnamurti. All of which happened long before I met him. By the time I had met him, he had been in Jungian analysis, which had a mythic basis.

Barbara Rose: *Did he know anything about Indian legends actually?*

Lee Krasner: He used to relate how his father took him on trips where they used to see where the Indians used to live, so he must have had some contact back there. How much he knew of the myths, I don't know. He had the Smithsonian books on the American Indian. I think there were twelve volumes of that, and since he had them I assume he had read them. In there, he could have dug out myths, if he didn't know of them prior to that.

Barbara Rose: *Pollock's actual materials—his brushes, paints, etc.—where did he get them? And did he prefer a certain range of color?*

Lee Krasner: He preferred house painter's brushes, rather than fine art brushes. He indulged in materials very heavily. That is to say for drawings, he had the most fantastic collection of pens I had ever seen. He would go into Rosenthal's art supply store before we moved out to Springs and would pick out every new form of pen that would come out. With regard to color, he started at some point in the late forties to use commercial paints. I don't know why. He never explained why.

Barbara Rose: *You didn't have plastic paints yet. No matter how you thinned oil down you could never get the liquidity of enamel or house paint.*

Lee Krasner: Exactly. I think that had more to do with his decision in getting commercial paint. He could do what he wanted to do with it. He also at one point got Du Pont to make up very special paints for him, and special thinners that were not turpentine. I don't know what it was.

Barbara Rose: *Do you remember how he got in touch with the paint chemist?*

Lee Krasner: I don't remember, but at the time the painting Rockefeller owned was burned, the restorer got in touch with me, and I had to go to the studio and write it out so they could contact the Du Pont people and find out precisely how to deal with it.

Barbara Rose: *What were these special paints that Du Pont developed for Pollock?*

Lee Krasner: I don't know. I simply gave them the name of the paints and asked them to be in touch with Du Pont's chemists to find out.

Barbara Rose: *During the period, when Pollock was doing the "drip" paintings, did he use a limited range of colors? After* The Key *he begins to use a completely different palette from the high-key Fauve color of the early forties.*

Lee Krasner: Why he shifts from one thing to another I couldn't say. Even in those commercial paints, there is quite a range of color. I would pick one color, and he would pick quite another. Color is a very personal thing. He had a choice within the range of commercial paints. He certainly never used the full range

that existed. He chose what he wanted.

Barbara Rose: *Do you have any idea why he used silver paint? Was that radiator enamel?*

Lee Krasner: I think it can be used on radiators, or pipes, or anything else. No, I have no idea why he used it. As a matter of fact, it came up quite recently. I think it was O'Connor who dug up some literature that Pollock read when he was involved with Eastern philosophy. He came up with an illustration of something that was very heavily dripped. If Pollock had seen that, it would mean he was aware of silver paint as well as the so-called "drip" way back somewhere. I can remember O'Connor saying that it was conceivable Pollock had read this pamphlet before he came East. It could have been something that he was aware of way back in California.

Barbara Rose: *Did he ever speak about materials?*

Lee Krasner: Rarely. I think he had read quite a bit about technique because in his library there were books about it. In fact, I still leave his books in Springs. So he was conscious and aware of the technical aspects of painting. But he would also say that you could not deal too much with the technique; there are certain basic rules you have to know, and then forget it.

Barbara Rose: *Do you have any idea why he used crushed glass in his paintings?*

Lee Krasner: He didn't use all that much. It was for a very short time. Texture interested him. Crushed glass created texture.

Barbara Rose: *Did you ever observe him painting?*

Lee Krasner: Yes. I saw him painting the mural on Eighth Street. I saw him painting *Number 7*, and *Number 8*, and *Moon Woman*. So I saw him paint before he moved out to the barn. Out in East Hampton, when he was in the barn, I saw him paint there too. When he called me in, I would see what he had done. He might start to work while I was there.

Barbara Rose: *He would call you in when he wanted to reflect on something?*

Lee Krasner: No. The pattern was that if he went out to work, I did not ever just come into the studio. But he might come back from the studio and I might say something like, "How did it go?", although I could tell before I asked the question. And he would say on occasion, "Not bad, would you like to see what I did?" I would go out with him and see what he did. Sometimes on these occasions he might pick up and start to work while I was there. I saw him do some cutouts, for example. At different times I saw him do bits and pieces.

Barbara Rose: *Do you have any idea why he cut out parts of the canvas?*

Lee Krasner: No more than why I might start to collage at some point.

Barbara Rose: *Is there anything you can remember about his working process? I guess he was simply very absorbed.*

Lee Krasner: When he worked, oh yes.

Barbara Rose: *You get the impression that it was like a trance.*

Lee Krasner: It's a romantic idea, but to a degree it is true. He would take off so

to speak. It is a form of leaving your surroundings. There were periods when he would just observe his work or be critical. There are both aspects—the total involvement and the subsequent objective criticism.

Barbara Rose: *That's very important. E. A. Carmean writes in his National Gallery text that there was a series of paintings all painted at the same time. He claims that the first layer of the "drip" was applied on all equally. He then left them and went back to them at different stages as a kind of critical revision.*

Lee Krasner: Sometimes he did revise and sometimes he didn't.

Barbara Rose: *He might do something, look at it, leave it, then go back to it?*

Lee Krasner: Certainly, although he didn't have a standard procedure. A painting like *Blue Poles* he reentered many, many times, and just kept saying, "This won't come through." That went on for quite a long time.

Barbara Rose: *How long, normally, would it take him to paint a painting?*

Lee Krasner: It really varied. When he got hung up in something, like *Blue Poles*, where he did get hung up, it took quite a long time. This went on beyond weeks. He might just walk away from it for a stretch of time, and then come back, reenter. Others came through more easily for him. When they came through, they came through rather rapidly. Relatively.

Barbara Rose: *What percentage of the work was destroyed?*

Lee Krasner: Very little. Generally, he wouldn't give up a canvas. He would just stay with it until it was resolved for him.

Barbara Rose: *It was my impression that a lot was destroyed because of the high risk element.*

Lee Krasner: Not at all. His assuredness at that time is frightening to me. The confidence, and the way he would do it was unbelievable at that time.

Barbara Rose: *How did this confidence evolve? Was it an outcome of all the years of drawing and the translation of that drawing into a larger gesture?*

Lee Krasner: That's right. Because the backlog of what he has, the drawings you speak of, was quite a body of work. At some point he was ready to let it all happen in the scale he wanted it to happen on.

Barbara Rose: *Then you don't know what inspired the "drip" technique?*

Lee Krasner: For me it is working in the air and knowing where it will land. It is really quite uncanny. Even the Indian sand painters were working in the sand, not in the air.

Barbara Rose: *That implies that there must have been a whole period of practicing the aerial gesture.*

Lee Krasner: There probably was on a smaller scale, but I wouldn't know.

Barbara Rose: *There are small "drip" paintings of course. In descriptions of Pollock, there is often reference to Pollock's "balletic" movements.*

Lee Krasner: It is all called dance in some form. He was a terrible social dancer. That's not a reflection of his rhythm.

Barbara Rose: *The physical grace of Pollock in Namuth's film is simply breathtaking. Was he athletic?*

Lee Krasner: No. No sport that I ever encountered. His interests were the antithesis of athletics. Except boxing. He liked to look at that occasionally on television.

Barbara Rose: *You listened to jazz together.*

Lee Krasner: He had his own thing about jazz. He would sometimes listen four or five consecutive days and nights to New Orleans jazz until I would go crazy. The house would be rocking and rolling with it.

Barbara Rose: *Any classical music?*

Lee Krasner: Not that I'm aware of. I like classical music, and if I had it on, Pollock would certainly listen. And he had some poetry on records that he would listen to.

Barbara Rose: *Did Pollock paint by natural light or artificial light?*

Lee Krasner: Natural light only, never artificial. He *never* worked at night.

Barbara Rose: *I remember being struck by the fact that the barn is filled with brilliant light from high windows, but entirely closed off at eye level. Was the fact that the studio had good natural light important?*

Lee Krasner: Oh, I think so. When the barn was moved, he wanted the window high, so as not to be able to look out. He didn't want to be disturbed by the scene around him. He wanted his studio totally closed off, I remember that very definitely. The barn was altered when it was moved to the side of the house from directly behind the house where it blocked our view. Where the window should be placed was really the only alteration. A new studio window was added. I remember asking him if whether it wouldn't be a good idea to place another window someplace else as well as where he said. He said, "No, no, I don't want to be disturbed by the outside view when I'm working."

Barbara Rose: *Why did he allow Namuth to photograph him?*

Lee Krasner: I haven't the faintest idea. He had been photographed by other people like Herbert Matter. It wasn't as if he had never been photographed before Namuth.

Barbara Rose: *But was he ever photographed painting before?*

Lee Krasner: No. That was the first time and consequently the only time he was photographed working.

Barbara Rose: *Did he say anything about the experience?*

Lee Krasner: In the past he said it made him uncomfortable. He wouldn't allow it.

Barbara Rose: *Yet he is not self-conscious in Namuth's film, not like someone being observed.*

Lee Krasner: When he was working, I think he would have been unaware of anything else.

Barbara Rose: *The glass painting he works on in the film is a curiosity, unlike anything else in Pollock's oeuvre. I understand it was Namuth's idea that he should paint on glass.*

Lee Krasner: Was it? I was there while Pollock painted it, certainly. But I wasn't there when Namuth suggested that he paint on glass. As far as I'm concerned, Jackson got a sheet of glass, and decided to paint on it, and Namuth photographed it.

Barbara Rose: *It didn't have the status of an art object until Pollock decided it was a painting, however.*

Lee Krasner: The first I heard of it, Pollock showed me a piece of glass. When I asked him what it was for, he said he wanted to try to paint on it. As you know, he was constantly experimenting. I always thought he got the idea of painting on glass from Duchamp.

Barbara Rose: *The painting on glass produced during the film is in a sense the literal realization of the idea of suspending an image in space—of eliminating the background by making it transparent. It evolves so logically out of Pollock's concerns at the time, I can't believe it was just a chance by-product of the film. However, the existence of the film is something of a miracle.*

Lee Krasner: I do not know why Pollock agreed to permit Namuth to film him working. It was entirely contrary to his nature. However, we are very fortunate that he did and that we have such a document.

Articles and Reviews

1943

Pollock's first solo exhibition opened at Peggy Guggenheim's gallery, Art of This Century, on November 9, 1943. The brief catalogue essay was written by curator and critic James Johnson Sweeney, who brought Pollock's work to Guggenheim's attention after seeing one of his pictures in a 1942 group show. (Sweeney's essay is cited extensively in the reviews, and therefore is not reprinted here.)

Edward Alden Jewell. "Art: Briefer Mention." *The New York Times*
NOVEMBER 14, 1943, SEC. 2, P. 6. COPYRIGHT © 1943 BY THE NEW YORK TIMES. REPRINTED BY PERMISSION.

Jackson Pollock, at Peggy Guggenheim's Art of This Century, conducts us, not without precipitate violence, into the realm of abstraction. These cannot be called non-objective abstractions, for most of them have fairly naturalistic titles, and two that are marked "Untitled" have become particularized by the artist since the catalogue went to press. What looks slightly like a dog begging turns out instead to be "Wounded Animal." The most recent canvas, a scattered design against pink, represents "Male and Female in Search of a Symbol."

We are thrice introduced to the "The Moon Woman"; once she is just herself, once cutting "the circle," and once she is mad. Most of the abstractions are large and nearly all of them are extravagantly, to say savagely, romantic. Here is obscurantism indeed, though it may become resolved and clarified as the artist proceeds. This is his first one-man show, James Johnson Sweeney, in his catalogue foreword, strikes exactly the right note:

"Pollack's [sic] talent is volcanic. It has fire. It is unpredictable. It is undisciplined. It spills itself out in a mineral prodigality not yet crystallized. It is lavish, explosive, untidy. But," adds Mr. Sweeney, "young painters, particularly Americans, tend to be too careful of opinion. Too often the dish is allowed to chill in the serving. What we need is more young men who paint from inner impulse without an ear to what the critic or spectator may feel—painters who will risk spoiling a canvas to say something in their own way. Pollock is one."

49

Maude Riley. "Fifty-Seventh Street in Review: Explosive First Show." *The Art Digest*
18, NO. 4 (NOVEMBER 15, 1943): 18.

"It is lavish, explosive, untidy" say James Johnson Sweeney of Jackson Pollock's
painting as displayed for the first time seriously by Art of This Century (until
Nov. 27), Peggy Guggenheim directing.

Pollock studied with Thomas Benton and in his early work showed a con-
ventional academic competence, according to his biographer, but now, says
Sweeney, "his creed is evidently that of Hugo: Ballast yourself with reality and
throw yourself into the sea. The sea is inspiration."

We like all this. Pollock is out a-questing and he goes hell-bent at each can-
vas, mostly big surfaces, not two sizes the same. Youthfully confident, he does
not even title some of these painted puzzles. And among the "untitled" is a pink
one he brought in, still wet with new birth, which probably pleased and sur-
prised him no end, when hung. Otherwise, he has painted a *She-Wolf,* slaty blue
and thoroughly mussed with animated white lines; a complicated *Guardians of
the Secret* with a wolf guarding below, and Beckmann panels right and left; a
series of *Moon-Woman* pictures which allow full license of symbolism, form and
explanation, for it is his legend, completely of his own devising.

There are elements of Miró in this show; plenty of whirl and swirl. But,
again, as Mr. Sweeney says, young American painters tend to be too careful of
opinion. Here's one who doesn't allow "the dish to chill in the serving."

Anon. "The Passing Shows: Jackson Pollock." *Art News*
42, NO. 13 (NOVEMBER 15–30, 1943): 23. COPYRIGHT © 1943, ARTNEWS LLC. REPRINTED COUR-
TESY OF THE PUBLISHER.

Jackson Pollock at Art of This Century presents fifteen oils and a number of
gouaches and drawings. A former student of Benton and a denizen of Wyoming,
California, and Arizona, his abstractions are free of Paris and contain a disci-
plined American fury. His work is personal, though occasionally one feels an
Indian influence. He has a fine sense of integration which preserves the indi-
viduality of each canvas. (Prices $25 to $750.)

Robert M. Coates. "The Art Galleries: Situation Well in Hand." *The New Yorker*
40, NO. 19 (NOVEMBER 20, 1943): 97–98. ©1943; REPRINTED BY PERMISSION OF CONDÉ NAST
PUBLICATIONS, INC. ALL RIGHTS RESERVED.

At Art of This Century there is what seems to be an authentic discovery—the
paintings of Jackson Pollock, a young Western artist who is having his first one-

man exhibition there. Mr. Pollock's style, which is a curious mixture of the abstract and the symbolic, is almost wholly individual, and the effect of his one noticeable influence, Picasso, is a healthy one, for it imposes a certain symmetry on his work without detracting from its basic force and vigor. Sometimes, as in "Stenographic Figure" and "The She-Wolf," Mr. Pollock's forcefulness, coupled with a persistent tendency to overwork his ideas, leads him into turgidity. But his color is always rich and daring, his approach mature, and his design remarkably fluent, and I had the satisfied feeling that in such pieces as "The Magic Mirror" and "The Wounded Animal" he had succeeded pretty well and pretty clearly in achieving just what he was aiming at.

Clement Greenberg. "Art." *The Nation*
157, NO. 22 (NOVEMBER 27, 1943): 621. REPRINTED BY PERMISSION OF UNIVERSITY OF CHICAGO PRESS. © 1943 CLEMENT GREENBERG.

There are both surprise and fulfillment in Jackson Pollock's not so abstract abstractions. He is the first painter I know of to have got something positive from the muddiness of color that so profoundly characterizes a great deal of American painting. It is the equivalent, even if in a negative, helpless way, of that American chiaroscuro which dominated Melville, Hawthorne, Poe, and has been best translated into painting by Blakelock and Ryder. The mud abounds in Pollock's larger works, and these, though the least consummated, are his most original and ambitious. Being young and full of energy, he takes orders he can't fill. In the large, audacious "Guardians of the Secret" he struggles between two slabs of inscribed mud (Pollock almost always *inscribes* his purer colors); and space tautens but does not burst into a picture; nor is the mud quite transmuted. Both this painting and "Male and Female" (Pollock's titles are pretentious) zigzag between the intensity of the easel picture and the blindness of the mural. The smaller works are much more conclusive: the smallest one of all, "Conflict," and "Wounded Animal," with its chalky incrustation, are among the strongest abstract paintings I have yet seen by an American. Here Pollock's force has just the right amount of space to expand in; whereas in larger format he spends himself in too many directions at once. Pollock has gone through the influences of Miró, Picasso, Mexican painting, and what not, and has come out on the other side at the age of thirty-one, painting mostly with his own brush. In his search for style he is liable to relapse into an influence, but if the times are propitious, it won't be for long.

1945

Pollock's second solo exhibition at Art of This Century opened on March 19, 1945.

Howard Devree. "Among the New Exhibitions." *The New York Times*
MARCH 25, 1945, SEC. 2, P. 8. COPYRIGHT © 1945 BY THE NEW YORK TIMES. REPRINTED BY
PERMISSION.

These big, sprawling coloramas impress me as being surcharged with violent
emotional reaction which never is clarified enough in the expression to establish
true communication with the observer. Only "The Night Dancer" of the current
crop conveys to me any intended message. "There Were Seven in Eight" as a title
is purely cryptic understatement; and one or two of the other paintings might
as well be called "explosion in a shingle mill," with their pother of paint and
flying forms.

Anon. "The Passing Shows: Jackson Pollock." *Art News*
44, NO. 4 (APRIL 1, 1945), P. 6. COPYRIGHT © 1945, ARTNEWS LLC. REPRINTED COURTESY OF THE
PUBLISHER.

Jackson Pollock, at Peggy Guggenheim's Art of This Century, derives his style
from that of Kandinsky though he lacks the airy freedom and imaginative color
of the earlier master. In an apparent effort to give his pictures compositional
unity he covers their surfaces with an elaborate network of white lines which
obscure the primary elements. Thus the identification of forms in paintings sur-
realistically titled *The Night Dancer* or *There Were Seven in Eight* is rendered almost
impossible. The artist suffers from a *horror vacui*; scarcely an inch of background
is left vacant, and the total effect is labored rather than spontaneous. This
reviewer preferred the drawings, in black line on blue or reddish backgrounds, to
the oils with their heavy impasto and over-complicated surface. (Prices from
$100 to $900.)

Clement Greenberg. "Art." *The Nation*
160, NO. 14 (APRIL 7, 1945): 397–98. REPRINTED BY PERMISSION OF UNIVERSITY OF CHICAGO
PRESS. © 1945 CLEMENT GREENBERG.

Jackson Pollock's second one-man show at Art of This Century (through April
14) establishes him, in my opinion, as the strongest painter of his generation
and perhaps the greatest one to appear since Miró. The only optimism in his
smoky, turbulent painting comes from his own manifest faith in the efficacy, for

him personally, of art. There has been a certain amount of self-deception in School of Paris art since the exit of cubism. In Pollock there is absolutely none, and he is not afraid to look ugly—all profoundly original art looks ugly at first. Those who find his oils overpowering are advised to approach him through his gouaches, which in trying less to wring every possible ounce of intensity from every square inch of surface achieve greater clarity and are less suffocatingly packed than the oils. Among the latter, however, are two—both called Totem Lessons—for which I cannot find strong enough words of praise. Pollock's single fault is not that he crowds his canvases too evenly but that he sometimes juxtaposes colors and values so abruptly that gaping holes are created.

Manny Farber. "Jackson Pollock." *The New Republic*
112, NO. 6 (JUNE 25, 1945): 871–72. REPRINTED BY PERMISSION OF MANNY FARBER.

The painting of Jackson Pollock, which has been called untalented and likened to "baked-macaroni" in *View* and to an "explosion in a shingle-mill" in the New York *Times*, has been, in at least three paintings I have seen, both masterful and miraculous. The three paintings include a wild abstraction twenty-six feet long, commissioned by Miss Peggy Guggenheim for the hallway of her home, and two gouache drawings being exhibited at Art of This Century. The mural is voluminously detailed with swirling line and form, painted spontaneously and seemingly without preliminary sketch, and is, I think, an almost incredible success. It is violent in its expression, endlessly fascinating in detail, without superficiality, so well ordered that it composes the wall in a quiet, contained, buoyant way. Pollock's aim in painting seems to be to express feeling that ranges from pleasant enthusiasm through wildness to explosiveness, as purely and as well as possible. The mode is abstract or nearly so, one that stems from Miró and Picasso but is a step further in abstraction. The style is personal and, unlike that of many painters of this period, the individuality is in the way the medium is used rather than in the peculiarities of subject matter.

The dominant effects in Pollock's work arise from the expressionistic painting of emotion and from the uninhibited, two-dimensional composing of the surface, in which the artist seems to have started at one point with a color and continued over the painting without stopping, until it has been composed with that color. In the process, great sections of the previous design may be painted out, or the design changed completely. The painting is laced with relaxed, graceful, swirling lines or violent ones, until the surface is patterned in whirling movement. In the best compositions these movements collide and repeat to project a continuing effect of virile, hectic action. The paint is jabbed on, splattered, painted in lava-like thicknesses and textures, scrabbled, made to look like smoke,

bleeding, fire and painted in great sweeping continuous lines. The painting is generally heavily detailed, and tries a great number of emphatic contrasts and horizontal movements in which a shape or a line will be improvised on and repeated in level, rhythmic steps and generally in a circular movement. One of the most characteristic notes is the way a shape is built out from the surface in great detail. The style is a rich, decorative kind that uses heavy, opaque color, extreme texturing and a broad, rounded list of colors. An extraordinary quality of Pollock's composing is the way he can continue a feeling with little deviation or loss of purity from one edge to the other of the most detailed design.

Pollock's painting often seems undramatic and too much on top of the surface, inert and mainly decorative, rather than painting whose surface actually seems to have been broken and worked into a continually living, deeply personal art. The linear part of the canvas is usually very dramatic (though some of the later work runs uninterestingly to pattern), but the spaces enclosed are, in later paintings, apt to be too similar, and are not a very active part of early paintings like "The She-Wolf." The color doesn't seem radiant, forceful or deep, though it always seems rich, fairly substantial and is used with great originality and daring. But there is little slightness in his work; it is really painted; it is thoroughly incautious, and in a period when it looks as if we are going to be drowned in charm, his painting generally backs up its charm.

Pollock's composing is consistently directed toward two-dimensional abstract design, and I think this kind of design is as unworked and rich in new art forms, devices and problems as naturalistic design is overworked to the point where nothing in it seems rich. Implicit in the change from naturalism to abstraction in painting is the change in attitude about surface: The surface is no longer considered as something to be designed into an approximation of a naturalistic, three-dimensional world, but, more realistically, is considered simply as flat, opaque and bounded. Pollock's work explores the possibilities and the character of horizontal design. He shows that each point of the surface in flat painting is capable of being made a major one and played for maximum effect, and that when the conflicting elements in three-dimensional painting are removed, the two-dimensional relationships are liberated and made more powerful and clear. His manner of building form and surface out rather than in has produced original, dramatic and decorative effects, and the painting as a whole demonstrates again that abstract art can be as voluptuous as Renaissance painting.

1946

Pollock's third solo exhibition at Art of This Century opened on April 2, 1946. In addition to the two notices cited here, it was reviewed by Clement Greenberg, who found it disappointing but nonetheless said that it confirmed Pollock's status as "the most original contemporary easel-painter under forty."

Ben Wolf. "By the Shores of Virtuosity." *The Art Digest*
20, NO. 14 (APRIL 15, 1946): 16.

Jackson Pollock's oils, currently to be seen at Art of This Century, remind one of Arthur B. Carles' answer when asked why he did not do more watercolors. Said Carles: "They terrify me . . . they get so beautiful so quick." Pollock suffers from this ability to achieve surface virtuosity that in the final analysis frequently forbids him to the promised land of plastic realization. The artist has the requisite equipment to cross that "last river," but somehow seems to prefer to dangle his toes in the warmer water along the shore of his facility.

When one regards the movement and color ranges of *Water Figure* one feels a genuine wrench upon viewing the dissipated composition of *Troubled Queen* that leans too heavily on its color and pigmentation. *Moon Vessel* charms with its considered surfaces and shows just what is wrong with the short-stopped *Once Upon a Time*. (Through April 20.)

Anon. "Reviews & Previews: Jackson Pollock." *Art News*
45, NO. 3 (MAY 1946): 63. COPYRIGHT © 1946, ARTNEWS LLC. REPRINTED COURTESY OF THE PUBLISHER.

Jackson Pollock is one of the most influential young American abstractionists, and he has reinforced his position in a recent exhibit at Art of This Century. (All his paintings are at the gallery and may be seen for the asking.) Once a student of Thomas Benton, his teacher's strong artistic personality caused a violent reaction. Today, Pollock still uses an automatic technique, pushing totemic and metaphorical shapes into swirling webs of pigment. However, he has also developed his newer "simplified" manner. Larger, more representational shapes are placed against flat, monochrome backgrounds; clarity increases at the expense of motion. This is a logical development in Pollock's attempt to create a new, abstract, mural style which will sustain a complexity of plastic and literary elements previously found only in small, three-dimensional easel paintings. (Prices $100 to $850.)

1947

Pollock's fourth exhibition at Art of This Century opened on January 14, 1947.

Anon. "Reviews & Previews: Jackson Pollock." *Art News*
45, NO. 12 (FEBRUARY 1947): 45. COPYRIGHT © 1947, ARTNEWS LLC. REPRINTED COURTESY OF
THE PUBLISHER.

Jackson Pollock (Art of This Century) unexpectedly comes from Wyoming and
in the deep, dark past was a Benton pupil. A favorite find of Peggy Guggenheim,
who has given him four shows within a few years, he characteristically works in
surging serpentines, thickly intertwined but transparent, thanks to a limited
color range dominated by white, yellow, and black. Latest pictures such as *The
Key*, being broader and more colorful, make it easier to assimilate the basic ener-
gy which flows through all his canvases. ($200–$1,200.)

Clement Greenberg. "Art." *The Nation*
164, NO. 5 (FEBRUARY 1, 1947): 137–39. REPRINTED BY PERMISSION OF UNIVERSITY OF CHICAGO
PRESS. © 1947 CLEMENT GREENBERG.

Jackson Pollock's fourth one-man show in so many years at Art of This Century
(through February 7) is his best since his first one and signals what may be a
major step in his development—which I regard as the most important so far of
the younger generation of American painters. He has now largely abandoned his
customary heavy black-and-whitish or gun-metal chiaroscuro for the higher
scales, for alizarins, cream-whites, cerulean blues, pinks, and sharp greens. Like
Dubuffet, however, whose art goes in a similar if less abstract direction, Pollock
remains essentially a draftsman in black and white who must as a rule rely on
these colors to maintain the consistency and power of surface of his pictures. As
is the case with almost all post-cubist painting of any real originality, it is the
tension inherent in the constructed, re-created flatness of the surface that pro-
duces the strength of his art.

Pollock, again like Dubuffet, tends to handle his canvas with an over-all
evenness; but at this moment he seems capable of more variety than the French
artist, and able to work with riskier elements—silhouettes and invented orna-
mental motifs—which he integrates in the plane surface with astounding force.
Dubuffet's sophistication enables him to "package" his canvases more skillfully
and pleasingly and achieve greater instantaneous unity, but Pollock, I feel, has
more to say in the end and is, fundamentally, and almost because he lacks equal
charm, the more original.

Pollock has gone beyond the stage where he needs to make his poetry explicit in ideographs. What he invents instead has perhaps, in its very abstractness and absence of assignable definition, a more reverberating meaning. He is American and rougher and more brutal, but he is also completer. In any case he is certainly less conservative, less of an easel-painter in the traditional sense than Dubuffet, whose most important historical achievement may be in the end to have preserved the easel picture for the post-Picasso generation of painters. Pollock points a way beyond the easel, beyond the mobile, framed picture, to the mural, perhaps—or perhaps not. I cannot tell.

1948

In spring 1947, Peggy Guggenheim returned to Europe, closing Art of This Century. She persuaded Betty Parsons, a young artist and art dealer, to take over her contract with Pollock. His first show at the Betty Parsons Gallery opened on January 5, 1948. It consisted largely but not exclusively of the new "drip" paintings he had begun making in 1947.

A[lonzo] L[ansford]. "Fifty-Seventh Street in Review: Automatic Pollock." *The Art Digest* 22, NO. 8 (JANUARY 15, 1948): 19.

You have to hand it to Jackson Pollock; he does get a rise out of his audience—either wild applause or thundering condemnation. Something must be said for such a performance, if only for the virtue of positiveness. At least two foremost critics here and in England have recently included Pollock in their lists of the half-dozen most important of America's "advanced" painters; other equally prestigious authorities have dismissed him, at least verbally, with an oath. It will be interesting to see the reactions to his present exhibition at the Betty Parsons Gallery.

Pollock has said that Thomas Benton was a good teacher because he taught him how not to paint like Benton; that he doesn't is startlingly patent. Pollock's current method seems to be a sort of automatism; apparently, while staring steadily up into the sky, he lets go a loaded brush on the canvas, rapidly swirling and looping and wriggling till the paint runs out. Then he repeats the procedure with another color, and another, till the canvas is covered. This, with much use of aluminum paint, results in a colorful and exciting panel. Probably it also results in the severest pain in the neck since Michelangelo painted the Sistine Ceiling.

Robert M. Coates. Excerpt from "The Art Galleries: Edward Hopper and Jackson Pollock." *The New Yorker*
23 (JANUARY 17, 1948): 56–57. ©1948; REPRINTED BY PERMISSION OF CONDÉ NAST PUBLICATIONS, INC. ALL RIGHTS RESERVED.

At the Betty Parsons, there is a showing of paintings by Jackson Pollock. Like Stanley William Hayter, who was discussed here a couple of weeks ago, Pollock is a member of that still loosely organized group of artists known as "symbolic Expressionists," and since I went into the characteristics of the school at some length during the Hayter exhibition, I shall merely repeat now that its basis is always in the abstract or the non-objective and the manner is Expressionistic, and that the work represents a style that, though it is still in process of forma-

tion, has already attracted a number of intelligent adherents.

Pollock is much harder to understand than most of his confreres. The main thing one gets from his work is an impression of tremendous energy, expressed in huge blobs of color alternating with lacings and interlacings of fine lines. Recognizable symbols are almost nonexistent, and he attempts to create by sheer color and movement the mood or atmosphere he wants to convey. Such a style has its dangers, for the threads of communication between artist and spectator are so very tenuous that the utmost attention is required to get the message through. There are times when communications break down entirely, and, with the best will in the world, I can say of such pieces as "Lucifer," "Reflection of the Big Dipper," and "Cathedral" only that they seem mere unorganized explosions of random energy, and therefore meaningless. I liked, though, his "Full Fathom Five," with its crusted greens and whites overlaid by black swirls, and "Sea Change," while both "Magic Lantern" and the larger "Enchanted Forest" have a good deal of poetic suggestion about them.

Clement Greenberg. "Art." *The Nation*
166, NO. 4 (JANUARY 24, 1948): 107–08. REPRINTED BY PERMISSION OF UNIVERSITY OF CHICAGO PRESS. © 1948 CLEMENT GREENBERG.

Jackson Pollock's most recent show, at Betty Parsons's, signals another step forward on his part. As before, his new work offers a puzzle to all those not sincerely in touch with contemporary painting. I already hear: "wallpaper patterns," "the picture does not finish inside the canvas," "raw, uncultivated emotion," and so on, and so on. Since Mondrian no one has driven the easel picture quite so far away from itself; but this is not altogether Pollock's own doing. In this day and age the art of painting increasingly rejects the easel and yearns for the wall. It is Pollock's culture as a painter that has made him so sensitive and receptive to a tendency that has brought with it, in his case, a greater concentration on surface texture and tactile qualities, to balance the danger of monotony that arises from the even, all-over design which has become Pollock's consistent practice.

In order to evolve, his art has necessarily had to abandon certain of its former virtues, but these are more than compensated for. Strong as it is, the large canvas *Gothic*, executed three years ago and shown here for the first time in New York, is inferior to the best of his recent work in style, harmony, and the inevitability of its logic. The combination of all three of these latter qualities, to be seen eminently in the strongest picture of the present show, *Cathedral*—a matter of much white, less black, and some aluminum paint—reminds one of Picasso's and Braque's masterpieces of the 1912–15 phase of cubism. There is something of the same encasement in a style that, so to speak, feels for the

painter and relieves him of the anguish and awkwardness of invention, leaving his gift free to function almost automatically.

Pollock's mood has become more cheerful these past two years, if the general higher key of his color can be taken as a criterion in this respect. Another very successful canvas, *Enchanted Forest*—which resembles *Cathedral*, though inferior in strength—is mostly whitish in tone and is distinguished by being the only picture in the show, aside from *Gothic*, without an infusion of aluminum paint. In many of the weaker canvases here, especially the smallest, and at the same time in two or three of the most successful—such as *Shooting Star* and *Magic Lantern*—the use of aluminum runs the picture startlingly close to prettiness, in the two last producing an oily over-ripeness that begins to be disturbing. The aluminum can also be felt as an unwarranted dissimulation of the artist's weakness as a colorist. But perhaps this impression will fade as one grows more accustomed to Pollock's new vein. I am certain that *Phosphorescence*, whose overpowering surface is stalagmited with metallic paint, will in the future blossom and swell into a superior magnificence; for the present it is almost too dazzling to be looked at indoors. And the quality of two other pictures, *Sea Change* and *Full Fathom Five*, both in much lower key, one black-green and the other black-gray, still remains to be decided.

It is indeed a mark of Pollock's powerful originality that he should present problems in judgment that must await the digestion of each new phase of his development before they can be solved. Since Marin—with whom Pollock will in time be able to compete for recognition as the greatest American painter of the twentieth century—no other American artist has presented such a case. And this is not the only point of similarity between these two superb painters.

Anon. "Reviews & Previews: Jackson Pollock." *Art News*
46, NO. 12 (FEBRUARY 1948): 58–59. COPYRIGHT © 1948, ARTNEWS LLC. REPRINTED COURTESY OF THE PUBLISHER.

Jackson Pollock's recently exhibited paintings, some of them extended into three dimensions, explore a kind of automatic, mechanical technique that has spasmodically interested the surrealists, more as a device, however, than as an end in itself. Judging from appearances, Pollock loads weighted strings, sticks, and such with paint, and with sweeping movements of the arm, builds up, in successive layers, a solid network on the canvas. Some, with silver paint shining out of the dense elliptical tracery, suggest quite beautiful astronomical effects. Despite Pollock's crashing energy, the work is lightweight, somehow, a perverse echo of Tobey's fine white writing. There is monotonous intensity except occasionally when Pollock lets some air into the composition. $150–$1,200.

1949

Pollock's second exhibition at the Betty Parsons Gallery opened on January 24, 1949.

Sam Hunter. "Among the New Shows." *The New York Times*
JANUARY 30, 1949, SEC. 2, P. 9. COPYRIGHT © 1949 BY THE NEW YORK TIMES. REPRINTED BY
PERMISSION.

Jackson Pollock's show at the Betty Parsons Gallery certainly reflects an
advanced stage of the disintegration of the modern painting. But it is disinte-
gration with a possibly liberating and cathartic effect and informed by a highly
individual rhythm. It would seem that the main intention of these curiously
webbed linear variations—in clamant streaks and rays of aluminum and reso-
nant blacks and grays for the most part—is a deliberate assault on our image-
making faculty. At every point of concentration of these high-tension moments
of bravura phrasing (which visually are like agitated coils of barbed wire) there
is a disappointing absence of resolution in an image or pictorial incident for all
their magical diffusion of power. And then wonder of wonders, by a curious
reversal which seems a natural paradox in art, the individual canvases assume a
whole image-making activity and singleness of aspect.

Certainly Pollock has carried the irrational quality in picture making to one
extremity. It is an absolute kind of expression and the danger for imitators in
such a directly physical expression of states of being rather than of thinking or
knowing is obvious. Even in his case the work is not perhaps sufficiently sus-
tained by a unifying or major theme or experience and is too prodigal with
clusters of surrealist intuitions. What does emerge is the large scale of Pollock's
operations, his highly personal rhythm and finally something like a pure calli-
graphic metaphor for a ravaging aggressive virility.

M[argaret] L[owengrund]. "Pollock Hieroglyphics." *The Art Digest*
23, NO. 9 (FEB. 1, 1949): 19–20.

There are textural surprises in Jackson Pollock's latest sailcloth panels; or, if they
are not sailcloth there is nothing the rough canvas so much resembles as the
dark and light colored sails in the Bay of Biscay or the Riviera—with wondrous
and oft-repeated winding lines scrawled across them as if blown by the breezes
of the sea. The longest panel in Pollock's show at the Parsons Gallery is a lively
pattern of spirited black and white with clear touches of yellow, blue and an
occasional red, marking time along its length. Of the Hieroglyphics School, this
is an exciting display. It seems to strive to eliminate spatial form in favor of line
and surface interest alone. (Until Feb. 12.)

Emily Genauer. "This Week in Art." *New York World-Telegram*
81, NO. 185 (FEBRUARY 7, 1949), P. 19.

Most of Jackson Pollock's paintings, at the Betty Parsons Gallery, resemble nothing so much as a mop of tangled hair I have an irresistible urge to comb out. One or two of them manage to be organized and interesting. Those called, "Blue, red, yellow," and "Yellow, gray, black," because of their less "accidental" development and their spatial depth, suggest how good a painter Pollock could really be.

Clement Greenberg. "Art." *The Nation*
168, NO. 9 (FEBRUARY 19, 1949): 221–22. REPRINTED BY PERMISSION OF UNIVERSITY OF CHICAGO PRESS. © 1949 CLEMENT GREENBERG.

Jackson Pollock's show this year at Betty Parsons's continued his astounding progress. His confidence in his gift appears to be almost enough of itself to cancel out or suppress his limitations—which, especially in regard to color, are certainly there. One large picture, "Number One," which carries the idea of last year's brilliant "Cathedral" more than a few steps farther, quieted any doubts this reviewer may have felt—and he does not in all honesty remember having felt many—as to the justness of the superlatives with which he has praised Pollock's art in the past. I do not know of any other painting by an American that I could safely put next to this huge baroque scrawl in aluminum, black, white, madder, and blue. Beneath the apparent monotony of its surface composition it reveals a sumptuous variety of design and incident, and as a whole it is as well contained in its canvas as anything by a Quattrocento master. Pollock has had the tendency lately to exaggerate the verticality or horizontality, as the case might be, of his pictures, but this one avoids any connotation of a frieze or hanging scroll and presents an almost square surface that belongs very much to easel painting. There were no other things in the show—which manifested in general a greater openness of design than before—that came off quite as conclusively as "Number One," but the general quality that emerged from such pictures as the one with the black cut-out shapes—"Number Two"—that hung next to it, and from numbers "Six," "Seven," "Eleven," "Thirteen," "Eighteen," and especially "Nineteen," seemed more than enough to justify the claim that Pollock is one of the major painters of our time.

Clement Greenberg's steady drumroll of praise had earned Pollock the attention of Time magazine as early as 1947, and in October 1948 Pollock had been included among the "Young American Extremists" discussed in "A Life Round Table on Modern Art." In 1949, the editors of Life commissioned a feature article on Pollock, written by staffer Dorothy Seiberling and illustrated with photographs by Arnold Newman and Martha Holmes, which made him famous far beyond the confines of the art world. Newman's portrait of a denim-clad Pollock, lounging against a painting and scowling defiantly at the viewer, seemed to announce the arrival of a new kind of artist and a new kind of art.

[Dorothy Seiberling]. "Jackson Pollock: Is He the Greatest Living Painter in the United States?" *Life*
27, NO. 6 (AUGUST 8, 1949): 42–45. © TIME INC. REPRINTED WITH PERMISSION.

Recently a formidably high-brow New York critic hailed the brooding puzzled-looking man shown above as a major artist of our time and a fine candidate to become "the greatest American painter of the 20th Century." Others believe that Jackson Pollock produces nothing more than interesting, if inexplicable, decorations. Still others condemn his pictures as degenerate and find them as unpalatable as yesterday's macaroni. Even so, Pollock, at the age of 37, has burst forth as the shining new phenomenon of American art.

Pollock was virtually unknown in 1944. Now his paintings hang in five U.S. museums and 40 private collections. Exhibiting in New York last winter, he sold 12 out of 18 pictures. Moreover his work has stirred up a fuss in Italy and this autumn he is slated for a one-man show in *avant-garde* Paris, where he is fast becoming the most talked-of and controversial U.S. painter. He has also won a following among his own neighbors in the village of Springs, N.Y., who amuse themselves by trying to decide what his paintings are about. His grocer bought one which he identifies for bewildered visiting salesmen as an aerial view of Siberia. For Pollock's own explanation of why he paints as he does, turn the page.

Jackson Pollock was born in Cody, Wyo. He studied in New York under Realist Thomas Benton but soon gave this up in utter frustration and turned to his present style. When Pollock decides to start a painting, the first thing he does is to tack a large piece of canvas on the floor of his barn. "My painting does not come from the easel," he explains, writing in a small magazine called *Possibilities 1.* "I need the resistance of a hard surface." Working on the floor gives him room to scramble around the canvas, attacking it from the top, the bottom or the side (if his pictures can be said to have a top, a bottom or a side) as the mood suits him. In this way, "I can . . . literally be *in* the painting." He surrounds himself with quart cans of aluminum paint and many hues of ordinary household enamel. Then, starting anywhere on the canvas, he goes to work. Sometimes he dribbles the paint on with a brush. Sometimes he scrawls it on with a stick, scoops

it with a trowel or even pours it on straight out of the can. In with it all he deliberately mixes sand, broken glass, nails, screws or other foreign matter lying around. Cigaret ashes and an occasional dead bee sometimes get in the picture inadvertently.

"When I am *in* my painting," says Pollock, "I'm not aware of what I'm doing." To find out what he has been doing he stops and contemplates the picture during what he calls his "get acquainted" period. Once in a while a lifelike image appears in the painting by mistake. But Pollock cheerfully rubs it out because the picture must retain "a life of its own." Finally, after days of brooding and doodling, Pollock decides the painting is finished, a deduction few others are equipped to make.

1949–1950

Pollock's third exhibition at the Betty Parsons Gallery, which opened on November 21, 1949, included a model of an imaginary museum devoted to Pollock's work designed by the architect Peter Blake. The usual brief reviews, published during the exhibition, were followed three months later by Parker Tyler's elegy to Pollock's "infinite labyrinth."

A[my] R[obinson]. "Jackson Pollock." *Art News*
48, NO. 8 (DECEMBER 1949), P. 43. COPYRIGHT © 1949, ARTNEWS LLC. REPRINTED COURTESY OF THE PUBLISHER.

Jackson Pollock, among the most publicized U.S. avant-garde painters, expresses a more intense emotion than ever in his newest pictures—tightly woven webs of paint applied in heavy streaks by weighted strings and sticks. Handled with a sweeping movement of the arm, solid networks of thick, shiny paint shield the canvases from all air. While the closely woven layers of different colored lines appear at first to represent an impulsive snapping of all restrictive bonds, including form, it is apparent that there is a definite pattern and feeling in each canvas, and forms emerge and recede from the crisscrossing calligraphies. The paintings remain within the area prescribed by the canvas edge—though some of the canvases, often pasted on masonite, are as large and larger than 10 feet long. Emotion is provoked not only by the treatment of lines, which become masses in themselves, but also and especially by the color relationships. Several of the canvases, like *#3* (all are numbered rather than titled), are fugal interplays of green, white and silver, while others involve reds like *#12*, with its splurges of tiger-striped hues. $150–$3,000.

Parker Tyler. "Jackson Pollock: The Infinite Labyrinth." *Magazine of Art*
(WASHINGTON, D.C.) 43, NO. 3 (MARCH 1950): 92–93.

To comprehend the painting of Jackson Pollock, one must appreciate in full measure the charm of the paradox: the apparent contradiction that remains a fact. His work has become increasingly complex in actual strokes, while it has been simplified in formal idea. This is a convenient paradox with which to begin. Even more fundamental is the painter's almost entire abandonment of the paint-stroke, if by "stroke" is meant the single gesture by which the fingers manipulate the handle of a brush or the palette knife to make a mark having beginning and end. The paint, scattered sometimes in centrifugal dots, is primarily poured on his surfaces (sometimes canvas, sometimes board) and poured in a revolving

continuity, so that the thin whorls of color not only form an interlacing skein but also must endure the imposition of an indefinite number of skeins provided by other colors. Thus the paint surface becomes a series of labyrinthine patinas—refined and coarse types intermingling, save in the case of small and simple works which resemble large oriental hieroglyphs. The relief resulting from the physical imposition of one color on another is important to the visual dimension of these works and unfortunately is almost totally lost in reproduction.

The relation of Pollock's "paint stream" to calligraphy supplies another paradox. For it has the continuity of the joined letters and the type of curve associated with the Western version of Arabic handwriting—yet it escapes the monotony of what we know as calligraphy. It is as though Pollock "wrote" non-representational imagery. So we have a paradox of abstract form in terms of an alphabet of unknown symbols. And our suspense while regarding these labyrinths of color is heightened by the awareness that part of the point is that this is a cuneiform or impregnable language of image, as well as beautiful and subtle patterns of pure form.

On ancient stelae, sometimes defaced by time, certain languages have come down to us whose messages experts have labored to interpret. The assumption is that every stroke is charged with definite if not always penetrable meaning. But in these works of Pollock, which look as fresh as though painted last night, a definite meaning is not always implicit. Or if we say that art always "means something," Pollock gives us a series of abstract images (sometimes horizontally extended like narrative murals) which by their nature can never be read for an original and indisputable meaning, but must exist absolutely, in the paradox that any system of meaning successfully applied to them would at the same time not apply, for it would fail to exhaust their inherent meaning.

Suppose we were to define these paintings, as already indicated, as "labyrinths"? The most unprepared spectator would immediately grasp the sense of the identification. But a labyrinth, from that of Dedalus in the myth of the Minotaur to some childish affair in a comic supplement, is a logically devised system of deception to which the creator alone has the immediate key, and which others can solve only through experiment. But even if the creator of these paintings could be assumed to have plotted his fantastic graphs, the most casual look at the more complex works would make it evident that solution is impossible because of so much superimposition. Thus we have a deliberate disorder of hypothetical hidden orders, or "multiple labyrinths."

By definition, a labyrinth is an arbitrary sequence of directions designed, through the presentation of many alternatives of movement, to mislead and imprison. But there is one true way out—to freedom. A mere unitary labyrinth, however, is simple, while in the world of Pollock's liquid threads, the color of Ariadne's affords no adequate clue, for usually threads of several other colors are

mixed with it and the same color crosses itself so often that alone it seems inextricable. Thus, what does the creator tell us with the images of his multiple labyrinths like so many rhythmic snarls of yarn? He is conveying a paradox. He is saying that his labyrinths are by their nature insoluble; they are not to be threaded by a single track as Theseus threaded his, but to be observed from the outside, all at once, as a mere spectacle of intertwined paths, in exactly the way that we look at the heavens with their invisible labyrinths of movement provided in cosmic time by the revolutions of the stars and the infinity of universes.

The perspective that invites the eye: this is the tradition of painting that Pollock has totally effaced; effaced not as certain other pure-abstract painters have done, such as Kandinsky and Mondrian, who present a lucid geometry and define space with relative simplicity, but deliberately, arbitrarily and extravagantly. In traditional nature-representation, the world seen is *this* one; the spectator's eye is merely the precursor of his body, beckoning his intelligence to follow it in as simple a sense as did the axial symmetry of renaissance perspective. But the intelligence must halt with a start on the threshold of Pollock's rectangularly bounded visions, as though brought up before a window outside which there is an absolute space, one inhabited only by the curving multicolored skeins of Pollock's paint. A Pollock labyrinth is one which has no main exit any more than it has a main entrance, for every movement is automatically a liberation—simultaneously entrance and exit. So the painter's labyrinthine imagery does not challenge to a "solution," the triumph of a physical passage guided by the eye into and out of spatial forms. The spectator does not project himself, however theoretically, into these works; he recoils from them, but somehow does not leave their presence: he clings to them as though to life, as though to a wall on which he hangs with his eyes.

In being so overwhelmingly non-geometrical, Pollock retires to a locus of remote control, placing the tool in the hand as much apart as possible from the surface to be painted. In regularly exiling the brush and not allowing any plastically used tool to convey medium to surface, the painter charges the distance between his agency and his work with as much *chance* as possible—in other words, the fluidity of the poured and scattered paint places maximum pressure against conscious design. And yet the design *is* conscious, the seemingly uncomposable, composed.

Pollock's paint flies through space like the elongating bodies of comets and, striking the blind alley of the flat canvas, bursts into frozen visibilities. What are his dense and spangled works but the viscera of an endless non-being of the universe? Something which cannot be recognized as any part of the universe is made to represent the universe in totality of being. So we reach the truly final paradox of these paintings: being in non-being.

1950

Originally published in the Italian journal L'Arte Moderna, *Bruno Alfieri's short essay was reprinted in the catalogue of an exhibition of Peggy Guggenheim's collection of Pollock's work that opened in Venice in July 1950 and later traveled to Milan. The essay soon attracted the attention of* Time *magazine.*

Bruno Alfieri. "A Short Statement on the Painting of Jackson Pollock."
L'Arte Moderna
(VENICE), JUNE 8, 1950.

It is easy to describe a picture by Jackson Pollock, easier than to describe the work of Sophie Taeuber-Arp or a drawing by Jean Dubuffet. If you want a rather precise idea of it, think of a canvas surface on which the following ingredients have been poured: the contents of several tubes of paint of the best quality; sand; glass; various powders; pastels, gouache; charcoal, etc. (if we are not mistaken, in some pictures you may detect a trace of his wife's lipstick). It is important to state immediately that these "colors" have not been distributed according to a logical plan (whether naturalistic, abstract or otherwise). This is essential. Jackson Pollock's paintings represent absolutely nothing: no facts, no ideas, no geometrical forms. Do not, therefore, be deceived by suggestive titles such as "Eyes in Heat" or "Circumcision": these are phony titles, invented merely to distinguish the canvases and identify them rapidly.

If we were not afraid of confusing the issue, we would say that no picture is more thoroughly abstract than a picture by Pollock. But today, unfortunately, the term "abstract" signifies many different, rather tedious things (rhythms, spaces and other big words created, mostly, in Milan).

No picture is more thoroughly abstract than a picture by Pollock: abstract from everything. Therefore, as a direct consequence, no picture is more automatic, involuntary, surrealistic, introverted and pure than a picture by Pollock. I do not refer to André Breton's surrealism, which often develops into a literary phenomenon, into a sort of snobbish deviation. I refer to real surrealism, which is nothing but uncontrolled impulse. (If you wish to have a clear understanding of the origin of Pollock's pictures, you should read his article in this magazine.)

In any case it is easy to detect the following things in all of his paintings:
—chaos
—absolute lack of harmony
—complete lack of structural organization
—total absence of technique, however rudimentary
—once again, chaos

But these are superficial impressions, first impressions. We will not be content with them. We will search for *something*, behind the surface of his canvases. And first of all we will observe the following things:

Those handfuls of color are thrown down with a certain barbaric ferocity.

But maybe it is not ferocity—it is sensuality. Perhaps it is not sensuality, it is automatism, gross and lecherous. What kind of a surrealist is this Pollock? He is a painter who does not think: how can he be a true surrealist if he does not concentrate on the unconscious? He does not think, therefore he cannot think of the subconscious or try to wrest from it its slightest sensations, its slightest emotions, its slightest tremors. Is he a savage?

It is true that he does not think; Pollock has broken all barriers between his picture and himself: his picture is the most immediate and spontaneous painting. Each one of his pictures is part of himself. But what kind of a man is he?—What is his inner world worth? Is it worth knowing, or is it totally undistinguished? Damn it, if I must judge a painting by the artist, it is no longer a painting that I am interested in, I no longer care about the formal values contained in it. On the other hand, however, Pollock never meant to insert formal values in his pastiches. What then? Nevertheless, there are some formal values in his picture; I can sense something there, because I can see shapes (garbled and contorted) that say something to me. What do they say? If they are pieces of Pollock, they will show Pollock to me—pieces of Pollock. That is, I start from the picture, and discover the man: suddenly, without reasoning, instantaneously, more instantaneously than with any other modern painter.

Consequently Jackson Pollock's picture are very easy, easy enough for a kindergartener: I am sure that an infant would take them in at a glance. Should you confront an infant with a Pollock painting he would cry "How lovely!" or "How awful!" and promptly burst into tears.

The exact conclusion is that Jackson Pollock is the modern painter who sits at the extreme apex of the most advanced and unprejudiced avant-garde of modern art. You might say that his position is too advanced, but you may not say that his pictures are ugly, because in that case you would destroy pieces of famous classical paintings and half of all contemporary art. Compared to Pollock, Picasso, poor Pablo Picasso, the little gentleman who, since a few decades, troubles the sleep of his colleagues with the everlasting nightmare of his destructive undertakings, becomes a quiet conformist, a painter of the past.

Anon. "Chaos, Damn It!" *Time*

56, NO. 21 (NOVEMBER 20, 1950): 70–71. © 1950 TIME INC. REPRINTED BY PERMISSION.

Jackson Pollock's abstractions (TIME, Dec. 1, 1947 *et seq.*) stump experts as well as laymen. Laymen wonder what to look for in the labyrinths which Pollock achieves by dripping paint onto canvases laid flat on the floor; experts wonder what on earth to say about the artist. One advance-guard U.S. critic has gone so far as to call him the "most powerful painter in America." Another, more cautious, reported that Pollock "has carried the irrational quality of picture-making to one extremity" (meaning, presumably, his foot). The Museum of Modern Art's earnest Alfred Barr, who picked Pollock, among others, to represent the U.S. in Venice's big *Biennale* exhibition last summer, described his art simply as "an energetic adventure for the eyes."

Pollock followed his canvases to Italy, exhibited them in private galleries in Venice and Milan. Italian critics tended to shrug off his shows. Only one, brash young (23) Critic Bruno Alfieri of Venice, took the bull by the horns.

"It is easy," Alfieri confidently began, "to describe a [Pollock]. Think of a canvas surface on which the following ingredients have been poured: the contents of several tubes of paint of the best quality, sand, glass, various powders, pastels, gouache, charcoal. . . . It is important to state immediately that these 'colors' have not been distributed according to a logical plan (whether naturalistic, abstract or otherwise). This is essential. Jackson Pollock's paintings represent absolutely nothing: no facts, no ideas, no geometrical forms. Do not, therefore, be deceived by such suggestive titles as 'Eyes in Heat' or 'Circumcision'. . . . It is easy to detect the following things in all of his paintings:

"Chaos.

"Absolute lack of harmony.

"Complete lack of structural organization.

"Total absence of technique, however rudimentary.

"Once again, chaos.

"But these are superficial impressions, first impressions. . . . Each one of his pictures is part of himself. But, what kind of man is he? What is his inner world worth? Is it worth knowing, or is it totally undistinguished? Damn it, if I must judge a painting by the artist it is no longer the painting that I am interested in. . . ."

Jackson Pollock. Letter to the Editor. *Time*

56, NO. 24 (DECEMBER 11, 1950): 10. © THE POLLOCK-KRASNER FOUNDATION, INC.

SIR:

NO CHAOS DAMN IT. DAMNED BUSY PAINTING AS YOU CAN SEE BY MY SHOW COMING UP NOV. 28. I'VE NEVER BEEN TO EUROPE, THINK YOU LEFT OUT MOST EXCITING PART OF MR. ALFIERI'S PIECE.

JACKSON POLLOCK

EAST HAMPTON, N.Y.

The most exciting part of Critic Alfieri's remarks, at least for Artist Pollock, may well have been the obvious conclusion that he "sits at the extreme apex of the most advanced and unprejudiced avant-garde of modern art."—Ed. *(Time)*

1950-1951

Pollock's third exhibition at the Betty Parsons Gallery, which opened on November 28,
1950, included three mural-scale canvases, Number 30, 1950, Number 31, 1950,
and Number 32, 1950, *each roughly nine-feet high and fifteen- or seventeen-feet wide.*
These were the largest works he had created since his 1943–44 Mural. *In his review of*
this show in The New Yorker, *Robert Coates refuted the charge of "chaos" that* Time
had leveled against Pollock in November.

Robert M. Coates. "The Art Galleries: Extremists." *The New Yorker*
26 (DECEMBER 9, 1950): 109–11. ©1950; REPRINTED BY PERMISSION OF CONDÉ NAST
PUBLICATIONS, INC. ALL RIGHTS RESERVED.

The critic confronted with such a phenomenon as Jackson Pollock, whose new
paintings are now on view at the Betty Parsons Gallery, is obliged to cling more
tightly than usual to his basic beliefs if he is to review the man's work with rea-
sonable intelligence. He must remind himself that artists are rarely humorous, at
least where their painting is concerned, and, despite what the cynical may say,
they are still less likely to devote themselves to a lifetime of foisting off practical
jokes on the public, especially when they make very little money in the process.
He should recall that even the most extravagant technical innovations generally
have some artistic justifications, and remember, too, that no matter how fantas-
tic and unconventional they may seem, there are always, underneath the sur-
face, some linkages with the past. So although Mr. Pollock—along with others of
the new "wild" school of moderns, like Hans Hofmann, Richard Pousette-Dart,
and Louis Schanker—has been accused of pretty much everything, from a dis-
gracefully sloppy painting technique to out-and-out chicanery, we can afford to
disregard or discount most of the charges. His unorthodox manner of applying
pigment (he is reported to work with the canvas flat on the floor, and just drib-
ble the paint on straight from the can or tube) and his fondness for such unusu-
al materials as aluminum paint, asphalt roofing cement, and Duco enamel,
though both were probably at the start gestures of rebellion against conven-
tional procedures, have a certain wry relation to the brisker industrial practices,
in which the brush is also abandoned in favor of directer methods and new
materials are constantly being experimented with. Odd and mazy as it is, his
painting style is far from sloppy, for the overlying webs on webs of varicolored
lines that make up most of his pictures are put on with obvious sureness, while
the complaint that it's all a vast hoax falls to the ground, it seems to me, because
of the size and, to date, the unprofitableness of his enterprise.

The question still remains: What is Pollock getting at? Here, I think, as is
true of others of the general school he belongs to, the concept of design makes
understanding the work a bit difficult. To most of us, form means outline, and,

conversely, when we see an outline on canvas, we try to make it contain a form. This is, it happens, a situation that the Cubists and such early Non-Objectivists as van Doesburg and Mondrian were up against, but because their designs were either angular or precisely curved, they instantly suggested the outlines and forms of simple geometry, and acquired for the spectator—by association, as it were—a feeling of inevitability and austere logic. In Pollock's work, though, the drawing is irregular and sinuously curved, while the composition, instead of being orderly and exact, is exuberant and explosive. Both suggest the organic, and since the lines of natural forms are varied and unpredictable, we search longer for the recognizable outline (which, of course, isn't there) and are all the more baffled when we cannot find it.

It is partly because of this difference, I believe, that Pollock's paintings, while they are actually no more arbitrary in their design than, say, Mondrian's, seem so much more difficult to "get into" immediately, but it is true, too, that the younger man has hardly yet acquired the wisdom and maturity of the other. It's still possible, though, to get past the apparent obscurities of Pollock's work, and the new show, which contains some thirty canvases, all but one of them dated this year, gives an excellent chance to observe both the strengths and the weaknesses of his work. Among the faults, I think—and this one is a failing of the whole school—is a tendency to let the incidental rule at the expense of the overall concept, with the result that the basic values of a composition are lost in a clutter of more or less meaningless embellishment. (All the pictures in the show are simply numbered, by the way, which makes reference to them here a bit dull.) This fault is particularly evident in the two large canvases numbered 30 and 31, while in some of the smaller ones, notably No. 15, a really exquisite rhythmic quality in the design is almost totally obscured by the same sort of overelaboration.

There is, as well, a slight repetitiousness in Pollock's color patterns. His favorite compositional device is the overlying webs and striations that I have mentioned, and though this gives an air of depth and spaciousness to his canvases that is quite distinctive, it seems to me that too often the progression is up from a background of blue-greens and reds, through a network of whites, to a bolder pattern in black, and I am grateful when occasionally, as in the lacy and delicate No. 1 and the snowy-looking No. 27, he varies the sequence. By no means all of the work is repetitious, however, as one can see if one turns from the boldly black No. 32 to No. 27, or to the frieze-like, somewhat smaller No. 7, and in general the work shows a healthy imaginativeness of attack. Pollock's main strength, though, lies in an exuberance and vitality that, though hard to define, lend a sparkle and an excitement to his painting. I felt this particularly in such pieces as the green-and-black No. 19 and the lively, small No. 18. But it's a quality that is apparent all through the show, and I hope that he doesn't end up by letting it run away with him.

R[obert] G[oodnough]. "Reviews & Previews: Jackson Pollock." *Art News*
49, NO. 8 (DECEMBER 1950): 47. COPYRIGHT © 1950, ARTNEWS LLC. REPRINTED COURTESY OF
THE PUBLISHER.

Jackson Pollock, the most highly publicized of the younger American abstrac-
tionists whose controversial reputation is beginning to grow abroad, has been
deeply occupied with some enormous paintings this summer—the largest are 20
by 9 feet. *No. 100* of this series is done in great, open black rhythms that dance
in disturbing degrees of intensity, ecstatically energizing the powerful image in
an almost hypnotic way. His strength and personal understanding of the
painter's means allow for rich experience that projects a highly individualized
(yet easily communicable to the unselfconscious observer) sense of vision that
carries as well through to the smaller colorful paintings in which convergences of
tensions rule. Pollock has found a discipline that releases tremendous emotive
energy combined with a sensitive statement that, if to some overpowering, can
not be absorbed in one viewing—one must return. $350–$4,500.

*Goodnough's influential article "Pollock Paints a Picture," published five months after
his brief review of the Parsons show, belonged to a series that* Art News *had begun in
September 1941 with "Mr. Matisse Paints a Picture." The text, accompanied by Hans
Namuth's dramatic photographs of Pollock at work on* Autumn Rhythm: Number 30,
1950, *gave the impression that Goodnough had been present in the studio when the pic-
ture was executed. But numerous inaccuracies (including the title of the painting, which
is given as* Number 4, 1950) *suggest that the article was based primarily on Namuth's
pictures, supplemented by post facto discussions with Pollock.*

Robert Goodnough. "Pollock Paints a Picture." *Art News*
50, NO. 3 (MAY 1951): 38–41, 60–61. COPYRIGHT © 1951, ARTNEWS LLC. REPRINTED COURTESY
OF THE PUBLISHER.

Far out on Long Island, in the tiny village of Springs, with the ocean as back-
ground and in close contact with open, tree-studded fields where cattle graze
peacefully, Jackson Pollock lives and paints. With the help of his wife, Lee
Krasner—former Hofmann student and an established painter in her own right—
he has remodeled a house purchased there to fit the needs of the way of life they
have chosen, and a short distance away is a barn which has been converted into
a studio. It is here that Pollock is engrossed in the strenuous job of creating his
unique world as a painter.

Before settling on the Island, Pollock worked for ten years in a Greenwich
Village studio. Intermittently he made trips across the country, riding freight
trains or driving a Model A Ford, developing a keen awareness of vast landscape and
open sky. "You get a wonderful view of the country from the top of a freight car,"

he explains. Pollock loves the outdoors and has carried with him and into his painting a sense of the freedom experienced before endless mountains and plains, and perhaps this is not surprising in an artist born in Cody, Wyoming (in 1912) and raised in Arizona and northern California. Included in his background is study with Thomas Benton—for whom he was at one time a baby sitter on New York's Hudson Street—but he has mainly developed by himself, in contemplation of the lonesome silence of the open, emerging in the last few years as the most publicized and controversial of younger abstractionists. He is also one of the most successful.

To enter Pollock's studio is to enter another world, a place where the intensity of the artist's mind and feelings are given full play. It is the unusual quality of this mind, penetrating nature to the core yet never striving to show its surface, that has been projected into paintings which captivate many and agitate others by their strange, often violent, ways of expression. At one end of the barn the floor is literally covered with large cans of enamel, aluminum and tube colors—the boards that do show are covered with paint drippings. Nearby a skull rests on a chest of drawers. Three or four cans contain stubby paint brushes of various sizes. About the rest of the studio, on the floor and walls, are paintings in various stages of completion, many of enormous proportions. Here Pollock often sits for hours in deep contemplation of work in progress, his face forming rigid lines and often settling in a heavy frown. A Pollock painting is not born easily, but comes into being after weeks, often months of work and thought. At times he paints with feverish activity, or again with slow deliberation.

After some years of preparation and experimentation, during which time he painted his pictures on an easel, Pollock has developed a method that is unique and that, because of its newness, shocks many. He has found that what he has to say is best accomplished by laying the canvas on the floor, walking around it and applying the paint from all sides. The paint—usually enamel, which he finds more pliable—is applied by dipping a small house brush or stick or trowel into the can and then, by rapid movements of the wrist, arm and body, quickly allowing it to fall in weaving rhythms over the surface. The brush seldom touches the canvas, but is a means to let color drip or run in stringy forms that allow for the complexity of design necessary to the artist.

In his recent show, at the Parsons Gallery, Pollock exhibited a very large work, titled *Number 4, 1950*. (Pollock used to give his pictures conventionally symbolic titles, but—like many contemporary abstractionists—he considers them misleading, and now simply numbers and dates each work as it is completed.) It was begun on a sunny day last June. The canvas, 9 by 17 feet, was laid out flat, occupying most of the floor of the studio and Pollock stood gazing at it for some time, puffing at a cigarette. After a while he took a can of black enamel (he usually starts with the color which is at hand at the time) and a stubby brush which he dipped into the paint and then began to move his arm rhyth-

75

mically about, letting the paint fall in a variety of movements on the surface. At times he would crouch, holding the brush close to the canvas, and again would stand and move around it or step on it to reach to the middle. Within a half hour the entire surface had taken on an activity of weaving rhythms. Pools of black, tiny streams and elongated forms seemed to become transformed and began to take on the appearance of an image. As he continued, still with black, going back over former areas, rhythms were intensified with counteracting movements. After some time he decided to stop to consider what had been done. This might be called the first step of the painting, though Pollock stressed that he does not work in stages. He did not know yet when he would feel strongly enough about the picture to work on it again, with the intensity needed, nor when he would finally be finished with it. The paint was allowed to dry, and the next day it was nailed to a wall of the studio for a period of study and concentration.

It was about two weeks before Pollock felt close enough to the work to go ahead again. This was a time of "getting acquainted" with the painting, of thinking about it and getting used to it so that he might tell what needed to be done to increase its strength. The feverish intensity of the actual painting process could not be kept up indefinitely, but long periods of contemplation and thought must aid in the preparation for renewed work. In the meantime other paintings were started. When he felt able to return to the large canvas with renewed energy, Pollock placed it back on the floor, selected a light reddish brown color and began again to work in rhythms and drops that fell on uncovered areas of canvas and over the black. Occasionally aluminum paint was added, tending to hold the other colors on the same plane as the canvas. (Pollock uses metallic paint much in the same sense that earlier painters applied gold leaf, to add a feeling of mystery and adornment to the work and to keep it from being thought of as occupying the accepted world of things. He finds that aluminum often accomplishes this more successfully than greys, which he first used.) Again the painting was allowed to dry and then hung on the wall for a few days' renewed consideration.

The final work on the painting was slow and deliberate. The design had become exceedingly complex and had to be brought to a state of complete organization. When finished and free from himself the painting would record a released experience. A few movements in white paint constituted the final act and the picture was hung on the wall; then the artist decided there was nothing more he could do with it.

Pollock felt that the work had become "concrete"—he says that he works "from the abstract to the concrete," rather than vice versa: the painting does not depend on reference to any object or tactile surface, but exists "on its own." Pollock feels that criticism of a work such as this should be directed at least in terms of what he is doing, rather than by standards of what painting ought to be. He is aware that a new way of expression in art is often difficult to see, but

he resents presentation of his work merely on the level of technical interest.

Such a summation of Pollock's way of working is, of course, only part of the story. It has developed after years of concentrated effort, during long periods when nothing was satisfactory to him. He explains that he spent four years painting "black pictures," pictures which were unsuccessful. Then his work began to be more sure. There was a period of painting symbols, usually of figures or monsters, violently expressed. Of them, *She Wolf*, now owned by the Museum of Modern Art, was a crucial work. Here areas of brush-work and paint-pouring were combined, the painting being done partly on the floor and partly on the easel. The change to his way of working today was gradual, accompanying his various needs for expression, and though there is a sense of the brutal in what he does this gradually seems to be giving way to greater calm.

During the cataclysmic upheavals painting has undergone in recent years there have been rather drastic measures taken with the object. It has been distorted and finally eliminated as a reference point by many artists. The questions arise as to what the artist is dealing with, where he gets his ideas, what his subject matter is, etc. The answer may be found partly in the consideration that these artists are not concerned with representing a preconceived idea, but rather with being involved in an experience of paint and canvas, directly, without interference from the suggested forms and colors of existing objects. The nature of the experience is important. It is not something that has lost contact with reality, but might be called a synthesis of countless contacts which have become refined in the area of the emotions during the act of painting. Is this merely an act of automatism? Pollock says it is not. He feels that his methods may be automatic at the start, but that they quickly step beyond that, becoming concerned with deeper and more involved emotions which carry the painting on to completion according to their degree of strength and purity. He does not know beforehand how a particular work of his will end. He is impelled to work by the urge to create and this urge and what it produces are forever unknowable. We see paint on a canvas, but the beauty to which we respond is of an intangible order. We can experience the unknowable, but not understand it intellectually. Pollock depends on the intensity of the moment of starting to paint to determine the release of his emotions and the direction the picture will take. No sketches are used. Decisions about the painting are made during its development and it is considered completed when he no longer feels any affinity with it.

The work of art may be called an image which is set between the artist and the spectator. A Pollock reveals his personal way of bringing this image into existence. Starting automatically, almost as a ritual dance might begin, the graceful rhythms of his movements seem to determine to a large extent the way the paint is applied, but underlying this is the complex Pollock mind. At first he is very much alone with a picture, forgetting that there is a world of people and activity

outside himself. Gradually he again becomes aware of the outside world and the image he has begun to project is thought of as related to both himself and other people. He is working toward something objective, something which in the end may exist independently of himself, and that may be presented directly to others. His work may be thought of as coming from landscape and even the movement of the stars—with which he seems almost intimate at times—yet it does not depend on representing these, but rather on creating an image as resulting from contemplation of a complex universe at work, as though to make his own world of reality and order. He is involved in the world of art, the area in which man undertakes to express his finest feelings, which, it seems, is best done through love. Pollock, a quiet man who speaks with reserve and to the point, is in love with his work and his whole life evolves about what he is doing.

He feels that his most successful paintings carry the same intensity directly to the edges of the canvas. "My paintings do not have a center," he says, "but depend on the same amount of interest throughout." Since it has no reference to objects that exist, or to ideal objects, such as circles and squares, his work must be considered from the point of view of expression through the integration of rhythm, color and design, which he feels beauty is composed of. Physical space is dispensed with as an element in painting—even the dimensions of the canvas do not represent measurements inside which relationships are set up, but rather only determine the ends of the image.

Pollock's *Number 4, 1950* is concerned with creating an image in these terms. In this it is like much of his other work, but it is also among his most successful paintings, its manifold tensions and rhythms balancing and counteracting each other so that the final state is one of rest. In his less realized paintings one feels a lack of rest: movements have not been resolved. Colors in *Number 4, 1950* have been applied so that one is not concerned with them as separate areas: the browns, blacks, silver and white move within one another to achieve an integrated whole in which one is aware of color rather than colors. Nor is the concern with space here. There is no feeling that one might walk bodily into the rectangle and move about. This is irrelevant, the pleasure being of a different nature. It is more of an emotional experience from which the physical has been removed, and to this intangible quality we sometimes apply the word "spiritual."

In this picture Pollock has almost completely eliminated everything that might interfere with enjoyment of the work on this level. It is true the painting is seen through the senses, but they are only a means for conveying the image to the aesthetic mind. One is not earthbound in looking at *Number 4, 1950*, in lesser paintings one does not feel this sense of release from physical reactions. The experience Pollock himself has had with this high kind of feeling is what gives quality to his work. Of course anyone can pour paint on a canvas, as anyone can bang on a piano, but to create one must purify the emotions; few have the strength, will or even the need, to do this.

1951–1952

In June 1951, Pollock wrote to his friends Alfonso Ossorio and Ted Dragon, "I've had a period of drawing on canvas in black—with some of my early images coming thru—think the non-objectivists will find them disturbing—and the kids who think it simple to splash a Pollock out." The new works appeared in Pollock's fourth exhibition at the Betty Parsons Gallery, which opened on November 26, 1951.

James Fitzsimmons. "Fifty-Seventh Street in Review: Jackson Pollock." *The Art Digest*
26, NO. 6 (DECEMBER 15, 1951): 19.

In most of his new paintings Pollock has limited himself to black—thin, intensely black paint, twisting, trickling and swooping across raw canvas. The effect at times suggests a wall of densely intertwined vines pierced here and there by light. Where color is used it is a single shade of reddish-brown, with black still dominant.

By eliminating the problems (and the delights) of color and texture, Pollock has simplified matters considerably. And yet this new work is his most ambitious and complex to date, for without losing the most essential quality of his earlier work—the intricate haptic rhythms—he has added something which reaches areas of meaning and feeling he left untouched before.

Now, from the webs and snares of black, faces and figures in ever changing combinations emerge, sometimes distinctly, sometimes only by suggestion. These faces seem to express many different emotions, often violently as in caricature. The twisting fragmentary figures keep changing, too. Sometimes reclining and voluptuous, sometimes strutting and chunky or seated yogi fashion, they are expressive of instinct rather than of usual esthetic notions.

In a number of the paintings the lines and the areas of raw canvas seem to work upward, layer upon layer, until from a distance a symmetrical, pyramidal organization is seen to emerge. Purely formal complexities and the element of surprise produced by abrupt changes in the character of line were always present in this artist's work—and these qualities remain. But now an intensely gripping game of hide and seek is played—instincts and emotions other than the esthetic are engaged.

By introducing associative elements into his work, Pollock has found his own way of dealing with human experience. In this sense, his new paintings possess an additional level of meaning and so transmit a more complex kind of experience than did his earlier work. It would seem that Pollock has confounded those who insisted he was up a blind alley.

Clement Greenberg. "Jackson Pollock's New Style." *Harper's Bazaar*
85, NO. 2883 (FEBRUARY 1952): 174. REPRINTED BY PERMISSION OF UNIVERSITY OF CHICAGO
PRESS. © 1952 CLEMENT GREENBERG.

The references to the human form in Pollock's latest paintings are symptoms of a new phase but not of a reversal of direction. Like some older masters of our time he develops according to a double rhythm in which each beat harks back to the one before the last. Thus anatomical motifs and compositional schemes sketched out in his first and less abstract phase are in this third one clarified and realized.

In Pollock's by now well-known second period, from 1947 to 1950, with its spidery lines spun out over congealed puddles of color, each picture is the result of the fusion, as it were, of dispersed particles of pigment into a more physical as well as aesthetic unity—whence the air-tight and monumental order of his best paintings of that time. In these latest paintings, however, the unity of the canvas is more traditional, therefore more open to imagery. Black, brown, and white forms now move within a thinner atmosphere, and around central points, not thrusting as insistently as before toward the corners to assert the canvas's rectangular shape and block it out as a solid physical object.

Even so, the change is not as great as it might seem. Line and the contrast of dark and light became the essential factors for Pollock in his second phase. Now he has them carry the picture without the aid of color and makes their interplay clearer and more graphic. The more explicit structure of the new work reveals much that was implicit in the preceding phase and should convince any one that this artist is much, much more than a grandiose decorator.

1955

In 1952 Pollock changed dealers, leaving Betty Parsons in favor of Sidney Janis, a well respected dealer and collector known for his insightful writing on modern art and his more aggressive approach to sales. Pollock showed new work at Janis in 1952 and 1954 to generally positive reviews, but as his psychological problems deepened, his production slowed virtually to a halt. His 1955 exhibition at Janis took the form of a retrospective. It opened on November 28 of that year.

Leo Steinberg. "Month in Review: Fifteen Years of Jackson Pollock." *Arts*
30, NO. 3 (DECEMBER 1955): 43–44, 46. REPRINTED BY PERMISSION OF LEO STEINBERG. © 1955
LEO STEINBERG.

Jackson Pollock's work has been shown every year since the early 1940's. This month, at the Sidney Janis Gallery (through December 31), brings the first opportunity to see the artist whole, from *The Flame* of 1937, before he joined the WPA, to the *White Light* of 1954, the only picture finished in the last two years. It is therefore as good a time as any for stock-taking.

More than any other living artist's, Pollock's work has become a shibboleth; I have heard the question "What d'you think of Jackson Pollock?" shouted from the floor of a public gathering in a tone of "Are you with us or against us?"

His supporters and detractors share a common vehemence of conviction— which is not necessarily, as some believe, a point in Pollock's favor. For the detractors are not galled by the pictures themselves, but by the claim that they are art. What annoys them is thus extrinsic to the work and throws no light on its quality.

It would be a mistake to regard the division of opinion as running simply between highbrow and low, between Bohemian and Philistine. Today's alignments are more complex than those that confronted the Armory exhibitors. Arrayed against the sheer validity of Pollock's work are the views of most art historians, of most literary men, and of many brilliant painters not in the *avant-garde*. Pollock's champions are a few critics and museum men, abstract painters who recognize in him a superior power, and, above all, those who know the man himself. Thus Pollock dramatizes the question—"For whom does the artist paint?"

I recall a conversation I once had with Paul Brach, himself an abstract painter. I suggested that the type of person who becomes an artist is not necessarily the same in every culture. Granted that artists in primitive societies, or in our Middle Ages, were men who expressed a communal myth, what does the man whose temper moves him to express such a myth choose to become in our time? Is he not likely to become a Hollywood director, a writer of science or detective fiction, or an advertising man? At which point Brach said, "Yes, and the sort of man who now becomes a painter would, in the Middle Ages, have

81

become an alchemist."

But who in the Middle Ages understood what alchemists were doing? Only the other alchemists, while patrons were content with hazy notions of their general objectives. Note also that a modern painting tends to be spoken of today as an experiment, not as a thing of terminal validity, but as a step in some mysterious progression impelled by a final cause. If the analogy will be allowed to hold for the length of a paragraph, then we are dealing today with a wholly esoteric art, and Pollock is a *cause célèbre* precisely because more than anyone he symbolizes a radical change in the social role of art.

To support this esoteric theory of contemporary painting there is this further point, already hinted at: "You've got to know the painter to appreciate and understand his work." I have heard this phrase repeatedly, most often in regard to Pollock. I have been puzzling over what it means, since obviously it flouts some very basic and traditional ideas about the autonomy of the art work.

Now it seems to me to mean surprisingly much. It means that modern-art appreciation is a sanctificationist cult, where the initiate can get himself into a private state of grace through the appropriate sacrament, to wit, the handshake of the painter.

Or else it can mean this: just as a full understanding of, say, Indian art is denied to one who is not steeped in India's religious lore, and who ignores the myths of which that art is a prime carrier, so a Pollock painting, charged with his personal mythology, remains meaningless to him for whom Pollock himself is not a tangible reality. As Indian sculpture is related to Vedic and Upanishadic thought, exactly so are Pollock's canvases related to his self. Ignore that relation and they remain anonymous and insignificant.

All the above has been excogitated in an armchair, with a few reproductions at my elbow. And the reader who has stuck it out this far may have observed that it ignores the fact of the exhibition at the Janis Gallery. Now the effect of that exhibition is utterly overwhelming. Questions as to the validity of Pollock's work, though they remain perfectly good in theory, are simply blasted out of relevance by these manifestations of Herculean effort, this evidence of mortal struggle between the man and his art. For the man mortifies his skill in dogged quest for something other than accomplishment. From first to last the artist tramples on his own facility and spurns the elegance that creeps into a style which he has practiced to the point of knowing how. Thus the *Masked Image* of 1938 is a strong, well-knit cubist work, perfectly realized; but it gives way to the scattered paleography of *Magic Mirror*, 1941. His *Gothic* (1944) is a new synthesis—which breaks apart again in the levitating Miroid forms of *Totem II* (1945). How good these pictures are I cannot tell, but know that they have something of the barbarism of an ancient epic. Does anybody ask whether the Song of Gilgamesh is any good?

82

Then come the celebrated "drip" paintings on huge canvas or board, like *Cockatoo* of 1948, and the red-figured *Out of the Web* from the following year. Such tangled skeins have not been seen in art since Kells and Lindisfarne, but in the Irish manuscripts one marvels most at the magic of artifice by which the labyrinthine coils are ordered and controlled; whereas, in the comparison, the Pollock looks as every Van Gogh looked fifty years ago—something that you and I could do as well. But this is surely what the artist means. He has no love for conspicuous diligence; and if it comes to that, have we? The Middle Ages gave high rank to the artifact as a symbol of perfection; the thing of cunning workmanship stood near the top in their hierarchy of values. For us who think in terms of function, the artifact *per se*, though of multiplied ingenuity, is no longer in the order of ideal things. And so the artist, in the excellent words of Parker Tyler, "charges the distance between his agency and his work with as much *chance* as possible, the fluidity of the poured and scattered paint placing maximum pressure against conscious design."

Of course it is possible to carp at such painting, and not from any lack of taste or sensitivity to art, but from a love for humanistic values. Where we get stupefaction instead of enlightenment, where the mind is not confirmed in authority but rather scandalized, where, instead of rationality and freedom, we confront the apparent sport of mindless ferocity and chance, there it becomes legitimate to waive the question of the artist's merit and to enquire what it might signify for our entire culture if such work as his is indeed our best.

His last painting, called *White Light*, turns away, as one would expect, from the facility of the developed mazes of the early fifties. They had perhaps become too beautiful. *White Light* presents again that labored stammer on the surface, as if the artist could not think but against heaped resistance. It looks like the end-stage of Balzac's *Unknown Masterpiece*—the story that drew tears from Cézanne. The dense, clogging pigment seems to choke or bleach out of visibility some kinder picture underneath.

To me the most hypnotic picture in the show is *Echo*, done in 1951; a huge ninety-two-inch world of whirling threads of black on white, each tendril seeming to drag with it a film of ground that bends inward and out and shapes itself mysteriously into a molded space. There is a real process here; something is actually happening. Therefore the picture can afford to be as careless of critique as the bad weather is of the objections of a would-be picnicker. With all my thought-sicklied misgivings about Pollock, this satisfies the surest test I know for a great work of art.

1956–1958

1956 should have been a banner year for Pollock. The Museum of Modern Art had chosen him to initiate a series of exhibitions featuring contemporary artists. But Pollock died in a car crash on August 11, and what was intended as a mid-career retrospective became instead a memorial exhibition. The following essay, by the artist Allan Kaprow, was written shortly after Pollock's death, but Art News *chose not to publish it until 1958. In the years that followed, assemblages, environments, and happenings by Kaprow and other artists sought to extend Pollock's methods beyond the borders of painting.*

Allan Kaprow. "The Legacy of Jackson Pollock." *Art News*
57, NO. 6 (OCTOBER 1958): 24–26, 55–57. COPYRIGHT © 1958, ARTNEWS LLC. REPRINTED COURTESY OF THE PUBLISHER.

The tragic news of Pollock's death two summers ago was profoundly depressing to many of us. We felt not only a sadness over the death of a great figure, but in some deeper way that something of ourselves had died too. We were a piece of him: he was, perhaps, the embodiment of our ambition for absolute liberation and a secretly cherished wish to overturn old tables of crockery and flat champagne. We saw in his example the possibility of an astounding freshness, a sort of ecstatic blindness.

But, in addition, there was a morbid side to his meaningfulness. To "die at the top" for being his kind of modern artist was, to many, I think, implicit in the work before he died. It was this bizarre consequence that was so moving. We remembered Van Gogh and Rimbaud. But here it was in our time, in a man some of us knew. This ultimate, sacrificial aspect of being an artist, while not a new idea, seemed, the way Pollock did it, terribly modern, and in him the statement and the ritual were so grand, so authoritative and all-encompassing in its scale and daring, that whatever our private convictions, we could not fail to be affected by its spirit.

It was probably this latter side of Pollock that lay at the root of our depression. Pollock's tragedy was more subtle than his death: for he did not die at the top. One could not avoid the fact that during the last five years of his life his strength had weakened and during the last three, he hardly worked at all. Though everyone knew, in the light of reason, that the man was very ill (and his death was perhaps a respite from almost certain future suffering), and that, in point of fact, he did not die as Stravinsky's fertility maidens did, in the very moment of creation/annihilation—we still could not escape the disturbing itch (metaphysical in nature) that this death was in some direct way connected with art. And the connection, rather than being climactic, was, in a way, inglorious.

If the end had to come, it came at the wrong time.

Was it not perfectly clear that modern art in general was slipping? Either it had become dull and repetitive qua the "advanced" style, or large numbers of formerly committed contemporary painters were defecting to earlier forms. America was celebrating a "sanity in art" movement and the flags were out. Thus, we reasoned, Pollock was the center in a great failure: the New Art. His heroic stand had been futile. Rather than releasing a freedom, which it at first promised, it caused him not only a loss of power and possible disillusionment, but a widespread admission that the jig was up. And those of us still resistant to this truth would end the same way, hardly at the top. Such were our thoughts in August, 1956.

But over two years have passed. What we felt then was genuine enough, but it was a limited tribute, if it was that at all. It was surely a manifestly human reaction on the part of those of us who were devoted to the most advanced of artists around us and who felt the shock of being thrown out on our own. But it did not actually seem that Pollock had indeed accomplished something, both by his attitude and by his very real gifts, which went beyond even those values recognized and acknowledged by sensitive artists and critics. The "Act of Painting," the new space, the personal mark that builds its own form and meaning, the endless tangle, the great scale, the new materials, etc. are by now clichés of college art departments. The innovations are accepted. They are becoming part of text books.

But some of the implications inherent in these new values are not at all as futile as we all began to believe; this kind of painting need not be called the "tragic" style. Not all the roads of this modern art lead to ideas of finality. I hazard the guess that Pollock may have vaguely sensed this, but was unable, because of illness or otherwise, to do anything about it.

He created some magnificent paintings. But he also *destroyed painting*. If we examine a few of the innovations mentioned above, it may be possible to see why this is so.

For instance, the "Act of Painting." In the last seventy-five years the random play of the hand upon the canvas or paper has become increasingly important. Strokes, smears, lines, dots, etc. became less and less attached to represented objects and existed more and more on their own, self-sufficiently. But from Impressionism up to, say, Gorky, the idea of an "order" to these markings was explicit enough. Even Dada, which purported to be free of such considerations as "composition," obeyed the Cubist esthetic. One colored shape balanced (or modified, or stimulated) others and these in turn were played off against (or with) the whole canvas, taking into account its size and shape—for the most part, quite consciously. In short, part-to-whole or part-to-part relationships, no matter how strained, were at least a good fifty percent of the making of a picture. (Most of the time it was a lot more, maybe ninety percent). With Pollock, how-

ever, the so-called "dance" of dripping, slashing, squeezing, daubing and what-
ever else went into a work, placed an almost absolute value upon a kind of diaris-
tic gesture. He was encouraged in this by the Surrealist painters and poets, but
next to him their work is consistently "artful," "arranged" and full of finesse—
aspects of outer control and training. With a choice of enormous scales, the can-
vas being placed upon the floor, thus making it difficult for the artist to see the
whole or any extended section of "parts," Pollock could truthfully say that he
was "in" his work. Here the direct application of an automatic approach to the
act makes it clear that not only is this not the old craft of painting, but it is per-
haps bordering on ritual itself, which *happens* to use paint as one of its materi-
als. (The European Surrealists may have *used* automatism as an ingredient but
hardly can we say they really practiced it wholeheartedly. In fact, it is only in a
few instances that the writers, rather than the painters, enjoyed any success in
this way. In retrospect, most of the Surrealist painters appear to be derived from
a psychology book or from each other: the empty vistas, the basic naturalism,
the sexual fantasies, the bleak surfaces so characteristic of this period have
always impressed most American artists as a collection of unconvincing clichés.
Hardly automatic, at that. And such real talents as Picasso, Klee and Miró belong
more to the stricter discipline of Cubism than did the others, and perhaps this
is why their work appears to us, paradoxically, more *free*. Surrealism attracted
Pollock as an attitude rather than as a collection of artistic examples.)

But I used the words "almost absolute" when I spoke of the diaristic gesture
as distinct from the process of judging each move upon the canvas. Pollock,
interrupting his work, would judge his "acts" very shrewdly and with care for
long periods of time before going into another "act." He knew the difference
between a good gesture and a bad one. This was his conscious artistry at work
and it makes him a part of the traditional community of painters. Yet the dis-
tance between the relatively self-contained works of the Europeans and the
seemingly chaotic, sprawling works of the American indicate at best a tenuous
connection to "paintings." (In fact, Jackson Pollock never really had a "*maler-
isch*" sensibility. The painterly aspects of his contemporaries, such as Mother-
well, Hofmann, de Kooning, Rothko, even Still, point up, if at one moment a
deficiency in him, at another moment, a liberating feature—and this one I
choose to consider the important one.)

I am convinced that to grasp a Pollock's impact properly, one must be
something of an acrobat, constantly vacillating between an identification with
the hands and body that flung the paint and stood "in" the canvas, and allow-
ing the markings to entangle and assault one into submitting to their permanent
and objective character. This is indeed far from the idea of a "complete" paint-
ing. The artist, the spectator and the outer world are much too interchangeably
involved here. (And if one objects to the difficulty of complete comprehension,

I insist that he either asks too little of art or refuses to look at reality.)

Then Form. In order to follow it, it is necessary to get rid of the usual idea of "Form," i.e. a beginning, middle and end, or any variant of this principle—such as fragmentation. You do not enter a painting of Pollock's in any one place (or hundred places). Anywhere is everywhere and you can dip in and out when and where you can. This has led to remarks that his art gives one the impression of going on forever—a true insight. It indicates that the confines of the rectangular field were ignored in lieu of an experience of a continuum going in all directions simultaneously, *beyond* the literal dimensions of any work. (Though there is evidence pointing to a probably unknowing slackening of the attack as Pollock came to the edges of his canvas, he compensated for this by tacking much of the painted surface around the back of his stretchers.) The four sides of the painting are thus an abrupt leaving-off of the activity which our imaginations continue outward indefinitely, as though refusing to accept the artificiality of an "ending." In an older work, the edge was a far more precise caesura: here ended the world of the artist; beyond began the world of the spectator and "reality."

We accept this innovation as valid because the artist understood with perfect naturalness "how to do it." Employing an iterative principle of a few highly charged elements constantly undergoing variation (improvising, like much Oriental music) Pollock gives us an all-over unity and at the same time a means continuously to respond to a freshness of personal choice. But this type of form allows us just as well an equally strong pleasure in participating in a delirium, a deadening of the reasoning faculties, a loss of "self" in the Western sense of the term. It is this strange combination of extreme individuality and selflessness which makes the work not only remarkably potent, but also indicative of a probably larger frame of psychological reference. And it is for this reason that any allusions to Pollock's being the maker of giant textures are completely incorrect. The point is missed and misunderstanding is bound to follow.

But, given the proper approach, a medium-sized exhibition space with the walls totally covered by Pollocks, offers the most complete and meaningful sense of his art possible.

Then scale. Pollock's choice of enormous sizes served many purposes, chief of which for our discussion is the fact that by making mural-scale paintings, they ceased to become paintings and became *environments*. Before a painting, one's size as a spectator, in relation to that of the picture, profoundly influences how much we are willing to give up consciousness of our temporal existence while experiencing it. Pollock's choice of great sizes resulted in our being confronted, assaulted, sucked in. Yet we must not confuse these with the hundreds of large paintings done in the Renaissance. They glorified an everyday world quite familiar to the observer, often, in fact, by means of trompe l'oeil, continuing the actual room into the painting. Pollock offers us no such familiarity and our everyday

world of convention and habit is replaced by that one created by the artist. Reversing the above procedure, the painting is continued on out into the room.

And this leads us to our final point: Space. The space of these creations is not *clearly* palpable as such. One can become entangled in the web to some extent, and by moving in and out of the skein of lines and splashings, *can* experience a kind of spatial extension. But even so, this space is an *al*lusion far more vague than even the few inches of space-reading a Cubist work affords. It may be that we are too aware of our need to identify with the process, the making of the whole affair, and this prevents a concentration on the specifics of before and behind, so important in a more traditional art. But what I believe *is* clearly discernible is that the *entire* painting comes out at the participant (I shall call him that, rather than observer) right into the room. It is possible to see in this connection how Pollock is the terminal result of a gradual trend that moved from the deep space of the fifteenth and sixteenth centuries, to the building out from the canvas of the Cubist collages. In the present case the "picture" has moved so far out that the canvas is no longer a reference point. Hence, although up on the wall, these marks surround us as they did the painter at work, so strict a correspondence has there been achieved between his impulse and the resultant art.

What we have then, is a type of art which tends to lose itself out of bounds, tends to fill our world with itself, an art which, in meaning, looks, impulse, seems to break fairly sharply with the traditions of painters back to at least the Greeks. Pollock's near destruction of this tradition may well be a return to the point where art was more actively involved in ritual, magic and life than we have known it in our recent past. If so, it is an exceedingly important step, and in its superior way, offers a solution to the complaints of those who would have us put a bit of life into art. But what do we do now?

There are two alternatives. One is to continue in this vein. Probably many good "near-paintings" can be done varying this esthetic of Pollock's without departing from it or going further. The other is to give up the making of paintings entirely, I mean the single, flat rectangle or oval as we know it. It has been seen how Pollock came pretty close to doing so himself. In the process, he came upon some newer values which are exceedingly difficult to discuss, yet they bear upon our present alternative. To say that he discovered things like marks, gestures, paint, colors, hardness, softness, flowing, stopping, space, the world, life, death—is to sound either naïve or stupid. Every artist worth his salt has "discovered" these things. But Pollock's discovery seems to have a peculiarly fascinating simplicity and directness about it. He was, for me, amazingly childlike, capable of becoming involved in the stuff of his art as a group of *concrete facts* seen for the first time. There is, as I said earlier, a certain blindness, a mute belief in everything he does, even up to the end. I urge that this be not seen as a simple issue. Few individuals can be lucky enough to possess the intensity of this

kind of knowing, and I hope that in the near future a careful study of this (perhaps) Zen quality of Pollock's personality will be undertaken. At any rate, for now, we may consider that, except for rare instances, Western art tends to need many more indirections in achieving itself, placing more or less equal emphasis upon "things" and the *relations* between them. The crudeness of Jackson Pollock is not, therefore, uncouth or designed as such; it is manifestly frank and uncultivated, unsullied by training, trade secrets, finesse—a directness which the European artists he liked hoped for and partially succeeded in, but which he never had to strive after because he had it by nature. This by itself would be enough to teach us something.

It does. Pollock, as I see him, left us at the point where we must become preoccupied with and even dazzled by the space and objects of our everyday life, either our bodies, clothes, rooms, or, if need be, the vastness of Forty-Second Street. Not satisfied with the *suggestion* through paint of our other senses, we shall utilize the specific substances of sight, sound, movements, people, odors, touch. Objects of every sort are materials for the new art: paint, chairs, food, electric and neon lights, smoke, water, old socks, a dog, movies, a thousand other things which will be discovered by the present generation of artists. Not only will these bold creators show us, as if for the first time, the world we have always had about us, but ignored, but they will disclose entirely unheard of happenings and events, found in garbage cans, police files, hotel lobbies, seen in store windows and on the streets, and sensed in dreams and horrible accidents. An odor of crushed strawberries, a letter from a friend or a billboard selling Draino; three taps on the front door, a scratch, a sigh or a voice lecturing endlessly, a blinding staccato flash, a bowler hat—all will become materials for this new concrete art.

The young artist of today need no longer say "I am a painter" or "a dancer." He is simply an "artist." All of life will be open to him. He will discover out of ordinary things the meaning of ordinariness. He will not try to make them extraordinary. Only their real meaning will be stated. But out of nothing he will devise the extraordinary and then maybe nothingness as well. People will be delighted or horrified, critics will be confused or amused, but these, I am sure, will be the alchemies of the 1960s.

1961

Although Pollock was discussed indirectly in Harold Rosenberg's influential 1952 essay, "The American Action Painters," he was not mentioned by name. In contrast to the high vatic tone of the earlier essay, Rosenberg's 1961 book review of Bryan Robertson's 1960 volume, Jackson Pollock, *took a worldly, humorous approach.*

Harold Rosenberg. "The Search for Jackson Pollock," *Art News*
59, NO. 10 (FEBRUARY 1961): 35, 58–60. COPYRIGHT © 1961, ARTNEWS LLC. REPRINTED COUR-
TESY OF THE PUBLISHER.

Jackson Pollock fits snugly into the semi-comic legend of the "ring-tailed roarer" of the American frontier—a legend that lives on abroad less flawed by time and fact than it does among us. "Strength was his obsession—size, scale, power: he seemed obliged to shout their symbols as if after all he were not wholly secure in their possession. He shouted as though he were intoxicated by shouting. He shouted in ritual, as though the emotions by which he was moved were bending him to some primitive celebration . . . his heel-crackings and competitive matches were like savage efforts to create strength for the tribe by exhibiting strength." Twenty-five witnesses can be found any night in the Cedar Street Tavern in New York City to certify to the accuracy of this description of Jackson Pollock. Yet it was not written about him, but is a quotation from *American Humor* by Constance Rourke first published thirty years ago.

Pollock's whackdoodle was a revival, stimulated and a bit modified by Western movies. He wore the high boots, the blue jeans and the "neckercher"; he crouched on his heels and pulled up blades of grass when he talked; he liked to go to saloons and play at bustin' up the joint. The original of Pollock's half-man-half-alligator vaudeville of a century ago was also a playactor, putting on a show in order to strengthen in himself the illusion of being master of conditions that were often too much for him. "Always in the forest waited an enemy," Miss Rourke reminds us. And always too, there was the half-amused, half-hostile condescension of the Europeans and the cultivated citizens of the seaboard cities. The backwoodsman met both the real threat and the threat to his self-esteem by exaggerating himself. Not that Daniel Boone's cry of "more elbow room" was insincere; but it was a *conscious* way of opposing empty space to the culture of the gentleman or scholar. Identifying oneself as the "new beast" was from the start a ruse by which to break even in a contest one was bound to lose under the existing code. The primary consciousness of this "primitive" was a consciousness of onlookers. "He possessed a gift for masquerade; he wore a blank countenance,"—once again, Miss Rourke could be speaking of Jackson Pollock. His furtive glance, his slyness, were additional testimony to his sense of being watched.

Gorky, de Kooning, Motherwell and others prepared for America's challenge in the 'forties to European esthetic superiority and snobbishness by acquiring an artistic culture at breakneck speed—Pollock by turning back to the legend of "the yaller blossom of the forest." In the creation of art, the puppet one makes of oneself is of the first importance. It can be inspired by the myth out of which it came to a logic that defies any visible rationale. Playing cowboy helped make it possible for Pollock to paint under hardships that regularly filled him with despair. What was new in his painting emerged out of the contact of this "act" with the specific development of New York thought and art in the years of the War and those immediately following it.

But the work of art is itself a mask, one produced out of motives generated in a person who has no other way of revealing himself. Thus the legend and its creations work against the man. "He boasted and rhapsodized and made a rising clamor . . . but he was full of sudden silences." Even those who knew Pollock for years are in the dark about many sides of this talented playactor. With his violent death four years ago, his legend closed around him. From that moment on, the search for Jackson Pollock would become increasingly difficult.

As the completed Pollock legend began to circle the world, it was followed closely by a retrospective exhibition of the artist's work organized by the Museum of Modern Art. In London this imposing display of American extremism—a kind of sideshow of a twentieth-century abstract Buffalo Bill—struck with hallucinating impact the imagination of the young director of the Whitechapel Art Gallery, where the retrospective was held. Converted to a vision of grandeur he had never previously suspected in the art of our time, Mr. Robertson a year later composed the text of *Jackson Pollock*, a deluxe volume containing 169 illustrations of the artist's work, including thirty-six reproductions in color.

Mr. Robertson's book is totally dedicated to the Pollock legend of primitive creation on a continental scale—with some exchange of detail it might have been approved by Pollock himself, both for its spirit of paean and for its utility as a disguise. The explosion of words and concepts sent up by Robertson effectively veils its subject and serves at the same time to mark the spot of "greatness."

Robertson wishes to find the source of Pollock's paintings in the American landscape and circumstance. Unfortunately, America to him is simply the cliché of Bigness turned into an esthetic concept by being translated into the word "space." A dozen times we are told that Pollock, and pretty much Pollock alone, initiated "a new pictorial space" (though we are not told what "pictorial" means); and one of "the general causes behind the adoption of this new scale in American painting [is] the size of America as a continent." Beyond the fact of its size, Robertson knows nothing about the United States—not of its history, nor of its types, nor of its art movement of the last fifteen–twenty years. As we shall see, he also knows next to nothing about Pollock, and much of what he does

know is false, the effect of a more or less deliberate distortion and suppression of fact on the part of his informants. But "space" is sufficient to answer all the questions Robertson should have asked; he devotes more words to space than to his hero—perhaps he regards them as identical or consubstantial. As to the substance of these words, I am reminded of Jimmy Durante's comment on the Grand Canyon: a canyon is a hole and a hole is nuttin.

Robertson's generalized conception of America belongs to the age of Whitman. We are told of "the consciousness of a people scattered across a continent," of a "widening of horizons." "Space" aside, he seems ignorant of the transformations that have marked our traditional giganticism, and is thus unable to place Pollock in his own time. Robertson is, for instance, under the mistaken impression, probably formed out of some random talk he heard in New York, that large paintings in America are an innovation of this century—it is plain he has never heard of Church and other Hudson River painters of huge landscapes nor of the mile-long cycloramas that delighted our citizens after the Civil War. Nevertheless this matter of the size of paintings is of great importance to him and he spends pages ruminating on their emergence as a novelty of our time. It seems to him that the background of today's big canvases is the WPA (which he calls FPA; perhaps Federal Art Project sounds more dignified than Works Progress Administration), although in the period following the close of the government's mural project big paintings were not in vogue. In similar manner most of Robertson's chronology is mixed into the mess of hearsay on which he based his text.

Moreover, Robertson is a very poor writer, at once vaguely theoretical, redundant and lacking in judgment. About Pollock's alcoholism he speculates that it may have come from "working on the land, in tough conditions, with groups of men mostly older than himself." Having used the word "sculpture," he feels obliged to advise the reader that this art is "the most primitive, immediate and direct activity in the field of creative expression" (he might have thought of sex). When he says that Pollock "was a rebel by nature," he tells us what this means by adding that our rebel "was not attracted by tradition or by authority" (naybur, sez we, you oughten run down are book larnin that fur). Faulty in diction, he declares of Pollock's large paintings of 1951 that in them the artist's imagery "has gained a new fulsomeness and grandiosity," never intending, I am sure, to say that the paintings are "offensive or disgusting because of excess," the definition of "fulsome," especially when linked with "grandiose."

In regard to Pollock's development as an artist, the percentage of information to theory is exceedingly small: Robertson seems to hope to capture its phases by juggling notions about the American land, Miró, Mondrian, Navaho sand painting, Spanish Colonial art, sculpture. Rarely does he touch a bit of data without being wounded by it. For instance, he says of Pollock that "the social 'message' in Benton's work did not interest him" and that he "moved steadily toward

a phase of painting strongly influenced by modern Mexican art, notably by Sequiros [Siqueiros?] and Oroszco [Orozco?], and containing his first imagery of an abstract, hieratic nature."

The inference is that Pollock abandoned Benton out of weariness with the social subjects of the art of the 'thirties and an early preference for abstraction and symbolism. But Siqueiros was the Communist thug who tried to assassinate Leon Trotsky, and Orozco was a Marxist, while Pollock himself, I have been told, joined the Communist Party. In short, Pollock left Benton's regionalism, which was scorned in New York, to go to the Left and to international art, which was the accepted idea, though he carried the regionalism with him in the form of his "frontier" behavior.

In his attempt to inflate Pollock's reputation in terms of current attitudes, Robertson has done everything possible to deprive the artist's life of substance. He has even overlooked his dog, Gyp, and his model A Ford, the companions which served Pollock as equivalents to the frontierman's gun and horse. What better proof is needed that Robertson has no interest in Pollock but only in a fabricated "master"? Speaking of Pollock's growing up in the West, he writes, "This early background to the age of sixteen can only be very sparsely charted." Why sparsely? Pollock's older brothers are alive, including one who is an artist and art teacher and who brought Jackson to New York. So are old friends who knew Pollock in high school on the Coast, for instance, Philip Guston and Reuben Kadish. So is his erstwhile analyst—hardly a person of Pollock's generation could have his early years more adequately documented. Not one of these individuals, however, is mentioned in the list of those consulted by Robertson, a list which does include Lillian Gish, a Lady Someone-or-other and such mysterious names as Nicolas Kallos. As for Pollock's maturer years, Robertson is no more revealing; the artist appears in his book as without friend, companion or influence, except for a couple of references to his having married Lee Krasner. Pollock's correspondence with the Thomas Bentons, which I am told went on even into the years of his late style, is totally ignored. Clement Greenberg is spoken of in a couple of sentences as if his part consisted merely in promoting Pollock's reputation, whereas there is no doubt that, for better or worse, Greenberg affected his work itself, shoring up the artist's arbitrariness with his own and pressing him onward.

Being unable to "chart" Pollock's background does not prevent our historian from concluding that "Pollock's taste was sophisticated from an early age," that he was "conscious of the dramatic distances and spaces of the western landscape," that he "observed the land and its formations at close quarters" and that having "seen the surfaces and textures and markings of minerals and ores . . . [he became] conscious, always with an artist's gaze, of the colors and properties of rocks and stones and earth. His later work shows always an extreme consciousness of surface and texture. . . ." One may pass by Robertson's theories concern-

93

ing Pollock's paintings as related to sculpture, sand painting and "the heroic diagonal." To the effort of the historian, Robertson prefers the claim jumping of the publicity agent, supported by whipped-up generalizations and cagey "perhapses." The publication of such a text in a volume so magnificent in the number and quality of its plates proves what many have suspected for some time, that the words in an art book are not meant to be read but are placed in columns among the illustrations as part of the conventional design of this odd product of the printing presses. "His [Pollock's] equation of time with space, made by the painting gesture and its mark or embodiment on the canvas, can be seen as space subduing time—or the American mistrust of the past being overcome—by opposing it, as the present and as the climax contained in the painting act." When he wrote this, the winds of American space must have been whistling through the author's cranium. Having concocted page after page on the significance of the blue poles in Pollock's pictures of that name, Robertson concludes, "They are merely poles, however we interpret their iconographic derivations." Well, there's no harm in talking about them, is there? More nonsensical is his "interpretation" of Pollock's death—the artist was killed not by hitting a tree in his car but by the effort to paint *Scent* the year before (I suspect it was two years, since Robertson's statement that Pollock "was working almost incessantly" to the end is a notorious untruth).

The only serious thing about a book like this is its distortion of the past. Were this an ordinary volume, one might overlook its misstatements along with its vacuity. But the imposing format is likely to discourage rival publications for some years to come and by that time Robertson's errors and incomprehensions will have become part of the record. The falsification of the history of art is not, of course, as dire as the falsification of the history of wars and revolutions, such as Hitler's re-telling of the events of the First World War which brought the Nazi extermination program into being, or Stalin's re-writing of the October Revolution out of which came the Moscow Trials and Siberian slave camps. Compared with these consequences of myth-making, the revision of the history of our current art movement is in the realm of farce. Farce, however, as the Greeks liked to remind themselves, goes hand in hand with tragedy and the False Witness and the Fury are sisters under the skin.

Having the minimum to say about Pollock's life and character and the influences that played upon him, Robertson attempts to fill out his subject by looting Pollock's contemporaries. Each detail of the artist's practice is presented as a significant innovation—e.g., his use of Duco, although Siqueiros lectured at the Artists Union in the 'thirties on the use of Duco and was known locally as "Il Duco." Intellectually, Pollock, like many good artists, was a magpie, attracted to glittering bits in ideas and techniques and incapable of sustained mental effort—you can see this in the drawings of 1938–43, with their pick-ups from the

constellation of Masson-Matta-Gorky, and especially if you compare these scattered pieces with the hundreds of drawings in which Gorky strove in 1929–32 to draw out the secrets of Picasso. Robertson tries to give Pollock an original title to everything he found—and even to things he didn't find. In his pages, Pollock is transformed into a purposeful, reflective agent of the age. "In a society which has lost or forgotten or disowned its tribal customs, Pollock tried to create a new ritual in visual terms." Miss Rourke's Mississippi River roarer was also a "ritualist," but he had no biographer to tell us what he was "trying to create."

We saw above that by living as a boy in California, Pollock became "conscious of dramatic distances." This dramatic perception did not, according to Robertson, stop with scene painting but stimulated Pollock to create a new conception of art as gesture that put him in the van of all his contemporaries. "During a conversation in 1949 with Harold Rosenberg, Pollock talked of the supremacy of *the act of painting* as in itself a source of magic. An observer with extreme intelligence, Rosenberg immediately coined the new phrase: action painting" (Robertson's italics). The aim of this statement is obviously, to present Pollock as the originator of Action Painting in theory and in practice, if not in name. Thus Willem de Kooning, Franz Kline, Hofmann, Guston, Tworkov, Elaine de Kooning, Michael Goldberg, Grace Hartigan, Joan Mitchell, Norman Bluhm, and dozens of others in the United States, England, Holland, Italy, Japan, become disciples of the muse of The Rocky Mountains. The statement is, of course, entirely false, and whoever informed Mr. Robertson that this conversation took place knew it was false. Pollock never spoke to Rosenberg about the "act of painting," of its "supremacy" (to what?) or of any "source of magic" in it. This can easily be demonstrated. The concept of Action Painting was first presented in the December, 1952, *ArtNews*, so that if the conversation described by Robertson had taken place in 1949 Rosenberg did not produce the phrase "immediately" but waited three years. It may have required that much time for him to penetrate the depths of Pollock's observation, but in that case one would be justified in questioning his "extreme intelligence." On the other hand, Rosenberg had *published* writings on the subject of action as constitutive of identity as far back as 1932; in 1948, a year before the alleged tip-off, he further elaborated the topic in an essay in *The Kenyon Review* entitled "The Resurrected Romans," which may have had something to do with "magic" but nothing to do with Pollock or with painting. A conversation between Pollock and Rosenberg did occur in 1952, immediately preceding the composition of "The American Action Painters," but in this talk Pollock said nothing about action. He spoke of identifying himself with a tree, a mode of self-stimulation not unknown in the tradition of which we have been speaking and much more relevant to the paintings for which he is famous. He also attacked a fellow artist for working from sketches, which in Pollock's opinion, made that artist "Renaissance" and backward (this point was reported

95

in the "Action Painters" essay, though without mentioning names). In his last years, Robertson informs us, Pollock liked to refer to the canvas he was working on as "the arena"—this term was garnered from "The American Action Painters," which says: "At a certain point the canvas began to appear to one American painter after another as an arena in which to act." Apparently, Pollock, or someone presently speaking for him, wished to acquire this thought for himself exclusively, although Rosenberg had told Pollock, in the presence of a witness, that the article was not "about" him, even if he had played a part in it. It is further noteworthy that in the published statements by Pollock quoted by Robertson the word "action" is never used, nor is there any thought on the subject, though Pollock's opinion about sketches is given under the date of 1951.

There is nothing objectionable, naturally, in an artist's enlarging his vocabulary, but what is to be gained by attributing to Pollock *literary discoveries* outside his range? The intellectualization of Pollock, based on no evidence whatsoever, can only push him still farther into the painful estrangement from which he suffered throughout his lifetime. If remarks touching on Pollock, or on contemporary art, which the artist chose to repeat are run back into his brain, as on a reversed tape, and then played out of his mouth as thoughts of his own, the effect is to substitute a mechanism for the man and to hide still deeper the tie between the soft, lyrical sensibility evident in his best paintings and the shy, gentle spirit that animated the blustering mimic of force who has so captivated the tired mythmaker of our day.

1965

The most brilliant exponent of Greenbergian formalism, after Greenberg himself, was Michael Fried. In 1965, while still a graduate student at Harvard, he organized an exhibition of Three American Painters—*Kenneth Noland, Jules Olitski, and Frank Stella—that served as a manifesto for Color Field painting. Fried's catalogue essay traced the new movement back to its roots in Pollock's work, and the section on Pollock was reprinted as an independent essay in* Artforum. *Fried's formalist interpretation has remained an essential point of reference for all subsequent critics.*

Michael Fried. "Jackson Pollock." *Artforum*
4, NO. 1 (SEPTEMBER 1965): 14–17. © ARTFORUM, SEPTEMBER 1965.

The almost complete failure of contemporary art criticism to come to grips with Pollock's accomplishment is striking. This failure has been due to several factors. First and least important, the tendency of art writers such as Harold Rosenberg and Thomas Hess to regard Pollock as a kind of natural existentialist has served to obscure the simple truth that Pollock was, on the contrary, a painter whose work is always inhabited by a subtle, questing formal intelligence of the highest order, and whose concern in his art was not with any fashionable metaphysics of despair but with making the best paintings of which he was capable. Second, in the face of Pollock's all-over drip paintings of 1947–50—the finest of which are, I believe, his masterpieces—the vocabulary of the most distinguished formal criticism of the past decades, deriving as it does chiefly from the study of Cubism and Late Cubist painting in Europe and America, begins to reach the furthest limits of its usefulness. Despite Pollock's intense involvement with Late Cubism through 1946, the formal issues at stake in his most successful paintings of the next four years cannot be characterized in Cubist terms,[1] and in general there is no more fundamental task confronting the formal critic today than the evolution and refinement of a post-Cubist critical vocabulary adequate to the job of defining the formal preoccupations of modernist painting since Pollock. What makes this task especially difficult is the fact that the formal issues with which Pollock and subsequent modernists such as Louis, Noland, Olitski and (though perhaps to a lesser degree) Stella have chosen to engage are of a phenomenological subtlety, complexity and richness without equal since Manet. The following discussion of Pollock's work will concentrate on a nexus of formal issues which, in my opinion, are central both to Pollock's art after 1947 and to some of the most salient characteristics of subsequent modernist painting. These issues concern the ability of line, in modernist painting of major ambition, to be read as bounding a shape or figure, whether abstract or representational. The discussion will begin with an attempt to describe the general nature of Pollock's work

between 1947 and 1950, and will move on to consider several specific paintings which illustrate the virtually self-contradictory character of Pollock's formal ambitions at this is time.

The Museum of Modern Art's "Number One" (1948), roughly typical of Pollock's best work during these years, was made by spilling and dripping skeins of paint on to a length of unsized canvas stretched on the floor which the artist worked on from all sides. The skeins of paint appear on the canvas as a continuous, all-over line which loops and snarls time and again upon itself until almost the entire surface of the canvas is covered by it. It is a kind of space-filling curve of immense complexity, responsive to the slightest impulse of the painter and responsive as well, one almost feels, to one's own act of looking. There are other elements in the painting besides Pollock's line: for example there are hovering spots of bright color, which provide momentary points of focus for one's attention, and in this and other paintings made during these years there are even handprints put there by the painter in the course of his work. But all these are woven together, chiefly by Pollock's line, to create an opulent and, in spite of their diversity, homogeneous visual fabric which both invites the act of seeing on the part of the spectator and yet gives his eye nowhere to rest once and for all. That is, Pollock's all-over drip paintings refuse to bring one's attention to a focus anywhere. This is important. Because it was only in the context of a style entirely homogeneous, all-over in nature and resistant to ultimate focus that the different elements in the painting—most important, line and color—could be made, for the first time in Western painting, to function as wholly autonomous pictorial elements.

At the same time, such a style could be achieved only if line itself could somehow be prized loose from the task of figuration. Thus an examination of "Number One," or of any of Pollock's finest paintings of these years, reveals that his all-over line does not give rise to positive and negative areas: we are not made to feel that one part of the canvas demands to be read as figure, whether abstract or representational, against another part of the canvas read as ground. There is no inside or outside to Pollock's line or to the space through which it moves. And this is tantamount to claiming that line, in Pollock's all-over drip paintings of 1947–50, has been freed at last from the job of describing contours and bounding shapes. It has been purged of its figurative character. Line, in these paintings, is entirely transparent both to the non-illusionistic space it inhabits but does not structure, and to the pulses of something like pure, disembodied energy that seem to move without resistance through them. Pollock's line bounds and delimits nothing—except, in a sense, eyesight. We tend not to look beyond it, and the raw canvas is wholly surrogate to the paint itself. We tend to read the raw canvas as if it were not there. In these works Pollock has managed to free line not only from its function of representing objects in the world, but

also from its task of describing or bounding shapes or figures, whether abstract or representational, on the surface of the canvas. In a painting such as "Number One" there is only a pictorial field so homogeneous, overall and devoid both of recognizable objects and of abstract shapes that I want to call it "optical," to distinguish it from the structured, essentially tactile pictorial field of previous modernist painting from Cubism to de Kooning and even Hans Hofmann. Pollock's field is optical because it addresses itself to eyesight alone. The materiality of his pigment is rendered sheerly visual, and the result is a new kind of space—if it still makes sense to call it space—in which conditions of seeing prevail rather than one in which objects exist, flat shapes are juxtaposed or physical events transpire.

To sum up then: in Pollock's masterpieces of 1947–50, line is used in such a way as to defy being read in terms of figuration. I hope it is clear that the opposition "figurative" versus "non-figurative," in the sense of the present argument, stands for a more fundamental issue than the opposition between the terms "representational" and "non-representational." It is possible for a painting or drawing to be both non-representational—what is usually termed "abstract"—and figurative at the same time. In fact, until Pollock that was the most that so-called "abstract" painting had ever been. This is true, for instance, of de Kooning, as well as of all those Abstract Expressionists whose work relies on Late Cubist principles of internal coherence. It is true also of Kandinsky, both early and late. For example, in Kandinsky's "Painting with White Forms" (1913), a heroic attempt has been made to allow line to work as freely as color. But one senses throughout the canvas how the line has been abstracted from various natural objects; and to the degree that one feels this, the line either possesses a residual but irreducible quality as of contour, so that one reads it as having an inside and an outside—as the last trace of a natural object that has been dissolved away by the forces at work in the pictorial field—or else it possesses the quality of an object in its own right: not merely as line, but as a kind of thing, like a branch or bolt of lightning, seen in a more or less illusionistic space. In his later work—"Yellow-Red-Blue" (1929) is a case in point—Kandinsky tried to overcome his dependence upon natural objects by restricting himself to geometrical shapes that could be made with compass and ruler; and he chose to emphasize or heighten the quality which his line possessed from the start, of being another kind of thing in the world. In paintings such as this, Kandinsky's line seems like segments of wire, either bent or straight, which are somehow poised in a space that is no less illusionistic than in the earlier paintings. Both these canvases by Kandinsky could be called non-representational; but both are clearly figurative, if we compare them with Pollock's all-over paintings of 1947–50.

Pollock, however, seems not to have been content with the non-figurative style of painting he had achieved, and after 1950 returned to figuration, at first

99

in a series of immensely fecund black-and-white stain paintings, and afterwards in works which tended to revert to something close to traditional drawing. These latter paintings probably mark Pollock's decline as a major artist. But it is important to observe that Pollock's involvement with figuration did not cease entirely between 1947 and 1950.

For example, the painting "White Cockatoo" (1948), was made by dripping black paint in a series of slow-moving loops and angular turns which come nowhere near covering the brown canvas; but instead of trying to create the kind of homogeneous visual fabric of paintings like "Number One," Pollock chose to fill in some of the areas accidentally circumscribed when his black line intersected itself; with gouts of red, yellow, green, blue and white oil paint, either knifed onto the canvas or squeezed in short bursts directly from the tube. It is significant that Pollock was careful not to fill in only the most conspicuous of these areas. Some of the most positive contours are left almost completely devoid of painted fill-in, whereas areas that seem to lie between more positive contours have been filled in. The result is that the painting leaves one with the strong impression that the black line, instead of retaining the non-figurative character it possesses in the optical paintings made at the same time, works to describe shapes and evoke forms seen as if against a colored background. By filling in certain areas isolated by his black line as it loops and angles back upon itself, Pollock restored to it some measure of line's traditional role in bounding and describing shapes and figures. And the fact that in "White Cockatoo" he filled in both predominantly convex and concave (or positive and negative) areas does not work to counteract the figurative character of the line. Rather, it creates a rough equivalent to a Synthetic Cubist ambiguity of figure versus ground, but without the rigor and strict consequentiality of Synthetic Cubism itself. "White Cockatoo," then, represents an awkward compromise among three stylistic modes: first, Synthetic or Late Cubism; second, what might be called naive abstract illusionism or naive abstract figuration, in which an abstract shape or figure is seen against a background situated an indeterminate distance behind it; and third, the all-over, optical, non-figurative abstraction of Pollock's best contemporary work. "White Cockatoo" is not a successful painting. But it is an important one, because it suggests that as early as 1948, when Pollock was realizing masterpiece after masterpiece in his optical style, he could not keep from chafing at the high price he had to pay for this achievement: the price of denying figuration, of refusing to allow his line to describe shapes, whether abstract or representational. It is significant, however, that "White Cockatoo" does not try to repudiate the techniques of paintings such as "Number One." Instead it suggests that Pollock had begun to cast about for some way to do what seems, on the face of it, impossible: to achieve figuration within the stylistic context of his all-over, optical style.

100

There are other paintings, such as "The Wooden Horse" (1948) and "Summertime" (1948), which reinforce this interpretation. In all of these Pollock seems to have been preoccupied with the problem of how to achieve figuration within the context of a style that entailed the denial of figuration; or to put it another way, with the problem of how to restore to line some measure of its traditional figurative capability, within the context of a style that entailed the renunciation of that capability. Only if we grasp, as vividly and even as painfully as we can, the contradiction implicit in what seems to have been Pollock's formal ambition in these works—to combine figuration with his all-over, optical style—will we be able to gauge the full measure of his achievement in two other paintings of these years.

The first of these I want to consider is the painting "Cut-Out" (1949). Either before he came to paint it or, more probably, in the course of painting it, Pollock arrived, almost certainly through intuition rather than rational analysis, at the realization that the only formally coherent way to combine his all-over, optical style with figuration was somehow to make the painting itself proclaim the contradiction implicit in this ambition. This sounds more paradoxical than in fact it is. It has been observed how Pollock's all-over style entailed the negation of figuration; and how figuration in turn entailed the negation of that style. In "Cut-Out" these negations become the fundamental means by which the painting is made. That is, in "Cut-Out" Pollock achieved figuration by negating part of the painted field—by taking something away from it—rather than by adding something as in "White Cockatoo," "The Wooden Horse" and "Summertime." Here Pollock actually cut away the figure or shape, which happens to be roughly humanoid in outline, from a piece of canvas on which an all-over painted field had previously been dripped, and then backed this piece with canvas-board. The result is that the figure is not seen as an object in the world, or shape on a flat surface—in fact it is not seen as the presence of anything—but rather as the absence, over a particular area, of the visual field. This enhances, I think, the force of the word "optical" with which I have tried to characterize Pollock's all-over style. Figuration is achieved in terms of eyesight alone, and not in terms that imply even the possibility of verification by touch. The figure is something we don't see—it is, literally, where we don't see—rather than something, a shape or object in the world, we do see. More than anything, it is like a kind of blind spot, a kind of defect in our visual apparatus; it is like part of our retina that is destroyed or for some reason is not registering the visual field over a certain area. This impression is strengthened if we ask ourselves where, in this painting, the cut-out area seems to lie in relation to the painted field. For me, at any rate, it does not lie behind the field, despite the fact that where the field is cut away we see the mostly blank canvas-board behind it; and it does not seem to lie on the surface, or in some tense, close juxtaposition with it, as in the shal-

101

low space of Synthetic Cubism. In the end, the relation between the field and the figure is simply not spatial at all: it is purely and wholly optical: so that the figure created by removing part of the painted field and backing it with canvas-board seems to lie somewhere within our own eyes, as strange as this may sound.

In "Cut-Out" Pollock succeeds, by means of the most radical surgery imaginable, in achieving figuration within the stylistic context of an opticality almost as unremitting as that which characterizes paintings such as "Number One." But there are two important respects in which "Cut-Out" remains inconsistent with Pollock's all-over, optical style. The first, is its tendency to focus our attention on the figure created where Pollock cut away the painted canvas. This figure is emphasized as no single visual incident or cluster of incidents is ever emphasized in those all-over pictures in which the painted fields are left intact. And the second has to do with the proportion of the total canvas occupied by the cut-out figure. In "Cut-Out" it is large enough to deprive the visual field of the sense of expansiveness, of sheer visual density, that we find in a painting such as "Number One." Both these qualifications disappear in the face of the last painting I want to consider in detail, "Out of the Web" (1949).

Again in "Out of the Web" Pollock achieved figuration by removing part of a painted field, which in this case had been dripped onto the smooth side of a piece of brown masonite. This time, however, the figures that result do not occupy the center of the field; they are not placed so as to dominate it and to focus the spectator's attention upon themselves. Instead they seem to swim across the field and even to lose themselves against it. In "Out of the Web," as in "Cut-Out," figuration is perceived as the absence, over a particular area, of the visual field. It is, again, like a kind of blind spot within our eyes. But unlike the figure in "Cut-Out," the sequence of figures in "Out of the Web" is almost as hard to see, to bring one's attention to bear on, as a sequence of actual blind spots would be. They seem on the verge of dancing off the visual field or of dissolving into it and into each other as we try to look at them.

"Out of the Web" is one of the finest paintings Pollock ever made. In it, for the first and only time, he succeeded completely in restoring to line its traditional capability to bound and describe figures within the context of his all-over, optical style—a style I have argued was largely founded on the liberation of line from the task of figuration. It is, however, not surprising, if one is at all familiar with Pollock's career, that he did not repeat his remarkable solution throughout a whole series of works; among the important American painters who have emerged since 1940 Pollock stands almost alone in his refusal to repeat himself. And having solved the problem of how to combine figurative line—the line of traditional drawing—with opticality in "Cut-Out" and "Out of the Web," Pollock abandoned the solution: because it could not be improved upon, or developed in any essential respect, and because to repeat the solution would have been to

debase it to the status of a mere device. In this sense Pollock's solution was both definitive and self-defeating, and from 1951 on his work shows the strong tendency already mentioned to revert to traditional drawing at the expense of opticality. But in a series of remarkable paintings made by staining thinned-down black paint into unsized canvas in 1951, Pollock seems to have been on the verge of an entirely new and different kind of painting, combining figuration with opticality in a new pictorial synthesis of virtually limitless potential; and it is part of the sadness of his last years that he appears not to have grasped the significance of what are perhaps the most fecund paintings he ever made.

[1]For example, in his essay "American-Type Painting," Clement Greenberg remarks on what seems to him the close visual relationship between Pollock's all-over painting and Analytical Cubism. "I do not think it exaggerated to say that Pollock's 1946–1950 manner really took up Analytical Cubism from the point at which Picasso and Braque had left it when, in their collages of 1912 and 1913, they drew back from the utter abstractness for which Analytical Cubism seemed headed." ("Art and Culture," Boston, 1961, p. 218.) One is always ill at ease disagreeing with Greenberg on visual grounds; however, I cannot help but see Pollock's all-over painting of these years in radically different terms.

1966

As if in reaction against the formalist readings of Greenberg and Fried, the mid-1960s saw an increasing interest in the biographical background of Pollock's artistic development.

Axel Horn. "Jackson Pollock: The Hollow and the Bump." *The Carleton Miscellany* (NORTHFIELD, MINN.) 7, NO. 3 (SUMMER 1966): 80–87.

I first met Jackson Pollock in the fall of 1933 when I registered to study with Thomas Benton at the Art Students League in NYC. Jack was the monitor that year, which meant that he was responsible for the running of the class, the hiring of models, and so on. For this he received free tuition.

The class at the time numbered about 12 people. This was par; Benton's classes were never large. On the day I walked into the classroom, they were all huddled in a tight group around the model stand in one corner of the room. Seated on stools and holding drawing boards on their laps, each student was busily scratching out a drawing with a grocer's pencil on brown wrapping paper. Several squatted on the stand itself, forming a solid group whose core was the model. She was a young girl with the pleasing fruity contours and surface textures of a warm peach. She also sat on a stool and was distinguishable from the rest because she was nude and without a drawing board. Otherwise she seemed as occupied and involved as everyone else.

From time to time, one or another of the students would slide off his stool, move in closer and stretching out a hand, would poke with a questioning finger some portion of the model's anatomy. (On subsequent days I did this many times myself. It was in order to identify the direction and shape of a particular muscle or bone. Sometimes a consultation with the model and confirming pokes by other students were necessary before positive identification was made. Such small rituals, the result of a strong unanimity of purpose and method, was what gave the Benton class whatever distinction it had.)

At the first rest period, one of the crouching figures on the stand opened upwards like a carpenter's rule and, brushing aside the sandy blonde hair that fell into his eyes, walked over to me with a slight smile and a puzzled frown. This expression—the smile barely tightening the corners of his mouth, the squint as if looking through early morning mountain haze, the knitting of the brows in what seemed to be (and was indeed) a continual attempt to comprehend a bewildering and complex world—stayed with Pollock (as later photographs testify) to the end of his life. With a diffident gesture he gave me to understand that what I had seen was what there was to know.

In a matter of weeks, drawing on brown wrapping paper with the characteristic scribbly line, I had adopted the class (Benton) objectives—to be able to

articulate and express the softness, the tensions, the recessions and the projections of the forms that together make up the human figure. Benton called this expressing the "hollow and the bump."

The members of the class obviously shared a common need, and we had all apparently gravitated there drawn by something that promised to fill this need. Other art students in the other classes were attempting to solve numbers of artistic problems concurrently; learning how to manipulate paint, how to express a form, how to draw, how to compose a picture—all on one canvas. We on the other hand, seemed to be the kind of people who needed to break down the total complex problem of creating a work of art into its smaller components and solve each of these by itself, one after the other. Benton taught this way and we all found in him a most satisfactory teacher. The pursuit of the "hollow and the bump" was one of these problems that we had separated out as one separates a mustang from the rest of the herd and we were out to break it to our bidding. The "hollow and the bump" had a symbolic significance like "yin and yang." It expressed for us the polarity from negative, recessive, softness to positive, solid, projecting forcefulness.

I learned to know fellow members of the class: Bruce Mitchell, Whitney Darrow, Jr., Manuel Tolegian, Mervin Jules and Deyo Jacobs. Inside this group was a hard core of devotees who spent much of their time outside of class with Benton, as his assistants and as models for a mural on which he was working, and also playing in the hill-billy band that he had organized. This "in" group composed partly of Westerners, carried to the level of a cult the regionalism of which Benton, together with John Stueart Curry and Grant Wood, was an important exponent.

Pollock was a Westerner himself, having come East following a half brother, Guy McCoy, to study with Benton, being followed in turn by another half-brother, Sande McCoy, who also joined the class for a time. Jackson Pollock was a perfect prototype of the man from the West. Rugged, shy, socially awkward, inarticulate, he was ordinarily the possessor of a temperament as sweet and gentle as prairie clover. And he soon became a part of the inner circle, painting, modelling, playing in the band. Low in the corner of the mural that Benton painted for the library of the first Whitney Museum on Eighth Street in New York City is an accurate portrait of Jackson playing a harmonica.

A small detail that contributed to Jack's country boy style was that half the middle finger of his right hand was missing. His story of how he lost it was as follows: He was playing as a young boy in the ranch yard with several other children. The day was hot, the flies were busy, the children bored. A pile of stove wood, with an axe bitten deep in a chopping stump, attracted the oldest boy in the group. Wrenching the axe from the stump, he raised it chest high and invited anyone to put his finger on the block. All eyes turned to Jack who was next

105

in age. Falling into the mood of the moment, he stepped forward and put his finger on the chopping block. The axe dropped. As the stunned group gazed at the severed finger fallen to the ground—before even Jack could react—a big buck rooster galloped up and, swallowing the finger, galloped off again.

Pollock was not always the country boy. At times this manner dropped from him, as dramatically at the League parties, which in those days were famous. They were fairly wild and colorful by any standards and to a suburban provincial like myself, the last word in daring and non-conformity. The first one I attended seemed the very essence of a Parisian orgy. What made it most memorable for me was the sight of Jack Pollock roaring like a Satyr in hot pursuit of a frightened nymph through the corridors, scattering bystanders like chips of wood. Out from the mildest and most recessive person I knew had emerged a bellowing fire-breathing dragon! A casual drink of whiskey had accomplished this transformation. The "hollow" had become a "bump." This duality of personality became for me, during the time that I knew him, one of the keys to the understanding of Jackson Pollock. It took a long association to get used to this fascinating Jekyll and Hyde performance and accept it with something approaching equanimity.

I have mentioned before the distinctive hairy scribble-scrabble drawing style that most Benton students affected. This technique resulted in forms built up by layer on layer of pencil strokes almost as in sculpture small dabs of clay are added one on the other. This method was slow—and useful; it kept one from being seduced by flashy drawing pyrotechnics. It was a way of feeling out a form just as we literally felt it on the model with a finger. Jack's drawings were easily the hairiest, with the possible exception of those of Deyo Jacobs. Furthermore, they were painfully indicative of the continuous running battle between himself and his artist's tools. Later on, this battle extended itself most dramatically in his painting. Jack fought paint and brushes all the way. They fought back, and the canvas was testimony to the struggle. His early paintings were tortuous with painfully disturbed surfaces. In his efforts to win these contests, he would often shift media in mid-painting. I have in mind as typical an early idealized portrait of a girl painted on a framed sheet of metal about 24 by 30 inches on which were combined lacquers, oils, chalks, pencil and ink. In his frantic efforts at realization, he would use anything within reach.

Benton's mode of pictorial composition was derived mainly from the High Renaissance. He required of his students that they analyze compositions of El Greco, Signorelli, Massaccio, Mantegna, Tintoretto, and others. His method of analysis, which we all used, was to reproduce in grey tones, a famous work of art, stressing the interplay of direction in the various forms by simplifying and accentuating changes in plane. Brueghel, Michelangelo and Assyrian bas-reliefs were also popular subjects for this exercise. We would, in addition, construct

actual three-dimensional dioramas in wood and clay, treating the painting as a deep relief, and also painting it in tones of greys, in order to discover for ourselves the rules by which each work was internally arranged and the forms related spatially. This process, again, was a way of separating one of the multitude of problems a painter faces from the others, in order to hold it up for study by itself. As a result, all of us became well grounded and highly influenced by the Renaissance artists.

Through all of this ran the search for the hollow and the bump; the ability to utilize and express recession, projection, tension and relaxation. One might characterize the Benton students as people who were searching for a tangible, defined set of standards for their own understanding and measurement of art. The "hollow and the bump" seemed to be part of the answer.

After about a year and a half, most us had reached the outer limits of what Benton's interwoven regionalism had to offer. The class split up and the people I had come to know broke away. Some experimented with other teachers at the League. Jack joined a sculpture class at the Greenwich House, paying for his tuition by acting as janitor. He made some attempts at cutting stone. However, his hand-to-hand combat with the medium kept him from any definitive production.

This was not an easy time for Pollock. He was frustrated in his attempts to achieve the technical proficiency and mode of expression that Benton had. Also frustrating was his need of and search for a girl. The polarity of his two selves, the recessive and gauche at one extreme and the frighteningly aggressive at the other, did nothing to solve his problems. He took refuge from the difficulties of social and artistic adjustment in drinking. He even disappeared for a while, supposedly seeking some kind of therapy.

He was back on the scene in the mid-thirties, however. Sande McCoy, his half brother, married a lovely ash-blond pioneer woman, and Jack lived with them. At about the same time two new influences made themselves felt in our lives. Many of us, including Pollock, were fortunate enough to get on the WPA Arts Project. Also, the Mexicans—Orozco, Rivera, Siqueiros—coming into ascendancy as painters and revolutionaries, provided us with a direction away from the parochialism in which most of us had been caught. Being mural-minded, or wall-eyed as someone once said, Jack, as well as the rest of the group, was deeply stirred by the Mexican artists' ability to combine social revolutionary themes with a widespread public usage of their talents to create a new artistic language.

In 1935 David Alfaro Siqueiros, active revolutionary and naughty boy of Mexican art, came to New York. Jack and myself, along with others of our group, became part of a workshop that Siqueiros started for the express purpose of experimentation with new technological developments in materials and tools. Paints including the then new nitro-cellulose lacquers and silicones, surfaces

107

such as plywoods and asbestos panels and paint applicators including airbrushes and sprayguns, were some of the materials and techniques to be explored and applied. We were going to put out to pasture the "stick with hairs on its end" as Siqueiros called the brush.

New art forms for the use and exposure to large masses of people were to be initiated. Our stated aim was to perfect such new media even though they might be comparatively impermanent, since they would be seen by hundreds of thousands of people in the form of floats, posters, changeable murals in subways, multi-reproduced graphics, etc.

Spurred on by Siqueiros, whose energy and torrential flow of ideas and new projects stimulated us all to a high pitch of activity, everything became material for our investigations. For instance; lacquer opened up enormous possibilities in the application of color. We sprayed through stencils and friskets, embedded wood, metal, sand and paper. We used it in thin glazes or built it up into thick globs. We poured it, dripped it, spattered it, hurled it at the picture surface. It dried quickly, almost instantly and could be removed at will even though thoroughly dry and hard. What emerged was an endless variety of accidental effects. Siqueiros soon constructed a theory and system of "controlled accidents."

I remember us secretly appropriating a Lazy Susan from one of the tables in a neighboring cafeteria. Fastening pieces of plywood to it, we poured different colored lacquers on it as it was spun. The striking halations of color due to centrifical action that resulted were forthwith introduced into our paintings. (I saw, this past summer, at several country fairs, this identical process being commercialized, whereby a spectator at a booth, for twenty-five cents, could select and pour from mustard squeeze bottles, colored lacquers on a card which was spun by a motor, providing him with his own personally contrived, quote, Jackson Pollock, unquote, painting.)

Of course, we used all of these devices to enhance paintings with literary content. No-one thought of them as ends in themselves. The genesis of Pollock's mature art began to be discernible only when he began to exploit these techniques as final statement.

In 1939, Siqueiros decided to go to Spain as artist and fighter in the Civil War on the Loyalist side. We gave him a farewell party in some-one's loft. A couple of bottles of liquor were producing notable effects and the gathering was typically noisy. Siqueiros sported a huge ivory-handled revolver given to him by Mexican well-wishers. However, when some-one proposed a toast to the departing warrior, he had disappeared. Pollock, whose scatological bellowing was usually much in evidence on such occasions, was also missing. Both men were eventually found. They were under a table. Each had his hands around the other's throat and was silently attempting to choke the other into unconsciousness, Jack in a wild exhilarated effort and Siqueiros in a desperate attempt to save himself.

Sande McCoy moved in and with a deft right to the jaw unlocked Jack's fingers. Four of us lifted him up and hustled him downstairs into Sande's model "A" Ford in which he was driven home. The next day Siqueiros left quietly for Spain.

After the Siqueiros workshop was dissolved, its members scattered in many directions. Subsequently, Pollock married a girl whom I recall as an active and enterprising member of an Artists' group to which we all belonged. It seems to me that this marriage was to crystallize him as an artist. My guess, knowing what I did of Pollock, is that his wife was first to see the potential of the experiments he had participated in at the workshop. The "dribble" of the Siqueiros Workshop developed into a way of art that sublimated many of his technical and emotional difficulties and evolved into the paintings that became his trademark.

The last time I met Jack was on Third Avenue and Fifty-Sixth Street during the middle forties. His brow puckered as always, he told me, "We bought a house in Sag Harbor. *I* don't know where we got the money." I never saw him again.

1967

The Museum of Modern Art's second Pollock retrospective, organized by William S. Lieberman, opened on April 5, 1967. The exhibition had a tremendous impact on artists, critics, and the general public. Even before it opened, William Rubin—a noted art historian and collector, later to become Director of the Department of Painting and Sculpture at the Modern—began publication in Artforum *of a multi-part essay tracing Pollock's complex relationship to the tradition of European modernism. In the exhibition catalogue, a young scholar, Francis V. O'Connor, published a detailed documentary chronology opening up multiple new perspectives on Pollock's development; he also published a major article titled "The Genesis of Jackson Pollock: 1912 to 1943," in the May issue of* Artforum. *Clement Greenberg, who had championed Pollock's first exhibitions but written comparatively little about him after 1948, now offered a detailed analysis of the "drip" paintings. Surprisingly, Minimalist artists such as Donald Judd and Robert Morris, who had defined their style as a revolt against Abstract Expressionism, now also began to express their admiration for Pollock's use of materials and unified compositions.*

Clement Greenberg. "Jackson Pollock: 'Inspiration, Vision, Intuitive Decision.'"
Vogue
149, NO. 7 (APRIL 1, 1967): 160–61. REPRINTED BY PERMISSION OF UNIVERSITY OF CHICAGO PRESS. © 1967 CLEMENT GREENBERG.

Pollock was not a "born" painter. He started out as a sculptor, at sixteen, but before he was eighteen had changed over to painting. He had to learn with effort to draw and paint. Matisse was twenty-one when he made his first picture, but it immediately revealed his gift of hand. Whether Pollock's first attempts revealed anything like that, I very much doubt. This is not to say that he did not have a gift. Pollock's gift lay in his temperament and intelligence, and above all in his inability to be less than honest.

It did not, at any rate, take him too long, apparently, to learn to draw from nature correctly if not fluently. (There is the evidence of drawings made while he was still studying with Thomas Hart Benton at the Art Students League.) Years later, long after he had committed himself to abstraction, a sudden return to naturalism in the linear face of a man he did in a painting of 1951 called *Number 27* shows him drawing with almost stylish facility. It is as though his skill of hand had developed underground during the intervening years into something like virtuosity. After 1951 Pollock's general accomplishedness, called on to supply what inspiration no longer could, began to be all too obvious. Then his honesty declared itself in the refusal to go on painting. From 1954 until his death in 1956 he finished no more than three or four pictures.

But that he had been a practised painter all along should have been evident in even the most abstract things he did before 1951. That it was not evident to

many people, and still is not, was the fault of his originality. The very uncon-
ventional way in which Pollock started to put paint to canvas in 1947 took peo-
ple very much aback. And so did the equally unconventional way in which, a lit-
tle earlier, he had begun to lay out or design his pictures. But even in his very
first one-man show, in 1943, his apparent want of smoothness and finish had
provoked resistance. (He was already painting great pictures by that time, some
of them as "difficult" and original as anything he did later—*Totem I* of 1944, for
example.)

Pollock's "drip" paintings, which began in 1947, eliminated the factor of
manual skill and seemed to eliminate the factor of control along with it.
Advanced painting had raised the question of the role of skill in pictorial art
before Pollock's time, but these pictures questioned that role more disturbingly
if not more radically than even Mondrian's geometrical art had. Mondrian's
canon of ruled stripes and flat, even color precludes the use of skill, but in com-
pensation makes control and order utterly explicit. Skill means difficulties over-
come swiftly and easily in the interests of control and order. These last qualities
Mondrian exhibits in the plainest conceptual or mechanical terms, whether or
not they are transmuted to aesthetic ones (which they are when the picture suc-
ceeds). Pollock's "all-over" "drip" paintings seem swiftness and spontaneity
incarnate, but their arabescal interlacings strike the uninitiated eye as excluding
anything that resembles control and order, not to mention skill.

Pollock's "all-over" layout has more to do with this impression, initially,
than his "drip" method does. In most cases this layout does not really repeat the
same figure or motif from one edge of the canvas to the other like a wallpaper
pattern. If it did that, an "all-over" Pollock would strike one as being almost as
self-evidently controlled and ordered as a Mondrian, sheer repetition being of
the essence of control and order. An "all-over" Pollock makes the impression of
being chaotic because it promises the order of mechanical repetition only to
betray it. An "all-over" Pollock is only vaguely, ambiguously symmetrical. When
it is pictorially effective and moves and excites the viewer, it does so in the same
general way in which all pictorial art does, by disrupting and restoring, by unbal-
ancing and balancing.

Where Mondrian wrests aesthetic from merely mechanical order, Pollock
wrests aesthetic order from the look of accident—but only from the look of it.
His strongest "all-over" paintings tend sometimes to be concentric in their pat-
terning; often the concentricity is that of several interlocking or overlapping
concentric patterns (as in the marvellous *Cathedral* of 1947). In other cases the
patterning consists in a rhythm of loopings that may or may not be counter-
pointed by a "system" of fainter straight lines. At the same time there is an oscil-
lating movement between different planes in shallow depth and the literal sur-
face plane—a movement reminiscent of Cézanne and Analytical Cubism.

111

True, all this is hard to discern at first. The seeming haphazardness of Pollock's execution, with its mazy trickling, dribbling, whipping, blotching, and staining of paint, appears to threaten to swallow up and extinguish every element of order. But this is more a matter of connotation than of actual effect. The strength of the art itself lies in the tension (to use an indispensable jargon word) between the connotations of haphazardness and the felt and actual aesthetic order, to which every detail of execution contributes. Order supervenes at the last moment, as it were, but all the more triumphantly because of that.

Like Mondrian, Pollock demonstrates that not skill or dexterity but inspiration, vision, intuitive decision, is what counts essentially in the creation of aesthetic quality. Inspiration declares itself in the overall conception of a work: the choosing, placing, and relating of what goes into it. Execution, in effect, takes care of itself. (Benedetto Croce, the Italian philosopher, perceived this long ago.) No matter how much execution may feed back to conception, the crucial decisions still belong to inspiration and not to manual skill. (Actually, manual skill itself is an affair of more or less inspired decisions, only they are mostly subliminal ones; inspiration in the larger sense is not exactly conscious either but it is nevertheless a good deal closer to that part of the mind which considers alternatives.)

Again like Mondrian, Pollock demonstrates that something related to skill is likewise unessential to the creation of aesthetic quality: namely, personal touch, individuality of execution, handwriting, "signature." In principle, any artist's touch can be imitated, but it takes hard work and great skill to imitate Hsia Kuei's, Leonardo's, Rembrandt's, or Ingres's. Mondrian's touch can be imitated, or rather *duplicated*, with no effort at all, by anybody. So, almost, can Pollock's touch in his "drip" period. With a little practice anybody can make dribbles and spatters and skeins of liquid paint that are indistinguishable from Pollock's in point purely of handwriting. But Mondrian's and Pollock's quality can no more be duplicated than Leonardo's or Rembrandt's. Again, it is driven home that, in the last analysis, conception, or inspiration, alone decides aesthetic quality. Not that discipline, learning, awareness, and the conjunction of circumstances are less than indispensable to the making of important art. But without the factor of inspiration, these are as nothing.

Pollock was far less interested than Mondrian in making theoretical points. He made them in his art, but without particularly bothering about them. He took to working with liquid paint and a "drip"-stick, and finally a basting syringe, simply—and yet not so simply—because he wanted to get away from the habits or mannerisms of fingers, wrist, elbow, and even shoulder that are brought into play by the use of a brush, knife, or any other implement that touches the picture surface. Even more important was the fact that marked lines or contours did not hold that surface with the same inevitability as those which resulted from

the falling or flowing of paint. Last but not least came Pollock's revulsion from "madeness," from the look of the intended and arranged and contrived and trimmed and "tickled." To him, almost all drawing with a brush or pencil began to look too deliberate. That in escaping "madeness" he went over into something like anonymity or impersonality of execution did not particularly strike Pollock—or any one else—at the time. The "naturalness" of this impersonality had, however, consequences for other, younger or later artists.

Ostensibly, the impersonality of handling that reigns in avant-garde art of the sixties is like Mondrian's. But it does not *feel* like Mondrian's, and this has to be explained in good part by the different interpretation of impersonality found in Pollock's "drip" paintings (as well as that found in Barnett Newman's only seemingly geometrical art). Ruled or compass-plotted edges don't feel as rigidly geometrical today as they did in geometrical art done in the past. The practice, descended from Pollock, of soaking pigment into raw canvas deprives these edges of their "cutting" power by making them bleed ever so slightly. But other, far less tangible factors are still more important, and it is hard to define these (and it would take too much space even to try to do so).

In any case, too much does not have to be claimed for Pollock. His art speaks for itself. Or it will eventually. Till now it has been, for the most part, extravagantly misunderstood. And what has been most misunderstood in it is its sophistication. Pollock's sophistication was of that ultimate kind which consists in an instinct for the relevant. He had also what Keats called Negative Capability: he could be doubtful and uncertain without becoming bewildered—that is, in what concerned his art. (It was quite different with his life, which was darkened by alcoholism.) People who knew Pollock personally were, I think, misled by his diffidence with words. They may also have been misled by his indifference to phrases and "ideas." He was beautifully right in that; in my opinion he saw more in art and knew more of it than did almost anybody (with the exception of his wife, the painter Lenore Krasner) who talked to him about it.

One of Pollock's deepest insight was that it was not necessary to *try* to hold on to the past of art; that it was there inside him anyhow, and that whether he wanted it to or not, the past remained implicated in everything he did. Unlike Gorky, de Kooning, and Hofmann, his nearest neighbors in New York art in the mid-forties, he did not believe in "good" painting, with its rules and cuisine. He believed only in good art. He saw that "good" painting was something every truly ambitious artist had to define all over again. Otherwise he would remain trapped in the provisional, not the abiding, past. It belonged to Pollock's sophistication that he could so well distinguish between the two. The provisional past was rules, precepts, craft practices, "paint quality," and canons of taste. The abiding past was concrete works of art and their quality.

Gorky, de Kooning, and Hofmann were naive by comparison with Pollock.

I am not trying to launch a startling paradox when I say this; it was something I felt twenty years ago, when Gorky was still alive. Gorky did not remain naive: Though his very best painting was done in 1945, the things he did just before his death in 1948 open up vistas that are larger and extend beyond "good" painting, which fact made his death that much more of a tragedy. Hofmann's enduringly naive faith in "good" painting is, I hazard, partly responsible for the miscomprehension that continues to dog his reputation, but the sheer force of his vision made him a great painter in spite of himself in the last ten years of his life—as great a painter as any in his time. De Kooning is the one who, for all his giftedness and brightness, has suffered most from naive faith in "good" painting—from faith in cuisine, handwriting, and Old Master machinery. That he remains at this moment the most celebrated of these three *naïfs* is the crowning but not enduring irony of his case.

Plenty of the provisional past clung to Pollock's art too, and it could not be otherwise, as he himself recognized. In the decrepitude of his art, from 1952 to his death in 1956, during which time he displayed proficiency in an obvious enough way to win admission to any guild of "good" painters, that past did more than cling; it closed in. Pollock himself was among the first to register this. His vision had exhausted itself, at least for the time being; he was filling in with "good" painting, and it was not enough.

Donald Judd. "Jackson Pollock," *Arts Magazine*
41, NO. 6 (APRIL 1967): 32–35. © ESTATE OF DONALD JUDD/LICENSED BY VAGA, NEW YORK, NY

Not much has been written on Pollock's work and most of that is mediocre or bad. And not much more has been written on anyone's work and usually not with any more thought. Art criticism is very inferior to the work it discusses. Bryan Robertson's book, published in 1960, is the only large one on Pollock; its text is useless. Whatever is accurate is factual and appeared earlier in Sam Hunter's short preface to the catalogue of the Museum of Modern Art's first show of Pollock's work in 1956–57 and in various reviews and general articles. There are only a couple of articles on Pollock, one in 1957 by Clement Greenberg. The rest of Robertson's book is wrong in one way or another, usually just glibly wrong. Frank O'Hara's small book, published in 1959 in the Braziller series, has the same biographical and received information as Sam Hunter's preface, some baloney and no real thought. There isn't anything reasonable, then, on Pollock's work but a few early reviews by Greenberg. They're all right as reviews; Greenberg was beginning to think about the paintings; but he quit. William Rubin has written a large book which will be published in the fall. The book may add something to the knowledge of Pollock's work. *Artforum*'s current publica-

tion of parts of it certainly acknowledges the show of Pollock's work at the Museum of Modern Art in May. The show at Marlborough-Gerson three years ago was pretty much ignored by the art magazines.

I'm not going to write here, in only a small article, what I think should be written about Pollock. Anyway I can't write it. That would take a book and complete attention. Also there's a big difference between thinking about someone's work and thinking about it in a way that others can understand. It would take a big effort for me or anyone to think about Pollock's work in a way that would be intelligible. A thorough discussion of Pollock's work or anyone's should be something of a construction. It's not necessary to build ways of talking about the work and of course to define all of the important words. Most discussion is loose and unreasonable. The primary information should be the nature of his work. Almost all other information should be based on what is there. This doesn't mean that the discussion should only be 'formalistic.' Almost any kind of statement can be derived from the work: philosophical, psychological, sociological, political. Such statements, usually nonsense, should refer to specific elements in the work and to any statements or biographical information that might be relevant. Certainly the discussion should go beyond formal considerations to the qualities and attitudes involved in the work. Arguments leading from the elements of the work to its general implications are difficult to form and should be formed very carefully. Quotations and biographical information should be considered more carefully than they usually are. Dumb interviewers often get dumb answers. So far there hasn't been anything thorough on anyone's work; certainly not Pollock's. Most historical studies are pretty sloppy and insufficient, too. The most common nonsense is the conclusion of a few pages of verified fact with a highly unverified cliché. Wittkower's book on Bernini is in example of a pretty thorough job.

Another thing essential to a good review, article or book is an estimate of how good the artist is. That includes a comparison with other artists, even though much is incommeasurable. Comparisons lead to ideas of how art develops and of what the connections are between artists. Usually those ideas are too simple. I want to make clear, even as just an assertion, how good I think Pollock's paintings are. Almost everyone thinks he's a great painter, but they also seem to give equal standing to quite a few other people. The quickest assertion of ability is of the comparative kind rather than through a complete discussion: I think Pollock's a greater artist than anyone working at the time or since. That gives him an edge on Barnett Newman, which I hate to admit. Most painting since Pollock's is somewhat conservative in comparison. The idea that Frankenthaler, Louis, Noland and Olitski form a line of advance from Pollock's work is ridiculous. There are some new and different aspects in Louis's and Noland's work but in general it is not as unusual and remarkable as Pollock's. David Smith's sculpture,

almost the only good sculpture until recently, is obviously somewhat conservative, even his last work, in comparison to Pollock's paintings. I think it's clear that Pollock created the large scale, wholeness and simplicity that have become common to almost all good work. *The Blue Unconscious, Eyes in the Heat* and *Shimmering Substance* were painted in 1946. *Full Fathom Five* and *Cathedral*, both typical all-over paintings, were done in 1947. Everyone else, some quickly, learned from these.

Pollock used paint and canvas in a new way. Everyone else, except Stella for the most part, used them in ways that were developments upon traditional European or Western ways of handling paint and canvas. This use is one of the most important aspects of Pollock's work, as important as scale and wholeness. The nature of this is difficult to make intelligible. It's one of the things which need considerable verbal building. It's a different idea of generality, of how a painting is unified. It's a different idea of the disparity between parts or aspects and it's a different idea of sensation. The effect of most painting is of the disparity increased as much as possible within the limits of a given quality, wholeness or generality. The disparate parts and aspects are particular and the whole they form is the general and main quality. The quality of the parts is like the quality of the whole. There's a gradation or evening out of the parts and aspects. The quality always has something of moderation, the long view and the unity of all things. By now this kind of resolution seems easy and also untrue. The elements and aspects of Pollock's paintings are polarized rather than amalgamated. The work doesn't have the moderated a priori generality usual in painting. Everything is fairly independent and specific.

The dripped paint in most of Pollock's paintings is dripped paint. It's that sensation, completely immediate and specific and nothing modifies it. It also does things that drips never do, but that doesn't change the specific sensation. It's not something else that alludes to dripped paint. The use of the paint and the whole of any painting are further apart in quality than is usual. A fragment of a Pollock would have a good deal less of the quality of the whole than a part of a De Kooning, for example, would have of the whole. This is true of the color, configuration and kind of space. There's a big difference between the sensation of dripped paint and the complex and highly varied configuration and space it forms. The various colors in any painting are more discrete than they are in most paintings, in which they are within a range or relate to an identifiable scheme. Most paintings seem harmonious in comparison. Also, the paints as materials and surfaces, as well as the canvas, are more discrete than they usually are. A painting of Pollock's that I saw recently, one owned by William Rubin and in the show at the Museum of Modern Art has aluminum paint and some other colors that I can't remember slung across a surface of burnt sienna, apparently painted on unprimed canvas. A recent painting of Noland's, by way of unfavorable com-

parison, might have the burnt sienna, burnt umber, a dark and a medium green, all the same canvas texture, and maybe a less related color. Noland's paintings, though, weren't always so harmonious.

The term 'Abstract Expressionism' was a big mistake. For one thing it implied that Pollock and De Kooning were alike and that both were Expressionists. Pollock's paintings are much more remarkable than that. De Kooning's paintings are substantially the same as those of the various Expressionist painters from Soutine back to Van Gogh and on back through the recurrent use of expressive brushwork. That portrays immediate emotions. It doesn't involve immediate sensations. That kind of expression of emotion occurs through a sequence of observing, feeling and recording. It's one of the main aspects of European or Western art. It's one kind of art, not all art. It's bad that it involves reactions to things to such an extent. It's premise that those reactions say something about the nature of the things observed is false. Obviously what you feel and what things are aren't the same. Anyway, Pollock's paintings don't involve the immediate emotions of traditional art and don't involve the ways in which these are generalized.

William Rubin. "Jackson Pollock and the Modern Tradition." *Artforum*
5, NO. 6 (FEBRUARY 1967): 14–22; 5, NO. 7 (MARCH 1967): 28–37; 5, NO. 8 (APRIL 1967): 18–31;
5, NO. 9 (MAY 1967): 28–33. © ARTFORUM, FEBRUARY–MAY 1967. REVISED 1999.

We dwell with satisfaction upon the poet's difference from his predecessors; we endeavor to find something that can be isolated in order to be enjoyed. Whereas if we approach a poet without this prejudice we shall often find that not only the best, but the most individual parts of his work may be those in which the dead poets, his ancestors, assert their immortality most vigorously. And I do not mean the impressionable period of adolescence, but the period of full maturity . . . the historical sense involves a perception, not only of the pastness of the past, but of its presence. . . . What happens when a new work of art is created is something that happens simultaneously to all the works of art which preceded it. The existing monuments form an ideal order among themselves which is modified by the introduction of the new (the really new) work of art among them.

—T. S. Eliot, *Tradition and the Individual Talent*

I. The Myths and the Paintings[1]

Myths are easier to grasp than new and original abstract art; that they should have gathered early around the art of Jackson Pollock was inevitable. With rare exceptions, admirers as well as critics developed notions about his paintings that are erroneous or only elliptically related to the art itself. Just as the mathematical principles that the actuary Princet thought he saw at work in Cubism "rationalized" that style and gave it cultural *cachet* for those blind to it as art, so the myths about Pollock made his painting "relevant," but only by misrepresenting it.

Pollock's detractors spoke of chaotic pictorial phenomena produced orgiastically by an artist who had surrendered decision-making to mindless kinetic activity. But they also spoke, and sometimes in the same breath,[2] of an even-textured "run-on" pictorial fabric that had no beginning or end,[3] and which Pollock was supposed to have sold by the yard like textile,[4] ostensibly for the purpose of interior decoration. Even Pollock's admirers wrote confusedly about the relation of his means and ends. Their conception of both led them to posit a Pollock who had entered art history like a meteor, whose so-called "drip" pictures came from out of nowhere, embodying an esthetic that was wholly new, and who painted virtually nothing but masterpieces.

The most popular of the localized Pollock myths is that of the cowboy painter, "the man out of the West,"[5] twirling "lariats" of color in the Wide Open Spaces[6] of immense canvases. This myth has been particularly popular abroad, especially among Frenchmen of the younger generation who have generalized far beyond the familiar analogies that couple Pollock with Whitman and Mel-

ville. For them the very virtue of "the American" is that he is supposedly naïve, unconscious of, or outside, any traditions of art, and hence "styleless"— a kind of Noble Savage. Pollock as cowboy not only fits into the French myth of an *école du pacifique*[7] (which reaches east to the Badlands as well as west to Japan), but sorts well with the cult of Hollywood Westerns celebrated by the young critics of the *Cahiers du cinéma*. (An unfounded rumor that Pollock had once been a cowboy threw his European admirers into rapture.)

As in most myths, there are seeds of truth here that we want to preserve.[8] Pollock was, indeed, born in the West (Cody, Wyoming—named for "Buffalo" Bill Cody) in 1912, and he spent his earliest years in Wyoming, Arizona, and northern California. When he was thirteen his family settled in Los Angeles. Four years later he left Los Angeles for New York, at the suggestion of his oldest brother, Charles, and studied with Thomas Hart Benton at the Art Students League. Though he made several trips back to the West in ensuing years, Pollock lived in New York from then until the last decade of his life, which he spent in Springs, East Hampton Long Island, which is only 125 miles from New York City.

Pollock's childhood in the West probably had some influence on his sense of scale. And the Navajo Indian sand painters' methods were much later of special interest to him as models of an art executed on the ground (or floor), thus free of many limitations of easel painting—though it is doubtful that he ever had any firsthand contact with sand painting before he saw Navajo artists at work in the Museum of Modern Art's lobby during an exhibition of American Indian art.[9] At its core Pollock's art is not ritualistic, primitive, collective, or provincial. It is individualistic, complex, subtle and sophisticated, and it developed amid— and reflected—the rhythms, fluxes, convergences and confrontations of modern metropolitan life. Moreover, it was, like all other serious painting of his time, firmly rooted in European traditions.

The acuity with which Pollock grasped the nature, the feel of life in the great city in which he lived derived precisely from his having come to it from outside. Much in the new American painting is no more imaginable without New York than Impressionism is without Paris. That Monet and Renoir came from the provinces, and Sisley and Pissarro from outside France, certainly enhanced their responsiveness to Paris and its life, about which they took less for granted than more native painters did.

If we are to subscribe to the environmental theorizing whereby the "wide open spaces" somehow informed the scale and size of Pollock's painting, then we must keep in mind that the New York environment is also a monumental one. Indeed, a consistent difference in scale can be observed between New York painters of Pollock's generation who were *not* brought up on the prairie and their Parisian counterparts. Moreover, the notion of Pollock as a painter of primarily outsize pictures is contrary to fact. As we shall see later, Pollock was, with

119

Newman, Rothko and Still, one of the pioneers of the outsize picture. But with the exception of a mural commissioned early in 1943 to decorate Peggy Guggenheim's apartment, executed in December of that year, it was only in 1950, the last year of the "all-over" poured and spattered "classic" pictures, that some of his canvases really took on wall size.[10] *One, Autumn Rhythm, Lavender Mist* and *Number 32* (all 1950) are the only wall-size pictures of the classic middle period. (There were, to be sure, about six horizontal-format pictures with widths of eight to ten feet—sizes equally common amongst European painters of the previous generation—and a few exceedingly long "friezes" whose height, however, never exceeds about three feet.) *Convergence* (1952) and *Blue Poles* (1953) complete the surprisingly short list of wall-size pictures.

Though he was one of those who pioneered it, the immense picture remained exceptional in Pollock's work as a kind of summation of experience. By the time of his death it had become a commonplace in American painting. An art based on line, such as Pollock's, does not lend itself to expansion in size like one based on color. In making his immense pictures Pollock was literally rupturing the inherently easel scale of his draftsmanly style, whence the tremendous effort and focus required to produce the pictures and explosiveness of their release into being.

Not a little of what has been written about Pollock reflects the "meteor" myth, according to which he comes to his crucial historical role from virtually nowhere—certainly from outside the central tradition of modern painting.[11] To be sure, this perspective sometimes admits the importance of the Mexican muralists, later Picasso and the literary side of Surrealism. But only in relation to Pollock's pre-1947 (i.e., his pre-"drip") painting. As for antecedents to the all-over poured Pollocks we hear of virtually nothing but the Navajo sand painters.[12] Impressionism, Cubism and Surrealist automatism go unmentioned. We are constantly told of Pollock's "absolute newness and rupture with the past,"[13] as a progenitor of a specifically American art described as "a real departure from zero."[14] Yet no less than the mature Cézanne was rooted in Impressionism, and Cubism rooted in Cézanne, was Pollock connected to the anterior tradition of modern painting. By dissociating him from any sort of past, blind admirers have reinforced the criticism, widely voiced by his detractors in the early fifties, that what Pollock made, however interesting, was "not painting"; European theorizers of *un art autre* provided further justifications for such criticism. Many earlier modernist styles have seemed to come from nowhere—at the time of their appearance. But they have always subsequently been recognized as steps in the unfolding of a tradition. A style can no more be without roots in the art that preceded it than a mature man can be independent of his society or culture. That such commonplaces should have to be voiced at all is a measure of the "meteor" myth's persistence in connection with Pollock. As for breaking with tradi-

tion, Manet and Impressionism represented, in terms of fundamental structure, a more radical rupture with Courbet, Delacroix and Ingres than did Pollock with the pre-World War II vanguard.

Reducing history to a formula in which everything comes out of everything else parodies the discipline. But properly considering the sources of a style is to help understand and characterize it. Rare artists are able to meld stylistic conceptions and components held antithetical in earlier art into viable and richer wholes. Pollock's greatness lay not in being a meteoric outsider but in building simultaneously (precisely in the all-over, poured pictures) on such diverse and seemingly irreconcilable sources as Impressionism, Cubism and Surrealism. These were strained through his own psyche and temperament and re-created in a new and unique symbolism of mid-twentieth century experience.

In associating the *mature* Pollock with Impressionism, Cubism and Surrealism I am not reducing his history to an absurd generality. His use of the past is selective. Almost as significant in understanding his classic period is to know the styles he did *not* build on, among them Expressionism (*pace* that hard-dying misnomer "Abstract Expressionism"[15]), Dadaism, Futurism and Fauvism.

Expressionism, derived not from the German Expressionists but from the Expressionist Picasso, *is* manifest in Pollock's painting. But only up to 1946, that is, before the great poured pictures (and, to a lesser extent, after them). In part, it seems to have reflected an incongruity, hence tension, between Pollock's extraordinary pictorial potentialities and his then inability to forge the proper vehicle for their fullest realization. This condition surely contributed to the anxiety, conflict, and ultimately, violence that are reflected in the iconographies of the 1942–46 pictures, a violence expressed plastically in their compositional discontinuities, convolutions, truncations, angularities and frequent asperity of color. This is not intended as a criticism of those works, but rather an attempt to distinguish them from the subsequent poured paintings. Indeed, there are masterpieces in Pollock's painting of 1942–46 that go beyond anything the Expressionist tradition had up to then proposed. (In the later forties Willem de Kooning was to give the Expressionist vein an extraordinary, new and quite different impetus.)

If, as I shall try to show, Pollock found inspiration in Impressionism, Cubism and Surrealism, these sources were so fused, so totally assimilated in Pollock's language by the time of his maturity, that they are not easily distinguished in the pictures. Some sophistication in modern painting and much very careful looking is required to discern them. This is not the case with the paintings of 1942–46, where the debts to Picasso in particular, and to a considerably lesser extent Masson, Miró and others are readily seen. When, in the winter of 1946–47, Pollock purged his art of these obvious borrowings in the style that realized his full identity, the Expressionist element disappeared and the violence,

121

frustration and tension were largely transformed into a passionate lyricism—a choreographically rhythmical art capable of an almost Rococo fragility and grace. The gap between an inherited language and a burgeoning new content, between instinct and self-awareness, in short, between the potential and the actual had been closed.

Another familiar Pollock myth celebrates the athlete whose works are supposedly residues of enactments of "events" in the "arena" of the canvas (the underpinning here is the notion of "Action Painting"). Again, the myth springs from a seed of reality. Pollock did work with exceptional spontaneity during the physical execution of the picture. As we shall see later, his aim was to circumvent the operation of those pictorial inhibitions which derive from habit, expectation and immersion in a tradition, and to reach, as the Surrealists had already tried through automatism, into areas of unconscious experience that might otherwise go untapped. While there are some crucial differences between Surrealist automatism and Pollock's methods, both were committed to the notion of beginning the picture without an *a priori* image or plan, and letting it gradually emerge (as had Klee in his "doodling"). Both Pollock and the Surrealists used automatism as a starting point, but subsequently applied conscious control to endow the picture with order and coherence. Surrealist automatism involved the artist's wrist, sometimes his arm; Pollock's involved his arm and especially in the larger pictures, his whole body.

The public's impression of Pollock's methods, much conditioned by the famous but misleading Namuth photographs of the painter at work, is almost entirely that of a "gestural," automatist artist functioning seismographically in response to immediate inspiration.[16] This is not so much wrong as incomplete; it shows us Pollock's "Romantic" side. (Indeed, Surrealism, which had stimulated Pollock's interest in the expression of unconscious ideas even as it had popularized automatism as a means of realizing them, may be considered the most recent evolution of 19th-century Romanticism.) Yet Pollock was also at work *during the hours he stared at the unfinished canvas* as it hung tacked to the wall of the studio or spread on the floor. This meditative phase—which more recalls the mood of Analytic Cubist and Mondrianesque picture-making—reflects Pollock's more "classical" side. Though Pollock obviously improvised a great deal while executing his poured paintings, sometimes in response to unexpected, accidental aspects of the picture-making process, it is certain that the frequently long periods of studying the canvas that preceded resumption of the painting activity (particularly once the picture was well under way) were concerned with planning what he would do next. Non-musicians are amazed to hear that Mozart wrote the entire overture to *Don Giovanni* the night before its final rehearsal. But, it had no doubt been taking form in his mind for some time before he wrote it down. The analogy is hardly an exact one, but I think we very much mistake Pol-

lock's methods if we do not recognize his capacity for *storing decisions* that would then counterpoint the more immediately improvisational aspects of his method when he was actually painting. The fact is that Pollock's very large paintings often took months to bring to completion.

Pollock pioneered a kind of painting that in spontaneity, abstraction and size went far beyond any proposed by Surrealist automatism—or any other previous improvisational art. It seemed to initiate (Pollock "broke the ice," Willlem de Kooning generously observed) and epitomize a liberation of the painting process experienced by many other painters of his generation in the late forties. The need for a description of this art was met in many quarters by acceptance of Harold Rosenberg's term "Action Painting." Insofar as it was widely used, and still is, simply as a convenient handle for a new and more gesturally executed art, this label is not problematic. But when Rosenberg's "Action" theory is used to define and characterize Pollock's way of working (and that is often the case), it profoundly falsifies matters. This is not the place for a thorough critique of the theory of Action Painting, nor do I wish to become embroiled in the polemics surrounding it,[17] but its frequent employment by writers on Pollock requires that we confront Rosenberg's misconstruction. Here are some essential passages from his text:

> At a certain moment the canvas began to appear to one American painter after another as an arena in which to act—rather than as a space in which to reproduce, re-design, analyze or "express" an object, actual or imagined. What was to go on the canvas was not a picture but an event. The painter no longer approached his easel with an image in mind; he went up to it with material in his hand to do something to that other piece of material in front of him. The image would be the result of this encounter. . . . The new painting has broken down every distinction between art and life. . . . If the picture is an act, it cannot be justified *as an act of genius* in a field whose whole measuring apparatus has been sent to the devil. Its value must be found apart from art. . . .
>
> Based on the phenomenon of conversion the new movement is, with majority of the painters, essentially a religious movement. In almost very case, however, the conversion has been experienced in private terms. The result has been the creation of private myths.[18] (Italics Mr. Rosenberg's.)

Just how an "event" was to go on the canvas was not clear in the original essay, so Mr. Rosenberg subsequently elaborated:

> The innovation of Action Painting was to dispense with the *representation* of the state in favor of *enacting* it in physical movement. The action on the canvas became its own representation. This was possible because an action, being made of both the psychic and the material, is by its nature a sign—it is the trace of a movement whose

beginning and character it does not in itself ever altogether reveal (e.g., Freud's point about love-making being mistaken in the imagination for assault); yet the action also exists as a "thing" in that it touches other things and affects them. . . . In its passage on the canvas each such line can establish the actual movement of the artist's body as an esthetic statement.[19]

Starting with the final observation about the artist's body movement as an esthetic statement we naturally ask, *in what medium?* As movement it has a right to be judged as choreography, just as the "enacting" of a "state" might be considered theater. But the marks these actions produce—if we consider them as painting—are part of *another order of symbols* in which their *simultaneous relation* to each other (the time of an "action," on the other hand, is continuous like that of theater, dance and music), to the frame (the space around the artist's body is boundless), their color and texture, in short their whole constitution as a picture have no equivalence (though they may clearly have affinities) with the possible "esthetics" of an "action." Moreover, marks have no inevitable relationship to the speed, character or range of the body-movements that produce them. Similar marks can be made in quite different ways just as similar body and wrist movements can lead to quite different marks.

But the fundamental contradictions of Action Painting are our problem only if we consider the kind of painting Mr. Rosenberg has in mind *as art.* Mr. Rosenberg need not answer to this, since his essay indicates that such was not his intent ("the canvas was not a picture but an event"—"broken down every distinction between art and life"—"its value must be found apart from art"). Insofar, however, as the term has been used, without qualification, about Pollock's painting, if indeed we are convinced that *painting* is what Pollock was about, Action Painting is a myth.[20]

What Mr. Rosenberg describes in "The American Action Painters," to whatever extent it may or may not justly describe painters other than Pollock, is an extension and elaboration of ideas regarding the importance of "the act" first advanced by the pioneer Dadaists[21] and further developed by certain of the Surrealist poets (as opposed to the painters) when they discussed automatism as an end in itself, independent of any esthetic concern.[22] To be sure, Mr. Rosenberg never credits these precedents in his text, but we can assume his familiarity with them as a leading literary critic who contributed to *surréalisant* magazines in the 1940s. When he observes that the Action canvas "at length was put aside to produce Happenings,"[23] he links what he is talking about with its Dadaist origins, Happenings having existed primitively as Dadaist and Surrealist "manifestations" and having been described, though never realized, in even more evolved form by Schwitters. This is not to say that Happenings lack original content any more than Rosenberg's essay is simply a rehash of Dadaist and Surrealist ideas.

Both are new impulses in a particular line of thought. The myth of Action Painting has had a compelling influence upon Happenings; indeed the "inventor" of Happenings, Allan Kaprow, reads—or, better, misreads—Pollock's works essentially as a link in this chain.[24]

The myth of the violent Pollock, the murderer of painting ("Jack the dripper" one critic called him[25]), is a concomitant of the myth of the painter as athlete. Writers have pressed the point of violence very hard: "The violence that feeds on everything typically American . . . becomes obsessive and unchained."[26] But such truth as this myth contains pertains more to the painter's life than to his art (and the two are not, and cannot, be the same). This image of Pollock was occasionally associated with the well-known fact of his alcoholism—which sometimes made him violent in his life—and which was alluded to by detractors in describing the supposed chaos of his art. The fact is that Pollock was "on the wagon" during his entire classic phase. In any event, the well-worn critical tradition by which innovations in modern painting are derided as the products of drink goes back to the time of Courbet and the Impressionists.[27]

I have already observed that Expressionist violence *is* evident in Pollock's work both iconographically and plastically before 1947. But the myth of the violent Pollock demands that this quality be seen as characteristic of the classic poured pictures of 1947–50. The question arises as to why these pictures—which situate whatever violence they contain in a wide spectrum of emotions containing far more of passion, joy, exuberance, ecstasy, delight, gravity, tenderness, suffering, grace, fragility, and, at moments, even charm—should have seemed so overwhelmingly violent, particularly when they first appeared. There are, no doubt, many reasons for this, among them the public's distorted and incomplete image of how Pollock actually worked. Perhaps what the public thought they saw in the pictures really lay in *Pollock's radical challenge to its accepted notions of painting.* Pollock *was,* indeed, doing violence to its expectations.

A final word now about what might be called the myth of the "faultless painter"—really just an exaggerated uncriticalness that has prevailed in some quarters of the recent literature on Pollock.[28] Even during the years of the great classic pictures Pollock was not without his failures, and he seems to have been as able to recognize the latter as anybody else. The same is true of the art of his earlier period and particularly of the last years, when Pollock was struggling with alcoholism and felt himself to be in perpetual crisis. There are great works in all his periods (the last pictures are as much criticized by his own previous work as by anything else). But uncriticalness does Pollock a great disservice, and is utterly foreign to his own spirit. Not to acknowledge his problematic pictures and outright failures is to miss the perilousness of his struggle and therefore its humanity, especially in view of the unusual risks his revolutionary methods involved. Pollock's failures measure for us the difficulty of making a picture, even for a

125

great painter, when he eschews formulas and throws the dice, in the Mallarméan sense, with each picture.

Pollock never treaded water; he perpetually challenged himself. Nor did he over-identify with a single style or single conception of painting. He kept his art open-ended and was not loath, in 1951, after almost four years of developing the all-over, poured pictures, to veer off in another direction. His unabating self-critical dialectic led to more stylistic and morphological variety during his mature career than is typical of other great painters of his generation. This variety has alternately been considered a sign both of strength and of unsureness. In fact, such stylistic multiplicity has no necessary bearing on the quality of an artist's work (Matisse's work does not suffer in comparison with Picasso's, despite his more limited stylistic range, or vice versa); but it is surely not without meaning in determining its character and spirit.

The unity in Pollock's diversity derived from the continuity of the terms of his interior dialogue, and reflected the *wholeness* of his being. This is a transcendent unity in which the painter sacrifices oneness on a level once removed from himself (his stylistic image through the course of time) in order to find it on the primary level (his self). For the spectator, the picture is an isolated object, a closed, self-contained system of meanings and, to that extent, an end. For the painter, the making of it is part of a process of self-interrogation and, hopefully, self-discovery, and is therefore also a means.

Equilibrium is a continuing dramatic factor in painting as it is in life, and must constantly be regained. For a painter such as Pollock, who rejected the crutch of yesterday's solutions, it made every new picture a peril. Risky as Pollock's technique was, his conception of painting was even riskier. His problem pictures and failures are testimonials to the courage of his quest as well as guarantors of the authenticity of his successes.

II. The All-Over Compositions and the So-Called Drip Technique

The virtues of the 1947–50 "classic" Pollocks are both intrinsic and historical. Their challenge to conventional conceptions of picture-making (as opposed to their particular style) operated on the spirits of many artists all over the world, granting them "permissions"[29] for new departures. But in their particulars, they had hardly any immediately recognizable influence on the work of other painters the way, for example, Willem de Kooning's paintings did. De Kooning's art lent itself to a variety of inflections and was cannibalized by most of the young painters who claimed attention in the mid-fifties; his style took genius to invent but it required only talent to exploit. The few painters obviously influenced by Pollock in the early or middle fifties, such as Helen Frankenthaler and Paul Jenkins, came out of his stained and puddled pictures of 1951–53 rather

126

than from the linear classic works. The labyrinthine webs of the latter constituted so personal, so qualitatively unique an image, that they resisted borrowings short of rank imitation.

The immediate historical influence of these pictures was of a subtler order: that influence consisted in the establishing of the "single image" and "all-over" conceptions of a picture as they subsequently emerged at the end of the forties in the work of many painters of Pollock's own generation (such as Rothko). Pollock's heraldic, frontal and nearly symmetrical images were also to exert influence in the middle fifties (and later) on many younger painters whose work bears no *prima facie* similarity to Pollock's, among them Sam Francis, Morris Louis, Kenneth Noland, Frank Stella and particularly Larry Poons; and, to the extent that they used all-over patterning, on such artists as Jasper Johns (in his "Numbers" and "Letters") and Andy Warhol (in his early soup cans and coke bottles).

From 1947 to 1950, all-over patterning and the pouring and spattering technique coincided in Pollock's works. But they were not identical, nor did they develop in the same moment. "All-over" refers to a generalized patterning of the surface of the canvas; the pouring and spattering, though they endowed the picture with certain properties of style, essentially constituted a technique for *extended drawing with paint*. The all-over patterning came first, and elicited the pouring technique as a solution to certain problems it posed. This happened late in 1946 in connection with transitional works like *Shimmering Substance* and *Eyes in the Heat I*.

From 1942 onward Pollock's painting is marked by a motor vigor that goes far beyond that of any of the improvisational artists who influenced him, even Picasso. The drawing in those pictures, while still representational, become increasingly galvanic and begins to unlock itself from the description of the totemic forms which, as we shall see, body forth Pollock's early dramas. The fragmentation of these forms, already quite advanced in *Night Ceremony* of 1944, leads to an almost autonomous rhythm of the line in certain gouaches and pastels of 1945 and early 1946. The larger paintings of that period, *Circumcision* (1946) and *The Blue Unconscious* (1946), though more descriptive in their forms, reveal a comparable progression toward compositional openness and linear autonomy.

Some time late in 1946, Pollock's drawing acquired sufficient acceleration to literally "take off" and leave the orbit of description, definition and containment that had always been the traditional role of line. In *Shimmering Substance* and *Eyes in the Heat I* Pollock's line[30] forms a series of looped and arabesqued patterns all roughly similar in character and in approximate size and more or less even in density over the whole surface of the picture. This is what is meant by an "all-over" configuration. As we study these key transitional works we become aware that fragments of Pollock's earlier totemistic presences are covered by the rhythmical linear pattern of white paint which dominates their surfaces. These

127

presences have not been wholly "painted out" but lurk mysteriously in the interstices of the white lines, taking the form in *Eyes in the Heat I* that the title suggests. Much less of the "underpicture," if we may call it that, is so literally visible in *Shimmering Substance*.

The process we are describing is one in which the literal metaphors of the poetic early works (as embodied in the figurative totems) were in effect *going underground*, beneath the new non-figurative painterly fabric. But to some extent their spirit continued to inform the new abstractness. Perhaps this is why Pollock's non-figurative painting so well exemplifies what seems to me the specifically poetic nature of much American abstract art in his generation (I think here particularly of Rothko, Newman, Still, Motherwell and Gottlieb).

The early and middle forties witnessed among these artists, as I have detailed elsewhere, the influence of Surrealist ideas of *peinture-poésie*.[31] Yet by 1950 the reaction of such pioneers of the new American painting against the Surrealist ambiance in their own earlier work appeared to be complete. Except in the case of Pollock's automatism, their mature styles seemed to reject out of hand everything Surrealism had stood for. Nevertheless, the new American painters produced a kind of abstraction markedly different in spirit from the nature-based, optically-rooted renderings to which Cubism, Fauvism and School of Paris work in general had led—or might be expected to lead. Movements descended from Cubism and Fauvism had already lost their momentum in Europe in the 1930s, and the American practitioners of Cubist abstraction in that decade found themselves at a dead end. Only a new spirit could have freed them.

To be sure, the new American painters' mature styles *did* ultimately descend from Cubism and (in the case of color-painters, such as Rothko) Fauvism. But it was their experience of Surrealism in the late thirties and middle forties that enabled these artists to "open up" the formal language they had inherited from earlier modernism, and thus preserve what was still viable in its styles. And while it is true that they expunged from their paintings the type of specifically metaphoric imagery that had related their earlier pictures to Surrealism, the *visionary character* of their now non-figurative art retained much of Surrealism's concern for poetry, albeit in a less obvious, more allusive form. The *poetic* content of the mature art of Pollock, Rothko, Newman, Still, Motherwell and Gottlieb does as much as do differences in technique or structure, to set them apart from the nature-based, literal abstractness of Matisse, Mondrian and the Cubist Picasso.[32]

The impulse towards poetic abstraction, fostered by contact with Surrealism, was abetted by the interest Pollock and other members of his generation had in ethnic and "primitive" art. Signs and symbols drawn from such sources, filtered through an awareness of Jung, alternate in Pollock's early work with iconographies suggested by classical mythology in surreal Freudianized form. They are also common in the work of other artists, as notably in the pictographs

of Adolph Gottlieb. Lawrence Alloway has pointed, in this connection, to the importance of the exhibition called *The Ideographic Picture*, organized by Barnett Newman in 1947.[33] Newman's catalog text speaks of "a new force in American painting as the modern counterpart of the primitive art impulse. . . . The abstract shape [the primitive artist] used, his entire plastic language, was directed by ritual will towards metaphysical understanding." Interest in ethnic symbolism dovetailed with that in the more familiar classical mythologies in Freudian form, as indicated in a statement signed by Newman, Gottlieb and Rothko five years earlier (which we shall consider later in a study of Pollock's iconographies).

The all-over style that Pollock broached in the transitional *Eyes in the Heat I* and *Shimmering Substance* led him to envision a kind of painting that required breaking with conventional methods of paint application. With his drawing now free from the constraints of description, how could he, *with paint*, make uninterrupted lines with the kind of extension that could be drawn with a pen or pencil? (The problem was one that had confronted "abstract" Surrealists such as Masson and Miró when, in 1925–27, they attempted to convert into painting the possibilities they had discovered in "automatic drawing"). The brush or palette-knife can be loaded with only so much pigment; a given line has to be interrupted with each reloading (which perhaps explains the smallness of the abstract "figure" or "motif" in Pollock's transitional pictures). Furthermore, the drag of a stick, knife or brush (though Pollock hardly used the latter as such after 1944) constrains and slows the drawing; at the same time, these tools tend to deposit the pigment unevenly, more heavily at the beginning of a stroke than afterwards. Finally, Pollock's transitional pictures, such as *Shimmering Substance*, support a fairly heavy pigment load due to the all-over patterning of conventional tube pigment. A very large picture of comparable surface incrustation might have risked seeming visually indigestible to Pollock due to the sheer charge of its cuisine. In any event, such a surface could never possess the airy fragility of the soon-to-come poured pictures.

Pollock's adoption of the pouring and spattering technique at this point was a brilliant solution to all these problems, and at once provided a new character and profile to his line, which was henceforth guaranteed against the familiar mannerisms and conventions of drawing as he had learned it. Now Pollock could pour liquid paint in a continuous unbroken line virtually indefinitely. Controlled pouring could thicken, thin and articulate the line at will *in a way a loaded brush could not*. The thinned oil paint and commercial enamels he employed could be used over large spaces without creating a surface burdened with a literal bas-relief of impasto. With the drag of the brush eliminated, the spontaneity of Pollock's drawing could reach a new level, and the anatomy of his line a new variety. "There has never been enough said," wrote Frank O'Hara, "about Pollock's draftsmanship, that amazing ability to quicken a line by thinning it, to

129

slow it up by flooding, to elaborate that simplest of elements, to build up an embarrassment of riches in the mass by drawing alone."[34]

This linear variety was subtly inflected by the different tools—sticks, dried and hardened brushes, basting syringes—that often mediated between the liquid paint in the can and the surface of the picture. (In some cases, such as *Number One, 1948* and *Lavender Mist*, Pollock smeared his hands with paint and printed them directly on the canvas.) His most common operation in the execution of his poured pictures was to place a stick in the can of paint and, by tilting the can, to let the pigment run down the stick onto the canvas. The latter had to be placed flat on the floor to prevent the liquid paint from running ("run-off" patterns are familiar in works by Matta and Gorky in the early forties when they painted, on the easel, pictures with a very thin medium). The stick or brush only rarely touched the canvas and when it did, the line changed character. Pollock could vary the nature of his line by changing the viscosity of his paint, altering the tilt of the can and thus the speed of the flow, and modifying the nature and rapidity of his own arm and body movements. All these determinations functioned in tandem to control a phenomenal range of drawing and surface patterning.

The pouring techniques thus made possible an almost ecstatic exploitation of linear automatism in the realization of all-over configurations on fields of large and, at times, wall-size proportions. It also opened up a new pictorial vocabulary of edges, spatters, puddlings and other patterns. The gatherings and the spreadings of the skein patterns—the "pneuma" of the work—are disposed with an approximate evenness over the surface, never *overly* focusing upon one point. There is an airy transparency to the webs; the better pictures never seem clogged nor opaque despite the multiplication of "layers" (as defined by the spreading of a color that must then be allowed to dry before work is resumed).

The special feature of Pollock's all-over style is that it combined the majestic impact of its immediately perceived singleness of image—what Alloway has called its "holistic character"[35]—with a maximum of remarkably delicate local variations in texture, drawing and color. We first perceive an instantaneous unity and all-over continuity, and then discover the multiplicity, and yet coherent interaction, of its myriad individual parts.

It is crucial in this respect not to be misled by the term "all-over," nor to judge the pictures primarily on the basis of reproductions, as certain of Pollock's critics have done. The term "all-over" is a relative one. (Compared to the hierarchical distribution of accents in Old Master compositions, the atomized textures of many Impressionist pictures are essentially "all-over.") It is surprising how frequently writers on Pollock use the term "all-over" as if it meant that the pictorial fabric was literally *the same all over the surface*. We read in one extensive monograph on Pollock that he "made every square inch of the surface of his paintings of equal intensity."[36] Whatever definition we give of "intensity"—

whether referring to chroma, value, hue, texture or to the character of the draw-
ing—such a remark is mindless; the writer relies on the jargon of art writing
instead of checking his words against first-hand experience.

Yet, neither is the local articulation of Pollock's surface based on a series of
entirely unrelated patterns. Anarchic variety might be produced by a series of
truly random accidents. But if these accidents were sufficiently multiplied over
a large enough surface, as Rudolf Arnheim has pointed out,[37] they would pro-
duce an inert and boring order. The virtues of Pollock's classic pictures depend
on his having introduced such great variety in their local areas while making
them cohere in an organically unified whole.

Pollock adhered instinctively to distributional orderings involving number,
size, and color that prevented any climactic emphasis on one point or section of
his essentially light-dark structured canvas. It meant that no single drawing
motif (if we can call it that) should ever become too dominant, and that each
quadrant of the canvas would have roughly the same number or density of any
size contours. It also meant that within the diverse local accents, Pollock would
have to find common denominators in the patterns, would have to *multiply and
enhance analogies*. The latter are developed among the larger as well as smaller
units: the angular rust brown "joints" of *Autumn Rhythm* or in the black and
white "hooks" of *Mural on Indian Red Ground*.

Eyes unable to distinguish the variations involved in Pollock's linear laby-
rinths—the "push and pull" over the surface, the "breathing" of the webs—
found his all-over paintings to be mere decoration: the "inorganic order of sim-
ple periodic repetitions,"[38] or, as Rosenberg would have it, "apocalyptic wallpa-
per."[39] No doubt, his poured pictures *do* relate elliptically to a Matissian tradition
of "decorative" painting that descends from the Impressionists, Nabis, Fauves
and Post-Impressionists, although this is only one dimension of their richness.
Mere decoration is definable as the formulaic repetition (hence predictability) of
impersonal marks in absolute symmetry on a field of potentially indefinite
extension. Pollock's art, contrarily, involves a mosaic of esthetic decisions in a
context of free choice over a field whose exact shape and size plays a crucial part.
The precarious poise of his all-over, single image is achieved through the equal-
ly precarious balancing of virtually endless asymmetries.

The technique of pouring and spattering fostered and enhanced one of
Pollock's most revolutionary accomplishments: a kind of line predicted but not
yet realized in his transitional works: a line which would no *longer indicate the
edge of a plane*. This invention, first remarked some years ago by Clement Green-
berg, has been excellently described by Michael Fried. Line is a stylistic conven-
tion and not, as the Impressionist pointed out, a fact of nature. It is a shorthand
convention for indicating the edge of a plane or surface. If we shade a simple
turning plane (the surface of an apple, for example) as the Old Masters did, the

black of the chiaroscuro becomes absolute (all color and light values disappear) at the very outer edge of the form. Erasing everything but that outer edge gives us the simple "outline". But the latter nevertheless implies the relieved plane of which it is the edge. It is, in fact, almost impossible to use line so that it would *not* suggest a plane. By wrenching line from that "servitude," Pollock opened a whole series of new possibilities for himself and others. Fried describes the accomplishment:

> Pollock's finest paintings. . . reveal that his all-over line does not give rise to positive or negative areas: we are not made to feel that one part of the canvas demands to be read as figure, whether abstract or representational, against another part of the canvas read as ground. There is no inside or outside to Pollock's line or to the space through which it moves. . . . Pollock has managed to free line not only from its function of representing objects in the world, but also from its task of describing or bounding shapes or figures, whether abstract or representational, on the surface of the canvas.[40]

In both abstracting line from representation (which had been done before) and from the simple creation of shapes (which had not), Pollock was aided by a factor not mentioned by Fried: the novel and particular *profile* of the poured or dripped line. Distending laterally, developing excrescences of all sorts from the "drop-like" to the "hairy," this line not only spreads out, but frequently "bites" into the canvas irregularly on both its (the line's) sides. In thus precluding our reading of one of its sides as the "outside" (which would therefore immediately imply its descriptive relation to a planar form), it sits flat on the surface, an entity in itself, like the black "lines" in the mature Mondrian.

This newly profiled line was not, however, in itself a guarantor against representation, nor even against the shaping of abstract planes. In fact, Pollock could and did use it descriptively in a few pictures; for example the "personage" of *Moon Vessel* (1946) and the skein-drawn head and shoulders on the right of *The Wooden Horse* (1948). In order to create an entirely non-figurative linear picture, free of even abstract contoured planes, Pollock had not only to use the kind of poured lines we have been describing, but he had to *run them together in so tight an interlacing that none of the ground showing through could be read as a plane outlined by a skein of paint.* When this was not done, as in the long, frieze shaped Duco drawing of 1950 [OT 797], the line tended to contour planes (even though it was not used here in the Rorschach-like, image-invoking manner that emerged in Pollock's work the following year). It is the scintillating, molecular fabric resulting from the *multiplication of the criss-crossings* that constitutes what I believe to be the consummation of Pollock's plastic accomplishments (which, though dependent upon his having liberated line, goes even further), that is, in effect, *his conversion of drawing into painting.* This at once transcended the familiar Wolffinean antithesis by creating an art that was *simultaneously "linear" and "painterly" (malerisch).*

If we consider the great painters in the modern tradition who were essentially draftsmen, we become aware that when they painted, they carried over into *painting* the linear contourings, hatch-marks and other shading devices proper to *drawing*. Van Gogh is a classic example. In exploiting possibilities of color and impasto opened up by Impressionist painting, he nevertheless remained true to the "handwriting" of his drawing. But in Pollock at a certain point, the criss-crossings, convergences and puddlings of the linear skeins fuse into a "painterly" fabric. As such, his painting reaches back behind styles of linear and planar determination, such as Cubism, to the scintillating painterly fields of Impressionism. In adapting drawing to painting, Van Gogh had reaffirmed its traditional character; in drawing with overlapping skeins of poured paint, Pollock atomized line drawing into a new form of painting. To do this, sometimes on a scale of epic proportions, took incredible concentration of effort, given the surface density the drawing had to achieve, and its accomplishment released in Pollock immense inertial energies only hinted at in his more conventionally drawn pre-classic pictures, which could only chaffingly accommodate his draftsmanly genius.

III. Impressionism and the Classic Pollock

Revivals of interest in styles which have gone out of fashion constitute a commentary on the history of art. And the transformation of American painting between the late forties and mid-fifties must be considered in the context of a concurrent re-evaluation of Impressionism, particularly of the virtually forgotten late Monet, and of a shift of interest on the part of painters in the late forties—Pollock among them—from Picasso to Matisse.

Classical Impressionism had ceased to be an issue for advanced painters well before the First World War. American avant-garde painting in the interwar period was essentially a provincialized Cubist proposition that became increasingly inflected by the Expressionist Picasso and by Surrealism during the late thirties and early forties. The Monet revival was no accident, coming as it did in the wake of Pollock's pioneering of the big "scintillating" picture. Though he was familiar with classical Impressionism, Pollock could only have known the big late Monets, if at all, through reproductions. The emergence of Pollock's work and the Monet revival suggest a convergence of responses to a certain spirit increasingly "in the air" toward 1950. While the large late Monets are of interest in this context as offering a type of the wall-size picture toward which Pollock was working quite independently, the classical Impressionism of the 1870s actually provided important points of departure for the tradition that culminated in Pollock's all-over style.

Impressionism had made many of the first great contributions to the

expanding definition of modern painting, establishing certain basic conditions which inform much—though by no means all—of the painting of the last hundred years. And as one of the great climaxes in this continuing tradition, the all-over Pollocks not only *assume* (i.e., presuppose) the Impressionist contribution to this definition, but *subsume* some of the particulars of the Impressionist style. Let us consider their affinities.

Though many works by the Old Masters contained heavily impastoed passages, the disposition and articulation (brushwork) of such areas were invariably related to the presence of the objects which the pictures illusionistically described. The hierarchies of brushwork patterns and impasto densities tended, in effect, to recapitulate the illustrated objects as textural relief on the picture surface. The development by the Impressionists in the later 1860s of an increasingly flecked and atomized brushwork led, in the first half of the following decade, to what Meyer Schapiro—who acutely characterized this transformation—calls "the autonomous, homogeneous crust of paint."[41] In the most abstract of Impressionist pictures—those of the 1870s, such as the *Duck Ponds* of Monet and Renoir—the brushwork patterns are almost totally disengaged from the contouring of objects (the painters sought consciously not to recognize the contours or identities of objects, but only to perceive color sensations). Despite its remove, this fracturing of line by the Impressionists adumbrated Pollock's liberation from contouring.

The homogeneous crust of paint that Schapiro describes is not only a question of the disengagement of brushwork from contouring but, above all, of the *approximate evenness of density all over the surface*. In the work of painterly Old Masters, such as Rembrandt, Velázquez and Goya, the clusters of heavy impasto are located here and there over the picture surfaces in varying *image-determined* quantities. Impressionist impasto is not so much thick as it is *evenly dosed*, and thus ideally free of the *hierarchies* formed by brushwork patterns in Old Master art. This is crucial to the formation of the all-over conception. But while its vaguely Monet-like brushwork patterns has led Pollock's late oil, *Scent* (1955), to be considered Impressionist-influenced, no one has as yet observed the capital importance of Impressionist innovations for his earlier, classic all-over pictures. The insistent materiality of Pollock's surfaces, which nevertheless end by scintillating in an essentially optical way (in this connection, consider the implications of the title of the transitional *Shimmering Substance*), the molecularization of shapes into myriad small sensations (by criss-crossing the variously colored lines), and the approximately even distribution of these pigment-sensations over the whole surface of the canvas are all features common to the most advanced Impressionist paintings of the 1870s.

Moreover, like the Impressionists, Pollock did his best to atomize and distribute single colors so that their sensations *would not combine to constitute a*

shape of color. When dealing with large shapes of a single local color (the terra-cotta-tiled roof of the house in Renoir's *Duck Pond*, for example) the Impressionists atomized them by interspersing complementaries and picking up reflected lights from adjacent motifs. (In this period and, indeed, in general, the Impressionists tended to avoid subjects and vistas that confronted them with dominant fields of a single color.) But the Impressionists were hampered by a primary commitment to the visual field before them ("truth" to their visual sensations). Free of these constraints, Pollock was able to elaborate some of their plastic ideas, bringing them to a more radical and natural fulfillment, by rendering them wholly consistent *from within.*

The degree to which particular poured paintings by Pollock may be said to relate to Impressionism—an art of color spots rather than line—is measured by the extent to which the density of their poured lines, hence the frequency of the latter's intersections, *isolates their segments as spot-like sensations,* and also by the extent to which the linear component is otherwise modified by spattering, patching and puddling (effects present in all classic Pollocks). *Number I* (1948), *One* and *Lavender Mist* (both 1950) strongly reflect these practices. *Autumn Rhythm* and *Number 32* (also both 1950), owing to their greater openness, remain more linear. The former three, along with such pictures as *Number 8, Number 27* and *Three* (all of 1950), show Pollock at his most "painterly" and thus at his closest to Impressionism.

Turning from the formal means of Impressionism to its expressive character, and its social and cultural implications, we find much in it that points directly to Pollock—much that Pollock, in effect, completes or even, as his art is essentially visionary, apotheosizes. What I mean here has to do with their common confrontation of the flux, rhythm, and complexities of modern life, especially as experienced in the great urban centers. While both the Impressionists and Pollock had great interest in landscape, the world of nature was shared by them with the artists of the past. Only modern painters can have confronted the metropolis; none have better understood its rhythms than the Impressionists and Pollock. By this I do not mean that Pollock was ever a painter of the city in the literal manner of Impressionism. Pollock specifically rejected such suggestions.[42] Pollock was not the painter of *anything* in a literal sense. His content—which must ultimately relate to some form of human experience outside the picture—has to be grasped in a more intuitive way.

Let us begin with the particular modernity of Impressionism *as an image of life,* a conception expounded with great beauty by Schapiro.[43] The Impressionists not only gave up those subjects—historical, mythological, religious, etc.—which were the staples of Old Master painting but chose from among the possibilities of contemporary life, the uncharged, commonplace activities (as opposed to events) of the pleasurable life around them (instead of those climactic and dra-

135

matic incidents selected by the Romantic Painters). To the extent that their images of crowds on the boulevards, in the cafés and at picnics belong to the world of relaxation and enjoyment, they have a far narrower expressive range than Pollock's alternately ecstatic and tragic art. Nevertheless, they constitute the first confrontation of the pace and molecularity of modern urban life, a confrontation which not only took place at the level of the *image*, but was also supported, as we have seen, by a new, looser articulation of the surface composition that atomized the forms in an analogous way.

Pollock's reflections of the rhythms of modern experience have occasionally been discussed in apocalyptic and pseudo-Einsteinian terms ("an effort to get out into the time flux and to embrace the cosmos"; "his equation of time with space"[44]). But the alternative to this discredited rhetoric (Einstein called the classic text relating Cubism to relativity theory "sheissig"[45]) need not be a retreat to purely formalist criticism. Pollock's expression of these specifically modern experiences, and the relationship of this expression to Impressionism, revolves largely around the question of *accidentality*.

In an essay which I believe to have been the result of a fatal misunderstanding of Pollock's art, Rudolf Arnheim, a leading Gestalt psychologist and author of numerous texts on art, distinguished between accident as image-content and as esthetic content.[46] Realism, he observed, is bound to mean confrontation with accidental life situations that one would not see in stylized arts, the Byzantine, for example. If the relative realism of Old Master art meant some confrontation with this, then the Realism of the mid-19th century meant (at least theoretically) an almost total acceptance of it as an image of the world. Such images of accidentality are thus common, Arnheim correctly observes, in the work of the Impressionists who are still rooted in naturalism in that sense:

> It also becomes evident, however, that while accidental relationships crept into the subject matter, the artistic representation of their effects was not based at all on chance selection or grouping. In order to have necessity . . . these pictorial compositions . . . must actually convey these ideas by compelling, neatly defined visual patterns. [The example given is Degas's *Cotton Exchange in New Orleans*.]

Such well organized images are then insightfully contrasted with:

> dismal examples that accumulated in the western art of the last centuries when the compositional patterns of realism became so complex that the average painter's eyes could no longer organize them. Here accidental patterns were produced not by intent but by the degeneration of the sense of form. The desire for the faithful imitation of nature finally conquered man's natural and traditional sense of form. . . .

136

Unfortunately the next step in the argument is the discussion of recent modern paintings as actual agglomerations of accidents as opposed to images of them (Pollock's *Greyed Rainbow* of 1953 is the example given). Presented in the bald manner common to much hostile Pollock criticism, such a contention would be beneath discussion. But Professor Arnheim's dialectic is rather subtle and constitutes the only serious presentation I know of this point of view.

Arnheim observes that if painters like Pollock were involved simply in *laissez-faire* paint-slinging "the monotonous rhythms" we supposedly see "would be disrupted by impulses, reminiscences, associations from other areas of mental functioning. . . . Only by careful supervision throughout the work will the artist obtain the perfect homogeneity of the texture, and such control must by guided by a definite image of what the artist is trying to accomplish." This is supposedly achieved by quantification—the multiplying of accidents which as Arnheim rightly demonstrates statistically, cancel each other out in time, the point-to-point interrelationships receding, and the common properties coming to the fore to produce "texture." Such a painting as *Greyed Rainbow*, Arnheim claims, can be perceived only as texture—not because the number or size of the units of which it is made up go beyond the range of the human eye's capacity but because the units do not fit into more comprehensive shapes.

Finally Arnheim adds that in such an image—the "visual embodiment of a maximum of accident"—we "recognize the portrait of life situation in which social, economical, political and psychological forces have become so complex that . . . nothing predictable seems to remain but the meaningless routine of daily activities, the undirected milling of anonymous crowds."

Here we have it—the order of imagery toward which all but the most rigorously formalist criticism must tend. Those crowds *are* there somewhere in the poetic allusiveness of Pollock's poured pictures. But like the real crowd, whose collective image is the sum total of purposeful movements, they are not milling undirectedly. Pollock's image is not, of course, a *picture* of a crowd, or anything else, but it is no less engaged with the feeling and pulse of such contemporary experiences. Like the pictures of life in older art (except at its most corrupt, as in Victorian realism) which were not images of the way life really was but the way it might ideally exist, Pollock accepts the challenges of the molecularity and *prima facie* confusion of modern life and transcends them, endowing them with a comprehensive order. His image is an equilibrated and ordered structure of modern experiences which as *art* provides symbolically precisely the unity, equilibrium and absolute completeness which life lacks.

As a closed and fixed system, a picture is able to show life whole—from the outside—in a way that man, "inside" life, can never experience directly. If we see only a piece of Pollock—in effect, the way we experience life—no matter how much richness is involved, we miss its essential structure, its monistic simultaneity. A

good deal of talk about "environmental painting" misses this point (see below).

Arnheim notwithstanding, the expressions of chance and accident in Pollock's painting are ultimately no less controlled, no less determined than in Impressionism, even though they are confronted in a more direct and hazardous way. The artist himself has said, "I *can* control the flow of paint: there is no accident."[47] Yet even a cursory glance at a poured Pollock shows that *on a purely operational level* this was not entirely true despite the remarkable virtuosity he developed in his technique. There are numerous small spots and puddlings which were manifestly not one hundred percent controlled *as they happened*. But they are accidental only then; in the final work they have been transmuted into esthetic decision. How does this occur?

Once the picture is under way (its "automatic" beginnings I shall discuss in connection with Surrealism) Pollock comes to it with a clear intent based upon the "stored decisions" of which I spoke.[48] Immediately he begins to work, drawing rapidly with the paint *in accordance, however improvisationally, with his will*, he confronts the fact that his method entails a *margin of accident*: an unintended mark or puddling (the latter is especially uncontrollable when—as happens only occasionally—two different wet colors fuse). In reacting to this the artist has essentially three possibilities open to him. If the accident is unfortunate, it can simply be painted out (too many of these produce "a mess," as Pollock called canvases with which he had "lost contact"[49]). But the accident might also contain the germ of an idea that had not previously occurred to Pollock, in which case he could build upon it improvisationally ("I have no fears of making changes, destroying the image, etc." because organically "the painting has a life of its own"[50]). The picture might change character as a result, and the accident disappear as such through its organic assimilation into the fabric of decisions. Finally, Pollock might have just let the accidental mark stand. The choice of this alternative was, nevertheless, very much an esthetic decision and so here, too, the accident has been transmuted into art. To whatever extent it was anything other than the results of the initial impulses of the will, *the finished picture was not made up of accidents but of responses to them*.

This confrontation and transcendence of accidentality, rather than being a sign of resignation before the complexities of life (*pace* Arnheim), is precisely the guarantor of Pollock's relevance. Given the immense role which unpredictable events, unexpected convergences and collisions, play in the denouements of modern existences, no art that did not on some level confront the accidental and improvisational could fully satisfy us as a symbolic structure for our own experience. The successful life, like the successful Pollock, is one that is very much held together and given meaning by *maximizing the favorable possibilities* and minimizing the unfavorable effects of the myriad accidental situations with which we are bombarded.

The nature and viability of Pollock's image reflects its recapitulation, in symbolic terms, of this life process. This is not "Action Painting," where a gestural act in the world of real space (supposedly) leaves an intrinsically meaningful imprint on the canvas. In Pollock, as in older art, everything significant happens on the canvas; the method is not mimetic. *And it is only a method.* The finished picture, as a statement of content—and as a success or failure—is, like all finished pictures, entirely independent of whatever means has been used to achieve it, however much that means may have given character to the work.

The antithesis established by Arnheim between Impressionism, as simply the image of accident, and Pollock, as the actuality of it, holds, in fact, no more for the former than for the latter. For concomitantly with their imaging of the accidental situations that articulate modern life, the Impressionists incorporated, in their revolutionary painting technique, a prophetic margin of accident. If we look closely at the pictures, especially those of the early 1870s where the flecking is maximally disengaged from shaping, we find that the rapidly executed brushwork is full of irregular edges, extensions and "tails" (as the brush is lifted) which were certainly not predetermined and whose final presence in the picture depended upon the same order of decision (leave it, develop it, paint it out) that confronted Pollock. Not that we cannot find something of this in the work of the most painterly Old Master, but it was confined there by the degree to which their brushwork was committed to contouring, to building up the illusion of objects. If one has any doubts about the marginal accidentality I attribute to the *facture* of Impressionist painting, one needs only look very closely at the surfaces of 1870s Monets or Renoirs. It is also instructive consider the public response to these pictures in their day. Cham's satirical cartoon image of an "Impressionist" (titled "Nouvelle Ecole—Peinture Independante") was shown creating a paint fabric that, because of its purportedly uncontrolled, ragged and atomized texture, shocked a public used to Salon painting as much as Pollock's methodology did the public of the late 1940s. In fact, the commentaries in the popular press during the two periods bear a remarkable resemblance.

In their rapid execution, the Impressionists initiated a freedom of facture, and a loosening of the paint fabric, which, enlarged upon by many subsequent artists, culminated in Pollock, who in this respect is unlikely to be matched. Impressionism thus stands midway between the Old Masters and Pollock. The Old Masters knew what they were going to do to the canvas before they did it. The Impressionist *assumed a posture* of naïeveté in regard to the "given" of the visual field, trying to isolate simply its *sensations*, and to build the work up progressively in response to those. To the extent, however, that his image was controlled by the field of sensations without (and it was to a considerable extent), any improvisation was largely illusory. Cézanne, not the Impressionists, invented the truly improvisational procedure for composing pictures. Abstract

139

and non-figurative painting had to be invented for this sort of improvisation to attain something like the autonomy it had in arts like music.

Nevertheless, despite the rapid working methods of certain Old Master paintings (Rubens, Hals and Magnasco, for example), the speed with which the Impressionists painted was a radical innovation; it responded in part to a desire to capture the sense of the moment in time, thus "freezing" the quality of movement peculiar to modern urban life. Like everything else in Impressionism it would not have developed similarly in the Florence or Odessa of the 1860s and 1870s or, for that matter, even in the Paris of fifty years earlier (Victor Hugo's "black city"). The notion of a very rapidly executed improvisational picture, which is, after all, *not* common to most modern styles, would be especially advanced in the 20th century by Picasso (in his more spontaneous works), by Klee (not so much by Kandinsky, except in his watercolors) and above all, by the automatism of the "abstract" Surrealists (Miró and Masson) who—in this regard—led directly to Pollock.

In Impressionism the molecularization of the paint surface went hand in hand with the break-down of Old Master compositional geometries; this two-fold process constituted the *first step in the direction of the all-over style*. Just as the Impressionists' paint fabric was atomized to achieve a newly homogeneous and autonomous crust, so the motifs themselves tended to be fragmented and more loosely distributed in the field of the composition (too loosely, Cézanne thought). Old Master composition had usually depended for its coherence on a single large geometry that incorporated all the crucial motifs of the image and locked them in a proper climactic order both optically (to the extent that the geometry functioned abstractly) and hierarchically (in terms of the intrinsic importance of the subject matter's components). These static, deceptively simple structures were no more apt for expressing life in Paris in 1870 than Cubism's structures would have been to express life in the New York of 1950.

Except in the minds of the most proper Victorians, the world of the 1870s no longer possessed the clearly stratified social hierarchy of the centuries prior to the Industrial Revolution, and the rigorously hierarchical political structures of the *ancien régime* were long since gone. The old life hung on in the provinces. But the new life in Paris called forth a different kind of art, in which the design hierarchies of Old Master painting—always the counterpart of those inherent in their subjects—would be fragmented into smaller more equal ("democratic") units deployed in looser, less geometrical, more casual relationships. If this anticipatory all-overism of Impressionism—the dissolution of hierarchies and the evening-out of the size, intensity and character of the compositional constituents—reflected the new configuration of Parisian life a century ago, the more advanced and intense form of it in Pollock's work emerged, in part, from the urban New York melting pot which provided the possibility of cultural (and

hence esthetic) syntheses and syncretisms of an unparalleled order.

The Impressionists were very good at eliminating the vestigial pictorial geometries which had persisted intact, as viable orderings, through Ingres and Delacroix (though they were already undermined in the realism of Courbet). But they were not always successful in implementing replacements. In their loosely articulated compositions, they substituted textural homogeneity and an evenness in the flickering light what had been heretofore a "geometrical" cohesiveness. This was achieved by an averaging-out of light values, made possible in turn by the breakdown of heretofore "solid" modeled forms into individual color flecks or "sensations." The resultant luminous and textural evenness were also to be essential to Pollock's all-over esthetic. But for density of pictorial "architecture" within a shallow space, Pollock found inspiration, at least indirectly, in Cézanne, via the high Analytic Cubism that preserved and distilled Cézanne's "restructuring" of Impressionism.

The compositional fragmentation of Impressionism was accepted by Cézanne as a starting point, as was its insistence upon *sensations* as the basic building blocks of the picture. But he locked these fragments or *sensations* into overall unities by analogies of shape, color, number, direction and texture with such subtlety that the "random" forms (e.g., the fruit on the tablecloth) seem fatally rooted in place. Cézanne fixed the Impressionist sensations within clear coordinates in shallow spatial structures, allowing them to model forms only in low relief. High Analytic Cubism, in its turn, dissected this pictorial architecture and Mondrian, as we shall see later, culminated this process in his works of 1913–14 (Picasso and Braque having left it "incomplete" a year earlier). The planar clarity with which the "sensations" that make up Pollock's layered webs relate to one another in their shallow frontal space[51] depended upon Pollock's grasp of this Cézannesque-Cubist tradition.

However, before proceeding to Cubism's particular contribution to the all-over configuration and to the articulation of shallow space, I should like to discuss some affinities of the classic Pollocks with the later pictures of Monet.

IV. Color and Scale; Affinities with the Late Monet

Thus far I have discussed the Impressionist style as it was held more or less in common between Monet, Renoir, Sisley and (to a much lesser extent) Pissarro during the 1860s, 1870s and early 1880s. My characterization was based upon its most abstract moments, which were not typical of its whole history, and I certainly meant to exclude such phases as Renoir's academizing "classical" period in the later 1880s.

The term "Impressionist" continues to be used in connection with the late Monets and, indeed, their style developed out of his earlier work. But these pic-

141

tures of the fin de siècle and the first decade of the 20th century, with which the classic Pollocks have some striking affinities, want characterization of a different kind. Their mood (so analogous to that of Debussy, who is also usually misla-beled an "Impressionist"[52]) is essentially *Symbolist* in character and they emerged coincidentally with the flourishing of Symbolist poetry. Unlike the Impression-ism of the period 1865–85, these "Mallarméan" later Monets are veiled, intro-spective, poetic pictures in which lonely contemplation—close in mood and even esthetic to the "musical" Whistlers of the '70s and '80s—has replaced the gay, molecular world of Impressionist Parisian sociability.

Classical *plein-air* Impressionism reflects a continuous retinal confrontation with the external motif. The later Monets, despite some confrontation of the motif, ended as studio pictures, with a more removed, internalized, at times even hermetic experience. They are therefore closer to Pollock's work in the poetic and visionary character that such "distance" from the motif encouraged. Like Pol-lock, the late Monet digests nature but recasts it poetically. But Pollock increased the distance between nature and its visualization even further, which allowed his exquisite allusions to it—as in *Lavender Mist, One* and *Autumn Rhythm*—to be simultaneously fused with alternate metaphors. The Impressionists, given their naturalistic commitment to the external visual world, had to choose between doing a landscape or cityscape; Pollock was able to fuse allusions to them in a single image.

The spirit of landscape in Pollock is carried primarily by the *atmospheric tonalities* and *large size* of the pictures (since they are not *illusions* of nature they are free to communicate its *qualities* in this more direct way). And it is to these properties especially we must turn in discussing his affinities with the late Monet. We must keep in mind throughout this discussion, however, that while some easel-size late Monet unpeopled landscapes were visible in New York in the years of Pollock's formation, the larger wall-size pictures were unknown to him (except, perhaps, through reproductions).

Classical Impressionist pictures of the 1870s were structured primarily by juxtapositions of pure color. The most advanced examples reveal a tendency to keep the flickering light averaged out *at an approximately even value* over the whole surface (the earliest Impressionist pictures had larger contrasts, but the painters worked *away* from this) and to articulate its forms by *changes in hue*. The tonal late Monets, beginning with the smaller pictures of the 1890s; tend to reverse this proposition. They frequently have *only one hue* (usually one rare in nature and hence poetically evocative, like purple or rose) and the picture is chromati-cally articulated by a *point-to-point inflection from light to dark and warm to cool* within that hue. In those that introduce a second hue, the light-dark nuancing is reinforced by an enhancement of the secondary continuum of warm to cool.

Though it is not essentially monochromatic, like that of the late Monet or

the Analytic Cubists, the Pollockian structure is fundamentally a light-dark one, as is to be expected for an art that grows out of drawing. Individual colors fuse in an all-over tonality; the color is applied, as Robert Goodnough observed, "so that one is not concerned with separate areas: the browns, blacks, silver and white (his example was *Autumn Rhythm*) move within one another to achieve an integrated whole in which *one is aware of color rather than colors.*"[53]

Two practices were necessary for Pollock to absorb the various colors into a tonal, chiaroscuro framework. First, in keeping with the all-over principle, the color would have to be distributed with approximate evenness, each quadrant of the canvas (and sometimes even the smaller subdivisions) having *at least some of every color used.* Second, the hues would have to be submerged in the non-hues. *Almost every classic poured picture is liberally dosed with black, white and aluminum paint.* The aluminum, since it reflects differently at different angles, covers a considerable range of the middle values, and its elusive light helps dissolve the skeins of color with which it interweaves into an all-over tonality. (It consequently has a special role in the structuring of Pollock's space, which will be discussed later.)

To enhance this tonal unity, Pollock usually kept away from strong, saturated colors. The greatest of the drip pictures introduce mostly pale colors, or those remote from the primaries, which he handled with exquisite nuancing. Colors like red and green were either used very sparingly, or made into the unifying tonality, either as a ground (e.g., *Number 24, 1948*)—though this was not common—or by dominating the picture's skeining, as in *Full Fathom Five* where the minuscule doses of other colors merely "season" the green. Hues like red, blue or yellow would not allowed in such pictures *in quantities that might challenge the hegemony of the dominant.* Even in the perhaps most colorful of the classic paintings, *Mural on Indian Red Ground* (colorful in the sense of its juxtaposition of more saturated yellows, greens and reds) the quantities of color are kept low in relation to the black, white and aluminum and its units are widely dispersed.

After his black, stained pictures of 1951 Pollock began using larger areas of bright color. This worked out most felicitously in *Number 12, 1952* (since severely damaged by fire). But when he tried working these more intense hues into the all-over webs of the poured pictures (which he resumed in 1952), the outcome was less happy. The reds of *Convergence* (1952) for example, have an unfortunate tendency to "pop" optically out of pictorial fabric. In the non-drip *Easter and the Totem* (1953) on the other hand, as in *Number 12*, he was able to juxtapose large panels of color with beautiful results.

It has been said that Pollock created "a new color,"[54] and his use of *certain* Duco and Devolac colors after 1951 was indeed new to serious painting (enamel house paints, however, had been used by Pollock's coevals, the Mexican painters, and by pre-World War II European painters). But we want here to watch

the use of superlatives in the description of Pollock's accomplishments lest they end by canceling each other out. Pollock did employ some new paint colors; this is a technical innovation. But except for the aluminum paint, he did not *use* them in a new way. Far too much emphasis tends to be placed upon the historical precedence in the invention of new techniques (the fuss about who invented "dripping" is a case in point) as opposed to what is done with them. Pollock did create a new use of line; but his color is in no wise as revolutionary nor as crucial to his esthetic, however beautiful it frequently was.

The large late Monets constitute the sole genuine precedent in the modern tradition for the wall-size picture pioneered by Pollock, Rothko, Newman and Still beginning in 1950.[55] These panoramic pictures, frequently exceeding twenty and sometimes reaching forty feet in width, were conceived by Monet as constituting a world in themselves (as experienced at the Orangerie) rather than as a "window" on a world, as is the traditional easel picture. Though they are the largest pictures in the modern tradition (excluding, of course, some institutional murals), they were painted independently of architecture which, like the largest canvases of the new American painters, they ideally *displace* rather than *decorate*.

Simply as large paintings, the Monets are not, to be sure, unique in modern art—architectural mural decorations such as those of the Mexicans apart. There were some very large Matisses, the *Bathers by a River* (8'7" x 12'10") especially,[56] and then of course Picasso's *Guernica* (11'6" x 25'8"). In fact, the Chilean Surrealist Matta had shown a number of extremely large canvases in his New York exhibitions of the mid and late forties (*Science, Conscience and Patience of the "Vitreur"* [1945] was 6'6" x 15', *Being With* [1946] 7'4" x 15'), some years before pictures of anything like comparable size were made by Americans. But in one way or another—either because of their figuration, illusionistic structure or particularized content—all but the Monets were fundamentally different in conception from the big picture that Pollock, in particular, and the American painters, in general, were to develop.

Guernica, though not really a *mural* in the sense of being designed to relate to (and not merely to fit within) a specific architecture, was nevertheless made to be shown in a public building, addressed to a collectivity, and dealt with a public subject. The compositional forms of modern painting do not lend themselves to a climactic statement of this order and Picasso fell back on some techniques of Old Master painting, superimposing on his composition a big pedimental device. Though a surface-embracing geometry, this was, nevertheless, unlike those of the Old Masters since it did not coalesce with its subject but cut through it. For Picasso, *Guernica* represented a considerable break with both the nature and structure of his other pictures; it was something of a sport in his *oeuvre*. Pollock's largest pictures are an entirely consistent outgrowth of his smaller ones.

Though the Symbolist character of Monet's *Nymphéas* is anticipated by his smaller Verlainesque late *House of Parliament* and *Views of Venice* dating just before and after the turn of the century, their large size is entirely a 20th-century contribution. (Those at the Orangerie date from about 1914.) Monet was carrying on this revolution in the nature of the easel picture quietly, while attention was focused on Fauvism and Cubism as the embodiments of vanguard art.

The large canvas involved Monet in a fundamental reversal of those implications which had previously made small formats virtually standard for Impressionism. The small size of the classical Impressionist picture was, in the first instance, a moral assertion. It proclaimed the painters' modesty of intent in the face of presumptuousness and windy rhetoric of the immense academic "machines" that filled the Salon. And it sorted well with the "candid," unposed and fragmentary treatment accorded the subject matter. But it also had another purpose, that of facilitating the fragmentation of shape, color and texture into the homogeneous, autonomous surface crust described earlier.

The most abstract Impressionist pictures of the 1870s involved such a thorough going pulverization of the surface, and required such fine visual discriminations, that the style of the pictures could not be sustained over a very large surface. Or so the painters seemed to think. For when the format was on occasion enlarged (compare Renoir's *Duck Pond*, 1873, 20" x 24½", with his *Sunday Afternoon Boating Party*, 1881, 51⅜" x 69¼") they markedly diminished the atomization of the surface, permitted some big contours in the brushwork and, as Meyer Schapiro observes, introduced large if discontinuous accents of compositional geometry into the design of the work. All this was done to sustain and cohere the activity of the eye over the larger surface by alluding to visual hierarchies of a type that they had originally worked away from.

In his large late pictures Monet developed another solution which involved a return to all-overness in the brushwork, but with a stroke now much broader than had originally prevailed (and that to some extent was necessitated by his failing eyesight). The compositional unity of these pictures usually depended on a mirror image-symmetry between the top and bottom of the picture (an optical equation of the sensations of the landscape forms and their reflection in the water) and in cases where the picture became very wide, on a placement of trees or drooping boughs at the lateral limits as bracketing devices (as in the largest pictures at the Orangerie). These compositional "parentheses," absent from the best of the *Nymphéas*, reflected Monet's fear that an exceedingly wide (in relation to its height) picture might otherwise lose cohesiveness. In his "friezes" of the late forties Pollock succeeded with such elongated formats without falling back on the support of bracketing devices.

The late Monet's success with the large picture seems to have depended on his shift from the earlier hue-juxtaposing structure (Impressionist) to a chro-

145

matic light-dark variation within a dominantly tonal color (Symbolist). And though Pollock introduced differing hues into his light-dark pictorial armatures, they still functioned *structurally*, as I have suggested, in terms of their light-value definition. An immense picture, dissected into a molecular mass of color spots of roughly even value but markedly differing in hue (comparable in that sense to the classical Impressionist structure of Renoir's *Duck Pond*, for example) has, to my knowledge, yet to be painted.

The large Monets announced a wholly new conception of size in a non-mural "easel" picture. But the announcement fell on deaf ears in a European art world where the avant-garde had long since ceased to look to Impressionism for its cues. Pollock's, Rothko's, Newman's and Still's wall-size pictures of 1950 were arrived at independently, by another route. In fact, the revival of the late Monet, which began at the end of the forties, represented, as I have already observed, a convergence of tastes in which the big Pollocks, Rothkos and Stills unquestionably played a role.[57]

The new large picture was of a private order. It had the size of a mural without the latter's binding esthetic structures or public mode of address. It was private in character, but unlike the easel picture (a "window" on the world), it displaced the wall. The monumental painting of the past was generally a public mural art, set within an architectural situation and in dialogue with that architecture, whether tectonically reinforcing its accents or anti-tectonically opposing them. Even when devised for private palazzos such murals—or their concomitant giant panel or easel pictures—constituted a public art insofar as the owners of the buildings were public figures and the uses of the large rooms in which they were situated were usually public too. Moreover, the subject matter of such art was almost invariably of a collective order—political, mythological, religious, historical, etc.—such as dominated Old Master art as a whole. (Genre subjects were reserved for easel paintings of cabinet size.)

The natural position of the spectator in regarding such mural pictures was one of sufficient distance for its illusion to hold and its narrative therefore to be comprehensible. Given the fact that they contained human figures and other motifs which functioned as modulars, the illusion of scale remained the same whatever the actual size of the mural. The realization of the new large-scale modern picture demanded consequently the elimination of illusions of—or schematic references to—recognizable images which are potential modulors. E. C. Goossen, in *The Big Canvas*, noted the importance, in this regard, of the elimination of human figures in the late Monets. (However, the latter was also, certainly, a poetic question.)

But insofar as Monet retained recognizable motifs from nature, the *absolute scale* of the immense American pictures was still closed to him. In the larger *Nymphéas* I believe Monet frequently tried to negate the relativistic scale inher-

146

ent in figurative painting by imaging the objects—trees, lily pads and the rest—
in their actual size thus making them function in terms of the proximity of the
spectator just as they do in life. This simultaneity of illusion and actuality
proved a dead end, however, and in terms of rendering scale autonomous the
American painters owed more to Mondrian and other pioneers of non-figurative
art than to Monet.

The peculiar experience of the large American pictures depends upon their
actual size *in relation to their intended private setting.* Goossen observes that their:

> footage in both directions is larger than the comprehensive image the eye is capable
> of taking in from the customary distance. The customary distance is that normally
> and previously satisfactory of a complete view of the average easel painting, prior to
> the increase of this average in the past ten years [*written in 1958, ed.*] Such can-
> vases have forced their way into rooms where they consume the entire wall space,
> and in turn affect the quality of life in the room pressing an emotional experience
> upon those who used to have to stand and peer.[58]

The experience that Goossen describes here in careful terms has given rise to
considerable loose talk and writing about "environmental painting" (as opposed
to "environmental sculpture" or just plain Environments, both of which are lit-
erally three-dimensional). Excepting certain types of mural decoration (and
unusual instances such as the oval room in the Orangerie in which the immense
late Monets are installed), paintings—or at least, *a painting*—cannot literally
encompass the spectator. Nevertheless, in apartments, where we are bound to
move frequently in close proximity to the wall, the Big Canvas brings us into
very close contact with its parts in such a way that we see the whole only with
difficulty. To do that we must step back, which exactly reverses the procedure
with the easel painting where the "customary distance" allows seeing the whole
and we step forward to study its parts.

Some confusion in the discussion of "environmental painting" has result-
ed from misconstruction of Pollock's oft-quoted statement that his painting
"does not come from the easel."

> I hardly ever stretch my canvas before painting. I prefer to tack the unstretched can-
> vas to the hard wall or floor . . . On the floor I am more at ease. I feel nearer, more a
> part of the painting, since this way I can walk around it, work from the four sides
> and literally be *in* the painting. . . .[59]

To be literally *in* the painting, i.e., walking on the surface, was a possibility only
when the canvas was large, and while it was on the floor. In fact, it was neces-
sary for the very largest pictures, where Pollock could not have reached the
entire surface from the outside edges. Once the work of art was hung vertically,
however, the order of its experience changed. Neither Pollock nor the spectator

147

could then be *literally* in the picture (any more than with any older art). Though from Goossen's "customary distance" one would be too close to see its entirety, one savored from there the richness of its local parts and the patterns of decision that articulated them. But just as Pollock could not comprehend the entirety of what he was about while literally in the picture—he had to climb a ladder or tack the picture to the wall for that—so the spectator cannot understand the work as the total, closed symbolic system it is *except when he sees it whole.* Any conception of environmental painting that precludes this possibility, that does not define painting as having simultaneously perceivable regular boundaries, deals with the art in less than its highest and most independent form (as it exists sometimes, for example, when serving as the handmaiden of architecture).

Since architecture is inherently more in the order of the collective than painting, a real mural art—as opposed to the autonomous wall-size pictures of the new American painters—is alien to the modern tradition *which has resolutely stressed the autonomy and personal, private character of painting.* It is not surprising that only those exceptional modern painters interested in collective experience, such as Léger (in his case the collectivity was political, i.e., Communist) have ever considered subordinating their painting to architecture. The wall-size picture of the Americans, as adumbrated by Monet, forms a new category in which the intimacy and environment of the cabinet-size easel painting is preserved while the picture—drained of illusion—achieves the size of a mural painting *independently of that genre's social and esthetic implications.* The "window," which was the traditional easel conception, has become the "wall."

The process by which the American painters replaced the mural conception of the painted wall with that of the wall of paint constitutes an interesting extension of what seems to me a fascinating and as yet unclarified development within Impressionism. The discussion of this, however, needs some preparation, and will depart from, but attempt to go one step beyond, the familiar "window" principle used to characterize western illusionism by Ortega y Gasset, Coomaraswamy and others.

Most historians are agreed that through undermining conventional modeling (by eliminating the middle values) and suppressing most vestiges of perspective space (sometimes even its minimal cue, the horizon line), Manet had effected—in such pictures as *The Woman with a Parrot* and *The Fifer*—a flattening of space which represented one of the first major breaks with the constants of Old Master illusionism, i.e., the common denominators of virtually all styles from around 1425 to 1850. What appeared at the time to be the almost playing-card flatness of Manet's most "abstract" pictures certainly constituted the first step in the modernist direction of Mondrian and the late Matisse.

But Manet's space, while squeezed inward toward the picture plane, was still patently illusionistic, and located "behind" the picture frame. The latter was

still a "window," though the world it looked out on no longer receded to infinity. What of the advanced Monets and Renoirs of the early 1870s which succeeded these Manets? Their position in relation to the development of the modern "flat" picture—to the tendency to treat the picture as a painted object rather than as an illusion—has never been adequately defined, perhaps due to their ambivalent spatial qualities.

When we compare pictures like Monet's and Renoir's *Duck Ponds* to the flattened illusionism of the Manets we have mentioned, our first reaction is to imagine that the Impressionists had reinstated deep space. And, indeed, on the *level of the illusion*, this is perfectly true. But that illusionism depends upon the spectators' being what was, in the days of the salon, the "customary distance" from the picture. From there, the individual touches of paint coalesce as colored light into discrete, recognizable, three-dimensional images. If, on the other hand, one gets close to the canvas, as the Impressionist picture invites us to do, the atomization of modeling and consequent dissolution of illusionistic forms into the flecked and autonomous brushwork patterns discussed earlier results in a view of the picture not as three-dimensional illusion but as a painted plane. The slightly relieved tangible surface crust is now seen no longer as disembodied light sensations but as "concrete" impasto texture.

In this sense then, the esthetic posture of Impressionist art was ambivalent, and the public, which had great difficulty at first reading it as illusion (after all, their eyes were used to Meissonier and the salon), naturally saw it as a disordered chaos of color spots. In time the public became able to read it as illusion, but still did not see it as painting (in the radical sense in which subsequent modern painters understood it, consciously or not).

Seen illusionistically, the advanced Impressionist picture restored the deep vista that Manet had eliminated; seen close up, it eliminated even the shallow illusionistic space that Manet had retained. Pursuing Ortega's image we can say that the "window" was now not transparent, but covered with a crust of paint that *materially affirmed the two-dimensional surface of the window pane* (picture plane) in a manner new to painting and fundamentally opposed to the shallow, "accordionized" space of the early Manet. It was as if, instead of seeing a duck pond through a window, one became aware that *somebody had put blue paint on the glass* where sensations of sky and water had previously been visible. The "window" ceased therefore being a "window" and became analogous to an enframed patch of painted "wall."

Viewed abstractly, the large late Monets may be said to have expanded the patch of "wall" of the classic Impressionist pictures to become *identical with whole wall*; conversely, read as illusions, they must be thought of as glass "walls" rather than "windows." The Impressionists had always loved the notion of dissolving the distinction between the inside of a building and the natural world;

149

Schapiro has noted that their friend Raffaelli predicted houses with three glass walls. The late Monets in effect do this for the spectator. But the late Monets contain the same ambivalence of possible readings evident in earlier Impressionism. Pollock was able to *confirm* the picture as painted "wall" *by eliminating any possibility of its being read illusionistically or figuratively.*

The big Pollocks are related to the late Monets not only in aspects of their plasticity, but in their *intimacy*, a quality they share with the wall-size pictures of Rothko, Newman and Still. As we have seen, unlike *Guernica* and the monumental works of the past, the large American pictures were intended for private apartments, and they address the spectator on an individual basis. The monumental Old Master picture expressed collective values and was set in an architecture that also embodied the order and hierarchy of these values (e.g., architectural progression leading to the basilican altar reenacting the iconographic drama). In true mural situations, whatever more personal, private qualities the art of painting, as against architecture, inherently possessed were subverted by its "servitude."

When Mark Rothko said he *painted large to be intimate*, he was expressing his interest in a kind of contact with human beings that the large American pictures bring about forcibly in apartments, where it displaces the wall, and operates in the spirit of Rimbaud's injunction to "change life." Many people assume that such large pictures were intended for museums. This is wrong; their presence in museums is a necessary cultural compromise. Apart from the fact that the usually vast spaces of the museum discourage the intimacy and closeness to the surface that the apartment fosters, the experience of the picture there is not private and contemplative (except perhaps for the curators before and after hours). And, in the end, the audience of the museum is but another collectivity (though in a world in which religious and political institutions have lost their power to inspire, one of the few viable ones).

V. Cubism and the Later Evolution of the All-Over Style

That the all-over Pollocks should have any connection at all with Analytic Cubism is a surprising suggestion (at least this writer found it so some years ago). So much in both the character and plastic structure of the poured pictures seems, at first consideration, diametrically opposed to that meditative, architectonic art. Yet the existence of such a relationship is the central thesis of Clement Greenberg, pioneer critic of the new American painting and particular supporter of, and commentator on, the work of Pollock; if for no other reason, it is an idea which any serious criticism is honor bound to at least consider. Yet of the two monographs on Pollock to have appeared by 1967, Mr. O'Hara's does not mention it, and Mr. Robertson's, after praising Greenberg for his "consistent

understanding of Pollock's work and admiration for his achievement," proceeds to attribute to him (Greenberg) the view that Pollock *had by 1943* "broken away from the traditional conception of pictorial space that had extended from the Renaissance to the Cubist period in art and that Pollock was making a new kind of space."[60] This astonishing attribution entirely reverses the burden of Greenberg's actual views which were that even the *poured* pictures, not to say the paintings of 1943–46, *"have an almost completely Cubist basis."* [61]

Moreover, Robertson's contention that a break with Cubism took place in 1943 runs counter to virtually all other Pollock criticism which considers the paintings of 1942–46 profoundly influenced by Synthetic Cubism, Picasso in particular. Lawrence Alloway, for example, judges them "one of the most brilliant achievements of Late Cubism."[62] But whereas these writers see Pollock rejecting Cubist structure in the all-over paintings of 1946–50, Greenberg considers that the Cubism—now Analytic rather than Synthetic—persists on what might be called the infra-structural level of the work. Even Michael Fried, the scholar whose critical methods have most in common with those of Greenberg, found that "despite Pollock's intense involvement with late Cubism through 1946, the formal issues at stake in his most successful paintings of the next four years cannot be characterized in Cubist terms."[63]

Alone among other writers on Pollock, Sam Hunter hinted (but only round-aboutly) at the possible value of Greenberg's thesis. "Picasso's Cubism," he wrote in the catalogue of the Museum of Modern Art's 1956 memorial exhibition, "impressed" on Pollock "the overriding importance and transforming function of plastic values. A vivid appreciation of the painting surface as a potential *architectonic organism* has lent a consistent stylistic logic throughout his career *even to Pollock's freest inventions."*[64]

I want to make clear at the outset that I do not accept Greenberg's contention that the poured pictures "have an almost completely Cubist basis." The reader will not be surprised that I consider Impressionism, if only indirectly, extremely important for them as well. (And Surrealism—though here more in the methodology and poetic spirit than in the plastic structure of the finished works.)

Nevertheless, Greenberg's thesis seems to me to contain a profound truth, however much he may overemphasize it and however little he has ever explicated or developed it:

> By means of his interlaced trickles and spatters, Pollock created an oscillation between an emphatic surface—and an illusion of indeterminate but somehow definitely shallow depth that reminds me of what Picasso and Braque arrived at thirty-odd years before, with the facet-planes of their Analytical Cubism. I do not think it exaggerated to say that Pollock's 1946–50 manner really took up Analytical Cubism from the point at which Picasso and Braque had left it when, in their collages of 1912

and 1913, they drew back from the utter abstractness to which Analytical Cubism seemed headed. There is a curious logic in the fact that it was only at this same point in his own stylistic evolution that Pollock himself became consistently and utterly abstract.[65]

The interstitial spots and areas left by Pollock's webs of paint answer Picasso's and Braque's original facet-planes, and create an analogously ambiguous illusion of shallow depth. This is played off, however, against a far more emphatic surface, and Pollock can open and close his webs with much greater freedom because they do not have to follow a model in nature.[66]

Beyond these statements, Greenberg has not clarified the relationship he postulates, nor has he mentioned the way in which the proliferating grids of late Analytic Cubism contributed historically to the integration of the all-over configuration. Rather he has been content to illustrate the Analytic Cubist and all-over Pollock pictures side by side[67] and let the reader make the connection. This seems to me virtually impossible to do because of the morphological and structural distance between the works, which distance may be mapped by a consideration of certain intervening steps, to which I shall turn shortly.

My own awareness of the value of Greenberg's insight came, curiously, during a prolonged investigation of Surrealist painting. In pursuing the development of "abstract" Surrealism (Arp, Miró, Masson and Ernst, the last primarily between 1925 and 1928) I found that these artists had not (with the partial exception of Miró) developed so thoroughgoingly new stylistic formulations as I had thought. The poetic content of the imagery was new and so was the shape-language (biomorphism) engendered to carry that content. But a morphology is only one component of style. It became increasingly clear to me that as far as space, compositional disposition, particularly in relation to the frame, and even (except in Miró) color were concerned, these artists clung to conceptions held over from the Cubism which all but Ernst had practiced extensively before their conversion to fantasy painting. It may very well be that Ernst's weaker conviction about abstraction (or, put otherwise, the frequency of post-Chirico illusionism in his work) reflected, in part, his more fleeting contacts with Cubism.

That paintings as different in a *prima facie* sense from Cubism as were these Surrealist works could still be rooted in it, that a biomorphic art could still dispose itself classically in regard to the frame, and somewhat reflect Analytic Cubism's shallow space and underlying rectilinear grid patterns, raised the same possibility in my mind for Pollock's curvilinear art.

Synthetic Cubism, which had bodied forth the poetic iconographies of Pollock's pre-1946 works, seemingly disappeared with the advent of the all-over style. Increasingly, I began to feel that Cubism nevertheless persisted in subtle

ways, transformed now in the direction of Analytic Cubism. Like Pollock's poetic iconography, which shifted in 1947 from an explicit to an implicit state, Cubism had gone underground. There, it gave his all-over poured pictures *precisely that architectonic tautness of structure which had been missing from the Impressionism which, I believe, also profoundly (though even more indirectly) informed their style.* When Cézanne carried Impressionism to a more complex formal level by "locking" its color sensations, now more architectonic as brushstrokes, into structures that located and fixed them in a shallow space as well as in the lateral expanse of the picture, he established a dialectic that was renewed in High Analytic Cubism and in the all-over Pollock.

To understand these relationships, we must clear our minds of certain popular misconceptions about Cubism. Just as there are no "cubes" in Cubism or, for that matter, any other *closed* three-dimensional geometries (or even many closed two-dimensional shapes) in Cubism's Analytic phase, so the prevailingly rectilinear morphology of the Braque and Picasso paintings of 1909–12 cannot be held—once we dismiss the term and just look at the pictures—necessarily to be the crucial aspect of the style. Equally, if not more important, are the space, light, distributional principle and hierarchy of accents. It is only by dissociating the rectilinear contouring from these other components of style that we can gauge the "carry-over" of Analytic Cubism in the works of the "abstract" Surrealists and various later "all-over" painters.[68]

The process by which the Cubism of 1911–12 contributed to the all-over style of the classic Pollocks can be more easily understood if we fill in the gap between them (developments which Greenberg does not discuss). The essential intervening developments (apart from the work of Mark Tobey, with whom I will deal shortly) are: first, the Mondrians of the winter of 1913–14, which carried Analytic Cubism further in its own explicit direction than had Picasso and Braque when they abandoned it something over a year earlier; second, the varieties of "abstract" Surrealist pictures which converted Cubism's rectilinear grid scaffoldings into prototypes of crowded, sometimes virtually all-over, *curvilinear* compositions, while preserving the distributional and spatial underpinnings of Analytic Cubism. (Picasso's curvilinear Cubist pictures all came out of flat, brightly colored *Synthetic* Cubism. They did not share the painterly shallow space and light-dark armatures of Analytic Cubism nor of the subsequent tradition I am describing. This line of development, which passes through the 1913–14 Mondrians as well as through aspects of "abstract" Surrealism, comprehends the classic, as opposed to the pre-1946, Pollocks.)

We must begin the discussion of the 1913–14 Mondrians with a crucial observation made about the classic Pollocks by Greenberg, Alloway and others: that the poured web—quite to the contrary of being a "run-on" fabric—usually *stops short of the edge (or "frame") of the picture,* frequently by doubling back on

itself. This may be observed to some extent in the transitional all-over (but not yet poured) paintings of 1946.[69] However, it is not marked until after 1947 due to the persistence of Synthetic Cubist tendencies to go out to the edge of the field. This recession from the frame, virtually consistent from 1948 through 1950, is more readily confirmed by looking at the actual pictures rather than at photographs. Aside from the fact that the distance (sometimes just an inch or two but often considerably more) by which the web backs away from the framing-edge is reduced to a virtually microscopic interval in a photograph of a large picture, many published photographs of poured Pollocks get slightly cropped or masked—which therefore renders invisible the fact we are discussing.

In itself, the web's retreat from the edge testifies to nothing more than the Pollockian configuration's "classical" relation to the frame (as opposed to the anti-classical tendency throughout history to controvert the binding and axial character of the frame). We do well to remember, however, that Analytic Cubism is the most *seminal* classical style of the 20th century. It is crucial to Greenberg's thesis here that Pollock's dissolution of the web short of the frame re-enacts the *fading near the edge* to which Picasso and Braque subjected their compositional scaffoldings increasingly over the period (1908–12) of Analytic Cubism's progress toward greater abstraction.

This fading near the edge represents, in the Analytic Cubist works of 1911–1912, the vestiges of the more sculptural figure-ground relationships that are evident in earlier, less abstract Cubist pictures. However, and it is here that Greenberg's thesis begins to be inadequate, the dissolution near the edge, even in the advanced pictures of 1911–12, takes place, with rare exceptions, on *only three sides*; the scaffoldings are usually anchored to the edge on at least one side, most commonly the bottom (from which they are supported as they build upwards, like architecture, narrowing toward the top).

This upward narrowing and dematerialization has always seemed to me, as it did to Wilhelm Uhde, somewhat akin to Gothic architecture, despite the fact that Picasso and Braque discovered these scaffoldings primarily in motifs of figures and still-life objects (which only confirms the remarkable autonomy of Cubist structure). I am convinced, however, that Mondrian perceived this analogy to the Gothic, and that it is reflected in his frequent use of cathedral facades as motifs precisely at the moment he was recapitulating this phase of Analytic Cubism (that is, in 1912).

In the crucial Mondrians of late 1913, such as the Guggenheim Museum's *Composition No. 7*, the dissolution of the scaffolding near the edge is *consistently carried out on all four sides*, as it is in the classic Pollock. Moreover, Mondrian's "floating" of his now more filigree structures in the *lateral as well as the shallow recessional space of the composition* gives them a lightness, and less allusively architectural appearance, more akin to Pollock than are the 1911–12 Picassos

and Braques. It seems to me of great significance that the transformation I am positing was reflected in Mondrian's shift, at this moment of passage into even greater abstraction than that of Picasso and Braque, *from the use of cathedral facades to water-scapes* as favored motifs. Looking at the sea, which extended before him laterally rather than rising perpendicularly (as did the facades), and which constituted a flickering and elusive *surface* rather than a concrete three-dimensional *object*, Mondrian found the motif in nature that is, perhaps, through its "formlessness," the most inherently abstract. It was not by accident that these are the pictures through which he evolves into the absolute abstractness (or non-figurativeness[70]) of the immediately succeeding "plus and minus" pictures.[71]

It is essential for the synthesis that Pollock brought to fulfillment in his all-over pictures that the Picassos and Braques of 1911–12, like *Ma Jolie*, contained a good deal of flecked and luminous Neo-Impressionist atmosphere (though their shadowy, monochromatic, and profoundly searching metaphor of human consciousness seems to me closer to Rembrandt than to Impressionism in spirit). This Impressionist content was enhanced in 1913 Mondrians like *Composition No, 7* by the shift to the water-scape, a motif particularly favored by the Impressionists. This is a subject which, for reasons which will soon be clear, reminds me of the pertinence at this point of the work of one of Pollock's coevals, Philip Guston, whose painting of the 1950s was deeply involved with synthesizing just these Impressionist and Cubist sources we have been discussing.

The work of small masters such as Guston is often useful in confirming developments that are less evident in the work of the great artists whose period they share, where the influences of past art are more completely transmuted. It does not seem to me accidental that the synthesizing process subtly going in Pollock's work should be more explicit and more parsable in Guston's pictures of the early 1950s, which followed hard upon the formation of the all-over style. Guston's work at that time was sometimes labeled Abstract-Impressionist, not so much because its consistently rosy coloring was reminiscent of such prototypical pictures as Monet's *Impression, soleil levant* (which it was), but because the myriad small strokes of pigment established an Impressionistic flickering, scintillating surface. Yet *unlike* Impressionist surfaces, characterized by their dancing, any-which-way flecked pigment, Guston's brushwork appeared "magnetized" axially as if by an underlying or implicit grid that organized his Impressionist-derived "sensations" in the architectonic distributional and spatial patterns of late Analytic Cubism, particularly the plus-and-minus Mondrians. Though these Gustons have a delicately nuanced impasto and touch as well as a winning and modest poetry, they appear plastically essentially synthetic. The elements, Impressionist and Cubist, are familiar, though their selection and quantification constituted a new recipe. (Their painterly qualities connect them more obviously, though no less actually, to French painting than does the more radical facture

155

of the poured Pollocks.)[72] This synthesizing is not readily perceived in the all-over Pollocks (which, in any case, preceded the Gustons) precisely because the process of transformation was more thorough-going and also served as a platform for further inspiration.

The Mondrians of 1913–14 also extended and confirmed two other as yet undiscussed aspects of Analytic Cubism that were to play essential roles in the esthetic of Pollock's all-over paintings: the fragmentation (or "analysis") into increasingly small units, and the distribution of these units (or accents) in frontal patterns (i.e., parallel to the picture plane). Increasing division of the surface into smaller units had been going on throughout the four year history of Analytic Cubism, but in the most advanced form to which Picasso and Braque carried that style, as exemplified by the former's *Ma Jolie*, 1911–12, there was still a considerable range or hierarchy from large to small and from emptier to more crowded surface areas. There were, to be sure, a few pictures such as Braque's *Soda*, 1911–12, that prophesied Mondrian's "floating" lattices. These, however, generally involved a break with the rectilinear scaffoldings that had hither to prevailed, which change appears to have been related to the tondo shape of the canvas. It may well be that the curvilinear support freed Braque here from an allegiance to "architecture" that had become limiting. But these exceptional variations were not further developed by Picasso or Braque. Such Mondrians as *Composition No. 7* have smaller and more numerous forms than 1911–12 Picassos, and they are distributed with such approximate evenness over the surface that they *certainly qualify as all-over lattices*. (Tony Smith recounted to me a conversation he had with Pollock at a Mondrian retrospective held at the Janis Gallery, in which Pollock specifically affirmed the connection in his mind between the 1913–14 Mondrians and the origins of all-over painting.)

The sculpturesque Cubism of 1908 to early 1910—a simulacrum of relief sculpture rather than of sculpture in the round, as we shall see—had necessarily to include many forms whose planes turned obliquely to that of the surface. But the increasing painterly dissolution of this simulated sculpture, and the greater abstractness of the succeeding pictures ended in making possible, by the winter of 1911–12, *a scaffolding of fragmentary planes and lines almost all of which had become frontal*. It remained for Mondrian in 1913 only to make this principle more explicit through the greater consistency and evenness with which his lattices adjusted to the surface. The plus-and-minus pictures rendered the conception even more absolute as the vestigial brushy indications of shallow atmospheric space were gradually eliminated.

With the shift from early to late Analytic Cubism came a related change in the nature of Cubist space, from one measured by the displacement of sculpturally relieved forms to one characterized by atmospheric illusion. This painterly residue of a shallow relief space, refined and narrowed in the 1913

Mondrians, was the springboard, *but only the springboard*, for that of Pollock's drip paintings. But in order to better demonstrate this, we must go back to the originator of that space, Paul Cézanne.

In the face of Manet's flattening of Old Master illusionistic space (in his most advanced pictures of the 1860s), and the subsequent Impressionist dissolution of modeled forms into juxtaposed patches of pigment, Cézanne invented a new kind of space which in a sense sought a compromise between illusionism and anti-illusionism. He made it clear that (among other objections) he found Impressionism too loosely structured and, above all, too light and airy (i.e., too dissolved into flecks of color sensation) to contain forms of sufficient weight and gravity to communicate the seriousness of his art. The latter were the Old Master qualities he yearned for.

Cézanne could have simply gone back to Old Master illusionism whole hog. Instead, he went forward to an art that accepted Impressionist *sensations* as its constitutive building blocks, but organized them in patterns that gave an *illusion of relief*. This frontal relief, and its concomitant sense of weight and gravity, is the *modern* form of the "tactile values" that Berenson identified with the monumental illusionism of the Italian tradition descended from Giotto. Cézanne considered that only an appearance of physical weight and gravity in the forms could provide the desired metaphysical gravity of spirit, and that this particular property could not be effected (and as yet no one has proven otherwise) without some degree of illusion, given the actual flatness of the canvas surface. (Sculpturesque reliefs of impasto, relieved collages and assemblages have been among the 20th-century "solutions" to this problem.)

Cézanne's pictures did not, however, go back to Old Master perspective space, which moved illusionistically *away* from the spectator and from the picture frame (which constituted the front limits of its illusion). Rather he accepted the insistence on the literal, and hence lateral, definition of the picture that was implicit in Manet and the Impressionists, and became explicit shortly afterwards as painters began consciously to treat pictures as "two-dimensional surfaces covered with colors arranged in a certain order."[73] But while Cézanne accepted laterality as a base, since it conformed to the actuality of the support (i.e., the two-dimensional surface of the stretched canvas), he did not carry forward the implications of Manet's relative flatness, which were to be advanced rather by Gauguin, and were to culminate in the late Matisse and such insistently flat styles as recent "hard-edge" abstraction. Instead, Cézanne created the "bumpy picture," *the simulacrum of a bas-relief* in which forms are modeled *not in the round, but in the front only*, and in which they pass into one another by openings of the contours (a process subsequently called *passage*) until the entire fabric is assimilated to a lateral plane in the rear, just as in a bas-relief.[74]

The monumental illusionism of the Italian Renaissance masters was built

157

upon a simulacrum of sculpture in the round; Cézanne built on the notion of frontal relief. The bas-relief is, in any case, generally closer to painting than it is to sculpture-in-the-round insofar as it contains its forms within a closed, regular lateral panel disposed at right angles to the spectator's eye. These forms, as in Cézanne's paintings in general, but in Analytic Cubism in particular, seem more to *project out toward the spectator* from the closed back plane than to move spatially away from him or her as in older perspective illusions.

Contrary to the Sunday Supplement versions of modern art history, the Cubists did not build upon Cézanne's supposed treatment of nature "by the cylinder, sphere and cone." These closed three-dimensional geometries are undiscoverable in Cézanne's paintings, and only people who look with their ears have ever been taken in by the meanings traditionally attributed to Cézanne's famous remark about them (which supposed meanings have been discredited by scholars).[75] In fact, rarely are there even any completely closed *two-dimensional geometries* in the mature Cézanne.[76] Such isolated shapes would have inhibited that melding of forms which makes possible Cézanne's extraordinary indivisibility of design.

What the Analytic Cubists *did* build upon was the simulacrum of bas-relief, which gave them, too, the possibility of solid, monumental forms with the gravity and solidity of architecture that were nevertheless readily assimilable to the two-dimensional plane of the canvas in a way that Old Master illusionism was not. They somewhat weakened Cézanne's conception of composition however, by so frequently "standing" their scaffoldings on the bottom of the frame. The Cézannesque conception was more sophisticated, and involved all sorts of distributions, such as compositions that "spill" downwards (and still paradoxically have the weight of architecture). Of course the Cubists had by 1911 dissolved the sculpturesque solidity inherited from Cézanne into a less tactile, more painterly fabric (but this, too, was at least anticipated in the work of Cézanne's last years).

The way in which late Analytic Cubist grids underlie subsequent all-over compositional structures is easier to see by once again turning from Pollock to one of his satellite painters, Bradley Walker Tomlin. In his all-over pictures of 1948–52, Tomlin evened out the hierarchies of forms and the distributions of accents but, partly under the influence of Gottlieb's pictograph grids, remained far more evidently than Pollock in the shallow space and rectangular grid structure of Cubism. Tomlin did explore some open, meandering linear designs in which the Cubist grid was more or less suppressed, but he pulled back from this, preferring to work within a grid design felt as *a priori*. Pollock showed that by accepting the challenge of wholly liberating his line, he could *reincorporate* the essence of Cubist architecture in a new way, *at the end of his process*, i.e., as the web filled out and the freely meandering lines became locked in an architecture of their own making.

The 1913 Mondrians still have clear vestiges of Analytic Cubism's shallow atmospheric space; the space of Pollock's drip pictures, though it has some affinities with them, is more complex. Contrary to what is sometimes said about Pollock's pictures, they are not flat in the sense of insistently affirming two-dimensionality in the manner of the late Matisse, or even the more "optically" spatial Newman. The linear webs hang both *actually* and *optically* in front of the plane of the canvas. To this extent—but only to this extent—they recall the bas-relief, forward-coming space of Analytic Cubism.[77]

Where the Pollocks differ is that they contain *no vestige at all of modeling.* Though their articulation is more a matter of light-dark than hue relationships, the chiaroscuro has been rendered autonomous by the disengagement of Pollock's line from contouring and therefore, even by implication, from shading.[78] The very shallow optical space of his pictures is not a matter of atmospheric illusion but of the actual overlapping of different color skeins and the tendency of certain colors to "recede" or "advance." Pollock worked to minimize any sense of spatial illusion by locking the warm colors quite literally inside the skeins of the non-hues, of which the ambiguously functioning aluminum, in particular was used to dissolve any sense of discreteness the space of the web might possess, in effect to "confuse" it into a unified mass of light sensations.

Thus the culmination of Pollock's mature style in the late forties required that Analytic Cubism's shallow but vestigially illusionistic space be *discarded* in favor of a non-illusionistic, optically spatial web of sensations that had the surface sense of Impressionism: an affirmation of the pigment as a material surface which nevertheless dissolves into disembodied light sensations in the retina. At this point in the coalescence of the Pollockian picture, Cubism has been subsumed by a kind of Impressionism carried far beyond Monet in having eliminated Impressionism's fundamental spatial equivocation.[79]

As an intervening phase in the development of the all-over style between the 1913–14 Mondrians and the painting of the 1940s it is necessary to consider the "abstract" Surrealists' metamorphoses of Analytic Cubism. André Masson's meandering line, in his best "automatic" pictures of the later twenties, disposes itself (like Pollock's) in relation to the frame in a manner that still betrays a recollection of the underlying Cubist grid that had dominated Masson's pre-Surrealist paintings. As the fantasy elements, carried primarily by curvilinear, organic forms, began to dominate the pictures, the Analytic Cubist grids faded into the background. But even when the meandering line had been quite liberated, as in *The Haunted Castle*, 1927, the vestiges of the grid were still explicit. Only in the tube-drawn, spilled-sand paintings, made later that year, does the grid wholly disappear. But the disposition of the drawn elements shows that, as in Pollock, it continued to influence the composition on an implicit level.

The same tendency to maintain an Analytic Cubist infrastructure and shal-

low space, even after adopting an anti-Cubist morphology, may be seen in Miró, Arp and in some of the more abstract Ernsts. Although biomorphism opened the way to a new vocabulary of forms, it did not itself constitute a style (in the sense that Impressionism or Cubism did). Rather it provided constituent shapes for paintings *in a variety of styles* while not determining or generating any new comprehensive principle of design or distribution of the total surface—*or of the illusion of space*—in the picture. On the contrary, when more than a few such shapes were used by the "abstract" Surrealists, we almost always find them disposed in relation to one another and to the picture frame in a manner analogous to the Cubist compositions. Thus, while we may speak of the form-language or morphology of Arp and Miró as anti-Cubist, this does not apply to the over-all structure of their compositions, since both painters cling on *that* level to organizational principles assimilated from their earlier Cubism.

This is the most easily illustrated by an extreme example, Miró's *Harlequins' Carnival* (1924–25), which should be compared with his "Cubistic" pictures of the early twenties. The *Harlequins' Carnival* is a full-blown Surrealist work, its iconography related to (Miró's own) poetry and its forms almost entirely biomorphic. But despite the considerable suppression of straight lines and vertical and horizontal accents, the multitude of little organic forms is distributed over an underlying Cubist grid, the picture's infrastructure, as if constrained by some rectilinear magnetism.

We see the distillation of this design principle in Miró's later "Constellations" (*The Poetess*, for example) which caused considerable interest following their arrival in New York in late 1944.[80] The originality of the "Constellations" does not lie in the range or inventiveness of their morphologies, which are, by Miró's standards, not particularly inventive. Beyond circles, stars, triangles and other simple geometrical items, we find relatively few of the freely meandering biomorphic shapes that gave character to Miró's most interesting earlier work. However, in certain of the "Constellations," the spotting of colors and shapes and the chaining in close proximity of the many minuscule forms destroy compositional focus and hierarchy in favor of all-over, pulsating compositions, in which piquant variations in density produce an animated flicker punctuated by brief flashes of pure bright color. As an optical experience, the "Constellations" were unprecedented, having no forerunners even in Miró's own work, except for *Harlequins' Carnival* (where the more diluted coloring and less dense distribution minimize the effect). The "Constellations" may be said to anticipate the interstitial flashes of pure color that emerge from Pollock's essentially light-dark webbing.

There are numerous other works of the twenties, thirties and early forties in which the "abstract" Surrealists "filled out" an underlying Cubist grid, in a manner approximating the all-over lattices of the 1913 Mondrians though with *curvilinear rather than rectilinear accents*. These constituted intervening steps adum-

brating Pollock's all-overness. Take, for example, Max Ernst's *100,000 Doves* (1925–26). Except for the rectilinear-curvilinear transformation (essentially the substitution of biomorphism for rectilinear geometry), we have here a painting ultimately very like advanced Analytic Cubism *in structure*. A grid used to create the *frottage* texture atomized the paint fabric into many small units distributed more or less evenly over the surface (but dissolving at the frame except at the bottom); the composition is fundamentally a light-dark value structure: cream tinted with blue and rose to create a shallow, frontal, painterly space. More recent all-over Ernsts obviously respond to the experience of Pollock and Tobey—indeed to the ubiquitousness of the all-over conception in the 1950s. But they are just as clearly a natural outgrowth of such early works as *100,000 Doves*. From the interlacing curvilinear patterns (results of string and other *frottage* textures used to make this picture), Ernst "divined" the doves, which he then "clarified" by contouring the birds' eyes and bodies. This visionary, poetic phase of the painting is its specifically Surrealist side, but the Analytic Cubist infrastructure abided. To see such a picture in juxtaposition with Mondrian's *Composition No. 7* on one side and certain Massons of the twenties and early forties and the Miró "Constellations" on the other is to see the plastic context that connects the all-over painting of the forties with developments prior to the First World War.

Whatever contribution the Surrealist painters made to the expansion of the all-over tendency inherited from Impressionism and late Analytic Cubism, there is no doubt that the same heritage was being developed (unbeknownst to them) directly out of late Cubism into a more fully realized statement of the all-over conception by Mark Tobey during the late thirties and early forties. In fact, such Tobeys as *Drift of Summer* (1942) and *Pacific Transition* (1943) fulfill certain aspects of all-overness in a manner anticipating the classic Pollocks of four years later. Pollock himself is said not to have seen this "white writing" when it was shown in the Willard Gallery in 1944. Indeed, the line of his integration of the all-over style, developing cues from Impressionism, Cubism and Surrealism, in no way presupposes contact with Tobey. Tobey himself had arrived at his all-over pictures not via Surrealist automatism but through Klee (his "doodling" and Cubist-influenced grid compositions) and, more significantly (and unfortunately, I believe, for his quality), through Oriental calligraphy.

The all-over idea is clearly adumbrated in Tobey's *Broadway* (c. 1935) where its descent from late Analytic Cubism is manifest. But Cubist drawing is here reduced to a schematic and decorative convention that remains more locked to the visual motif (i.e., much less conditioned by the process of "analysis") than in the Cubist models that inspired it. The conviction of a deep and pre-modernist perspective space is relieved here only to the extent that the white contouring is disengaged from the darker ground and generalized by the eye as a net-

work on the surface. This contradiction is only partly resolved in *Broadway Boogie* (1942) which carried the conception of the earlier picture into more marked abstraction. It is with the non-figurative and, hence, less descriptively calligraphic *Drift of Summer* (1942) and *New York* (1944) that Tobey achieved an even, shallow space that matched his now more even and entirely all-over patterning.

But except in their recession from the edge and in their shallow space, *Drift of Summer* and *New York* betray little of their Cubist background. The flickering, scintillating character of their "white writing," however, recalls Impressionism and, indeed, Tobey referred even to the earlier *Broadway* as made up of "some Impressionism, some Cubism, and writing."[81] The white writing derived, of course, from Tobey's explorations of Oriental calligraphy to which he had been introduced by a friend, a Chinese student named Teng Kuei in the winter of 1923–24; shortly before that he had made what he later called his "personal discovery of Cubism." By animating the Impressionist-Cubist scintillating, all-over conception by means of calligraphy, Tobey moved in a direction that recapitulated Miró's and Masson's automatism, but at a greater remove from the center of the modernist tradition.

Though on rare occasions Tobey's linear webs are painted "off the picture," seemingly uninfluenced by the frame (as are a few of the Pollocks of 1947), the great majority "fade" near the frame, leaving the tracery comfortably adjusted to its edges and evenly hung in a shallow, frontal space. The webs have an evenness of density, free of such marked hierarchical relations as might compromise their all-overness and, at the same time, an airiness and transparency. All this, Tobey's pictures hold in common with the classic Pollocks, which derived these qualities from much the same sources.

What strikes us, however, about the confrontation of Tobey and Pollock (questions of quality apart) is how utterly different they appear despite such crucial common denominators. Some reasons for this are obvious, others much less so.

If not strictly a miniaturist, Tobey was nevertheless—like Klee, and for some of the same reasons—a painter of very small pictures. Naturally, most Pollocks make a profoundly different impression on the basis of their size alone. Size, however, is only one aspect of Tobey's extreme modesty, a modesty that sometimes leads, as Thomas Hess observes, to "understatement to the point of preciosity and restraint to the degree where statement is innocuous—both flaws which so often mark Oriental painting."[82] Tobey's virtually consistent eschewal of oil paint in favor of tempera results in pictures that lack the substantial material richness we appreciate in Pollock (and most of his American coevals). Tobey sought this "bodilessness," to be sure, and was committed to it philosophically, as well as propelled toward it by his study of Chinese painting. And however much he may have considered his work influenced by Impressionism, it is precisely Impressionism's dual emphasis (on the stuff of the pigment as well as the

162

latter's dissolution into sensations) that is missing in Tobey and present in Pollock. Tobey's light and space remind us more immediately of the "dematerialized" imagery of Byzantine and Oriental art.

William Seitz has pointed to the importance in Tobey of "unfilled and unlimited space—as a void"[83] observing its centrality in Oriental art and its alienness to the Western tradition. Pollock's drawing derives from a tradition in which space is not thought of as an autonomous void but in reciprocity with solids. Even though Pollock's space is drained of illusion, his articulation is informed by the optical vestiges of this Western spatial bipolarization. Though Tobey frequently covers his "voids" with a massing of lines, the lines do not carry with them, as do Pollock's, the connotations of infrastructural forms from which contouring has been liberated. Despite the autonomy of Pollock's line, his webs constitute a metamorphosis of a spatial structure that goes back to Cézanne. Tobey's webs do not fix themselves in the shallow space, nor do they seem locked to the ground plane as do Pollock's. This makes their reading much simpler and leads to a decorative, "textured" appearance rather too readily.

The relative impersonality of Tobey's all-over essays is abetted by the centrality of calligraphy in his method. This "writing" (Tobey's word), like all writing, *tends to fall unconsciously into pre-set patterns*. Seitz has described an "inventory of Tobey's brush signs"[84] which is fairly extensive. But that such an inventory can be made at all is an indication of the problem. Pollock's meandering poured line technique was invented in part precisely to free him from the habitual conventions of the drawing he had learned. Though he develops analogies within given paintings, Pollock's line is unpredictable in a way that Tobey's is not. Pollock's web results from a dramatic point-to-point improvisation; Tobey's looks like it was conceived in advance as a whole, and then simply executed. Hence, its more decorative appearance. It is not so much that Tobey's markings are repetitious in a verbatim sense, as that the differences we discriminate amongst them are limited in range and frequently not endowed with sufficient pictorial meaning or interest to warrant the effort required to disengage them.

If Pollock arrived at his all-over style without having seen the Tobeys we have been describing, he had, nevertheless, seen in 1944 and again in 1946 a few paintings by Janet Sobel that prophesied his own style more closely than did the Tobeys. "Grandma" Sobel was an autodidact, a "primitive" painter whose work drew the attention of Peggy Guggenheim as well as the then collector and critic, Sidney Janis. Born in Russia in 1894, Mrs. Sobel came to America at the age of fourteen, married, had had five children and numerous grandchildren when she took up painting in 1939. She had her first one-man show at the Puma Gallery in April 1944 (with an introductory note by John Dewey); her work had already been exhibited at the Arts Club in Chicago and the Brooklyn Museum. By the time of her show, and the concurrent publication of Janis's *Abstract and*

Surrealist Art in America, Mrs. Sobel had gone beyond her conventionally "prim-itive" images to a highly abstract and decidedly all-over kind of painting. *Music* was illustrated in Janis's book in color and was shown in the exhibition that he arranged at the Mortimer Brandt Gallery in connection with its publication. It was inspired, the painter says, by Shostakovich's music which "stimulated me . . . I have tried to present those feelings in my picture." The picture was improvised quickly ("the method here is so free," wrote Janis, "that it approaches pure auto-matism")[85] and arranged in an all-over configuration that governed not simply the drawing motif but the color distribution as well. *Music* is much closer to Pollock than is anything in Tobey's painting, in part because of the substantial corporeality of the pigment. The line, however, is not continuous or meander-ing but forms cluster patterns suggesting the superimposition of the vein pat-terns of leaves. This picture was dismissed by one reviewer as "a heightened sort of doodling"[86] and praised by another for the "near Persian richness of color and inventive design."[87] Painted in Duco, the texture of Mrs. Sobel's abstract pictures seemed "compounded of marble, mother-of-pearl, multi-colored spider webs and a spatter of milk."[88]

Music was among the Sobel paintings included in a group show at Peggy Guggenheim's Art of This Century early in 1944. (She gave Sobel a one-woman show there in 1946.) "Pollock (and I myself) admired these pictures rather furtively," Clement Greenberg recalls. "The effect—and it was the first really 'all-over' one that I had seen since Tobey's show came months later—was strangely pleasing. Later on, Pollock admitted that these pictures had made an impression on him."[89] Greenberg goes on to observe, however, that Pollock had anticipated his own all-overness to some extent in the Peggy Guggenheim *Mural* of 1943. He had, in fact, anticipated it in an even more marked way, though on a much smaller scale, in an untitled painting of the late 1930s [OT 33].

With the wall-size pictures of 1950 Pollock brought the possibilities of the all-over configuration to a level of realization that may have made further work in that style appear redundant to him. It was then, in any case, that he veered off in the direction of the blotty, Rorschach-like black pictures which dominate 1951 and early 1952. In the transitional pictures, such as *No. 17, 1951*, which lead into the latter group, the absence of the long, meandering poured line shows us Pollock's all-over configuration in closer proximity to its Cubist sources than it ever appears in the work of 1947–50, where the Cubist "jointing" must be recognized through the picture's curvilinear tracery. Though Pollock returned to a modified form of all-overness in a group of pictures of 1952–53, he never recaptured the exquisite transparency and equilibrium of the earlier poured paintings.

Pollock's later work was largely aimed at developing alternatives to all-overness. But that configuration was meanwhile taking root—in at least cer-

tain of its aspects—in New York painting. Indeed, it was fast becoming a *lingua franca* of abstract painting throughout Europe as well. Arman, for example, used it to transform Cornell's Surrealism into Abstract Expressionism; painters as different as Dubuffet and Ernst adapted it to the purposes of their respective poetries. We even find it—quite independently arrived at—among the marvelously variegated compositional ideas that inform the large, late Matisse paper pictures (e.g., *La Perruche et la sirène*). To some extent this general development may be traced to European contacts with the art of both Pollock and Tobey. But the spread of this configuration transcended the immediate catalysts of Pollock and Tobey, realizing implications that go back to the very roots of the modern tradition.

Pollock passed into total abstraction in his all-over pictures of 1946–47 and returned to figuration when he abandoned these in 1951. His linear webs were, in the radical nature of their all-over drawing, ultimately incompatible with literal representation.[90] But in its less radical realizations, all-overness was no more inhospitable to figuration in the 1950s than it had been in its anticipatory, pre-Pollockian forms. In Pollock's immediate circle, Alfonso Ossorio, for example, invested all-over patterning with recognizable metaphoric imagery and gradually transformed this into a personal form of relief collage. De Kooning may be said to have come close to all-overness in such 1949–50 works as *Attic* and *Excavation*. And the European artists mentioned above were equally committed to retaining subject matter in this new idiom.

In general, all-overness in America was to take a less obvious form among the younger painters than it did in Europe. If, on occasion, it was directly stated in the compositions of Johns and Warhol, its survival depended, as I suggested earlier, on the isolation of certain of its qualities and their incorporation in "single-image" or "holistic" paintings by such artists as Francis, Louis, Noland and Stella. Practitioners of the more immediately recognizable all-over manners both here and abroad have since largely abandoned it; its ubiquity by 1960 doomed it to being all over in a chronological sense as well.

Pollock's all-over pictures of 1947–50 remain his best. Even his most successful later works contained less of him and less of the richness of the past art which he had assimilated. This richness, the influences of a tradition leading from Impressionism through Cézanne to Cubism, had been integrated with his own inventions in part through the catalyst of automatism, the crucial Surrealist device that survived Pollock's progression from fantasy imagery to total abstraction in he winter of 1946–47. As a method that attempted to draw upon the stored recollections of the unconscious, automatism was an ideal technique for the instantaneous fusion of cues from other painting styles. In the last section of this essay I shall discuss the way in which Pollock's use of the pouring and spattering technique freed automatism to play a role of a kind its Surrealist inventors had never conceived.

165

VI. An Aspect of Automatism

The origin of the so-called "drip" technique has become something of a sore point in discussions about Pollock. Certain writers insist on his having been the first painter to "drip" or pour pictures; others stress Max Ernst's and Hans Hofmann's claims in this regard. But to the extent that it was not the dripping, pouring, staining or spattering *per se*, but what Pollock *did* with them that counted, all these arguments are beside the point. The particular character Pollock gave the pouring technique, and the unique pictorial fabric he *drew* from it, can be clarified by a consideration of its anticipations in the work of other artists. In the broadest sense, Pollock's poured paintings descend from a tendency within the modern tradition that emphasized an increasing loosening in the fabric of the picture surface in a "painterly" way; I have already discussed Impressionism as constituting the modernist origin of this. The Impressionists, of course, still used the brush, and used paints of tube consistency. Crucial to Pollock's drawing were the possibilities opened up by a more indirect relationship of his hand to the surface combined with his use of a more liquid *matière*.

In 1917 Picabia had spilled ink on a sheet of paper to make an "accidental" spatter pattern—which he then titled, *La Sainte Vièrge*. This was, in essence, a Dadaist gesture, akin to Duchamp's adding a moustache and beard to the Mona Lisa, or to Schmalhausen's doctoring of a plaster bust of Beethoven. Nothing probably seemed more iconoclastic, more in the spirit of "anti-art" than this (Picabia's *Portrait of Cézanne* was an assemblage with a stuffed monkey). Any splash could have made the point. Nevertheless, the degree to which even Picabia was seduced by the particular profile of the spatter is reflected in his un-Dadaistically having put aside the earliest version, in favor of an "improved" one when he reproduced it in his review, *391*. André Masson reported a conversation with Miró in the mid-twenties in which Picabia's unintentional discovery of this pleasing new effect was discussed in relation to the Surrealist idea of exploiting the edges, shapes and even images different *matières* might produce "if left to find their own form." Miró was at that moment exploring the use of spilled liquid pigment in his large *Birth of the World* (1925). Using rags, a sponge and paint thinned to the consistency of turpentine, Miró poured patches and veils of blue wash over a lightly primed burlap ground. Passages of automatic drawing and shapes of flat primary colors permitted him to draw an incipient iconography out of the "chaos" of the spilled washes. As its patterns indicate, *The Birth of the World* was painted vertically; later, in such pictures as *Amour* (1926), Miró spilled liquid *matière* over a stretched canvas cradled horizontally.

In their attempts to provoke *new* images through chance and accident, and in their desire to bypass traditional methods of painting, the Surrealists explored a whole series of so-called automatic techniques. *Coulage* (pouring), by its elimination of the direct touch of the brush, knife or other instrument—but only in

that—adumbrated the mechanics of Pollock's pouring. It was practiced by Gordon Onslow-Ford and Wolfgang Paalen in Paris in 1938–39. Pollock never saw these pictures and despite the fact that Onslow-Ford was present on the New York scene briefly in the early forties, he probably never knew of their existence; they are simply of historical interest as a step in modern painting's liberation from what the Surrealists called "the tyranny of the brush."

With no *a priori* image in mind, Onslow-Ford poured cans of Ripolin enamel over the surfaces of his canvases (laid flat on the floor of the studio) watching the configurations which the paint itself took on. The partial fusion of the color produced effects somewhat related to Matta's early "Psychological Morphologies" and Thomas Wilfred's clavelux. Since the Ripolin took weeks to dry, and even then did not harden all the way through, Onslow-Ford found it possible to peel layers off the surface, thus revealing different configurations underneath. These "peelings" suggested both figurative and spatial effects that he then "detailed" with linear drawing. Very different results with *coulage* were obtained by Wolfgang Paalen in the pouring of colored inks which fused much more readily and completely than the enamel paints and produced effects vaguely suggesting the recent paintings of Paul Jenkins (not that Jenkins ever saw these, of course).

Like decalcomania and *frottage*, *coulage* was an essentially passive or "inductive" technique, in which the artist hoped that an image would, in effect, form itself, or at least magically provide those clues which would allow the artist to conjure it forth. This is entirely alien to the willful, actively-directed drawing-with-paint that Pollock did. The latter had less to do with *coulage* than with automatic drawing. The fusion of different colors into "marbleized" swirls and pools—such as are produced by *coulage*—is extremely rare and pictorially incidental in Pollock where the lines and patches of any given color were almost always allowed to dry discretely.

Better known—and later supposed prototypes for the poured Pollocks—were pictures executed by Max Ernst in 1942. *The Mad Planet* and the *Non-Euclidean Fly* contain more or less symmetrical, elliptical linear patterns achieved by swinging a paint can with a pin-hole in it at the end of a string. On the basis of this practice, Patrick Waldberg, author of the major monograph on Ernst, has the following to say:

> *The Mad Planet* and the *Non-Euclidean Fly* had, historically, unexpected repercussions.
> . . . When these canvases were exhibited late in 1942, painters Motherwell and
> Jackson Pollock were astounded by the delicacy of their structures and begged Max
> Ernst to tell them their secret. It was a simple one (i.e., the string and can mechanism) and Jackson Pollock later used this technique, called 'dripping', most systematically. Later, he was credited with its invention.[91]

Similar claims are made—or at least repeated—frequently in European writing

on Ernst; in fact, Ernst himself told the French critic Françoise Choay that Pollock had discovered his technique through Ernst's pictures. Motherwell, who formed an important link with the Surrealists-in-exile in America during World War II, responded that these Ernst paintings were really of little interest to him as compared with other works in Ernst's *oeuvre*, and noted that Pollock was certainly not "astounded" by them. One look at the Ernsts in question makes it clear that the mechanically preordained patterns determined by the gyrating of the can have nothing in common with the meandering and freely improvisational linearity of Pollock's pictures five years later. Pollock's method was an outgrowth of, and solution to, the problems posed by his own all-over "brush" paintings of late 1946. His pouring and spattering implemented a style; Max Ernst's remained a technique for "forcing inspiration." The difference is manifest, moreover, if we study the way in which Ernst filled in the lines of *Euclidean Fly* with color in 1947, (some five years after he first executed it, thus recreating the painting as *Young Man Intrigued by the Flight of a Non-Euclidean Fly*). It is evident that he thought of the black lines of his picture as planar edges—precisely opposite in function to the "autonomous" line invented by Pollock.

Commercial enamels had been used by Picasso before World War I. By the early forties, the practice of spilling Duco and letting it run on the surface was not at all uncommon as a marginal, "coloristic" effect. Gerome Kamrowski, who showed at Betty Parsons, and Tony Smith, later Pollock's close friend, had used it that way. Moreover, Pollock had unquestionably seen some of the same effects as early as 1935, when he assisted in Siqueiros's workshop on Union Square, where he and his brother Sande were briefly participants. "Some of the technical resources employed there are of interest," writes Charles Pollock, Jackson's eldest brother. "The violation of accepted craft procedures, certain felicities of accidental effect (the consequences of using Duco and the spray-gun on vertical surfaces), and scale, must have stuck in [Jackson's] mind to be recalled later, even if unconsciously, in evolving his mature painting style."[92]

Since Hans Hofmann's style in the early forties was much closer than Ernst's to Pollock's painting of the time, we are not surprised to find in affinity between his and Pollock's first essays in spilling. The first of these, which dates from 1940, is *Spring*, where the pattern of spilled lines and patches spreads out over the surface, though clustering in the upper left. On the basis of *Spring* and other "spilled" paintings of 1943–45 Clement Greenberg has characterized Hofmann as "the first 'drip' painter." "These works are the first I know of," Greenberg continues, "to state that dissatisfaction with the facile, 'handwritten' edges left by the brush, stick, or knife which animates the most radical painting of the present."[93] This appears to me an exaggerated, even extravagant claim, as apart from the entire battery of Surrealist techniques—which were certainly devoted to bypassing the refined mechanics of the "pure painting" tradition—the torn edges of col-

lage had answered even earlier to the "dissatisfaction" of which Greenberg speaks.

Spring was rightly described by Sam Hunter as "something of a 'sport' or maverick" in Hofmann's work since this sort of "automatism" did not reappear until three years later and was "never again to be given such exclusive attention."[94] Pollock did not see *Spring* or the other "drip" Hofmanns until later. By the time of Hofmann's second essay in pouring (1943)—or at least very soon afterward—Pollock had himself begun spilling pigment and flicking it from a stick. In this regard, *Untitled Abstraction [Composition with Pouring II]* is of particular historical interest. Probably painted sometime in 1943, though it might date from about a year later (it was sold early in 1945), it certainly antedates the all-over drip pictures by at least two years. The spilled line here functions much as it does in such Hofmanns of the same date as *Fantasia*, that is, it tends to relate to the contours of the color patches below, either outlining them or endowing them with linear grace-notes. This effect—a form of pictorial "colorism"—has little in common with the independently coherent linear fabric of Pollock's later work. It was not until *after* the adoption of the all-over configuration, late in 1946, that pouring or spattering could cease being incidental in Pollock and function to implement style. In effect—as I observed in Part II of this essay—the real development of the pouring technique only took place in 1947.

It was only with the liberation of Pollock's line from contouring that the line itself developed the variety of characteristics which mark Pollock's mature "handwriting." This was not wholly confirmed until after the first months of 1947. The dripping, pouring and spattering in *some* of the pictures of late 1945 (*Moon Vessel*), 1946, and early 1947 (*Galaxy*) are still superimposed on the kind of totemic figuration that dominated Pollock's work until that time. Despite the considerable independence and roughly even distribution of the frothy whites of *Galaxy*, they have still to accommodate themselves to the "personages" below. By the late spring of 1947 the latter had gone completely underground—suppressed in favor of a fabric now non-figurative even in its inception—only to reassert themselves in the black pictures of 1951.

My mention of Pollock's "handwriting" above alludes to an aspect of his draftsmanly genius which has recently been questioned by Clement Greenberg:

> Pollock's "drip" paintings, which began in 1947, eliminated the factor of manual skill and seemed to eliminate the factor of control along with it. Advanced painting had raised the question of the role of skill in pictorial art before Pollock's time, but these pictures questioned that role more disturbingly if not more radically than even Mondrian's geometrical art had. . . . Again like Mondrian, Pollock demonstrates that something related to skill is likewise unessential to the creation of aesthetic quality: namely, personal touch, individuality of execution, handwriting, "signature." In principle, any artist's touch can be imitated, but it takes hard work and great skill to imitate Hsia Kuei's, Leonardo's, Rembrandt's or Ingres'. . . . With a little practice any-

one can make dribbles and spatters and skeins of liquid paint that are indistinguish-
able from Pollock's in point purely of handwriting . . . Ostensibly, the impersonality
of handling that reigns in avant-garde art of the sixties is like Mondrian's. But, it does
not *feel* like Mondrian's, and this has to be explained in good part by the different
interpretation of impersonality found in Pollock's "drip" paintings (as well as that
found in Barnett Newman's only seemingly geometrical art).[95]

While there is no question of the indebtedness to Pollock's work of the canvas-
es of such painters as Noland, Louis, Stella and Poons, whom Greenberg had in
mind here, this relation seems to me to reside, as I have detailed in my earlier
articles, elsewhere than in Pollock's supposed impersonality and absence of
"touch." Greenberg's view not only *feels* wrong to me, but rests, I think, on some
demonstrably false assumptions.

That any two people dripping or pouring a line with liquid paint will get
somewhat similar results says nothing more than is true of a pencil, brush or
knife line. The extraordinary range and variety of effects Pollock achieved
depended upon a number of choices which not only had to be made, but had to
be *linked in tandem*: viscosity of the paint, the speed and gestural manner of
pouring (flicking, flinging, dripping, flooding, spattering, etc.), the intermediary
instruments used (e.g., stick, brush, trowel, basting syringe). Contrary to Green-
berg's assertion, the use of this battery demanded a great deal of skill (we can see
this developing between late 1946 and late 1947) and Pollock himself always
asserted the importance of control in this method. (It may very well be that the
physical mastery needed to control a larger "figure" in this technique partly
explains why the more bodily inflected patterns of the wall-size pictures came
only after three years of working with it.)

Neither the skill nor the touch of a painterly Old Master resides in a single
brushstroke—anymore than in an inch of Pollock's line. The handwriting depends
upon *the succession of accents*. Here Pollock too worked within a framework of
myriad choices. His genius—like that of old artists—lay in deciding what to do;
Pollock's skill, not to say virtuosity, in articulating his effects imparts an unde-
niable sense of touch. The mere fact that a brush or knife is not touching the sur-
face is not crucial here as long as Pollock knows what he wants the paint to do
and how to make the paint do it. After all, a far more mechanical and impersonal
process intervenes between the pianist's finger and the sound he produces, but
who would deny each of the great pianists his distinctive "touch"?

Notes

1. The text of "Jackson Pollock and the Modern Tradition" was published serially in *Artforum* from February through April 1967. The six sections constituted drafts of chapters intended subsequently to be edited by the author and published in book form by Harry N. Abrams. Because of responsibilities at The Museum of Modern Art, whose staff I joined soon after the essay was published, this project was permitted to lapse.

This text was written in great haste, most of it while traveling in Europe, and it was subjected to no editing either by the magazine or myself. At more than thirty years distance its language seemed depressingly imprecise to me at many points. For this republication, I have sharpened the language so that the arguments will be clear to present day readers; this seemed all the more important since the text here is not accompanied by the many reproductions that were part of the original presentation.

I have introduced no new arguments, references, nor citations; I have merely tried to clarify the old ones. Aware, nevertheless, that even such clarifications as these inevitably alter the meaning of a text, I have dated the present version 1967–99. Students of the historiography of the 1960s can easily access the original version in any art library. My 1979 text on Pollock's Jungian critics, also reprinted in this volume, is published unaltered.

2. Thomas Hart Benton ("Random Thoughts on Art," *The New York Times Magazine*, Oct. 28, 1962) speaks of Pollock's "paint-slinging binges" which somehow "always ended attractively" (though they were "completely without human significance"). Michel Tapié, a detractor only in an unwitting sense, sees Pollock's art "totally developed in anarchic drunkenness (*ivresse*)" yet finds it not without continuity of patterning (*Un art autre*, Paris 1952, pages unnumbered).

3. This view was held by some of Pollock's admirers as well. "In order to follow it [Pollock's form]," writes Allan Kaprow ("The Legacy of Jackson Pollock," *Art News*, vol. 57, no. 6, 1958), "it is necessary to get rid of the usual idea of 'Form,' i.e., a beginning, a middle and end, or any variant of this principle. . . . It indicates that the confines of the rectangular field were ignored in lieu of an experience of a continuum going in all directions simultaneously, *beyond* the literal dimensions of any work." (Italics Kaprow's.)

4. "He [Pollock] even cut and sold the immense surfaces obtained in this [drip] manner by the meter." Marcel Jean, *Histoire de la peinture surréaliste*, Paris, 1959, p. 347.
5. Pierre Restany, "America for the Americans," *Ring des arts*, 1960.
6. Rudi Blesh, (*Modern Art, U.S.A.*, New York, 1956, p. 253) is typical in calling Pollock's canvas his "cattle range." Bryan Robertson (*Jackson Pollock*, 1960, p. 35) sees him timing his movements "in the way that a cow-hand wields a lariat."
7. The notion of a "Pacific School" of American painting was first popularized in France by Michel Tapié. It had been proposed to him in 1947 by the Metropolitan Museum's director, Francis Henry Taylor, "as a movement of capital importance" (cf. Tapié, *Morphologie autre*, Torino, 1960). The popularity of Tobey's work on the European continent— far greater than that he enjoyed in the United States—helped cement an image, always popular in the French mind, of an America mediating between the cultures of the European West and the Orient. To this thinking, New York is merely a province of Europe; the real America begins somewhere around the Mississippi.
8. Personal testimony on this point is contradictory, to say the least. Axel Horn, who studied with Benton alongside Pollock, remembers him as the "perfect prototype" of the Westerner: "Rugged, shy socially, awkward, inarticulate, he was ordinarily the possessor of a temperament as sweet and gentle as prairie clover." ("Jackson Pollock: The Hollow and the Bump," *The Carleton Miscellany*, Summer 1966). Harold Rosenberg describes him as "playing cowboy" wearing "high boots, the blue jeans and the 'neckercher'; he crouched on his heels and pulled up blades of grass when he talked; he liked to go to saloons and play bustin' up the joint." ("The Search for Jackson Pollock," *Art News*, vol. 59, no. 10, Feb. 1961). Clement Greenberg (*The New York Times Magazine*, April 16, 1961) writes:

Where myth and legend have taken over with a vengeance is with regard to Pollock's early life. That he was born in Wyoming and spent his boyhood on truck farms in the Southwest has caused many people to visualize him as a kind of frontier character. . . . Pollock himself was not entirely guiltless in this matter. When in the country, he continued to wear high-heeled cowboy boots. . . . The truth is that Pollock and his four older brothers were raised by a mother filled with cultural aspirations, and when he began to study art at high school in Los Angeles, it was in the

footsteps of his oldest brother Charles, a painter who now teaches at Michigan State University. Pollock himself always regretted that he had not gone to college and become more of an intellectual. He was only 18 when he came East to continue studying art, and the rest of his life was passed in New York and in East Hampton, Long Island.

That Pollock played some role in the implementation of his own myth is certain; the importance of his direct participation upon those who took up and embroidered his various myths, especially in Europe, is more doubtful, as is the relation of these myths to the content of his painting. And though the self-image projected by an artist comes from the same psyche as his painting, it does not necessarily follow that such a self-image, insofar as it crystallizes a mythology, is *contained* in the painting. Thomas Hess ("Pollock: The Art of Myth," *Art News*, vol. 62 no. 9, January, 1964) asserts that Pollock "chose his own self-image, gave it disciplined shape, intermingled it with his painting. He did not debunk the rumors about himself. . . . Always attracted to mythologies, Pollock willed himself into a myth." Hess considers that the Pollock myth is, in most of its ramifications, "a piece of his art; it reflects an aspect of the content of his painting." But to *assume* that this mythological content is there (and it is unclear whether for Hess it is an assumption, a judgment, or both) too much equates a painter's relation to the exigencies of his world with the nature of his artistic message. It risks bringing to the pictures *a priori* expectations leading to misreadings. Yet even Hess foresees a time when "Pollock's art will change again, finally, into cool objects . . . that can speak only about what they seem to be."
9. *Indian Art of the United States*, 1941. On this subject, Pollock's oldest brother, Charles, who can speak both as an artist and as the person closest to his brother's situation until his marriage to Lee Krasner, has the following to say (from a letter to this writer):

There were of course many Indians living fairly close by—mostly I think of the Pima tribe—when the family lived in the Salt River Valley between Tempe and Phoenix, Arizona, from 1913 to 1917. They came into Phoenix on Saturdays by horse, wagon and buggy to sell their wares and to trade. There must also have been Indians from other tribes and from greater distances, for the sellers sitting on the sidewalks displayed not only pots and baskets, but silver and blankets as well. Though Jackson saw much of this he would surely

have been too young to retain very firm impressions. [He was then age two to five.]

Jackson, with Sande and Frank, was with his father and mother in northern Arizona in the summer of 1927. My father was employed in some capacity which is now vague to me—ranching, or lumber perhaps. It is possible that they returned there in the summer of 1928. It is evident that they did a certain amount of exploring: I have a photograph of them at one of the cliff dwelling sites on the northern rim of the Grand Canyon.

Whether Jack or any of them had contact with the Indians in the area it is now impossible to say. Jack was fifteen at the time.

My brother Jay had a collection of perhaps two dozen Indian blankets and rugs. He started collecting these in Los Angeles, in 1924 or 1925. In a letter to me (10 October 1960) he says he traded these to Jack for a painting. Date of trade not mentioned. Jack certainly saw them many times before coming to New York in 1930, but if he ever had them in the East I did not see them.

Jack and I made a long (8000 mile) trip together in the summer of 1934: through . . . Pennsylvania, West Virginia and Kentucky, into the deep South and New Orleans, through Texas to El Paso, through Arizona to Los Angeles. We did not visit any Indian reservations nor museums of Indian art, nor do I recall any talk of doing so.

Jack made two or three later trips West on his own but I doubt that he had the leisure or the money to investigate Indian ritual.

I have the Eighth Annual Report of the Bureau of Ethnology (Washington, Government Printing Office, 1891). Among other things, it contains 12 chromo-lithographic plates. Four of these are sand paintings, the other ritualistic paraphernalia—blankets, feather, paints, etc. Jack had several volumes of this kind. As I remember, we brought them together in one of the then innumerable second-hand bookstores on 4th Avenue— sometime between 1930 and 1935.

Without denying that Indian art, cowboys, Western air and landscape may have had an influence on Jackson, *I cannot myself see any evidence for a specific relevance at the point in his development when painting influences were crucial.*

In my view the important elements were the following: the analytical methods of Benton with their reference to Renaissance & Baroque art, the emotional overtones & controlled violence in Orozco, and finally an acute awareness of contemporary French painting (your article on the importance of Masson in this context is a case in point). I think also that his experience and memory of Siqueiros workshop has been overlooked.

10. The idea that Pollock painted numerous wall-size pictures—as is, indeed, the case with such painters as Rothko and Still—is one of the most persistent of his myths. Equally incorrect is the widespread impression that such giant pictures began to be made by the New York painters in the late forties. Irving Sandler begins an otherwise well informed discussion,

"When Jackson Pollock's wall-size pictures . . . were shown in 1947. . . ." (*New York Post Magazine*, Jan. 26, 1964.) Bryan Robertson (op. cit. p. 53) writes typically that Pollock's pictures "frequently attain the practical (sic) measurements of mural size paintings" . . . in the context of a "late 1940s" movement. Even E. C. Goossen, in his pioneering article "The Big Canvas" (*Art International*, vol. 2, no. 8, 1958) slightly mistakes the date: "The first big canvases of the post-war period were done between 1949 and 1951 by Jackson Pollock and Barnett Newman. Prior to that there was little of equal size done in the United States except a lot of second-rate official art. . . . "

None of the wall-size Pollocks or Newmans dates before the winter of 1949–50. Moreover, Mr. Goossen's statement needs amplification in view of the fact that the earliest large Rothkos are contemporaneous with those of Pollock and Newman. Clyfford Still probably also painted wall-size pictures in 1950. (To be sure, exhibitions of Still's paintings have included giant canvases dated in the forties, but there is no evidence, based upon work exhibited at the time, of any such pictures before the fifties.) In regard to the idea of size alone, the Goossen statement also needs modification in view of the fact that Matta painted many pictures of 9' by 15' (and larger) in the years 1946–49. A number of these were shown in his annual exhibitions at the Pierre Matisse Gallery. Matta was then very much on the New York "scene" and his work, which has nothing in common with Goossen's "official art," provides, at least with regard to footage alone, a precedent. His painting was, of course, illusionistic and in that sense related back to *Guernica* rather than forward to Pollock. In fact, as will be seen in my discussion in the next section of this essay, the giant American picture distinguished itself not so much by actual size as by the projection into that size, for the first time in the history of art, of an intimate and personal style with no scale referent tied to the world of objects. With few partial exceptions (notably Monet's *Nymphéas*) giant pictures had previously been public in content (hence figurative), in manner and in intended context.

11. Michel Ragon (*Naissance d'un art nouveau*, Paris, 1963, p. 73) speaks of Pollock's "departure from *tabula rasa*." Jean-Clarence Lambert ("Observations sur Jackson Pollock et la nouvelle peinture americaine," *Cahiers du*

musée de poche, no. 2, June 1959) sees Pollock's painting "in revolt against everything . . . in the western tradition." An unnamed editor of *Art News* writes of Pollock "demolishing a two-thousand-year-old corpus of world style." (Introduction to Parker Tyler's "Hopper/Pollock," *Art News Annual*, No. 26, 1957). Yet in the same magazine, Thomas Hess (op. cit.) affirmed the fact that Pollock "deliberately chose to work in the great tradition of Western art. He believed in history, in the continuity of the avant-garde. . . . As strong a case can be made for Pollock as a conservative painter as can be made for Cézanne."

12. Robertson's monograph is a case in point. Here the real sources of Pollock's style are unacknowledged, but his shift into abstraction (called his "liquidation of the image") is attributed to "a most loving understanding of art . . . made by the Navaho Indians." (op. cit., p. 82); "he [Pollock] was most directly affected by the practice of Indian sand painting." (Ibid., p. 87.) On this question see footnote no. 9.

13. Ragon, op. cit., p. 73.

14. Tapié, op. cit.

15. The term "Abstract Expressionism" was coined around 1929 by Alfred Barr as a way of distinguishing some of the painting of Kandinsky from the expressionistically deformed realism of the *Brücke* painters. Apposite as it was for that purpose, the term achieved a vogue only in the 1950s, as a description of the new abstract painting in America. It was Robert Coates, art critic of the *New Yorker* magazine, who first used it in that connection. The heterogeneity of manners in a group containing Pollock, de Kooning, Newman, Rothko, Still, Baziotes, *et al.* precludes their being rightly gathered under a single *stylistic* label. The classic periods of Pollock, Rothko and Newman are manifestly not Expressionist (though de Kooning and Kline's painting might qualify for such an appellation). Kandinsky's influence on this New York painting has been much exaggerated as a result of this confusion of terms. It is demonstrably important only in the work of Gorky (around 1943) who was, in any case, as close to Surrealism as to Kandinsky, and in the second generation of the new American art, which developed *after* Gorky's death in 1947. The more general term—"The New American Painting"—devised by Barr for the Museum of Modern Art's touring exhibition of 1958–59 is valuable, but was more so at that

time than since the emergence of a strong, and very differently profiled, "second generation" of painters in New York.

16. Irving Lavin describes the creation of a large picture such as *Autumn Rhythm* as demanding "let's say six hours of actual painting time." No allowance is made in this supposed procedure for analysis or reflection. Other than the "actual painting time" Pollock is described as just "sleeping, eating or what have you." ("Abstraction in Modern Painting, " *Metropolitan Museum of Art Bulletin,* vol. 19, no. 6, 1961.)

17. Clement Greenberg, "How Art Writing Earns Its Bad Name," *Encounter,* no. 111, Dec. 1962. Harold Rosenberg, "The Premises of Action Painting," *Encounter,* no. 116, May 1963.

18. Rosenberg, "The American Actions Painters" reprinted in *The Tradition of the New,* New York, 1959, pp. 23–39.

19. Rosenberg, "Hans Hofmann: Nature in Action," *Art News,* May 1957.

20. This, of course, does not preclude Rosenberg from trying to define the esthetics of a new art, though that does not seem to have been his aim. It may very well be that of Allan Kaprow (see note 24).

21. The Pure Dadaist was not a painter, or even a poet, but some whose essence was expressed in acts and gestures. "Dada," Tristan Tzara insisted, "shows its truth in action." This action had to be instinctive and disinterested. "Everyone," according to Richard Huelsenbeck, "can be a Dadaist. . . The Dadaist is the completely active type, who lives only through action because it hold the possibility of achieving knowledge."

22. Surrealist automatism, whether verbal, pictorial or directed in such actions as public "manifestations" was always in theory "beyond any esthetic . . . preoccupations" (Breton, *Manifesto of Surrealism*). Miró and Masson, who had adjoining studios during their pioneer days in the movement, frequently joked about humoring Breton with regard to such absolutist anti-art notions and then returning home to paint pictures.

23. Rosenberg, "The Premises of Action Painting," op. cit.

24. We have seen earlier (note 3) that Kaprow's Pollock rejects the usual form of painting insofar as it is bounded; he ignores the confines of the field in favor of a continuum that expands outwards in all direction. "Pollock's choice of enormous sizes (sic) served many purposes," Kaprow

continues. "They [the enormous canvases] ceased to become paintings and became *environments* . . . But what do we do now?" (op. cit.) Kaprow had earlier characterized Pollock in terms of Action Painting: "the work placed an almost absolute value upon a kind of diaristic gesture," ". . . perhaps bordering on ritual itself which *happens* to use paint as one of its materials," "to grasp Pollock's impact properly, one must be something of an acrobat . . . [identifying] with the hands and body that flung the paint and stood 'in' the canvas." When Kaprow, still speaking of Pollock, asserted that "the artist, the spectator and the outer world are too interchangeably involved here" [to be mere painting], he spelled out the dialectic by which the putative environmental and action components would fuse into Happenings. In a letter to *Art News* (Dec., 1958) Irving Sandler criticized Kaprow for treating Pollock "as a stepping stone for Kaprow's own still unrealized art."

25. Restany, "Jackson Pollock, l'éclabousseur," *Prisme des arts,* no. 15, 1958.

26. Giovanni Galteri, "Jackson Pollock," *Avanti,* (Rome), March 22, 1958. Blesh (op. cit.) writes of Pollock's "deeds of incredible violence done with paint." The opening sentences of Robertson's monograph (op. cit.) characterize Pollock as "drawn to violence" and "absorbed all through his life by the structure of violence . . ." When Pollock tried to "go against the momentum of life, which produced circumspection," Robertson continues, "it was as if he crashed an immensely heavy object on to a table. . . . This was his attempt to disrupt the time-flux and invoke a new contingency."

27. A classic example is the absinthe bottle in the foreground of Couture's *The Realist Painter.* Benton's reference to Pollock's "paint-slinging binges" (cf. note 2) is worthy of this snide tradition.

28. Both Robertson's and O'Hara's monographs are cases in point. Though guilty of such excesses as likening Pollock's problematic *The Deep* (which the painter himself considered a failure) to Manet's *Olympia,* O'Hara nevertheless makes an occasional critical observation. In the whole of Robertson's monograph there is not a single critical remark about the work. Reading it, one would never know Pollock painted a bad picture, not to say many of them.

29. I first heard this term from the painter Paul Brach; as a young artist in the center of the New York scene

he could measure clearly the psychological effect of pioneering inventions by the older painters even on young artist who did not choose to follow them up in their work.

30. Pollock used his fingers here—as well as sticks and knives—more than brushes.

31. Cf. the Epilogue of my *Dada and Surrealist Art* (Harry N. Abrams & Co.) New York, 1968.

32. In France, where, as the result of displacements caused by the war, painters then around the age of thirty were largely deprived of first-hand contact with Surrealism, the impulse toward "informal" abstraction was much weaker and the visionary, poetic tendency virtually nil. An earlier generation (Dubuffet, Fautrier and Hartung) had experienced this exposure in the 1920s and 1930s; Wols had some contact with Surrealism but derived far more from Klee. But the large majority of younger painters took their cues from seniors like Jean Bazaine and Nicholas de Staël whose art teetered on the edge of an effete late Cubism and, in most cases, led into a blind alley. Even the supposedly "informal," and certainly rapidly improvised, tube drawing of Georges Mathieu almost always disposes itself in rigid, obviously Cubist patterns.

33. Lawrence Alloway, Introduction to *Jackson Pollock* (exhibition catalogue), Marlborough Fine Arts Gallery, Ltd., London, 1961.

34. Frank O'Hara, *Jackson Pollock,* New York, 1959, p. 26.

35. Lawrence Alloway, *Systematic Painting* (exhibition catalogue), Guggenheim Museum, New York, fall 1966, and elsewhere.

36. Robertson, op. cit., p. 38.

37. Rudolf Arnheim, "Accident and the Necessity of Art," *The Journal of Aesthetics & Art Criticism,* vol. 16, no. 1, Sept. 1957.

38. Meyer Schapiro, "The Younger American Painters of Today," *The Listener,* vol. 55, no. 22, Nov. 22, 1958. This is how Schapiro defines decoration. However, he excepts Pollock for the most part from this tendency.

39. Rosenberg, "The American Action Painters," op. cit.

40. Michael Fried, *Three American Painters* (exhibition catalogue), Cambridge, Mass.: Fogg Art Museum, April 21–May 30, 1965, p. 34.

41. Meyer Schapiro, Lectures at Columbia University, 1950–51.

42. Cf., Selden Rodman, *Conversations with Artists,* New York, 1957, p. 84.

43. Schapiro, Lectures.

173

44. Robertson, op.cit., pp. 51, 53.
45. Schapiro, Lectures.
46. Arnheim, op. cit.
47. Jackson Pollock, from the sound track of a film on the artist made in 1951 by Hans Namuth and Paul Falkenberg.
48. See Part I of this essay.
49. Pollock, "My Painting," *Possibilities I*, New York, Winter 1947–48
50. Ibid.
51. An extended discussion of this and other possible readings of Pollock's space is contained Part III of this essay, "Cubism and the Later Evolution of the All-Over Style."
52. Cf., Rollo Myers, *Claude Debussy*, New York, 1949, for the only satisfactory discussion of that composer's relation to Symbolism as over and against Impressionism.
53. Robert Goodnough, "Pollock Paints a Picture," *Art News*, vol. 50, no. 3, May 1951.
54. Robertson, op. cit., p. 30.
55. See Part III of this essay.
56. Greenberg considers that this picture was especially influential (see "The Late Thirties in New York," reprinted with changes in *Art and Culture*, Boston, 1961).
57. Newman was the first of the New York painters to speak of rejecting Cézanne as "my father," insisting on Monet and Pissarro as "the true revolutionaries" in whom he had more interest. While not arguing his own direct descent from Impressionism (or that of any of his contemporaries), Newman's emphasis on Monet was important in generating the Monet revival.
58. Goossen, op. cit.
59. Pollock, "My Painting," op. cit.
60. Bryan Robertson, op. cit., pp. 143–44.
61. Clement Greenberg, "How Art Writing Earns Its Bad Name," op. cit. Greenberg has observed privately that Pollock was fully conscious of the relationship of his all-over style to Cubism; so has Tony Smith, to whom Pollock made observations specifically confirming that relationship.
62. Alloway, op. cit.
63. Fried, op. cit., p. 13.
64. Sam Hunter, "Jackson Pollock," *The Museum of Modern Art Bulletin*, vol. 24, no. 2, 1956–57.
65. Greenberg, "'American-Type' Painting" (written in 1955, revised in 1958) in *Art and Culture*, Boston, 1961, pp. 208–229.
66. Greenberg in the *New York Times Magazine*, April 16, 1961.
67. Ibid. The pictures illustrated are Picasso's *Ma Jolie*, 1911–12 and Pollock's *Autumn Rhythm*, 1950.

68. Cf. my "A Post–Cubist Morphology" (note 17, in particular) in *Artforum*, vol. 5, no. 1, September 1966.
69. For example, *Shimmering Substance* and *Eyes in the Heat I*. These pictures are more "contained" within the frame than the first all-over poured pictures which followed hard upon. Not until the end of 1947 did comparable recession from the frame become typical of the poured paintings.
70. I have used this term in the interest of clarity simply because it is commonly so used (or, to be sure, misused). Michael Fried distinguishes between abstract figurative and non-figurative drawing (op. cit.), defining a line that contours a non-representational shape as figurative. This use of language is quite consistent and logical. But I fear that his precision in this regard has resulted in considerable confusion among his readers.
71. It is important to note that, at the time of Pollock's formation, Mondrian's works of this transitional period were in the permanent collections of the Museum of Modern Art, in Peggy Guggenheim's "Art of this Century," where Pollock had his first shows, and in the Museum of Non-Objective Painting (now the Solomon R. Guggenheim Museum), where Pollock worked as a part-time carpenter in the early forties. Mondrian himself was among the artists in exile who were spending the war years in New York.
72. Pollock liked to think of his work as alien to French modern painting. He was reported to have minimized the role of de Kooning with the remark, "Bill is a good painter but he's a *French* painter." (Rodman, op. cit., p. 85). At our present remove the all-over Pollocks seem immeasurably closer to the spirit and character of French art than the painting of de Kooning, or most other artists of the "first generation."
73. This famous old saw of Maurice Denis is frequently cited in books on modern art as a programmatic pronouncement. Indeed, in the history of modern religious art, with which Denis was involved, it played that role; for modern painting in general, it was simply a verbal summation of an already well established painterly attitude.
74. This closure in the rear of the shallow space is easiest to understand in the still lifes and portraits. In the landscapes, the illusion *attributed* to the space of the picture by the viewer, who brings in his knowledge of the extra-pictorial space the motif suggests, makes for greater

difficulty.
75. Theodore Reff, "Cézanne and Poussin," *Journal of the Warburg and the Courtauld Institutes*, vol. 23, nos. 1–2 1960, demonstrates that this famous passage from a letter to Émile Bernard was not a description of the forms Cézanne used in painting, but a reference—framed in conventional terms—to certain problems of perspective. Its subsequent exploitation, in isolation from its context, related to the needs of neo-Platonic theorizing in the circle around Bernard.
76. The "polyphonic," open character of Cézanne's contouring, and its relationship to frontal modeling, first came to my attention as an undergraduate at Columbia University in Meyer Schapiro's lectures.
77. I believe that this same space obtains in the mature Rothko. Rothko's ground color is almost always applied evenly and opaquely, and his painting of that part of the canvas, wrapped around the side of the stretcher, enhances this sense of the support as a solid plaque that closes the space. Rothko's rectangles sit within the lateral bounds of this field, adjusting to its edges in a manner analogous to Pollock's webs (his symmetrical structure also relates him to all-over, holistic painting). These rectangles also hang *in front* of the ground, in a space seeming to project outward toward the spectator, reinventing the space of Analytic Cubism. The painterly tonal variations of the rectangles, and their fuzzy edges in particular, serve to dissolve them into the ground, locking them to the surface in a manner different from—but analogous to—the manner in which Pollock's dissolving painterly web anchors to the back plane.
78. See Part II of this essay.
79. Michael Fried ("Jackson Pollock," *Artforum*, Sept. 1965) recognizes this sheerly optical dissolution of sensations and considers it "a new kind of space." He does not, however, recognize its antecedents, which I see as deriving from a perfectly understandable development of the anti-illusionist side of Impressionism as modified by Cézanne and late Analytic Cubism; the shallow illusionist space used by Cézanne to "order" Impressionist sensations having been then drained off by Pollock. Moreover, I question Fried's characterization of Pollock's space as one "achieved in terms of eyesight alone, and not in terms than even *imply the possibility* of verification by touch."

(Ibid., italics mine.) This is overstated since it applies only to the *illusion* of tactility. In Pollock, as in Impressionist painting, the experience shifts away from the totally optic situation when we get close to the surface. There, we become aware of the stuff of the pigment, recognize the layers of the web *on top of one another* as material entities creating an extremely shallow "laminated" space by their own overlapping and displacement.

Robert Goldwater concurs with my reading of Pollock's space as shallow and frontal but insists that another simultaneous reading exists in which we look "through" the ground of the canvas to an illusion of infinite space, the ambiguity created by these simultaneous readings being central to the pictures' poetry. But such a reading, however much it might be envisioned in the more open poured pictures on unpainted grounds, seems to me unequivocally precluded in pictures on colored grounds. When Pollock used a colored ground, he painted it on evenly, *not* in a "painterly" (*malerisch*) illusion of atmospheric space. (His grounds thus compare with Rothko's opaque, evenly painted grounds and are polar opposites of the vague, infinite spaces suggested by the uneven grounds in such pictures as the "cosmic" Mattas of 1944.) In these pictures, Pollock clearly wanted to "close off" the back of the space in the manner I have discussed. Such pictures seem to me to provide the least ambiguous clue as to what Pollock was about spatially.

80. The "Constellations" constituted Miró's last truly major invention. Against a modulated ground of diluted tones he placed labyrinths of tiny, flat shapes, generally linked by tenuous webs of lines. The compactness and complexity of these diaphanous compositions are astonishing. "I would set out with no preconceived idea," Miró recalls. "A few forms suggested here would call for forms elsewhere to balance them. These in turn demand others. . . . I would take it (each gouache) up day after day to paint in other tiny spots, stars, washes, infinitesimal dots of color, in order to achieve a full and complex equilibrium." Pierre Matisse's wartime exhibition of these works drew enormous attention, not only due to their quality and originality, but because New York painters had been deprived by the exigencies of wartime of any idea of what their two favorite painters, Miró and Picasso, had been doing.

81. Cited in William Seitz, *Mark Tobey*. New York, Museum of Modern Art, 1962. p. 27.
82. Thomas B. Hess. *Abstract Painting*. New York, 1951. p. 121.
83. Seitz, op. cit. p. 23.
84. Ibid., p. 22.
85. Sidney Janis, *Abstract and Surrealist Art in America*. New York, 1944. p. 87.
86. Review (unsigned) in *Art News*, vol. 43, May, 1944. p. 20.
87. Josephine Gibbs, review in *Art Digest*, vol. 18, May 1944. p. 7.
88. Review (unsigned) in *Art News*, vol. 44, January 15, 1946. p. 22.
89. Greenberg, "'American-Type' Painting," op. cit.
90. The poured line was in itself by no means incompatible with representation, as I observed in Part II of this essay, nor, as we have seen, was all-overness. It was only the conjunction of the two that militated against it. Nevertheless, Thomas Hess, partly on the basis of a remark made by Pollock himself, believes that even the all-over poured pictures of 1947–50, usually held to be entirely abstract, are figurative to the extent that the first stages of the drawing represented landscape or figural forms that were then "painted out" during the application of the succeeding layers. While it is true that some poured patterns in pictures of late 1946 and early 1947 are woven over manifestly figural shapes, the poetry of the full-blown, all-over poured paintings seems to me metaphysically rather than literally present. In many of the paintings of 1948–50 we can make out quite clearly the first "layer" of the web (*No. 32, 1950*, for example, is a single "layer" picture); these contain none of the patently anthropomorphic and landscape-like morphologies that reappear in the black pictures of 1951. The abstract beginnings, as well as endings, of the 1948–50 canvases has been affirmed by Tony Smith, one of the few people often present when Pollock began pictures; it can be further confirmed by reference to the photographs and motion picture made by Hans Namuth.
91. Patrick Waldberg, *Max Ernst*. Paris, 1958. p. 388.
92. In a letter to the author dated November 29, 1966.
93. Greenberg, *Hans Hofmann*. Paris, 1961. pp. 18 and 27.
94. Sam Hunter, *Hans Hofmann*. New York, 1963. p. 20.
95. Greenberg, "Jackson Pollock: Inspiration, Vision, Intuitive Decision," *Vogue*, April 1, 1967.

175

1971

The disclosure of a group of drawings that Pollock had supplied his psychoanalyst in 1939–40 offered new material and new perspectives for critical analysis. C. L. Wysuph, in the first publication devoted to these drawings, suggested that their psychologically conflicted imagery persisted, in veiled form, in Pollock's later, seemingly abstract work. In contrast, Rosalind Krauss concluded that the most significant aspect of the drawings was their formal structure, which revealed Pollock's independence from Cubism and other European models.

Rosalind Krauss. "Jackson Pollock's Drawings." *Artforum*
9, NO. 5 (JANUARY 1971): 58–61. © ARTFORUM, JANUARY 1971.

During the eighteen months of his analysis in 1939–40 Jackson Pollock produced for discussion between himself and his analyst, Dr. Joseph Henderson, 69 pages of drawings, 13 of which bore images on both front and back. The imagery on almost half of these sheets relates directly to Picasso's *Guernica*. In conversation, Dr. Henderson has said that these drawings were dream representations which Pollock produced specifically for his analytic sessions—rather than drawings made independently of the therapy and brought into the sessions to facilitate the process of association. Are we to think, then, that in 1939–40 Pollock's dream life was taken up with the *Guernica*?

Last year, with the consent of Lee Krasner Pollock, Dr. Henderson sold 67 of these sheets to the Maxwell Gallery in San Francisco. Only two of them had been exhibited previously ("Jackson Pollock," The Museum of Modern Art, 1968). Some years earlier Dr. Henderson had presented a paper to the San Francisco Psychoanalytic Institute of which he was then head, on the relationship between Jungian theory and the imagery of the Pollock drawings. Upon acquiring them, the Maxwell Gallery commissioned a monograph on the drawings and arranged an exhibition of them at the Whitney Museum—both acts undertaken without the advice or the knowledge of Dr. Henderson. The result has been to dump onto the art historical and critical community a cache of material which is strangely contextless. There is almost no extra-analytic production from these same years with which to compare this body of work. The text of the monograph provides us with little that is substantive from the course of the analysis itself: pitifully abbreviated quotes from Dr. Henderson's unpublished paper provide no insight into this area beyond what has appeared in other monographs on Pollock. We are left with a panorama of drawings, the primary subject of which is double and triple figures locked into acts of mutilation, the frame of reference for which is the most authoritative picture of the late thirties—the *Guernica*.

What we have no way of gauging is the role that transference might have played in the selection of this frame of reference. Pollock's doctor was an analysand of Jung, and by the time the therapy began Pollock already knew a fair amount about Jungian theory. (This was from his friend Helen Marot, a teacher at the school where Pollock worked briefly as a janitor.) Given the Jungian analytic model, in which individuation is pictured as in a titanic struggle between opposing psychic forces, Pollock might have turned his attention to the most relevant battle picture of the decade in an effort to win the approval of his doctor. If this is true, it was a strategy that paid off because Henderson (then in his first year of practice) writes: "I wonder why I neglected to find out, study or analyze his personal problems in the first year of his work . . . I wonder why I did not seem to try to cure his alcoholism . . . I have decided that it is because his unconscious drawings brought me strongly into a state of counter-transference to the symbolic material he produced. Thus I was compelled to follow the movement of his symbolism as inevitably as he was motivated to produce it." This symbolism takes up, among such Jungian staples as the mandala and the tree-of-life, the open-mouthed horse's head from *Guernica*, pincering down on a shriek, the dagger-tongued weeping woman, and the mêlée of figurative fragments including the horse, bull and severed warrior's head from the final composition. (The other major constellation of images throughout the drawings involves American Indian and African tribal motifs.)

Whatever the causes for Pollock's attraction to the *Guernica*, his drawings deviate rather consistently from the late Cubist mode of design monumentalized within its perimeters. In the *Guernica*, as in Picasso's late Cubist works in general, there is an attempt to endow every shape within the picture with figurative implications. Nothing is intended as merely interstitial background, but rather every area is to be read positively. What we take initially to be the dark, blank ground behind an anguished woman holding a dead child, is the flank and legs of a bull, or again, the black wall of a house reads just as persuasively as the garment of a figure emerging from an opened window. Thus the picture slowly spews every part of itself out onto the surface like sewage erupting onto a pavement. But in some of the studies for the *Guernica*, particularly the ones for the head of the weeping woman, a different strategy is suggested; and it is this formulation that seems to have been taken up and extended in Pollock's own drawings. There, one faces a configuration in which areas of the figure get reconverted into ground for new, yet more autonomous pieces of figuration, they in turn becoming ground for further figures. Since Picasso retains the ultimate unity of the initial figure (the contour of the head as a single entity is never challenged), this tactic comes across as powerfully expressive but not formally very radical. In some of Pollock's drawings, on the other hand, one has the feeling that no area is circumscribed as figure but that it is not designated as ground for yet another

177

figure, and further, that this begins to break down the autonomy of figuration itself. (See, particularly, [OT 499] and [OT 514].) The effect is not at all like looking at a late Cubist array, but like looking at a wall on which the presence of posters has served as the provocation for the posting of further sets of images until the sense of the image is only that it is a ground. If the dark/light structure in *Guernica* is ultimately decorative, with black areas given the same forward thrust as light ones, in Pollock's work the effect of modeling in light and dark goes back to the sense of chiaroscuro where darkness reads as that part of the figure which is obscured from light, enshrouded by blackness and therefore usurped to read as ground.

What begins to emerge from some of the drawings of 1939–40, then, is a preoccupation with imagery which is conceived of as fundamentally unstable— unstable in a way that bears on a central attitude of picture-making for any Cubist-informed sensibility. In the 1942–43 paintings and collages that follow the psychoanalytic drawings, it is simply not accurate to describe Pollock's method as "late Cubist." If he was concerned with the modernist problem of, as Greenberg has put it, delimiting or recreating flatness, it was not approached in Picasso's or any other late Cubist's terms. The only works it bears a remote resemblance to are Miró's *Constellations*, and those Pollock could not have seen until after the war. In practical terms this meant that Pollock was making extremely large pictures, canvases with dimensions of six and eight feet, in which there was no formal room for structure. Late Cubist pictures had recourse to organization by means of structure as a macro-figurative element—the pedimental shape by which Picasso intends the unification of *Guernica* is a particularly obvious example. In *Pasiphaë, Gothic* and *Night Ceremony* (*Male and Female* and *Guardians of the Secret* are the only possible exceptions to this), Pollock's conversion of figure into ground leaves him no access to structural patternings or armatures of any kind.

The analysis of the work of post-war American painters and sculptors has tended to run to formulas about a mixture of Cubism and Surrealism with a pinch of this and a dash of that. The literature on Pollock, de Kooning and David Smith, for example, has had tedious recourse to this recipe which in increasingly obvious ways fails to intersect with the work of these men on any meaningful or accurate level. In the case I know most about—the work of Smith—drawings of a highly private nature proved crucial to opening up a new way of looking at the sculpture and arriving at a characterization of it that was about its own formal and contextual premises and not about those of its putative sources. The drawings to which I am referring suggested an obsessive concern on Smith's part with a very limited group of images and a formal aspiration that seems to have been the correlative of those thematic concerns. Very generally this involved a question of sexual violation giving rise to the problem of some kind of formal prohibition against touch. My hunch is that the Pollock

drawings made available at the Whitney will have a similar function in shaking off the grip of an outworn methodology and suggesting a more specific way to understand what Pollock was after in the early 1940s. What I have raised in the above paragraphs is only the vaguest suggestion of one possible analysis.

Immediately upon its opening, the Whitney show was surrounded by little bonfires of moral indignation that confidential material was being brought before the public—material deemed esthetically uninteresting on its face. One has only to think of the case of Van Gogh to realize that with reference to the work of many artists any information about their perceptual sets is gratefully accepted—confidential or not. Whether Dr. Henderson should have sold the drawings or given them to an archive is a matter which does not concern me as an art historian. I only know that had David Smith's private sketches been inaccessible to me, I would have been left with fragments of a puzzle for which crucial pieces were missing. And it was a puzzle that was wholly esthetic in nature. The level of scholarship in the field of modern art is not so high that we can indulge in graceful little aversions of the head or mews of displeasure. What's needed, it seems to me, is hard work.

1977

1960s interpretations of Pollock in terms of "truth to materials" or "opticality" had reflected the aesthetics of contemporary movements such as Minimalism and Color Field painting. The open-armed pluralism of 1970s art seems, similarly, to be represented in Charles F. Stuckey's wide-ranging analysis of Pollock's imagery.

Charles F. Stuckey. "Another Side of Jackson Pollock." *Art in America*
65, NO. 6 (NOVEMBER–DECEMBER 1977): 80–91. ORIGINALLY PUBLISHED IN ART IN AMERICA, BRANT PUBLICATIONS, INC., NOVEMBER/DECEMBER 1977.

Hear the sound of one hand clapping.
(Zen Koan)

Cézanne: "I have my motif. . . ." (He joins his hands).
Gasquet: "What?"
Cézanne: "Yes. . . ." (He repeats his gesture, spreads his hands, the ten fingers open, brings them together slowly, slowly, then joins them, squeezes them, clenches them, inserts them together.) "There's what must be attained. . . . There must not be a single link too loose, a hole through which the emotion, the light or the truth may escape. I advance my entire picture at one time, you understand. . . . I bring together in the same spirit, the same faith, all that is scattered. . . . I take from right, from left, from here, there, everywhere, tones, colors, shades; I fix them; I bring them together. . . . My canvas joins hands. It does not vacillate."

> —J. Gasquet, *Cézanne*, Paris, 1921, p. 80; based upon a translation by Lawrence Gowing, who generously pointed out the passage to me.

Among the most fetching comments on the art of Jackson Pollock is the series of three paintings Roy Lichtenstein made in 1964, all with the title *Composition*.[1] Each represents the marbled black-and-white front cover of a common, inexpensive notebook labeled "Compositions." In school-room jargon "Compositions" referred to the essays the student had to learn to write. In the context of Lichtenstein's paintings, however, the term inevitably suggests an important pictorial concern, the arrangement of the unit parts of a picture to one another and to the picture as a whole. The notebook covers, especially at the 5- and 6-foot dimensions of Lichtenstein's paintings, share the "look" of paintings by Pollock. The similar scale, the reduction of color, the absence of representational marks and the homogeneous repetitive texture that characterize Pollock's paintings from about 1947 to 1950, what is commonly called their "overall" or "allover" quality, all find commercial counterparts in Lichtenstein's notebook covers, which are like swollen found objects. Unlike the Pollocks which they recall, they contain nothing other than representational marks, in terms both of form and

color. Unlike the Pollocks that so earnestly and heroically manage to avoid any spatial configuration, and consequently manage both to preserve and promote the integrity of the flat picture plane, Lichtenstein's pictures blandly accept a banal object oriented in space so that its literal physical flatness coincides with the flat picture plane, as if it must.[2]

A schematic "version" of a painting by Pollock within the frame of reference of a notebook testifies to the importance his art had for painters who continued or began to paint after his death. I gather that in 1964 Lichtenstein wished to complain good-naturedly that artists could not avoid being "schooled" in Pollock's compositional innovations. These wonderfully snide paintings mimic Pollock's best-known work like an irreverent student.

The notebook covers call upon not just the issues of overall composition and flatness, but that of content. Book covers are signs of a substance they wrap—a content, even if it be blank pages. While Lichtenstein compared Pollock's art with bland commercial design, he questioned Pollock's meaning, and in doing so impinged on the concern of critics and historians to determine what was behind Pollock's decision or inclination to paint pictures (such as he did between 1947 and 1950) for the most part without any trace of recognizable images or forms. Insofar as Lichtenstein's notebook covers imply something behind the rich webs of Pollock's paintings, they manage to characterize a sense of latent content which I refer to for simplicity's sake as the "other side" of Pollock's work.

To find out what any of Pollock's pictures "means" is like trying to crack some alien code.[3] The ambitious titles of his paintings from the early 1940s I shall assume summarize what he felt he had painted or what he had imagined and tried to paint: *Guardians of the Secret, Moon Woman Cuts the Circle, Male and Female.* As Thomas Hess rightly insisted, Pollock "still takes the Big Subject for his premise."[4] When Clement Greenberg brushed aside the titles as "pretentious,"[5] he did so only to arrive more quickly at the pictures' fundamental issues, not to deny their role: "Pollock has gone beyond the state where he needs to make his poetry explicit in ideographs. What he invents instead has perhaps, in its very abstractness and absence of assignable definition, a more reverberating meaning."[6] That meaning Greenberg found, as had Robert Motherwell,[7] in Pollock's manner of painting itself, rather than in what he chose to represent in the paintings. "It is the tension inherent in the constructed, re-created flatness of the surface that produces the strength of his art," Greenberg correctly point out.[8] The flatness alone was characteristic of Pollock's concepts of "guardians" and "secrets" and sexual opposites. I wish to suggest in what way or ways the visual property of flatness served the content of his art, as well as to indicate other less abstract devices which Pollock enlisted to ratify that function of the visual flatness he achieved.

181

The one-man show of Pollock's pictures at the Betty Parsons Gallery early in 1949, the first occasion when Pollock abandoned specific titles for plain numerical designations, allowed Greenberg, singling out *Number One*, finally to claim that "Pollock is one of the major painters of our time."[9] *Number One* is rich in pictorial devices which insist upon the "re-created flatness" Greenberg had isolated as the special potency of earlier pictures by Pollock. I cannot possibly describe these devices as well as Michael Fried already has—interestingly, within a year after Lichtenstein painted his enormous notebook covers.

> Thus an examination of *Number One*, or of any of Pollock's finest paintings of these years, reveals that his all-over line does not give rise to positive and negative areas: we are not made to feel that one part of the canvas demands to be read as figure, whether abstract or representational, against another part of the canvas read as ground. There is no inside or outside to Pollock's line or to the space through which, it moves. . . . Pollock's line bounds and delimits nothing—except, in a sense, eyesight. We tend not to look beyond it, and the raw canvas is wholly surrogate to the paint itself. . . . In a painting such as *Number One* there is only a pictorial field so homogeneous . . . that I want to call it *optical,* to distinguish it from the structured, essentially tactile pictorial field of previous modernist painting. . . . The materiality of his pigment is rendered sheerly visual, and the result is a new kind of space—if it still makes sense to call it space—in which conditions of seeing prevail rather than one in which objects exist, flat shapes are juxtaposed or physical events transpire.[10]

Number One, unlike the majority of Pollock's other large abstractions, includes numerous handprints within its complex non-representational surface. They seem only to intensify the swirls of paint, as if their repetition along the top of the picture had been meant cinematically, to express a rapidity of movement through the paint itself. The handprints recall, if we follow this line of thought, the swift succession of spatial position explored, for example, in Marcel Duchamp's *Nude Descending a Staircase,* or in Futurist works. But in addition the handprints are signatory, since they bear witness to Pollock's physical role in the creation of the painting and confirm the interpretation of his work as "action painting," reminding us of Pollock's stated desire to be "more a part of the painting," to "literally be *in* the painting."[11] But even if the illusions of rapid movement or self-presence amount to excuses for the handprints, they do not sum up to a coherent understanding of the motif. Why would Pollock wish to suggest those ideas, and where did he find the desire to try to do so?

Before examining possible sources for the handprints, it is important to ask whether they are merely marks upon the surface comparable exactly to the non-representational skeins of paint around them or whether they are in essence different from the other marks of paint. If we force them to function representationally, they pose a conundrum, for handprints are enantiomorphs.[12] Do the

182

handprints in *Number One* testify to pressure cast upon the surface from without (as they should, since Pollock made them in that way), or do they "represent" the palms of hands? Can we imagine them exerting pressure from within and being limited by the painting's surface from extending out into the space of the spectator? Are they the prints of left hands attempting to penetrate the canvas, or are they representations of right hands trying to escape it?

The question of "side" (i.e., behind and before) becomes more intriguing if we recall Lee Krasner's description of Pollock's working method.

> I saw his paintings evolve. Many of them, many of the most abstract, began with more or less recognizable imagery—heads, parts of the body, fantastic creatures. Once I asked Jackson why he didn't stop the painting when a given image was exposed. He said, "I choose to veil the imagery." Well, that was that painting. With the black-and-whites he chose mostly to expose the imagery. I can't say why. I wonder if he could have.[13]

An attempt has been made to follow the psychological implications of Pollock's unusual procedure.[14] But his choice "to veil the imagery" not only could "repress" protectively something he had begun with; it supplied him with sides, behind and before. The handprints in *Number One* call attention to either or both sides.

Pollock's decision in 1950 to make a large abstraction on glass, *Number 29*, was at least partially a result of Hans Namuth's cinematic study; the glass picture support was a commonsensical solution to the special problems of filming the process of painting.[15] In our present context, however, the glass, by its transparency, may be judged as ideally capable of dealing with the issue of sidedness. Even the wire mesh which Pollock included in *Number 29* stresses the visual accessibility of one side from the other.[16]

Pollock's interest in "sides" appears as early as 1943–44, when he experimented with a signature in mirror script. David Freke, who suggested that Pollock may have attempted the reversed signature in order to emulate the understandably backwards script common to Picasso's graphics signed in the plate, noticed that on a gouache [OT 1024] of that date Pollock's entire name, except for the "son" in Jackson, is reversed as in a mirror.[17] Could the inconsistency probe the possibility of the drawing's surface representing at once its own front and back? The drawing includes a hand, and its proximity to the bizarre signature could argue for Pollock's understanding the enantiomorphic nature of the hand image.

The handprint device had served Man Ray[18] and Alberto Giacometti.[19] Miró, too, used it, as early as 1935,[20] perhaps to recall paleolithic cave paintings or the Catalan coat-of-arms. Picasso tried it in his illustrations to Éluard's *La Barre d'appui* (1936). Since Pollock's interest in American Indian art is often "mentioned, we

should note that the mark of a hand was a prevalent image for some tribes, to which George Catlin's *The White Cloud, Head Chief of the Iowas* testifies.[21]

An even more interesting precedent is Hans Hofmann's *The Third Hand*, 1947, in which a central distinct handprint is surrounded by less precise variations on the motif. The nature and extent of Hofmann's role in Pollock's development have often been debated.[22] As Lee Krasner and Clement Greenberg had been students of Hofmann, their informed appreciation of his art would have interested Pollock. Hofmann's use of the handprint image in this work could be understood to embody his famous principle of "push and pull." Those paired tensions were vital to Hofmann's metaphysics of the picture plane, which emphasized the idea of "sides," as his 1932 article on "Plastic Creation" makes clear.

> The form problem is a space problem. Form exists through space and space through form. Form can therefore not exist alone since it is only a part of space. Space, through form, becomes tripartite—and so we differentiate between:
>
> > the space *in front* of the object,
> >
> > the space *in* the object, and
> >
> > the space *in back* of the object.
>
> The space in the object incorporates our objective world in its limits, and space in front of and behind the object infinity. Space discloses itself to us through volumes. The "objects" are positive volumes and the "vacancies" are negative volumes. The "vacancies" are also a concrete form that forces itself to our attention as negative space, through the expansion of the limits of the object world. The conception of the vacancy, "the unfulfilled space," as a negative form is necessary to reconcile the positive form, the fulfilled space, and is therefore an object. The unfulfilled space and the objectively fulfilled space together resolve into unity of space.[23]

We should recall Hofmann's "vacancies" shortly, when we discuss Pollock's *Out of the Web*. Considering either *Number One* or *The Third Hand*, it is easy to grasp how the handprint, with its shadow-thin existence, perfectly adjusts form to space so that an awareness of the "tripartite" nature of space can be had.

Pollock's scruffy handprints recall not only Hofmann's theories. They may also suggest French thinkers as diverse as Rimbaud, Breton and Diderot. Harold Rosenberg remembers that Pollock read a translation of Rimbaud's *A Season in Hell*, and that Lee Krasner also admired it enough to quote it, if Rosenberg can trust his memory, on her studio wall.[24] The translation in question must be Louise Varèse's, published by New Directions in 1945. The poem itself bewails, "What an age of hands! I shall never have my hand," but the image receives no special emphasis.[25] Another matter altogether, however, is Val Telberg's remarkable photograph for the dust jacket. The kneeling figure with his upraised hands groping on a threshold is enmeshed in spooky shadows and lights. Is *Number One* a recollection of this powerful image?

Because of Pollock's close association with Peggy Guggenheim and her gallery, we can be fairly certain that Pollock knew her anthology, *Art of This Century*, which appeared in 1942 and contained André Breton's essay "Genesis and Perspective of Surrealism." Breton begins by quoting Diderot's *Letter on the Blind*:

> I asked the blind man. . . exactly what he meant by a mirror. "A machine," he replied, "which situates things in relief at a distance from themselves provided these things are suitably placed in relation to it. It is like my hand which I must place upon (and not beside) an object if I wish to feel it. . . ." "And in your opinion," M. de . . . asked him, "what are eyes?" "They are an organ," the blind man replied, "on which air produces the same effect that my staff produces on my hand. . . . This is so true that when I place my hand between your eyes and an object, my hand is present to your sight but the object is absent from it. . . ."[26]

Pollock's most intense flirtation with Surrealist ideologies was during his association with the Art of This Century Gallery, from late 1942 until 1947. Under the circumstances do the handprints in *Number One* signify the groping of the blind? The hand that hides the object from sight in the Diderot quotation could buttress Pollock's notion of images hidden or "veiled" from sight by his webs, if we recall again Krasner's description of Pollock's work procedure. But later in his essay Breton, explaining the automatism in Masson's art, emphasizes the role of the artist's hand freed from rational control. Consequently Pollock's use of the motif may celebrate his own freedom from any preconceived ideas about painting—in addition to suggesting "sides" or his own presence.[27]

Among the contacts Pollock made at Art of This Century was Marcel Duchamp, who aided him in the installation of the oversized mural which Peggy Guggenheim had commissioned.[28] Duchamp's art offered Pollock not merely more handprints, but webs and veils as well. For example, Pollock must have noted Duchamp's installation of the "First Papers of Surrealism" exhibition for the Coordinating Council of French Relief Societies at 451 Madison Avenue in 1942, since Pollock could have participated, had he chosen to do so, as did his colleagues Motherwell and Baziotes.[29] The taut labyrinth of string which Duchamp stretched throughout the exhibition galleries traded, of course, upon associations with the awful trap of the Minotaur, a creature for whom Pollock would show some enthusiasm.[30] Duchamp's tangled string literally blocked physical access to the works of art—like the "veils" Pollock later would invent to cover his images.

The handprint appears frequently in Duchamp's work, or in Duchampiana. The most telling example is his signature for the film *Anemic Cinema*, 1925, the title of which itself approximates the mirror reversibility of the fingerprint that signs the credits frame. *Minotaure* in 1935 featured the handprints of Duchamp along with those of other notable personalities, to allow that the seemingly ran-

dom lines marking their palms were codes of the individuals' fates and charac-
ters, written in a strange lost script.[31] Duchamp did not, so far as we know,
endorse palmistry; nonetheless, his handprint appeared again in the special
March 1945 issue of *View* devoted to him. A photograph of the print of
Duchamp's right hand is the dramatic opening image in the photocollage
sequence Frederick Kiesler contributed to the issue. Kiesler inserted into the area
of the upper palm a second related photograph, a detail of the malic moulds
from the lower portion of Duchamp's *Large Glass*. Since the *Large Glass* had been
accidentally shattered (and then repaired), Kiesler's insert photograph unavoid-
ably includes the crisscross cracks that appear to entangle the malic moulds and
their own comparatively orderly network of stoppages. Undoubtedly Kiesler
intended the cracks in the *Large Glass* to echo the wayward lines of Duchamp's
handprint and suggest that the hand and the art that it made were fundamen-
tally the same. The illegible interlacings of the palm within whose mysterious
image men seek prophecies and self-understanding amount to a small-scale cor-
relative to the whipped linear energies of Pollock's grandest abstractions. Both
complex patterns are absolutely flat and conceal some interior form, as if it were
a secret. If Pollock's webs are partially inspired by the hieroglyphic lines of his
palm, it is necessary to mention that de Kooning found one stimulus to formal
invention in his own fingerprints.[32]

Pollock used only his left hand to make the prints on the surface of *Number
One*. He evidently was fond of telling a story about a slight deformity to his right
hand. The most complete version of the story was preserved by Axel Horn, a fel-
low student with Pollock at the Art Students League beginning in late 1933.

> A small detail that contributed to Jack's country boy style was that half the middle
> finger of his right hand was missing. His story of how he lost it was as follows: He
> was playing as a young boy in the ranch yard with several other children. The day
> was hot, the flies were busy, the children bored. A pile of stove wood, with an axe
> bitten deep in a chopping stump, attracted the oldest boy in the group. Wrenching
> the axe from the stump, he raised it chest high and invited anyone to put his finger
> on the block. All eyes turned to Jack who was next in age. Falling into the mood of
> the moment, he stepped forward and put his finger on the block. The axe dropped.
> As the stunned group gazed at the severed finger fallen to the ground—before even
> Jack could react—a big buck rooster galloped up and, swallowing the finger, galloped
> off again.[33]

Less ghoulishly prolonged versions end with the fingertip sewn back whole.[34]

In itself the anecdote is simply colorful. But Pollock appears to have includ-
ed references to it in his art. *Guardians of the Secret*, 1943, includes two totemic
figures at the right and left sides and between them a horizontal panel, which
can be interpreted as a picture within a picture. The figure at the right is most

likely male (in contrast to a female at the left).[35] The clearest identifying feature is the ejaculation it has, one which falls impotently at the nose of a large dog lying obediently beneath the central panel. It was along the trajectory of the ejaculation that Pollock chose to write his signature, a detail which goes toward identifying the totemic creature as Pollock himself (or at least some aspect of his self), as does a second curious detail. The figure's right arm rests upon the panel's upper border. At the point where we should find the right hand Pollock has drawn in red paint what seems unmistakably to represent a rooster. The powerful ink drawing of 1948 in which a crowing cock presides within an explosive composition [OT 782] repeats the motif. Did the bull rooster that galloped off with Pollock's fingertip become his totem animal? Had the hand with which he painted acquired the potency of the bull rooster?

The central panel flanked by two totemic figures must be the secret mentioned in his title. We have already seen that the energetically calligraphic style of this panel predicts the non-representational abstractions Pollock developed after 1947.[36] The scene depicted is one of apocalyptic mayhem. Stick figures struggle in an agitated ocean, above which a sickly yellow crescent moon watches. Most remarkable is the large scissor-tailed fish hurtling through the sky like a furious whale.

Curiously, an investigation of Pollock's images of his hand requires us (as shall become clear shortly) to follow briefly his well-recorded enthusiasm for giant marine life. His *Pasiphaë*, 1943, he had intended to call "Moby Dick," until James Johnson Sweeney dissuaded him.[37] Reportedly Melville's novel was among Pollock's favorites.[38] He even named one of his pet dogs "Ahab." Match the central panel of the *Guardians* with Ishmael's reaction to the grimy old painting he encountered in the Spouter Inn and the measure of Pollock's interest in the tale suggests itself.

But what most puzzled and confounded you was a long, limber, portentous, black mass of something hovering in the centre of the picture over three blue, dim, perpendicular lines floating in a nameless yeast. A boggy, soggy, squitchy picture truly. . . . Yet was there a sort of indefinite, half-attained, unimaginable sublimity about it that fairly froze you to it, till you involuntarily took an oath with yourself to find out what that marvellous painting meant. Ever and anon a bright, but, alas, deceptive idea would dart you through. —It's the Black Sea in a midnight gale. —It's the unnatural combat of the four primal elements. . . . But at last all these fancies yielded to that one portentous something in the picture's midst. *That* once found out, and all the rest were plain. But stop; does it not bear a faint resemblance to a gigantic fish? even the great leviathan himself?

In fact the artist's design seemed this: . . . The picture represents a Cape-Horner in a large hurricane; the half-foundered ship weltering there with its three dismantled

187

masts alone visible; and an exasperated whale purposing to spring clean over the craft, is in the enormous act of impaling himself upon the three mast-heads.[39]

It would be foolish to suggest that Pollock ever intended to illustrate this exact passage. Pollock's close involvement with oceanic themes, however, cannot be ignored.

Consider Pollock's use of the fish (or whale) motif in a large canvas of 1949, *Out of the Web*.[40] I refer to the leftmost shape with its scissor-like tail raised above its massive whalelike head. That figure and the others in *Out of the Web* Pollock "drew" with a knife, literally cutting out their shapes from an already completed and thoroughly non-representational canvas. What we call shapes are actually holes in the fabric of the canvas.[41] As holes, they permit an interpenetration between the two sides of the painting's surface. The cut-out shapes underline the role of Pollock's painted surface as barrier, or as intersection between observer and observed, if we recall Hofmann's "vacancies."

If the whale-shape here is related to that in the central "secret" panel of *Guardians of the Secret*, it perhaps follows that Pollock's abstractions (one of which he called a "web") either conceal a secret or amount to one. In a related canvas, *Cut-Out*, 1949, Pollock again used the device of negative figural shape, but the emptiness is humanoid in appearance.[42] Does he, and do his fellows in *Out of the Web*, beckon us to follow into the hidden beyond behind the surface? If so, we should gauge the hands in *Number One* against those in *Moby Dick*:

> To grope down into the bottom of the sea after them (whales); to have one's hands among the unspeakable foundations, ribs and very pelvis of the world; this is a fearful thing.

And,

> Squeeze! squeeze! squeeze! all the morning long; I squeezed that sperm till I myself almost melted into it;. . . till a strange sort of insanity came over me; and I found myself unwittingly squeezing my co-laborers' hands in it, mistaking their hands for the gentle globules. . . . Come; let us squeeze hands all round; nay, let us all squeeze ourselves into each other; let us squeeze ourselves universally into the very milk and sperm of kindness.[43]

Both men longed for communicative reciprocity between here and there. The titles Pollock chose for some of his non-representational canvases refer to spooky presences embedded in or hidden behind tangled, nearly impervious barriers, and to the deep seas: *Full Fathom Five* (1947), *Eyes in the Heat* (1946), *Enchanted Wood* (1947), *Ocean Grayness* (1953), *The Deep* (1953), to name the most obvious.[44] The hint that beings exist beyond the surface membrane, the border of perception, makes the picture's flatness a hinge joining us and them, here and

there, or twin aspects of our own awareness (for example, the conscious and the unconscious).[45]

B. H. Friedman happily saved at one remove an anecdote to support this reading of Pollock's abstract surfaces.

> And finally, there's an image—just that, not even a sentence—which an acquaintance reports Pollock used one night at the Cedar in much the same way he used his own locked hands or the spike in the living room floor to indicate the connection between seeming opposites. The image, profoundly impressed upon his mind, was something he had seen in the Gettysburg National Military Park—two musketballs, one Confederate, one Union, which had collided and fused in midair.[46]

The impossible encounter that the bullets proved had taken place symbolized for Pollock the terrible coming together of opposites from facing sides which he explored in his art.

Portrait and a Dream, 1953, is a diagrammatic reprise of Pollock's most presiding theme.[47] Here the opposite forces address one another from left and right, not from behind and before. As in *Guardians of the Secret*, what appears to be the male force, a savagely cubistic head, is on the right. On the left the mad jumble of lines is a contorted female, a sister to de Kooning's *Woman, I* (1952).[48] Between them is a dramatic gap of white canvas. Lee Krasner remembers a conversation that took place in front of this painting:

> Jackson talked for a long time about the left section. He spoke freely and brilliantly. I wish I had had a tape recorder. The only thing I remember was that he described the upper right-hand corner of the left panel as "the dark side of the moon."[49]

The located detail is a great crescent, its two points turned upwards as if to form the hideous smile of the female image. Probably that identifies her as "Moon Woman," the presiding deity of several works from 1943–44. Crucial to our discussion is Pollock's phrase, "the dark side of the moon." We cannot see it without a spaceship. It stubbornly remains hidden, demanding our belief in things we cannot see. *Portrait and a Dream* amounts to a confrontation in the free space of a dream between a spectator and the hidden beyond, an encounter as unique and full of impact as the collision of the enemies' bullets on the bloody field at Gettysburg.

Portrait and a Dream was foreshadowed in at least two pictures from 1951, both black Duco enamel on canvas. In *Number Twenty-Seven*, a similar crescent form hangs above a contorted figure on the left, while on the right are two heads superimposed one above the other. The two heads together own a vision that can straddle and possess both sides of the lunar apparition before it (as had the split head in *Portrait and a Dream* which suggested self-consciousness). In *Number Seven*, the place on the right is occupied by a standing female figure; and on the

189

left her opponent consists of a tribe of thin vertical marks. Assuming that Pollock maintained the sexual contrast between sides, the slashing stick figures indicate a multiple male presence, like Duchamp's squadron of Bachelors. Whatever their exact identification, they foreshadow the vertical marks (reminiscent of Melville"s "blue, dim, perpendicular lines floating in a nemeless yeast"), in *Blue Poles*, 1952. [50] They also deal with the union of powerful opposites, as had the negative shapes in *Out of the Web* and the handprints in *Number One*.

Pollock's paintings, as Lichtenstein intimated, pose problems not only of pictorial structure, but also of content. Pollock's obsession with the other side, and its possible implications for subsequent works of American art, should not be ignored. Otherwise we miss that burly, mystic focus upon the commonplace and elementary that was Pollock's way of pondering his soul without resorting to bathos. "Where was the beginning, middle and end of his pictures?" asked George Segal. "How could he fly and still be rooted to cigarette butts and his own handprints?"[51]

Notes

I. Roy Lichtenstein told Bruce Glaser ("Oldenburg, Lichtenstein, Warhol: A Discussion," *Artforum*, Feb. 1966, p. 23): "I did a composition book in which the background was a bit like Pollock or Youngerman."

2. Lichtenstein commented, "In Abstract Expressionism the paintings symbolize the idea of ground-directedness as opposed to object-directedness. . . . The difference is that rather than symbolize this ground-directedness I do an object-directed appearing thing. There is humor here. . . . This tension between apparent object-directed products and actual ground-directed processes is an important strength of Pop Art." See "Roy Lichtenstein," interview with G. R. Swenson, reprinted in John Russell and Suzi Gablik, *Pop Art Redefined*, N.Y., 1969, pp. 92–3. Brian O'Doherty, ("Inside the White Cube: Notes on Gallery Space—Part 1," *Artforum*, Mar. 1976, p. 29), questions the "desperate wit" of recent pictures that trade on "flat things that lie obligingly on the literal surface and fuse with it."

3. The photograph reproduced in Richard D. McKinzie, *The New Deal for Artists*, Princeton, 1973, p. 168, shows a window display to advertise a course in cryptography (1942). The team responsible for the display was headed by Lee Krasner and included Pollock.

4. Thomas B. Hess, "Pollock: The Art of a Myth," *Art News*, Jan. 1964, p. 63.

5. Clement Greenberg, review, *The Nation*, Nov. 27, 1943, p. 621.

6. Clement Greenberg, review, *The Nation*, Feb. 1, 1947, p. 139.

7. Robert Motherwell, "Painters' Objects," *Partisan Review*, Winter 1944, p. 97: "His principal problem is to discover what his true *subject* is. And since painting is his thought's medium, the resolution must grow out of the process of painting itself."

8. Greenberg, *The Nation*, Feb. 1, 1947, p. 137.

9. Clement Greenberg, review, *The Nation*, Feb. 19, 1949, p. 221.

10. Michael Fried, *Three American Painters*, Fogg Art Museum, Cambridge, Mass., 1965, pp. 13–14.

II. Jackson Pollock, "My Painting," *Possibilities*, Winter 1947–8, p. 79. Of course, Pollock's handprints appear in other works, such as *Lavender Mist*, although less obtrusively. Also, Carla Gottlieb, "*Addendum à l'art de la signature: la signature au xxe siècle*," *Revue de l'art*, 1976, pp. 74–6.

12. Martin Gardner, *The Ambidextrous Universe*, rev. ed., N.Y. and Toronto, 1969, p. 26. Fundamental to the notion is section 13 of Kant's *Prolegomena to Any Future Metaphysics* (1783).

13. B. H. Friedman, "An Interview with Lee Krasner Pollock," *Jackson Pollock, Black and White*, Marlborough-Gerson Gallery, Inc., N.Y., 1969, p. 7; a similar method was observed by Robert Goodnough, "Pollock Paints a Picture," *Art News*, May 1951, pp. 40–1.

14. C. L. Wysuph, "Behind the Veil," *Art News*, Oct. 1970, pp. 52–5; and idem., *Jackson Pollock: Psychoanalytic Drawings*, N.Y., 1970, pp. 19–23, 29–30.

15. B. H. Friedman, *Jackson Pollock: Energy Made Visible*, N.Y., 1972, pp. 162–3.

16. Frank O'Hara, *Jackson Pollock*, N.Y., pp. 26–7; John Cage, *A Year from Monday*, 1967, p. 71, noting the importance of Duchamp's example for *Number 29*, wrote in 1962: "We must nowadays be able to look through to what's beyond—as though we were in it looking out."

17. David Freke, "Jackson Pollock: A Symbolic Self-Portrait," *Studio International*, Dec. 1972, pp. 219–20. Pollock's interest in special signatory devices could have found support in John Graham, *System and Dialectics of Art* (1937), intro. Marcia Epstein

Allentuck, Baltimore, 1971, p. 191.

18. His *Self-Portrait*, 1916, contained a handprint as a signature: see Man Ray, *Self Portrait*, Boston, 1963, p. 71; and Werner Hofmann, "'L'Orateur' von Man Ray," *Jahrbuch der Hamburger Kunstsammlungen*, 1972, p. 150. Man Ray also used the image in his film *Emak Bakia* (1926).

19. Giacometti used the outline of the hand for poetic evocation in *Caresse* (or *Malgré les Mains*) of 1932. His bronze *La Main*, 1947, may also have provoked Pollock.

20. *Apparitions*, a gouache of 1935, includes the motif, which detail served as the cover illustration for the catalogue of Miró's exhibition at the Pierre Matisse Gallery in 1936. See James Johnson Sweeney, "Miró," *Art News Annual*, 1954, pp. 65, 69; Jacques Dupin, *Joan Miró, Life and Work*, N.Y., 1962, pp. 13, 284, 440; and William Rubin, *Miró in the Collection of the Museum of Modern Art*, N.Y., 1973, pp. 119–20.

21. Frederick J. Dockstader, *Indian Art in America*, Greenwich, Conn., 1961, #29, explains, "The use of the hand as a decorative motif is very widely distributed. . . ; it is particularly common in cave, costume, and mask art. . . . The design is not known to have any common significance among the various regions in which it is employed."

22. For the best discussion, see Clement Greenberg, *Hofmann*, Paris, 1961. For an account of Pollock's initial meeting with Hofmann, see Bruce Glaser, "Jackson Pollock: An Interview with Lee Krasner," *Arts Magazine*, Apr. 1967, p. 38.

23. Reprinted in Sam Hunter, *Hans Hofmann*, 2nd ed., N.Y., 1963, p. 37. In an essay first published in 1954, "The Resurrection of the Plastic Arts," Hofmann put it this way: *"Plasticity means to bring the picture surface to 'automatic' plastic response. The picture surface answers every plastic animation 'automatically' with an aesthetic equivalent in the opposite direction of the received impulse. Push* answers with the corresponding equivalent of *pull*, and *pull* correspondingly with *push*. A plastic animation 'into the depth' is answered with a radarlike 'echo' out of the depth, and vice versa.* Impulse and echo establish two-dimensionality with an added dynamic enlivenment of created breathing depth." (Reprinted in Hunter, p. 44).

24. Harold Rosenberg, "The Mythic Act," in *Artwork and Packages*, N.Y., 1969, p. 63.

25. Arthur Rimbaud, *A Season in Hell and The Drunken Boat*, trans. Louise

Varèse, N.Y., 1945, pp. 6–7.

26. André Breton, "Genesis and Perspective of Surrealism," in *Art of This Century*, ed. Peggy Guggenheim, N.Y., 1942, p. 13.

27. Ibid., p.20. We should also mention the fingerprints visible in the incisions of the slipcase for the portfolio of graphics published early in 1942 to raise funds for the publication of *VVV* because of Breton's role in that undertaking.

28. Peggy Guggenheim, *Confessions of an Art Addict*, N.Y., 1960, p. 106.

29. Friedman, *Jackson Pollock*, p. 55.

30. William Rubin, "Notes on Masson and Pollock," *Arts*, Nov. 1959, pp. 36–43; and Rubin and Carolyn Lanchner, *André Masson*, N.Y., 1976, p. 119.

31. Lotte Wolff, "Les Révélations psychiques de la main," *Minotaure*, Winter 1935, pp. 35–48.

32. Thomas B. Hess, *Willem de Kooning Drawings*, Greenwich, Conn., 1972, pp. 20–21. Consider the following passage from *Moby Dick* to estimate the power of the image of the hand and the web: "As I kept passing and repassing the filling or woof of marline between the long yarns of the warp, using my own hand for the shuttle. . . . it seemed as if this were the Loom of Time, and I myself were a shuttle mechanically weaving and weaving away at the Fates. . . . here, thought I, with my own hand I ply my own shuttle and weave my own destiny into these unalterable threads." Herman Melville, *Moby Dick*, N.Y., 1950, p. 214 (Chapter XLVII).

33. Axel Horn, "Jackson Pollock: The Hollow and the Bump," *The Carleton Miscellany*, summer 1966, p. 82.

34. Friedman, *Jackson Pollock*, p. 6. Francis V. L. O'Connor, *Jackson Pollock*, Museum of Modern Art, N.Y., 1967, p. 13, dates the incident around 1923.

35. Judith Wolfe, "Jungian Aspects of Jackson Pollock's Imagery," *Artforum*, Nov. 1972, p. 68.

36. O'Hara, *Jackson Pollock*, p. 21; and Bryan Robertson, *Jackson Pollock*, N.Y., 1960, pp. 44–45.

37. Robertson, *Jackson Pollock*, p. 139. See Friedman, *Jackson Pollock*, p. 94, for the opinion that this incident characterizes Pollock's careless attitude to his titles, a generalization I fear it is misleading to accept. Also see Wysuph, *Jackson Pollock*, p. 25.

38. Robertson, *Jackson Pollock*, p. 139; and Friedman, *Jackson Pollock*, p. 91.

39. Melville, *Moby Dick*, Chapter III, p. 11. Consider as well the picture carried by the maimed beggar at the opening of Chapter LVII. That shows

three whales and three boats, the accident in which the beggar lost his leg. Pollock's rooster refers in the same way to his lost fingertip.

40. Robertson, *Jackson Pollock*, p. 81.

41. The best discussion is Michael Fried, *Three American Painters*, p. 18; and idem, *Morris Louis*, N.Y., 1971, pp. 18–20.

42. Robertson, *Jackson Pollock*, pp. 81–82; Fried, *Three American Painters*, pp. 17–18.

43. Melville, *Moby Dick*, Chapter XXXII, p. 131, and Chapter XCIV, pp. 414–15.

44. Robertson, *Jackson Pollock*, pp. 138–39; Rosenberg, "The Mythic Act," p. 74.

45. The standard discussion of two-sided perception is Gaston Bachelard, "The Dialectics of Outside and Inside" in *The Poetics of Space*, trans., Maria Jolas, Boston, 1969, p. 211 f.

46. Friedman, *Jackson Pollock*, p. 229.

47. Robertson, *Jackson Pollock*, p.81; Wysuph, *Jackson Pollock*, p. 29.

48. Hess, *Willem de Kooning Drawings*, p. 38.

49. Friedman, "An Interview," p. 8.

50. Robertson, *Jackson Pollock*, p. 19 f; and Stanley P. Friedman, "Loopholes in 'Blue Poles'," *New York*, Oct. 29, 1973, pp. 48–50.

51. "Jackson Pollock: An Artist's Symposium, Part 2," *Art News*, May 1967, p. 69.

1979

In late 1978, Francis V. O'Connor and Eugene Thaw published their four-volume
Jackson Pollock: A Catalogue Raisonné of Paintings, Drawings, and Other Works,
providing meticulous documentation on over a thousand works and including an
expanded version of the documentary chronology that O'Connor had originally pub-
lished in 1967. Arts Magazine *celebrated this event by publishing a special Pollock*
issue with a baker's dozen of scholarly articles. Two notable newcomers were Stephen
Polcari, who explored Thomas Hart Benton's artistic theories and their probable effect
on Pollock, and Elizabeth L. Langhorne, who offered an erudite reading of the symbol-
ism of Pollock's early work. Along with other articles by scholars such as David Freke,
Jonathan Welch, and Judith Wolfe, Langhorne's essay seemed to bring the Jungian
interpretation of Pollock to critical mass, attracting the attention of William Rubin,
then Director of the Department of Painting and Sculpture at MoMA. Rubin's response,
in "Pollock as Jungian Illustrator," offered a searching examination of the psychologi-
cal aspects of Pollock's work but reasserted the importance of formal criteria.

Stephen Polcari. "Jackson Pollock and Thomas Hart Benton." *Arts Magazine*
53, NO. 7 (MARCH 1979): 120–24. REPRINTED BY PERMISSION OF STEPHEN POLCARI.

Central to Jackson Pollock's art throughout his career has been rhythmic struc-
ture. He consistently sought to combine figure and ground, two-dimensional
design and three-dimensional space, and light-dark composition within a
unified image of repeated shapes, active, energetic curving contours, and con-
trapuntal accents, whether of color, surface marks, or line. It is as though he
attempted to imbue exterior forms with a sense of interior driving forces and
energies. This quality is as true of his early student work as of the legendary
abstract poured pictures of his mature style.

While there were many influences to account for Pollock's central concept
of rhythmic structure apart from his personal inclination, including Surrealist
automatism, one influence has been consistently undervalued—that of Thomas
Hart Benton.[1] Benton, with whom Pollock studied at the Art Students League
from 1930 through 1932, with whom he worked and visited until 1937, and
with whom he remained in contact until his death in 1956,[2] was a master of con-
ceptual, plastic rhythm. Pollock seems to have chosen to work with Benton not
only because of the latter's prominence in the 1930s as a leader of American
painting and his availability as a teacher at the Art Students League, but also
because of Benton's emphasis on rhythmic design. On January 31, 1930, Pollock
wrote his brother Charles from California: "my drawing I will tell you frankly is
rotten it seems to lack freedom and rhythm it is cold and lifeless."[3] Later in that
year when he moved to New York, he began to study with the artist probably

most suited to resolve these difficulties.

For most writers, Benton's influence on Pollock's development has been limited to Pollock's American Scene painting of the early 1930s. Pollock himself contributed to the view that his later work owed little to Benton when he stated in 1950 that he reacted strongly against Benton's realism.[4] While independence of Benton is certainly true of his work after 1938 in terms of subject matter, technique, and style, it is not true in essential structural design and impulse. And whatever Pollock may have said later, Benton felt that his student retained aspects of his methods of formal organization. "Jack did not have a logical mind. But he did catch on to the contrapuntal logic of occidental[5] form construction quite quickly. In his analytic work he got things out of proportion but found the essential rhythms. . . . Jack did finally reject my ideas about the social function of art. . . . He followed a Benton *example* but this was in matters of form rather than content."[6]

Pollock, an anti-realist painter throughout his career, could draw on Benton's art because Benton's style incorporated more modernist elements than either Benton or observers of his art have acknowledged. Despite the American Culture as subject matter, the three-dimensional space, modeled forms, and his often-stated antagonism to modern European art, Benton shared modern painting's emphasis on abstract two-dimensional patterning and all-over design. A comparison of Benton's characteristic work with pre-modern painting reveals the clear ideational and modern stylistic elements of his art despite its deep space, recognizable subjects, and modeled form. Benton's "realist" art does not belong to any century but the twentieth. He never intended it simply to duplicate nature but, like other modern artists, to form a parallel order.[7] For Benton, this order was one of all-over rhythmic mass and space.

Observers of Benton's art have easily analyzed the conceptual structure he imposed on figurative subjects. In *Discovery* of 1920, a panel from his first mural series in the early 1920s, *The American Historical Epic*, a large oval rhythm from the foreground Indian to the boat and boatmen in the distance organizes the entire design in two and three dimensions. "Inside that oval," writes Matthew Baigell, "curving forms echo and parallel one another, and light and dark areas alternate. Edges of one form glide into those of others or simply share a common contour."[8] Dennis Cate has noted, in the same composition, that every animate and inanimate object interacts to create a unifying sinuous rhythm.[9] Foreground figures and deep space are thus united, creating an integrated surface and spatial pattern. Thus, despite obvious traditional forms, the intellectualized abstract rhythmic interaction of curving shapes, the all-over fluctuating light and dark pattern, and the spatial arrangement which pulls all forms in depth back to the surface are modern elements. These elements foretell major characteristics of Pollock's art, and also dictated major aspects of Benton's teaching, as will be shown.

193

When, in the murals of the 1930s, Benton "nativized" his style, that is, painted more detailed scenes of American life through representations of contemporary customs, gestures, and activities of the common American, his pictorial structure opened up and became less abstract. This was probably partially a result of the large wall surfaces now available to him, his increasing familiarity with Mexican mural art, and the further development of his idea of the need to communicate with large audiences. In a typical panel from one of his well-known murals of the early 1930s, *City Activities* from the murals for the New School for Social Research, he illustrated a scene of the pulsating energies of American life. (Pollock posed for some of the figures in these murals.[10]) Like other murals of the 1930s, several individual scenes are combined in one panel. This panel from *City Activities* consists of separate views of boxers, prayer meetings, subways, park bench lovers, and burlesque. Yet they spill over into one another at a portion of their boundaries, creating an all-over unity somewhat like that of Analytic Cubist *passage*—an original "imagistic" *passage*. Each individual scene, framed on three sides as an Analytic Cubist shape is outlined, flows into the neighboring space. Attention cannot be focused on one scene for too long without being led into the next. The space moves from surface to depth and back again. Figures and forms of high value are sharply contrasted with darker ones or blended into even lighter shapes, resulting in an all-over flashing of lights and darks. The figures reinforce this ever-changing rhythmic pattern. The eye is led from scene to scene and point to point by their exaggerated shapes, poses, and movements. Their curving and straight contours reinforce or contrast with similar lines formed by the internal frames (of Art Deco design).

Benton's mural style (which shares many characteristics with his easel painting), despite its traditional elements, presents, then, many features based in modern painting which could as well describe much of Pollock's work: surface emphasis and design, all-over interrelationship of shape and lights and darks, conceptualized form, and, above all, contrapuntal rhythms. To the extent that Pollock absorbed these elements from Benton, however, it was not merely through the example of Benton's finished paintings. Benton had devised an instructional system for his teaching at the Art Students League incorporating his abstract theoretical principles of pictorial structure and composition. Pollock, during his years of study with Benton, must have been exposed to them. These principles and the accompanying illustrations are even more evocative of aspects of Pollock's art than Benton's paintings.

An illustrated account of Benton's instructional methods is available in a series of articles he published in *The Arts* in 1926–1927.[11] These articles demonstrated in "stripped-down" form, that is, in geometric shapes and not in representational forms, what he considered to be the fundamental factors that underlie what we generally respond to as aesthetic values. In his teaching, as these arti-

cles demonstrate, Benton showed that the organization of pictorial elements involved the creation of a simple, unified pattern. While the method of geometric diagrams and many of the main points were not necessarily original with Benton, the emphasis on rhythmic movement and the diagrams themselves point to the direction Pollock's art was to take.

In his first article, Benton stated what he considered to be the most important factors of form construction. The first is equilibrium: "The parts must. . . be held in a state of balance." In the construction of interrelations in a dynamic picture (Benton's examples always emphasize the dynamic), dynamic balance is asymmetrical as equilibrium is held by a series of shifts and countershifts which are never exactly parallel. Pictorial balance must take in the canvas as a whole, for balance is constructed in regard to the canvas frame. The second factor is sequence or connection; "Attention should be led from one element to another." In discussing incomplete circles as an example of sequence, Benton suggested that in following an isolated segment of a circle there is a natural tendency to complete the circle in imagination. If there is an opposed segment, however, the eye follows the line of opposition until it is itself opposed, and so on.

The third factor is rhythm: "Rhythm . . . is *the repetition in a dynamic sequence, at alternating intervals, of similar factors* . . . All plastic rhythm is based on the principle of variety in conformity" of shapes and pictorial elements. An additional factor had to be considered when constructing rhythmic sequences of masses. The edges of masses become important: "In order to hold the rhythmic flow and to keep the attention on the main oppositional directions, the edges should interlock. . ." or 'fit in'. [Fig. 15, in Thomas Hart Benton, "Mechanics of Form Organization in Painting," *The Arts*] diagrams the interlocking of straight edges. [Benton, fig. 18] shows the interlocking of straight and curved shapes in a rhythmic balance.

Benton also felt that an excellent rhythmic organization too often ignored is "centrifugal opposition." Centripetal opposition is more common. Typical, too, in most compositions, is the arrangement of rhythmic sequences around one central vertically oriented imaginary pole. Horizontally extended rhythms of this type were unusual. Benton believed that for an artist to compose in the latter way, several vertical poles would have to be extended laterally across the canvas and rhythmic sequences disposed around each one. Benton's diagrams use these imaginary poles.

Most of the discussion in Benton's first article centers on two-dimensional design. In the next two articles, he discusses form organization in three dimensions, that is, sculpture and illusionistic painting. Here the same principles hold. Benton diagrams figurative sculpture in terms of homogeneous cubic (volumetric) masses rhythmically rotated around an imaginary pole. The pole forms the vertical axis of the masses independently of their contours. In illusionistic

figurative painting, the pole is recessed in space and masses can be rotated from the picture plane around the pole and back to the surface. For Benton, whether in sculpture in the round or in illusionistic painting, this rotation consists of convex and concave projections always arranged in a rhythmic flow. Benton believed that illusionistic painting is actually created by the superimposition of form upon form and not through the laws of perspective. The realization of depth for him is largely inferential and must always be balanced by equal attention to surface organization.

In Benton's fourth article, he presents a particular elaboration of his principles of rhythmic form organization which is based on the study of anatomy. Strongly evocative of another aspect of Pollock's art, it has heretofore surprisingly been ignored in the Pollock literature. Benton describes the movements and countermovements of the muscles of the upper arm as a rhythmic interplay of convexities and concavities—"bumps and hollows"—around the bone which corresponds to his central pole:

> There are here a series of masses which bulge and hollows which recede. These are organized around a central vertical, the bone, and are so distributed that there is no possibility of collision between the bulging masses when a change in the arm's position causes them to shift. This shifting takes place along the lines of the hollows which are filled, emptied and refilled with the changing positions of the arm. For every movement of a mass there is an equilibrated countermovement which finds "expression" also in a new alignment of the hollows. . . . It will be noticed that the arrangement of these hollows and bulges forms a very clear rhythmical pattern, that is, there are repetitions at alternate intervals of similar movements, different in the different positions of the arm.

Benton goes on to make a bizarre leap from specific anatomical function to the entire construction of artistic compositions, attributing this analogue to Renaissance painters as a result of their study of anatomy:

> Muscular shift and countershift as visible external phenomena became a specific compositional determinant. . . . The strictly mechanical values of all Renaissance composition from Signorelli to Rubens can be traced to an extension of muscular action patterns. . . .

Going still further, Benton sees the idea of dynamic composition as deriving from organic sources within man's experience of consciousness. The analogy is restated as follows:

> [Benton, figs. J, K] indicate an analytic method which is applicable for the study of the plastic values of our own muscular functions and for the rhythmical structural arrangements that function in building up a work of art.

196

Finally, he draws a reasoned parallel between the forms of life and the forms of art: Forms in plastic construction are never strictly created. They are taken from common experience, re-combined and re-oriented. This re-orientation follows lines of preference also having definite biological origin. Stability, equilibrium, connection, sequence movement, rhythm symbolizing the flux and flow of energy are main factors in these lines. In the "feel" of our own bodies, in the sight of the bodies of others, in the bodies of animals, in the shapes of growing and moving things, in the forces of nature, and in the engines of man the rhythmic principle of movement and counter-movement is made manifest. But in our own bodies it can be isolated, felt and understood. This mechanical principle which we share with all life can be abstracted and used in constructing and analyzing things which also in their way have life and reality. For Benton, the principle is mechanical, however, and cannot function alone. "Non-mechanical" factors such as "human interest" must be added to make a true work of art. The passage is nevertheless highly suggestive of Pollock's eventual development, to be treated below, and is moreover surprisingly anticipatory of the "organic forties," though written in 1926–27.

Benton's theoretical principles, then, principles he utilized in the visualization of his subject, the American experience and culture, add up to a form of conceptual realism. It is a realism that is by no means a simple imitation of nature but a synthesis of original ideas and modern and traditional elements.

Benton's influence on Pollock is, of course, clearly evident in Pollock's early work when he follows Benton in subject as well as style. Typical is *Going West* of c. 1934–1938. An all-over curve unites the foreground—of rocks and earth—and the background—of the clouds "behind" the mountains. The straight lines of the wagons both counter and reinforce the ground curve from right to left while the bumpy mountains and straight edges of the house provide a counterpoint to the single curve of the clouds. Light and dark areas flicker across the surface. Thus, while there is a firm three-dimensional spatial construction, the all-over design is as evident in two dimensions as three. In addition, a reminiscence of Ryder's influence, the only American master Pollock said ever interested him,[12] is also present in the intense darkness, the thick painterly treatment, the rugged simple shapes, and the piercing moon and dramatic sky. Benton's cubic figures evident in his Synchromist pictures, in his diagrams, and in his studies for pictures such as the *Palisades* of *The American Historical Epic* appear, for example, in Pollock's *Deposition* of c. 1930–1933. The figures consist of sharply contrasting light or dark planes without value transitions. They are so densely packed that there is a surface pattern of crisscrossing blocks and planes. *Composition with Figures and Banners* of 1934–1938 utilizes Benton's poles and curvilinear shapes of his diagrams and painting in an all-over two- and three-dimensional swirling rhythm. Thus, Pollock's work of the 1930s follows Benton's stylistic principles, though

Pollock's individuality is evident in the more painterly flatness and more intro-spective mood. When, in 1938–1939, he rejects Benton's subject matter and his traditional formal elements, his work may at first appear to be free of Benton's influence. However, his rhythmic counterpoint, rooted in Bentonian theory and practice, remains characteristic of the remainder of his work. Moreover, specific Bentonian design ideas reappear throughout Pollock's oeuvre although certainly not in every picture.

Thus, in addition to Pollock's absorption of American Indian motifs, Mexican subjects, Picassoid form and Surrealist automatism and biomorphism, there remains a Bentonian element in the make-up of nearly all of his work. The arrangement of curving and straight shapes and forms around an imaginary pole, for instance, is evident in *Birth* of c. 1938–1941, which also reflects Picasso's *Girl with a Cock* and *The Demoiselles d'Avignon*,[13] Orozco color, and American Indian totem poles. The vertical design is reinforced by the verticality of the can-vas format. *Bird* of c. 1938–1941 is a more triangular version of this idea while *Masqued Image* of the same period is squarer. *Moon Woman Cuts the Circle* of 1943, a Jungian subject,[14] is composed mainly of a flattened, long curve and a shorter, rounder countercurve, reflecting the central lines of [Benton, fig. 24]. Thus, new subjects and new stylistic sources are combined with Bentonian organizing prin-ciples and rhythmic shapes as illustrated in the diagrams.

In *Mural* of 1943 Pollock took up Benton's challenge of creating a horizon-tally extended rhythmic pattern. In such a composition, Benton suggested, sev-eral poles would have to be disposed along the horizontal axis and rhythmic counterpoint disposed around them. Pollock's "poles" are arbitrarily lengthened vertical contours, and around them are disposed myriad biomorphic forms. (*Mural* also resembles Analytic Cubism in its distinct contours and its intercon-nected though biomorphic planes.) The strongly emphasized contours also cre-ate a rhythmic pattern which organizes the entire picture surface, thereby echo-ing another Bentonian idea. Thus, the composition of *Mural*, which actually foretells Pollock's eventual freeing of line from plane, reveals the continued debt of Pollock to Benton.

Pollock's most obvious use of poles occurs in *Blue Poles* of 1952. On this subject, Benton has written to O'Connor:

> I think it highly improbable that anybody but Jack would have thought of them (the poles)—anybody, I mean who had not studied composition with me. (Note articles. . . in "The Arts". . . .) In one of these, poles are shown in a diagram and explained in the text. . . . In an actual composition I always erased the poles or most times sim-ply imagined them. I never made them parts of a composition as did Jack in the "Blue Poles" painting. But it was probably some vague memory of my theory demon-strations that caused him to "inject" the poles in that painting. Their use however is

a purely Pollock concept. . . The only possible precedent, *that I know of*, is shown in "The Arts" diagrams of '26–27 and that is a minor one.[15]

Blue Poles, like *Mural*, echoes Benton's diagrams as well as Benton paintings such as the *Prayer* of *The American Historical Epic*. In this recapitulation of his holistic poured painting style of two years earlier, Pollock has taken care to integrate the poles, which might have seemed discontinuous, with the all-over design. The strong blue color repeats the high-pitched yellows and oranges. Skeins of paint are added to the poles to repeat the skeins in between, and the poles themselves tilt left and right so that they seem to respond to the general rhythmic quality of the entire surface.

Benton's ideas about the role of the framing edges is evident in a number of Pollock's paintings. The device of considering the edges as static elements and splaying rhythmic counterpoint within them (one may also consider the edges peripheral poles) appears in Pollock's *Gothic* and *Night Ceremony* of 1944. *Gothic* consists of the rhythmic interplay of curvilinear and straight-edged contours (of flattened "concave" and "convex" biomorphic shapes) in a vertically oriented canvas. The design of numerous interlocking lines of this picture involves the multiplication and variation of a similar design evident in Benton's diagrams as well as the shapes of earlier Pollock forms such as the tent of *Camp with Oil Rig*. In *Full Fathom Five* and *Cathedral* of 1947, both among the first poured paintings, Pollock similarly disposes his contrapuntal curvilinear rhythms, now simply lines rather than shapes, within a vertical format. *Ritual* and *Moon Vibrations*, both of 1953, internalize the frame edge (or "peripheral" pole) and swing rhythms between and around them.

The reflection of still other Benton diagrams may be evident in the Accabonic Creek series of 1946. The *Key* of 1946, for instance, while seemingly based on Picasso's *Night Fishing at Antibes* and including a figure from *Guernica*, echoes the flat, truncated, curvilinear shapes of both the negative and positive parts of Benton's diagrams. And like a typical Benton, the figures seem rhythmically to echo one another. *The Troubled Queen* of 1946 and *Out of the Web* of 1948 also seem to use similar shapes. Finally, *Sleeping Effort* and *Numbers 11* and *14, 1951* may reflect the horizontally rolling curves of Pollock's *Rolling Hills* of c. 1934–38, Benton's *Cradling Wheat*, and [Benton, fig. 11].

Perhaps the best example of Benton's influence is in Pollock's all-over poured pictures. In these abstract works, Pollock's ideas of automatist spontaneity, the independence of line from its traditional role of contouring, and are holistic design combined with the principles of Benton's rhythmic structuring. *One (Number 31, 1950)*, one of Pollock's greatest poured paintings, consists of an all-over rhythm of innumerable curves, straight lines, and countercurves—a kind of "frozen" dynamic equilibrium. Pollock has eliminated shape altogether,

and lines—of different color, size, direction, and position—are now free to echo, parallel, and counter one another ceaselessly. *One*, in fact, seems to be nothing but endless rhythm and energy. It thus reflects Benton's conception of rhythm as the endless repetition and variation of similar elements. Furthermore, pictorial balance is achieved with respect to the whole of the canvas and in regard to the frame of the canvas. Space is continuous if not deep, as lines and colors advance and then quickly recede under others. Space is thus created by the layering of line upon line which is analogous to Benton's conception of space as the "superimposition" of form upon form.

Pollock's famous technique of pouring paint and using the entire arm, not just the wrist, in the creation of a rhythmic composition probably reflects Benton's original suggestion of the paralleling of physiological movement in plastic structure. The all-over rhythms in *One*, as in all of Pollock's poured paintings, reflect a conception of energy and rhythm similar to Benton's idea of rhythm which underlies all organic experience and form. Certainly Pollock's conception is of a different order than Benton's, involving a synthesis of automatist psychic as well as physical energy in his representation of rhythmic flux and flow.[16] However, Benton's ideas must have helped him realize in his original way his famous statement "I am nature."

In sum, the rhythmic concepts of Benton's work and, in particular, of his instructional diagrams must be considered a significant factor in the total make-up of Pollock's styles. Certainly, he rejected the obvious qualities of Benton's style—its American subjects, its sculptural form, and its deep space. Certainly, he drew on a number of European and other sources vastly different from Benton. Certainly, Benton's curvilinear design was part of the common vocabulary shared by a number of very different styles of the period, e.g., Surrealist biomorphism, Art Deco, and Streamline design. It cannot be denied, however, that Pollock re-created elements of Benton's rhythmic structure in another guise. The heretofore widely heralded "spontaneity" of Pollock's art, especially his poured paintings, seems to reflect not just unconscious impulses but a sense of order rooted in his study and training with the seemingly antithetical American Scene painter, Thomas Hart Benton.

Notes

1. An exception has been in the writing of Francis V. O'Connor. See F. V. O'Connor, "The Genesis of Jackson Pollock: 1912 to 1943," *Artforum*, 5, 9, May 1967, pp. 16–23, and F. V. O'Connor and E. V. Thaw, *Jackson Pollock: Catalogue Raisonné of Paintings, Drawings, and Other Works*, New Haven, 1978, vol. 2, p. 196.

2. O'Connor, "The Genesis of Jackson Pollock," pp. 17–18.

3. O'Connor and Thaw, *Jackson Pollock*, vol. 4, p. 209.

4. Pollock, quoted in "Unframed Space," *The New Yorker*, XXVI, August 5, 1950, p. 16.

5. Erroneously spelled "accidental" in original text. See letter by F. V. O'Connor, *Artforum*, 5, 10, summer 1967, p. 5.

6. Benton, quoted in O'Connor, "The Genesis of Jackson Pollock," p. 17.

7. See T. H. Benton, "Form and the Subject," *The Arts*, V, June 1924, pp. 303–08.

8. M. Baigell, *Thomas Hart Benton* (concise edition), New York, 1975, p. 43.

9. *Thomas Hart Benton: A Retrospective of His Early Years, 1907–1929*, introduction by P. H. Cate, Rutgers University Art Gallery, New Brunswick, 1972, n. p.

10. O'Connor, "The Genesis of Jackson Pollock," p. 17.

11. T. H. Benton, "The Mechanics of Form Organization," *The Arts*, I, November 1926, pp. 285–89; II, December 1926, pp. 340–42; III, January 1927, pp. 43–44; IV, February 1927, pp. 95–96; V, March 1927, pp. 145–48.

12. Answers to a questionnaire, *Arts & Architecture*, LXI, February 1944, p. 14.

13. The influence of *The Demoiselles d'Avignon* has been pointed out by J. Wolfe, "Jungian Aspects of Pollock," *Artforum*, 11, 3, November 1972, p. 66.

14. Ibid., p. 68.

15. O'Connor and Thaw, *Jackson Pollock*, vol. 2, p. 196. O'Connor also mentions two Pollock drawings with poles, vol. 3, no. 845, and vol. 4, no. 1014.

16. There are many issues here beyond the scope of this article. They will be dealt with in a forthcoming article.

Elizabeth L. Langhorne. "Jackson Pollock's 'The Moon Woman Cuts the Circle.' "
Arts Magazine
53, NO. 7 (MARCH 1979): 128–37. REPRINTED BY PERMISSION OF ELIZABETH L. LANGHORNE.

The imagery in Jackson Pollock's early work is not only remarkably specific, but lends itself to quite precise interpretation in light of Jungian psychology. Pollock knew of Jung's work as early as 1934.[1] He underwent Jungian analysis from 1939 through 1942, with Dr. Henderson for eighteen months in 1939–40, and with Dr. Violet Staub de Laszlo in 1941–42. As late as 1956, a few months before his death, Pollock said, "I've been a Jungian for a long time."[2]

"Jungian" might have referred to either of two major aspects of Jung's work: Jung as psychotherapist, bringing an individual's troubled unconscious into harmony with his conscious mind; Jung as compiler of myths and other archetypal manifestations to be found in man's culture. In his comparative studies Jung found that the archetypes, the basic structural elements of man's unconscious, underlie modern dreams as well as ancient myth. From this he concluded that there was a collective, that is, a universal and timeless, unconscious.[3] Jung's compilation of archetypal material and his belief in a collective unconscious appealed to such artists as Gottlieb, Rothko, and Newman as they made their search in the early 1940s for a "tragic and timeless" subject matter.[4] This aspect of Jung undoubtedly appealed to Pollock as well. Witness his youthful involvement with the mysticism of theosophy and its espousal of archetypal unities.[5] So far, scholars seeking to fathom the meaning of Pollock's early imagery have turned to Jung's anthologies of myth and dream, hoping to locate visual or literary sources. Meanwhile, the importance for Pollock of Jung the psychotherapist has only been hinted at.[6] Pollock's four years of Jungian psychotherapy are, I feel, at the core of his involvement with Jung. They clearly distinguish his involvement from that of Gottlieb, Rothko, and Newman. A Jungian interpretation of Pollock's images must go beyond an understanding of Jung as compiler of myth to an understanding of Jung as psychotherapist, and focus on Pollock's images as expressions of conscious and unconscious psychic forces and as vehicles of his search for psychic health.

Pollock's 1947 statement, "The source of my painting is the unconscious," is frequently cited in describing Pollock's abstract paintings of 1947 onwards.[7] It is also a surprisingly exact description of the meaning of the images in one of Pollock's early works, *The Moon Woman Cuts the Circle* of 1943. The painting is a particularly important one, done at a crucial time in Pollock's career, when in early 1943 he made his first contact with the dealer Peggy Guggenheim and was promised his first one-man show in the fall of that year.[8] A thorough understanding of this one painting is an occasion not only for reviewing the efforts to find visual and literary sources for the painting in Jung's writings, but also for

exploring the variety of sources to be found in Pollock's own earlier work. A review of these sources reveals the range of Pollock's sometimes quite esoteric interests in primitive art, Picasso, alchemy, and Eastern mysticism. But these borrowings are not merely casual. They are always subsumed in the personal and psychological meaning of his imagery, which invites the most rewarding of interpretations, a Jungian psychoanalytic interpretation.

Sir Herbert Read, Lawrence Alloway, and Judith Wolfe have all suggested that the imagery in *Moon Woman Cuts the Circle* derives from an illustration in Jung's *Psychology of the Unconscious*, a Haida Indian tattoo pattern representing the woman in the moon; However, as pointed out by David Freke, the tattoo pattern could not have been a visual source for the simple reason that though the text was published in English in 1916, the illustration was not published until the fourth German edition in 1952.[9] Before this edition there are very few illustrations in Jung's work; Jung as a visual source for Pollock's imagery is very largely a false assumption.

Still the possibility of Jung as a literary source for the painting remains. Both David Freke and Judith Wolfe cite the text accompanying the tattoo pattern. It relates the Hiawatha legend. I paraphrase: A male lover sees Hiawatha's grandmother as a young girl, swinging on a grapevine, in the moon, where she lives. Jealous, he cuts the vine and causes Hiawatha's grandmother to fall from the moon. As she falls, she somehow conceives Hiawatha's mother. While *Moon Woman Cuts the Circle* certainly does not illustrate this story, the ideas in the text, those of woman in the moon, symbolic union, birth from a heavenly body, are to be found in the painting. But for both Jung and Pollock these are fundamental ideas that are not confined to the Hiawatha legend or to *Moon Woman Cuts the Circle*.

Having questioned Jung's writings as a visual or literary source for *Moon Woman Cuts the Circle*, let us turn to the most immediate source in Pollock's own work, the painting *Moon Woman* of 1942. The moon woman, an anthropomorphic figure with breasts and billowing buttocks, is shown seated, facing right. Her face is a double one, frontal and profile. The frontal view contains two eyes, the profile view a third and larger eye. This third eye is a striking configuration of the eye itself and a crescent shape with which it intersects. The crescent-eye is a variation on what I shall call the disc-crescent or sun-moon motif, an understanding of which is crucial to a final understanding of *Moon Woman Cuts the Circle*.

To elucidate the meaning of the disc-crescent or sun-moon motif, I will pinpoint a few of its earlier appearances in Pollock's work.[10] Though there is a wealth of motif in this work, I ask the reader to focus on this one important motif. In the bottom of the upper right-hand quadrant of an untitled drawing, conventionally dated c. 1938–41 [OT 633], one can see a sun disc projecting its rays into a crescent moon. Directly to the left the disc and crescent are joined so

as to form a volute-foetal shape. Another drawing, c. 1939–40 [OT 547], one of the eighty-three drawings given by Pollock to his Jungian analyst Dr. Henderson, reveals that Pollock associates the crescent moon with female. The yellow crescent appears in the pubic area as one of the many female symbols in a composite image of woman. This assignation of sex to the celestial bodies, female moon and therefore male sun, occurs throughout world myth, and is often pointed out by Jung.[11] In Pollock's sun-moon motif we already have the incipient presence of the "moon woman."

The simple evolution of the volute-foetal shape from a joining of disc and crescent is paradigmatic of the manner in which the basic abstract configuration of the disc-crescent lends itself to metamorphosis and growth until it is incorporated into *Moon Woman* (1942) and *Moon Woman Cuts the Circle* (1943). The metamorphoses of the disc-crescent motif in conjunction with a mask motif, in such works as untitled painting (*Man with Mask*), *Mask*, *Masqued Image*, and in conjunction with a plumed serpent motif in *Head*, *Birth*, and *Bird*, involves Pollock's early responses to the artist-writer John Graham, Picasso, and primitive art, a nexus of interests too complicated to explore here.[12] For the purpose of understanding *Moon Woman Cuts the Circle*, it is sufficient to verify the identity of the volute-foetal form as plumed serpent in *Birth*, c. 1938–41, and in *Bird*, c. 1941.

In the upper right-hand corner of *Birth* the red disc is joined to the white crescent to make a volute form intended to be foetal, as the title indicates.[13] The bent leg and the hand at the bottom of the painting both seem to give birth to the forms as they bubble upwards. A drawing done c. 1939–40 [OT 521], another of those given by Pollock to Dr. Henderson, shows that the form in *Birth* derives from the Aztec motif of the plumed serpent. The figure found in the middle left of the page, in which the coils of a snake are plumed with feathers, can be correlated almost exactly with the foetal form in *Birth*. This variant of the Aztec plumed serpent probably derives from an American Indian stone disc incised with a coiling plumed serpent which Pollock could have seen in the 1941 exhibition of Indian art at the Museum of Modern Art in New York.[14]

The volute-foetal form as plumed serpent is a striking example of Pollock's interest in the primitive and is also an unusual metamorphosis of the disc-crescent motif. The plumed serpent as a conflation of bird and serpent combines that which is high and low: the bird that flies upwards, the serpent that crawls on the ground. Thus the disc-crescent, sun-moon motif, until now basically a male-female motif, has metamorphosized to incorporate connotations of bird-serpent, high-low. In *Bird* the volute-foetal plumed serpent is found in the middle register of the painting, but in yet another metamorphosis the component parts of the plumed serpent are separated out along the vertical axis of the painting. The snake, coiled, is found below, joining the two Indian heads in the dark lower register, and the plumed serpent itself has large gray wings, indicat-

ing that it should fly up to the eye in the white upper register. Since the bird element of the plumed serpent motif predominates, we have the title *Bird*.

Even this brief glance at Pollock's variations on the disc-crescent motif reveals that he is involved in a process of private symbol making. The original disc-crescent or sun-moon motif is metamorphosized into a volute-foetal form which is translated into a plumed serpent motif in *Birth*, which is then put into a larger and somewhat mysterious context in *Bird*. One can say that this symbol making revolves around the general theme of union of opposites, whether sun-moon, male-female, bird-serpent, high-low. I would like to further suggest that this process of symbol making is intimately related to Pollock's mental, that is, his psychic, life.

That Pollock had severe psychological problems accompanied by heavy drinking is well known. In the summer and fall of 1938 he was hospitalized in a psychiatric institution for six months.[15] A letter written by Pollock's brother Sanford to another brother, Charles, in 1941 indicates that the probable source of Jackson's psychic problems was his mother. "Since part of his trouble (perhaps a large part) lies in his childhood relationship with his Mother in particular and family in general, it would be extremely trying and might be disastrous for him to see her at this time."[16]

An impasse in his art was also a part of his problem. The neo-baroque style and American Regionalist subject matter of his teacher Thomas Hart Benton largely dominated Pollock's art up until 1938. In the spring of that year Pollock was to have gone on a sketching trip with Benton. As Sanford put it, he "needs material badly."[17] But the Federal Art Project, for which Pollock worked, refused him a leave of absence. This obstacle, compounded with his other personal problems and his alcoholism, precipitated his hospitalization in 1938. Pollock's problems persisted and in 1939 he started Jungian analysis.

In Jungian theory libido, that is, psychic energy, is viewed as being polarized into opposites, extraversion-introversion, thinking-feeling, conscious-unconscious, etc.[18] If the psyche is healthy, libido flows smoothly. If the psyche attempts some method of adaptation that is not appropriate to the environment in which it finds itself, the flow of psychic energy is dammed up. The pairs of opposites begin to break up and the personality begins to split, leading to neurosis and schizophrenia.[19] The regression of psychic energy back toward the unconscious activates the unconscious archetypes. Symbol to express the archetypes begin to form. These bubble up to the surface of consciousness through dreams, fantasies, and sometimes drawings.[20]

We know that Pollock has been symbol making. But what archetypes do his symbols express? Those of interest here are the anima and the self. The anima is the feminine, unconscious, and potentially creative component of every young man's psyche.[21] A young man's anima is, in the course of his lifetime, projected

205

first onto his mother, then perhaps his sister, then a lover or wife, and if he is an artist, onto his art. Pollock's problems with his mother and his art in the late 1930s indicate that Pollock had what Jung would term a negative anima or Terrible Mother complex.[22] Pollock painted a number of devastating images of women in the 1930s, for instance *Woman*, c. 1934, where a grotesque earth goddess is surrounded by six skeletonlike figures, and *Woman*, c. 1938–41, where an Indian head calmly presides over a stormy scene of destruction and severed limbs. Perhaps the most explicit indication of Pollock's negative anima complex occurs in one of the drawings [OT 508] that he gave to Dr. Henderson. A huge fleshy woman raises her hand to slap away a child who reaches out to suckle at its mother's breast. This speaks clearly of, in Henderson's phrase, Pollock's "frustrated longing for the all-giving mother."[23]

For a young man the negative anima complex can only be overcome by a union with the female anima, in other words by a union of opposites. This union can be envisioned as occurring between a male child and his mother or, more generally, between any two male and female principles.[24] On a psychological level, the male symbolizes consciousness and the female unconsciousness.[25] The union of opposites is essentially a union of conscious and unconscious psychic forces. The process of bringing these opposites into a harmonious balance Jung calls individuation. The goal is realization of the archetypal self, a fully balanced and integrated psyche.[26] Since Pollock's symbol making in the period around 1938–41 at which we have been looking revolves around the theme of a union of opposites, I feel that I can safely say that his symbol making, that is, his art, is related to his psychic life and, more specifically, to his efforts to resolve his negative anima complex and to achieve a union of psychological opposites, a harmony of self.

A further Jungian interpretation of Pollock's symbols is in order. Sun and moon are, according to Jung, archetypal symbols for male consciousness and female unconsciousness.[27] Because there is a scale of symbolism for projecting self that ranges from astral to animal to human, the evolution of the sun disc-crescent moon into the volute-foetal plumed serpent symbolizes some psychological progress.[28] The snake is an archetypal symbol for the negative female unconscious; the bird is an archetypal symbol for aspirations toward masculine consciousness.[29] Thus the plumed serpent is dramatically more than the borrowing of a primitive motif. It symbolizes a union of unconscious and conscious forces, an embryonic effort at psychological self-birth. Recall that the motif first occurs in a painting entitled *Birth*. Its presence in the more complicated context of *Bird* symbolizes striving for self-birth on a higher level. The emphasis on the wings of the plumed serpent dramatizes the longing of psychic energies for higher consciousness. The floating eye, toward which the plumed serpent flies, is the archetypal symbol for a conscious union of opposites, that is, self on an

elevated level.[30] However, the means, to achieving this higher level is the human, which in *Bird* is still embedded in the darkness of the lower register, symbolized by the two barely differentiated Indian heads. Both darkness and images of Indians are archetypally associated with the unconscious.[31] *Bird* is but an early step along the long path of individuation toward conscious self.

Pollock seems to have painted the schema for psychological growth in *Bird*, from the Indian heads via the plumed serpent to the eye, as if the very act of painting the symbols could help attain his goal. Indeed, this ritualistic attitude is paralleled and most probably reinforced by Jungian theory, for Jung says that symbol making is psychotherapeutic insofar as symbols bring to the surface contents of the mind that otherwise remain unconscious.[32]

The archetypal nature of Pollock's symbols, and of the individuation process they describe, invites comment. Did Pollock simply read Jung? From the recollections of those who knew Pollock, it seems that he did not. While his library as it existed at his death indicates his sympathy with the same kind of richly archetypal material that attracted Jung, most of the books he owned on the primitive, mythology, things Eastern, etc., were published in the middle and late forties.[33] The only book he owned by Jung himself, Jung's and Kerenyi's *Essays on a Science of Mythology*, was not published until 1949. A more likely explanation for the archetypal nature of Pollock's imagery around 1941 is saturation in Jungian thought while under Jungian analysis. It is a common phenomenon for Jungian patients to project both archetypal symbols and processes.[34] Though Pollock quit Jungian analysis in 1942, he in effect continues his auto-psychoanalysis, mediated by the images of his art.

In looking once again at *Moon Woman* (1942), the meaning of both the curious third eye, an eye-crescent, and its presence in a humanoid figure becomes clear. As in *Bird*, the third or single eye signifies a conscious union of opposites or self, even more clearly so in *Moon Woman* because the third eye is itself a variant of the disc-crescent motif. Instead of floating freely as it did in *Bird*, it is lodged in the forehead of an anthropomorphic figure whom Pollock calls in the title the moon woman. Pollock's anima, once expressed as a literal crescent moon, is now projected on a human level. The presence of the disc-crescent eye on the forehead of the moon woman announces that the locus of the drama of the union of opposites has shifted. No longer found on masks or associated with the plumed serpent, as in *Birth* and *Bird*, it is located within the moon woman herself. Pollock's anima, that is, the unconscious side of his psyche, contains the disc-crescent eye, promise of self-fulfillment. However, the motif is feverishly lodged in her forehead, as indicated by the surrounding frenetic lines. Before pursuing the resolution of the moon woman's tension in *Moon Woman Cuts The Circle* (1943), we should first trace the sources for the anthropomorphic woman in Pollock's work, which we will find related to a final reading of the painting.

One of the first appearances of Pollock's anima in full anthropomorphic form is found in a motif in the lower left-hand corner of a drawing entitled *Sleeping Woman*, c. 1941. Her fulsome white body is held by a rising serpent, suspended between earthy depths below and a many-eyed face above. Her forehead contains the third or one eye. In the lower left-hand motif of an untitled drawing, c. 1941 [OT 616], the "sleeping woman" awakes in the manner of Picasso's *Girl before a Mirror* (1932), which Pollock undoubtedly knew as it was purchased by the Museum of Modern Art in 1938.[35] Pollock's use of the double head is one of the first of several borrowings from Picasso, as he fashions the image of his anima as woman.[36] In *Stenographic Figure*, 1942, the awakening of Pollock's anima includes awareness of a male personage on the right of the painting. The anima figure on the left is a big-breasted Indian woman. Notice the featherlike projection from the top of her head. Though the female and the male are joined by reaching hands, the woman is, in fact, facing away from the male. Only the curious and very large eye faces his direction.[37]

Number symbolism and, as we shall shortly see, color symbolism become increasingly evident in Pollock's work from around 1942 onwards.[38] We may restrict ourselves here to recognizing the numbers and colors that bear most directly on Pollock's basic theme of a union of opposites. Out of the many stenographic notations covering the surface of *Stenographic Figure*, I would like to take note of just one numerical equation, 66=42, found on the red arm of the woman that reaches toward the man. Jung notes that the number 6 traditionally represents the hermaphrodite, or fusion of male and female.[39] The number 4 traditionally represents the totality of self.[40] For Pollock the totality of self is to be achieved by the union of two. Thus the numerical formula 66 = 42 can be seen as yet another statement of Pollock's desire for a union of opposites. Once questioned by Lee Krasner about the numbers 4 and 6, Pollock "insisted that 46 was his 'magic number.'"[41]

In *Male and Female*, 1942, as in *Stenographic Figure*, both male and female are present. But this time an actual union is depicted. The painting consists of roughly five upright rectangular panels, the second and fourth being tall humanoid figures. The buxom torsos of the figures, the diamond shapes found between them, and the resemblance of the central white rectangular area to another painting by Pollock entitled *Magic Mirror* (1941) all suggest another reference by Pollock to Picasso's *Girl before a Mirror*. While Picasso shows a voluptuous girl staring at her reflection in a mirror against a diamond-patterned background, Pollock, as he indicates with his title, wishes to show both a male and a female figure. The male and the female are difficult to distinguish because they both possess female torsos, one white, one red; however, the figure on the left has a curling limp phallus that is red, indicating that the figure is male, and the one on the right has a yellow triangle in the pubic area, indicating that she is female.[42]

Red and yellow are among the first colors to acquire a distinct symbolic

significance for Pollock.[43] They do so in conjunction with the male sun disc/ female crescent moon motif. We recall that in one of the drawings given by Pollock to Henderson the crescent moon, placed in the pelvic area of the composite image of woman, is yellow [OT 547]. By contrast, in others of these drawings the sun disc is red.[44] Thus yellow is associated with female, red with male. These color assignations reoccur in *Male and Female*: yellow female pubic triangle, red male phallus.

That the theme of *Male and Female* is actually the union of male and female is suggested by the appearance of both colors on each figure—note especially their heads—and by the ejaculation, represented by the scumbled pigment, from the white column on the left side and from the pubic triangle on the right side. The scumbled material on the far right-hand panel mounts up the canvas in the middle forming a volute shape, indicating that the female's sexuality should produce a foetus. Amid the many numbers scribbled on the adjacent black panel, 1, 2, 4, 1, and 6 are prominent at the top, underlined in red. 2, 4, and 6 were found in *Stenographic Figure*. Now the bringing together of opposites, 2, in order to make the union of opposites, 4, even the hermaphroditic fusion of male and female, 6, seems to be actually occurring in the sexual activity. The union of male and female is further represented by the central white rectangular area where three diamond shapes appear. A diamond shape in the belly of the Indian woman in an untitled drawing done c. 1942 [OT 610] suggests that the shape signifies fertility.[45] The same association of diamond with fertility seems to be made by Picasso in *Girl before a Mirror*, where the field of diamonds provides the wallpaper setting for the girl's contemplation of her sexual nature.

The presence of diamonds in *Male and Female* also suggests Pollock's reference to the esoteric lore of alchemy, a reference necessary to understand because diamonds play an important role in *Moon Woman Cuts the Circle*. Jung tells us in *The Integration of the Personality* that the diamond is a common symbol for the alchemical philosopher's stone.[46] That Pollock's interest in alchemy almost certainly derives from John Graham around 1941 is too extensive a topic to pursue here.[47] In 1942 his interest could have been reinforced by a number of sources. The Surrealist Matta, with whom Pollock had close contact in fall 1942–43, refers to alchemy in his paintings, the rocks with lines and dots inside them being philosopher's stones.[48] Another Surrealist, Kurt Seligmann, in his 1942 article in *View*, demonstrates a knowledge of alchemy, stating: "According to Jung, the alchemic process is mainly of a psychic nature."[49] Certainly Pollock, as a result of undergoing Jungian analysis, shared this view.

In *The Integration of the Personality*, published in English in 1939, Jung develops his theory that the alchemical process is a very apt metaphor for the psychic process of individuation. In alchemy, a protoscience originating in ancient Egypt but widely practiced in the Middle Ages and the Renaissance, the

alchemist attempts to transform base material into gold. As base material, prima materia, goes through four, sometimes seven stages of transformation in order to become gold or the philosopher's stone, so unordered psychic energy goes through the process of individuation in order to achieve self. Thus the philosopher's stone is a metaphor for individuated self.[50] Pollock probably painted the diamonds on the central rectangle between the figures in *Male and Female* as symbols not only of fecundity, or of philosopher's stones, but more importantly of psychological self, to be brought about by a union of male and female opposites. Alchemy is more than an esoteric source for Pollock; its symbols serve to express basic psychological desires.

Pollock seems to have been well acquainted with the rich store of alchemical symbols. While the philosopher's stone can be a diamond, gold, a pearl, a child, etc., the process for creating it can be a union of sun and moon, of male and female, of King and Queen, etc. The alchemical vessel can be a glass retort, a uterus, etc.[51] Pollock's awareness in *Male and Female* of alchemical symbols is suggested not only by the appearance of the diamonds and of the union of male and female figures, but also by the appearance of what could well be the alchemical vessel as uterus.[52] The white rectangular area is extended to the left by a yellow line that creates the overall shape of a uterus plugged into the torso of the male. That Pollock meant this shape to refer to the womb is evident in the upper right-hand motif in *Sleeping Woman* (1941).

The hopefulness in *Male and Female*, both of the depiction of the union of opposites and of the alchemical references, relates interestingly to Pollock's private life. In 1942, when *Male and Female* was painted, Lee Krasner, Pollock's future wife, moved in to live with him at 46 East 8th Street. Thus the numbers 4 and 6, scrawled on the black panel in the painting, take on very real associations with a union of male and female. Perhaps the progress in his personal life accounts for his treatment of the theme of union in increasingly human terms. Pollock's anima has grown from an incipient anthropomorphic stage in *Sleeping Woman* (c. 1941) to a more fully realized female in union with another male anthropomorphic figure in *Male and Female*. One might say that *Male and Female* commemorates a point at which his anima is more fully projected into his art, for *Male and Female* is recognized as one of Pollock's first masterpieces.

Despite the presence of both a male and a female figure in *Male and Female*, their separate identities are difficult to distinguish. In Pollock's painting in 1942 the male remains weak, sometimes nonexistent, and the moon woman remains the focal character. This is most evident in *Moon Woman* (1942). In this painting the moon woman has most of the anthropomorphic traits that I have traced as characteristic of the anima up to this point. She is double-headed, three-eyed, fully human, and even more strikingly Picassoid than Pollock's other representations of the anima.

Pollock's *Moon Woman* resembles Picasso's *La Niceuse*, a work that he could have seen in the 1937 *Cahiers d'Art*. In both works the eyes of the women are prominent and made up of disc-crescent motifs. In both, the women gaze at flowers. While Pollock's association of the eye with the disc-crescent motif is undoubtedly influenced by Picasso's use of a disc-crescent eye, it is immediately evident how Pollock subsumes borrowed motifs into his own psychological drama.[53] The flower, at which Pollock's moon woman gazes, plays the role of disc in yet another disc-crescent configuration. This floating motif reflects what is in her own disc-crescent eye. She has two other little eyes and points to yet a fourth eye. The moon woman, Pollock's anima, the creative side of his psyche, seems singularly intent upon seeing, that is, becoming conscious of, the symbol of the union of opposites, which in fact is feverishly lodged in her own person. This is as if to say that Pollock's potential for self-fulfillment resides in his creative anima.

An untitled drawing, c. 1943 [OT 704], serves to describe the all-containing quality of Pollock's moon woman. In the drawing the moon woman is shown throwing her head backwards as she prepares to pierce herself with a dagger. Her large eye stares at a tail-eating snake floating just above her face. Just as the floating motif in *Moon Woman* reflects what is in the moon woman's own eye, so the floating tail-eating snake is a reflection of the moon woman's nature. Though we have encountered the snake before as a symbol of the negative anima, it appears here in its very special form as a tail-eating snake. Pollock would probably have been familiar with a similar tail-eating plumed serpent illustrated in one of the Smithsonian volumes he owned and in Jung's *Integration of the Personality*.[54] According to Jung, the tail-eating snake is a symbol for the Uroborus, the primal self-contained Deity, containing both male and female principles, consciousness and unconsciousness, which are as yet undifferentiated. Governed by the uroboric snake, the moon woman is in Jungian terminology a Uroboric Great Mother.[55] The one or third eye, symbol of a conscious union of opposites, has been contained within her uroboric person since around 1941. Archetypally, the Uroboric Great Mother must break or cut the uroboric circle of her nature if there is to be any further growth of consciousness and subsequently any higher union of opposites.[56]

Pollock's awareness that an effort must be made in the direction of consciousness is indicated by the words aligned on the right side of the untitled drawing. Written words are rarely found in Pollock's work. However, Pollock and Lee Krasner did experiment on several occasions in 1942 with writing automatic poetry with Motherwell, Baziotes, and their wives. The words here are: "thick thin / Chinese American Indian/sun snake woman life/effort reality/total." The words deal with things that are opposite and with synthesis. As thick is opposed to thin, so Chinese seems to be opposed to American Indian. As we know, the American Indian has been used so far in Pollock's work to image forth his unconscious. Chinese would seem to refer to the conscious and, as we shall see, more

211

specifically to the Tao, the Chinese mystic's conscious way to a union of opposites.

The description of the Tao given in *The Secret of the Golden Flower*, a book variously described as being on Chinese yoga or mystical alchemy, and containing a commentary by Jung, seems to have a striking relevance to *Moon Woman* (1942). The book was translated into English in 1931 by Mrs. Cary Baynes, the woman who through Helen Marot referred Pollock to his first Jungian analyst.[57] This fact alone might well have brought the book to Pollock's attention. Jung's commentary explains that the Eastern world has always felt the collision of opposites, such as the intellect and the primordial, and so seeks a way to unite and perhaps transcend them. Tao is the method or conscious way to unite what is separated. Its symbol is the Golden Flower.[58] The yellow flower at which the moon woman stares in *Moon Woman* is unique in Pollock's work. It very likely refers to the Golden Flower as described in *The Secret of the Golden Flower*. If so, the flower in Pollock's painting dramatizes that consciousness for which the moon woman so intently strives.

Hidden allusions to yoga reinforce those to Tao. The seven hieroglyphs on the left of *Moon Woman* echo the seven *chakras* of yoga, illustrated in F. Yeats-Brown's *Yoga Explained*, 1937, a book owned by Pollock. The sixth *chakra*, or nerve center through which universal cosmic energy flows, is a third sun-moon eye, presenting a high level of psychic integration. Here we have another possible source for Pollock's use of a disc-crescent eye in *Moon Woman*.[59] But the moon woman's disc-crescent eye is in a state of tension. The seventh and topmost *chakra* represents a state of enlightenment. The analogous top hieroglyph is yellow. Therefore both the meaning and the color of the top hieroglyph would seem to echo that of the yellow flower, symbol of Tao. The moon woman's contemplative mood can be interpreted as focusing either on Tao or on yogic enlightenment. We recall that Tao is sometimes referred to as Chinese yoga.

The moon woman's contemplative mood gives way to action in *Moon Woman Cuts the Circle*. The figure of the 1942 moon woman is still present but she now has an Indian head, as in *Bird* and *Stenographic Figure*, and an extended crescent arm. This arm, wielding a yellow triangular dagger, cuts out the third eye, which had so agitated her earlier. There is a gash in her forehead and the circular eye is seen connected to the dagger by a red line. Literally, the moon woman cuts the circle. This action provides the title of the painting. As she cuts the circle of the third eye from her forehead, diamond shapes flow from the billowing area that joins the crescent shape and the Indian head. Cutting out the third eye, symbol of a union of opposites on one level, leads to the flow of diamonds, symbols of a union of opposites on the higher level of an individuated self. Knowledge of Pollock's earlier work and its symbols permits us to recognize the creativity of the moon woman's act of cutting the circle. It represents an extraordinary release of self-potential.

How does the moon woman manage to accomplish this creative act? She does so by differentiating into her male and female parts and by actually enacting a union of opposites. We already know that she contains a male-female duality because of her all-containing uroboric nature, indicated in the untitled drawing of c. 1943, and because of her disc-crescent eye in *Moon Woman* (1942).[60] The duality of male and female is stated in a number of small ways: for instance, the general dispersal of both red and yellow colors throughout the painting, and the appearance of the hermaphroditic number 6 in the lower left-hand corner of the painting. More significantly, the whole configuration of the painting can be viewed as an elaboration of the disc-crescent motif with its male-female connotations. The Indian head can be likened to a disc in relationship to the crescent arm. The reading of the painting as a confrontation between disc and crescent opposites is confirmed by a related untitled drawing done c. 1943 [OT 678]. There a dagger-wielding crescent confronts a feathered creature, and to the left a crescent hovers over a disc, which spews forth, gives birth to, a humanoid figure. The humanoid figure finds its equivalent in the painting *Moon Woman Cuts the Circle* in the diamond shapes. The ability of the moon woman to accomplish the creative act of cutting the circle would seem to depend upon this differentiation into her disc-crescent, male-female parts. The male force that makes this a particularly conscious act is most clearly indicated by the feathers that the moon woman wears. In adorning herself with a feathered headdress, the moon woman not only makes herself an Indian but also acquires the masculine and conscious attributes of a bird.[61] Recalling the moon woman's association with the uroboric serpent, one might say that Pollock is differentiating the moon woman not only into her disc-crescent parts but also into her bird and serpent parts, as she precipitates the confrontation of opposites in her nature.

The confrontation of opposites in the moon woman's nature is a paradoxical blend, at once a kind of death, involving violence and self-sacrifice, and a rebirth, engendering diamonds. Up until now, metamorphosis in Pollock's imagery has been in the direction of growth and birth. From *Moon Woman Cuts the Circle* onwards, the metamorphosis, though basically positive, is characterized by pendulum swings of death and rebirth. The belief in the necessity of death or an act of sacrifice preceding fertility or growth is widespread. Pollock could have encountered it in any number of places, one being alchemy.[62] Following the continuation of the alchemical metaphor in *Moon Woman Cuts the Circle* is one way of elucidating the sequence, even paradoxical simultaneity, of death and rebirth that occurs.

The tail-eating snake at which the moon woman stares in the untitled drawing, c. 1943, can be seen not only as the uroboric snake but also as the tail-eating snake of alchemy, probably the oldest pictorial symbol in alchemy.[63] This alchemical reference is expanded by the appearance of the numbers 1 and 3

within the circle of the tail-eating snake. The gold, or philosopher's stone, is often referred to in alchemical literature as the "trinus et unus."[64] But to reach it one must first slay the alchemical dragon or snake. The slaying of the alchemical tail-eating snake is implicit in *Moon Woman Cuts the Circle*, as is the alchemical reference bearing on rebirth, the hermetic vessel as womb. In *Male and Female* the hermetic vessel is suggested by the uterine shape plugged into the male. In *Moon Woman Cuts the Circle* the hermetic vessel is suggested by the whole abdomen area of the moon woman. The moon woman herself is the alchemical vessel, the locus of transformation. The diamonds she releases are the coveted philosopher's stones, or following their psychological meaning, symbols for an individuated self.

Once one has knowledge of Pollock's earlier paintings, the ramifications of *Moon Woman Cuts the Circle* proliferate and one sees just how deeply rooted the painting is in Pollock's earlier work. Certainly there is no longer a need to insist on the Haida tattoo pattern or the Hiawatha legend as sources for the moon woman and her act of cutting the circle.[65] Now we have seen that the moon woman does literally cut the circle of the third eye from her forehead, or one might say that she cuts the circle of the alchemical snake. Her act is the culmination so far of Pollock's basic theme of a union of opposites, whether conceived of as disc-crescent or bird-serpent. The peculiar nature of this particular union is that it is at once a death and a rebirth. But no matter how much Pollock complicates his basic theme of a union of opposites, no matter how richly he clothes this theme with primitive, Picassoid, alchemical or Eastern mystical imagery, its most essential meaning is psychological.

Moon Woman Cuts the Circle can be interpreted as the moon woman's act of cutting the circle of her own uroboric nature, where consciousness and unconsciousness remain largely undifferentiated. The confrontation that occurs in the moon woman's person is not only of male-female elements, whether disc-crescent or bird-serpent, but also of the analogous conscious and unconscious psychic forces. The unconscious moon woman, by making herself more conscious, precipitates the confrontation of the unconsciousness and consciousness within her own person. In this way she succeeds in cutting out the eye, symbol of self on one level, and releasing the diamonds, symbols of self on the highest level of all, individuated self, the most harmonious balancing of conscious and unconscious psychic forces. Here Pollock's American Indian moon woman proves herself to be a "Chinese American Indian" as she works toward a more conscious union of opposites.

Cutting the uroboric circle is an important early step in individuation.[66] Every young man must sacrifice a union of opposites contained within the psychological mother and thereby free himself for an encounter with the next stage of psychic life, a union of opposites on a more differentiated level between a rec-

ognized unconsciousness and a separate consciousness. Confirmation that Pollock's anima did release a new male consciousness comes in a most interesting untitled collage [OT 1024]. It is related to work Pollock did for an exhibition of collages that Peggy Guggenheim held at Art of This Century Gallery in spring 1943. For stylistic reasons David Freke dates this collage after *Moon Woman Cuts the Circle*.[67] I would concur, adding the psychological meaning of the collage as a confirmation of this chronology. Though it looks at first as if it did not contain any figural elements, the collage has in fact a head, with the profile facing right, and a hand attached to the left side of the head. On the head the numbers 4 and 7 are prominent. At the level of the neck Pollock's signature appears, written in a shaky mirror writing with only the "son" of Jackson Pollock seen in forward script.

One can conjecture that the head is the head of Pollock himself. If this is so, it is one of the first major appearances of his head in his art. The head traditionally connotes the more conscious aspects of a man, and the hand has spermatic and creative significance.[68] A conscious, male presence is evident. The numbers 4 and 7 have alchemical meaning. There are most often seven stages of alchemical transformation leading up to the final totality or quaternity of the philosopher's stone, or following the psychological metaphor, of psychological self.[69] Why the curious signature? The writing of "son" in forward script would seem to say that it is not just a part of Pollock's signature, but that it is his new name, "son," one presumes the son of the Great Mother, newly released from the uroboric womb in *Moon Woman Cuts the Circle*. Following *Moon Woman Cuts the Circle*, the collage marks the rebirth of the male psychic principle, as ego consciousness and son.[70] Characterized by a conscious head and a creative hand, the male is now free to pursue the female unconscious and achieve a union of opposites on a higher and more differentiated level.

Beyond generating psychological birth of an independent male consciousness, *Moon Woman Cuts the Circle* can be seen as Pollock's self-birth as an artist. The painting of *Moon Woman Cuts the Circle* coincides remarkably with the making of his contract with Peggy Guggenheim and the promise of his first one-man show that fall. *Moon Woman Cuts the Circle* can even be seen as the image of the act of creation itself. To embody the movements and transformations of his psychic energy, which are essentially the subject matter of his art, Pollock had begun to master the metamorphic quality of line, visible in the various metamorphoses of the disc-crescent motif. In *Moon Woman Cuts the Circle*, he for the first time depicts this transformation of psychic energy in terms of an actual physical action, the swing of the crescent arm, the gashing of the forehead. For Pollock, the act of creation is not just the action of the imagination, but is increasingly a physical act. Eventually he will be able to translate the depiction of an action in terms of images into a sense for the movement of paint itself, and

215

ultimately into the action of his own arm and body, as he pours paint onto the canvas.

Moon Woman Cuts the Circle can be seen as the psychological paradigm for the creative act in Pollock's work, not only in 1943 but also throughout his career. "The source of my painting is the unconscious." This 1947 statement is made explicit in the imagery of *Moon Woman Cuts the Circle*. The moon woman, Pollock's unconscious anima, is the source of the creative act. As Pollock tells us in the title, it is the moon woman who cuts the circle. The unconsciousness of her nature differentiates into consciousness, precipitating a confrontation or union of the unconscious and conscious, which of itself releases the diamonds. There is the promise here of eventual complete harmony. Of course consciousness changes over the years. As Pollock's consciousness gains in strength, the union of psychological opposites becomes more harmonious. To trace the growth of these psychological forces through the imagery of his paintings between 1943 and 1947, and the integration of these psychological forces with stylistic transformation, would require a book. A look at one painting, however, shows that the moon woman's creativity, first announced in *Moon Woman Cuts the Circle*, does fulfill its rich promise. In *Development of the Foetus*, 1946, the male conscious figure unites harmoniously with the female unconscious figure, the anima, and engenders in her womb not diamonds, not even a literal child, but abstract raw pigment, the stuff with which Pollock will create his mature abstract paintings of 1947.

Notes

Ever since this article appeared in 1979 my approach has been pegged as "Jungian," a label that fails to do justice to even that article, and even less to my current work. In this article I did not present Pollock as a "Jungian illustrator," nor did I think Jungian theories "correct," as Michael Leja charges (see *Reframing Abstract Expressionism: Subjectivity and Painting in the 1940's*, New Haven, 1993, p. 353, n. 84). I doubt whether "correctness" can ever be demanded of such theories. Jung's was but one attempt to articulate the human project, an attempt I find both prejudiced, but also unusually illuminating. I do remain convinced that Jungian ideas played an important part in the development of Pollock's art. For one, they offered him a lens through which to look at his own art and life; for another, they offered him occasions to which he responded with his own visual thinking. And there can be no doubt that Jungian ideas encouraged him to understand his own very personal quest as one possessing significance for humanity. It is possible to object that in my attention to the symbolism of Pollock's art I failed to pay sufficient attention to its concrete materiality and form. I gladly grant this point. But this article is concerned first of all with symbols. That something does not get mentioned does not mean that I consider it unimportant. Two recent articles show more clearly what I take to matter; and in a book that is nearing completion I hope to show that to do justice to Pollock we have to leave behind both Greenberg's version of modernism and various reactions to it, that we should place him instead in the tradition of a far richer, even romantic, modernism, that includes not only Picasso, but also Kandinsky, Mondrian, and the Surrealists. It is in this context that Pollock's appropriation of Jungian ideas gains its significance. An understanding of Pollock's distinctive pictorial energy, even in the poured paintings, will, I feel, grow out of attention to the dialectic between the evolution of his symbolic imagination and the evolution of his picture making. And to understand this dialectic, which threads the entirety of Pollock's art, we must look at the symbols in the paintings and related drawings. And here this 1979 article still has a contribution to make.

I. In 1934 the already emotionally troubled Pollock, working as a janitor at the City and Country School in New York City, was befriended there by a teacher, Helen Marot, a woman in her early seventies. Marot was deeply interested in psychology. She was closer to Sherrington, Herrick, and the behaviourists, but she knew the work of Freud and Jung. In 1939, with Marot's help, Pollock was referred to a Jungian analyst. Francis V. O'Connor, "The Genesis of Jackson Pollock: 1912 to 1943" (Ph.D. diss., Johns Hopkins University, 1965), p. 93, n. 33.
2. This statement is excepted from a conversation on the labels "nonobjective" and "non-representational." The full quote is: "I'm very representational some of the time, and a little all of the time. But when you are painting out of your unconscious, figures are bound to emerge. We're all of us influenced by Freud, I guess. I've been a Jungian for a long time." Quoted by Selden Rodman, *Conversations with Artists* (New York: Devin Adair, 1957), p. 82. The painter Barnett Newman, who knew Pollock in the 1940s, has stated, "Jackson was very Jungian." Telephone interview of Barbara Reise with Barnett Newman, April 20, 1965, quoted in Reise, "'Primitivism' in the Writings of Barnett Newman" (unpublished Master's thesis, Columbia University, 1965), p. 41.
3. On archetypes, see Carl G. Jung, *The Interpretation of the Personality* (New York: Farrar and Rhinehart, 1939), pp. 52–53; on their universality, see Jung, *The Archetypes and the Collective Unconscious*, Bollingen Series 20, The Collected Works of C. G. Jung [hereafter referred to as C.W.], vol. 9, part 1 (Princeton: Princeton University Press, 1968), pp. 79–80.
4. Adolph Gottlieb and Mark Rothko (in collaboration with Barnett Newman), "Letter to the Editor," *New York Times*, June 13, 1943, sec. 2, p. 9, quoted in Irving Sandler, *The Triumph of American Painting: A History of Abstract Expressionism* (New York: Praeger, 1970), p. 62.
5. See O'Connor, "Genesis," pp. 13–20.
6. For review of literature touching on Pollock and Jungian psychology, see Langhorne, "A Jungian Interpretation of Jackson Pollock's Art through 1946," (Ph.D dissertation, University of Pennsylvania, 1977), pp. 4–7.
7. Statement quoted in Francis V. O'Connor, *Jackson Pollock* (New York: The Museum of Modern Art, 1967), p. 40. See especially Harold

Rosenberg, "The Mythic Act," *New Yorker*, 43 (May 6, 1967), p. 162.
8. The dating of this painting is discussed by David Freke, "Jackson Pollock: A Symbolic Self-Portrait," *Studio International*, 186 (December 1973), p. 219.
9. Judith Wolfe, "Jungian Aspects of Jackson Pollock's Imagery," *Artforum*, 11 (November 1972), pp. 69–70; Freke, p. 219.
10. I have already published some of this material in a more abbreviated form in a Letter to the Editor, *Artforum*, 11 (March 1973), p. 7. For a full discussion of the motif and its appearances, see Langhorne, "A Jungian Interpretation," pp. 99–135.
II. On moon, see Jung, *Symbols of Transformation*, C.W., 5 (Princeton: Princeton University Press, 1967), pp. 203, 318; on sun, pp. 89, 203, 205. [*Symbols of Transformation* is a revised edition of *Psychology of the Unconscious*, first published under the new title in 1952 in German, then in 1956 in English.] Also see Erich Neumann, *The Great Mother: An Analysis of the Archetype*, Bollingen Series, 47 (Princeton: Princeton University Press, 1963), pp. 55–57.
12. See Langhorne, "A Jungian Interpretation," pp. 106–35. I plan to publish this material in the near future in an article to be titled "Jackson Pollock and John Graham."
13. The foetal connotations of the volute form are corroborated by the following small detail. The curving strings of dots on the outer circumference of the foetal shape in *Birth* are reminiscent of a similar string of dots in one of the psychoanalytic drawings, illus. in Wysuph, *Jackson Pollock*, plate 13. This motif derives from a diagram of the female pelvic region illustrated in William Graves, *Gynecology* (Philadelphia: W. B. Saunders & Co., 1916), p. 412, owned by Pollock. In drawing the volute shape, Pollock definitely had in mind a foetal connotation.
14. See exhibition catalogue, *Indian Art of the U.S.* (Museum of Modern Art, 1941), p. 87. Another figure in the upper middle of the untitled drawing [OT 521], a serpent with feathers, echoes the one found in Orozco's Dartmouth Library panel, *Aztec Warriors* (1932–34), suggesting that Pollock's interest in the Aztec motif stems from Orozco. Pollock could have been familiar with this panel through reproductions in either Albert Dickerson's edition of *The Orozco Frescoes at Dartmouth* (Dartmouth, 1934) or Lawrence E. Schmeckebier, *Modern Mexican Art* (Minneapolis: University of Minne-

sota Press, 1939).

15. O'Connor, *Jackson Pollock* (1967), p. 23.

16. Quoted in O'Connor, "Genesis," pp. 71–72.

17. Quoted in ibid.

18. For discussion of libido theory, see Jung, "On Psychic Energy," in *The Structure and Dynamics of the Psyche*, C.W., 8 (Princeton: Princeton University Press, 1969). Also see Jung, *Symbols of Transformation*, part 2, chap. 2, and p. 173.

19. Dr. Henderson diagnosed Pollock's illness at its worst as being near schizophrenia. See Anonymous, "How a Disturbed Genius Talked to His Analyst with Art," *Medical World News*, February 5, 1971, p. 18.

20. See Jung, *Modern Man in Search of a Soul* (New York: Harcourt Brace, 1933), pp. 68–70.

21. On the anima, see Jung, *The Integration of the Personality*, pp. 73–81, and Jung, *Psychological Types*, C.W., 6 (Princeton: Princeton University Press, 1971), pp. 467–72.

22. On the negative anima, see Jung, *Symbols of Transformation*, pp. 174–75, 179.

23. Excerpt from Henderson's unpublished essay, "Jackson Pollock: A Psychological Commentary," which focuses on the drawings given Henderson by Pollock during the course of analysis. Quoted in C. L. Wysuph, *Jackson Pollock: Psychoanalytic Drawings* (New York: Horizon Press, 1970), p. 17.

24. Jung, *Psychology of the Unconscious* (New York: Moffat Yard & Co., 1916), p. 194.

25. Ibid., p. 251.

26. Jung, *The Integration of the Personality*, pp. 30–51, also pp. 26–27, 95.

27. See note 11.

28. Jung, *Symbols of Transformation*, pp. 23, 171.

29. On snake, Jung, *Psychology of the Unconscious*, p. 292; on bird, Jung, *Symbols of Transformation*, p. 347, and Jung, *Psychology and Alchemy*, C.W., 12 (Princeton: Princeton University Press, 1968), p. 201. [*Psychology and Alchemy* is a revised edition of *The Integration of the Personality*, first published under the new title in 1944 in German, and in 1953 in English.]

30. Jung, *Symbols of Transformation*, p. 91.

31. On darkness, see Jung, *Psychology and Alchemy*, p. 329; on images of Indians, see Jung, *Psychology of the Unconscious*, pp. 205–07. For a history of Pollock's interest in Indians, see Langhorne, "A Jungian Interpretation," pp. 101–05.

32. Jung, *The Integration of the Personality*, pp. 89–91.

33. See Langhorne, "A Jungian Interpretation," Appendix A, pp. 354–55, for a partial list of Jackson Pollock's library as it existed at his death.

34. See Joseph L. Henderson, *Thresholds of Initiation* (Middleton, Conn.: Wesleyan University Press), p. 52.

35. In borrowing from Picasso to create his moon woman, Pollock stresses lunar aspects latent in *Girl before a Mirror*. He extends the girl's tuft of hair before a mirror to become the two tips of a crescent moon. Meyer Schapiro has also noticed the lunar aspect in the Picasso, likening the profile of the girl before the mirror to "a moon crescent," in "A Life Round Table on Modern Art," *Life*, 25, no. 15 (October 11, 1948), p. 58.

36. *Girl before a Mirror* probably also provoked Pollock's earlier use of the double head in *Masqued Image*, c. 1938–41. See Langhorne, "A Jungian Interpretation," p. 114.

37. Another instance of Picasso's influence on Pollock's depiction of his anima occurs in *Stenographic Figure*. In both the painting and a related study, illustrated in O'Connor, *Jackson Pollock* (1967), p. 85, the woman's stance, with her profile facing left, her eye frantically dislodged, and her hand reaching to the right, as well as the black vertical backdrop behind her, suggests Picasso's woman with a dead child, the extreme left-hand figure in *Guernica*. The distraught eye of the Pollock woman does not convey anguish over a dead child, but rather agitation at the confrontation with a male personage.

38. For more complete discussion of number symbolism in *Stenographic Figure*, see Langhorne, "A Jungian Interpretation," p. 147. Pollock could have encountered number symbolism in a variety of places: Theosophy, see Madame Blavatsky, *The Secret Doctrine* (1947), 11, p. 592; primitive lore, see W. J. McGee, "Primitive Numbers," *Ann. Rept., Bur. of Am. Ethnology*, 19, part 2 (1897–98), a volume owned by Pollock; Jung, and alchemy as discussed by Jung, see note 40; John Graham, see Langhorne, "A Jungian Interpretation," p. 356; Kurt Seligmann, see Seligmann, "Magic Circles," *View*, 1, no. 11–12 (February–March 1942), n. p.

39. Jung, *The Practice of Psychotherapy*, C.W., 16 (New York: Pantheon Books, 1966), p. 238, note 8.

40. Jung, *The Integration of the Personality*, pp. 40–41; Jung, *Psychology and Alchemy*, p. 26; Henderson, *Thresholds of Initiation*, p. 61.

41. Conversation of Judith Wolfe with Lee Krasner, noted in Wolfe, "Jungian Aspects," *Artforum*, 11 (November 1972), n. 65.

42. Freke, p. 218, also points out the relevance of Picasso's *Girl before a Mirror*, noting its bisexual characteristics, which reinforce the eroticism of the image, and which are treated by Pollock more analytically. I would note Pollock's extreme psychoanalytic treatment. Each figure, both male and female, has two sides to it. The male figure on the left with his black semi-circular head, having yellow-red starry eyes, has the indications of a second face. Notice the delineations of a nose and a mouth facing right. The female figure on the right seems to have a back mysterious part, consisting of the black, numbered, rectangular panel, surmounted by a red crescent and yellow triangular nose and eye motif. Her front side consists of the buxom white torso and a part of a full white disc face with the indication of an eye facing the man. The white disc face can be likened to a full moon, and the red crescent to a crescent moon. The female is in effect a moon woman. One might say that Pollock was drawing the dual natures of male and female, showing both the conscious white side of the female and her unconscious dark side, her animus. Interestingly, it is the conscious male animus side of the man which is least developed of the four psychological aspects, and which is reaffirmed in the untitled (*Jack'son'*) collage of c. 1943. See OT 1024.

43. Color symbolism is common in Indian ritual and in alchemy, both probably inspiring Pollock. In both, red is associated with a procreative male force. See Jung, *Psychology and Alchemy*, pp. 231–32. See *Ann. Rept., Bur. of Am. Ethnology*, 11 (1889–90), p. 529, a volume owned by Pollock.

44. For sun disc, see Wysuph, *Jackson Pollock*, plate 59.

45. This drawing probably derives from an untitled Mougins drawing by Picasso, August 5, 1938, illustrated in *Cahiers d'Art*, vol. 13, no. 3–10, 1938, p. 169, and owned by Mrs. Meric Callery of New York City.

46. Jung, *The Integration of the Personality*, p. 266.

47. See Langhorne, "A Jungian Interpretation," pp. 127–31.

48. The painter Onslow-Ford reports that Matta stated this. Conversation of Irene Clurman with Onslow-Ford, February 22, 1969, quoted in Clurman, *Surrealism and the Painting of Matta and Magritte*, Stanford Honors Essay in Humanities, no. 14

(Stanford, Calif., 1970), p. 19, n. 49.

49. Seligmann, "Magic Circles."

50. See Jung, *The Integration of the Personality*, pp. 189, 266.

51. See Jung, *Psychology and Alchemy*, pp. 231–32

52. Ibid. The colors associated with the four steps of the alchemical process, in sequence black, white, yellow, and red, are also all present in *Male and Female*. Blackness or *nigredo* is the initial chaotic, death-like stage. Whiteness or *albedo* is the second, positive, washed and conse-crated stage, associated with day-break and the moon condition of the female. Yellowing or *citrinitas* is in alchemy a transitory stage to redden-ing or *rubedo*, associated with sunrise and the sun condition of the male. When *rubedo* is achieved, the final union of male and female can take place. The predominance of the white rectangular panel in *Male and Female* suggests the early hopeful stage of *albedo*.

53. The appearance of the disc-cres-cent eye in Picasso's *La Niceuse* sug-gests Picasso as a source for Pollock's earlier uses of the disc-crescent motif. Picasso used the disc-crescent motif frequently in the early 1930s in other depictions of woman, for instance *Figure in a Red Chair* (1932), and in depictions of bullfight scenes, for instance *Bullfight* (July 1934), and in depictions of playful encounter, for instance *Circus (Acrobats)* (1933) or *Three Women by the Sea* (1932). He also used it in his studies for *Guer-nica*, for instance *Weeping Head* (October 13, 1937).

54. *Ann. Rept., Bur. of Am. Ethnology*, 17, part 2 (1895–96), fig. 266; Jung, *Integration of the Personality*, p. 227, plate 7.

55. See Erich Neumann, *The Origins and History of Consciousness*, C.W., 42 (Princeton: Princeton University Press, 1954), pp. 5–38, 46, 95. Also see Jung, *Integration of the Personality*, p. 46.

56. Neumann, p. 105.

57. Wysuph, *Jackson Pollock*, p. 13.

58. Jung, "Commentary," in *The Secret of the Golden Flower: A Chinese Book of Life* (New York: Causeway Books, 1975), p. 98.

59. The sun-moon *chakra* suggests yoga as a source for Pollock's earlier uses of the disc-crescent, sun-moon motif. As a third eye, it also perhaps accounts for the appearance of the one eye in *Bird*. Their meanings are similar.

60. The bisexual characteristics of the Uroboric Great Mother are described by Neumann, p. 95.

61. Jung describes, in *Symbols of*

Transformation, p. 183, a similar acquiring of attributes when Miss Miller fantasizes an Aztec head wear-ing a feathered headdress. While Jung describes the animus of a young woman, Pollock depicts the more conscious and male aspects of his anima.

62. Sacrifice preceding fertility is a theme of Frazer's *The Golden Bough*, a book owned by Pollock. It figures in the story of Hiawatha, as told by Jung in *Psychology of the Unconscious*. Cutting a woman away from the moon is one of the events leading up to the birth of the hero Hiawatha. But, as we now know, the Hiawatha story is but one possible source for Pollock's ideas. The human sacrifices made by the Aztecs to the Terrible Mother to induce fertility and good crops were also probably known to Pollock. Images of Aztec warriors rip-ping out the heart of a living man with an obsidian knife are illustrated in *Cahiers d'Art*, vol. 14, no. 14, 1939, p. 49.

63. Jung, *The Integration of the Personality*, p. 227.

64. Ibid., p. 249.

65. While the amount of compara-tive material relevant to *Moon Woman Cuts the Circle* that can be drawn from Jung's *Psychology of the Unconscious* (see notes 61 and 62) is striking, it should be noted that Pollock was actually experiencing the archetypal psychological process-es described in the book. Freke's the-sis, p. 217, that Pollock's themes derive from a reading of the book, especially chapter 7, does not acknowledge the organic and truly psychological nature of Pollock's treatment of the themes. For Pollock's continued references in *Moon Woman Cuts the Circle* to Picasso's *Girl before a Mirror*, see Levin, "Jackson Pollock," in Robert C. Hobbs and Gail Levin, *Abstract Expressionism: The Formative Years* (New York: Herbert F. Johnson Mus-eum of Art and Whitney Museum of American Art, 1978), p. 99.

66. Neumann, pp. 35, 105–06.

67. Freke, p. 219.

68. Jung, *Symbols of Transformation*, p. 183; Neumann, p. 141.

69. On 7, Jung, *Integration of the Personality*, p. 112; on 4, Jung, *Psychology and Alchemy*, pp. 218, 346. The alchemical reference is extended in a related untitled drawing in which we see a man's head defined by a quadrangle superimposed with a triangle, illustrated in Langhorne, "A Jungian Interpretation," plate 141. Jung quotes *Rosarium*, an alchemical guidebook: "Out of a

man and a woman (opposites) make a round circle and extract the quad-rangle from this and from this quad-rangle the triangle. Thus make a round circle and you will have the philosopher's stone," in *Psychology and Alchemy*, p. 128. The man's head, made up of a quadrangle and a trian-gle, can be seen as part of the process of making the philosopher's stone, the new self. The first round circle might be viewed as the circle of the plumed serpent in *Birth* and *Bird*, or the circle which the moon woman cuts in 1943.

70. Interestingly, the anthropomor-phic male "son" image in Pollock's work later acquires the attributes of sun and bird, recapitulating Pollock's earlier use of these symbols of a male principle. For instance, see Lang-horne, "A Jungian Interpretation," pp. 205–06.

William Rubin. "Pollock as Jungian Illustrator: The Limits of Psychological Criticism." *Art in America*

67, NO. 7 (NOVEMBER 1979): 104–23; 67, NO. 8 (DECEMBER 1979): 72–91. ORIGINALLY PUBLISHED IN ART IN AMERICA, BRANT PUBLICATIONS, INC., NOVEMBER AND DECEMBER 1979.

One might even say that Pollock himself used the . . . hermeneutic method.

—Elizabeth Langhorne

The work of the five authors examined in this article warrants characterizing the '70s as the "Jungian decade" of Pollock criticism. Their thinking is highly speculative and their theories often ingenious—although many of their prime demonstrations collapse under close scrutiny of the paintings involved. Art resists interpretation through closed systems. While Jungian hermeneutics unquestionably illuminates aspects of Pollock's early enterprise, its application by these critics as an exclusive approach both falsifies and leaves too much unsaid. Nevertheless, the seriousness of their endeavor obliges a critique in kind.

Earlier commentators had largely passed over the possible significance for Pollock's work of his involvement with Jungian analysis.[1] Carl Gustave Jung's name went unmentioned, for example, in the perceptive essay by Sam Hunter that introduced the catalogue of the first Museum of Modern Art retrospective (1956) and in the earliest monograph on Pollock, that of Frank O'Hara, published in 1959. Both authors related the early '40s figurative pictures to Picasso and late Surrealism, emphasizing especially the interest in myth and ethnological art shared by the Surrealists and many of the New York painters. O'Hara analyzed key early works in terms of the psychological implications of various classical myths but mentioned Freud alone—and only in passing.

The earliest reference I know to the influence of Jung on a specific image of Pollock occurs in Bryan Robertson's monograph of 1960. Alluding to the interest of the American painters of Pollock's generation in "the theories of Freud and Jung," Robertson noted that Pollock was "in close touch with a Jungian analyst" and "greatly influenced by the writings and teachings of Jung"; in this context he cited a few examples of the artist's "concern for a Jungian interpretation of mythology" insisting especially on *Moon Woman Cuts the Circle*, 1943, which "comes very clearly from a Jungian interpretation of matriarchy in which the moon is the matriarchal sphere. . . ."[2] He attempted no "reading" of the picture, however, beyond that somewhat vague observation (vague in that there is, after all, no moon in the painting—though there are some roughly crescent-shaped forms—and neither the personage on the right, who wears a male Indian headdress, nor the serpentine form on the left would be taken for a female protagonist without the prompting of the title).[3]

A year after Robertson's monograph, Lawrence Alloway prepared an excel-

lent catalogue for a small Pollock retrospective at London's Marlborough Gallery and published a related text in *Art International*. His observations, though summary, ring truer than much subsequently written on the subject of psychology in Pollock's art. "Psychology, clinically experienced or as a part of the 20th-century history of ideas," Alloway wrote apropos of Pollock's figurative pictures, "has reduced the distance between archaic gods and heroes and ourselves. . . . Myth in Pollock's hands was never an exercise in classical allusion but kept that enigmatic center which it is the function of myth to preserve." To that end, "the figurative works are not pre-planned but improvised." "They are," Alloway insisted, "images invented and found in the act of painting." While Pollock's "sessions with a Jungian analyst" were mentioned, they were seen only as a possible "reinforcement" to the myth-making attitude he shared with other New York artists.[4] Francis V. O'Connor's doctoral dissertation of 1965 took a somewhat similar approach to the question of specificity in Pollock's early-'40s psycho-symbolic imagery: ". . . where recognizable motifs are utilized," he wrote, "their context is usually deliberately mysterious—deliberately poetic—and never dictated by theoretical considerations or a desire for legible 'meaning.'"[5]

My own texts in *Artforum* in 1967, devoted as they were to the allover poured[6] paintings, touched only lightly on the possible sources—psychological or otherwise—of Pollock's earlier art. Among my theses were that the nonfigurative 1947–50 paintings represented (along with the mature art of Rothko, Newman, Still and others) a new kind of poetic, indeed, visionary abstraction, very different from that of high Cubism or of Delaunay, Mondrian or Kandinsky, all of which had emerged primarily from perceptual imagery, that is, from a process of selecting and transforming data observed in the world without. "The impulse toward poetic abstraction," I noted, "[was] fostered by contact with Surrealism [and] abetted by the interest Pollock and other members of his generation had in ethnic and primitive art. Signs and symbols drawn from such sources—and filtered through an awareness of Jung—alternate in Pollock's [early] work with iconographies suggested by classical mythology in surreal, Freudianized form."[7] This symbolic "myth-making" imagery of the early Pollock I saw as "going underground" during the transition into the "classic" poured paintings. With the establishment of the latter style, the imagery disappears, though we recognize its psychic wellsprings in the poetic and visionary spirit immanent in these wholly abstract works.

With the exception of a note on *Moon Woman Cuts the Circle*, in which Alloway referred to a letter from Herbert Read suggesting a specifically Jungian source for the image,[8] Pollock criticism, it would be fair to say, had treated the subject of a possible "psychological iconography" only summarily up to 1970, the year in which the so-called "Psychoanalytic Drawings" surfaced. The exhibition that year at the Whitney Museum of the works on paper Pollock had left

with one of his Jungian analysts, Dr. Joseph Henderson, announced the Jungian decade (though the publication three years earlier of O'Connor's invaluable chronology[9] was no doubt also a stimulus). The catalogue of the 1970 exhibition by C. L. Wysuph[10] and the subsequent articles by Judith Wolfe,[11] David Freke,[12] Elizabeth Langhorne (also author of a brilliantly researched doctoral dissertation on Pollock and Jung)[13] and Jonathan Welch,[14] form a critical constellation anchored in Jungian hermeneutics and unified, despite individual differences, by a number of shared assumptions. Foremost among these is that the referential character of Pollock's early-'40s imagery is "specific" ("fairly" so for Freke, "remarkably" so for Langhorne), and that it "lends itself to quite precise interpretation in the light of Jungian psychology" (Langhorne). All seem to accept, as Freke puts it, that in the early '40s Pollock adopted "a consciously Jungian program for his work."

The contrast between the paucity of references to Jung in the Pollock criticism of the '50s and '60s and the central role the Swiss psychiatrist plays in that of the last decade, suggests more than a reflexive tendency often operative within criticism. The writing of the earlier decades had addressed itself largely, though far from exclusively, to Pollock's allover poured pictures. These were quite rightly judged his most daring, most original and best works; they were also the ones that seemed most difficult to grasp and therefore the most in need of analysis and elucidation. As the total abstractness of those paintings prevented the identification of specific iconographies, there was little inclination to think of Jung. Freud came more readily to mind insofar as the paintings' automatist aspects—and their evident, if peripheral, involvement with chance and accident—were at least partially related to Surrealist ideas and practices inspired by Jung's mentor.

This understandable concentration on Pollock's "classic" paintings did an inadvertent injustice to the later work, particularly the stained black pictures of 1951–52, and to the paintings of 1942–46; the latter, though undeniably less original than the work that followed, nevertheless number among them some extraordinary masterpieces.

While the criticism of 1950–70 ran the gamut from the analytic to the poetic, the nature of the poured pictures on which it focused virtually guaranteed an important role to stylistic analysis. Moreover, the critics were writing during a period in which two generations of major artists were keeping alive in their work the challenges and problems of ambitious abstract and non-figurative painting. The rarity of formal discussion of Pollock in the '70s—E. A. Carmean's informative essay on the 1950 paintings[15] is the sole important exception—and the emphasis on iconography in general and Jung in particular no doubt reflect a pervasive tendency of the past decade. Nor does it seem to me accidental that this focus on iconography—on ideas capable of being verbalized rather than on

painterly structure or poetic allusiveness—should have emerged during a period that has experienced simultaneously a crisis in abstract painting and a new movement, Conceptual Art, whose more "advanced" forms may exist only semantically, requiring no embodiment in a precisely determined object.

Whatever reinforcement of the tendency to purely iconographic explication may be attributed to the zeitgeist, a shift in the backgrounds of the critics themselves may also have played a role. Most of the pre-1970 Pollock writing came from critics—some of them painters and poets—who circulated elsewhere than in a university art-history environment. Moreover, those few art historians who did discuss Pollock in the '60s were also—with perhaps one exception—active critics of contemporary art who haunted the studios and numbered important painters of the Pollock and the post-Pollock generations among their friends. As the international consensus on Pollock's importance confirmed itself in the '60s, he became increasingly a subject for art history. Much of the commentary on him in the last decade, the Jungian criticism especially, has come from young writers just emerging from art-history graduate schools (many of which witnessed in the '70s a marked impetus in favor of social, political and psychological—as against stylistic—studies). Whether influenced by this trend or no, the Jungians have adopted an almost exclusively literary, intellectual approach that smacks more of the library than the studio. Little sense of Pollock as painter comes through; in fact, almost everything they say about his work could have been said about a bad painter working with another method in another style—a retardataire Surrealist *imagier*, for example—as long as he used the same symbols. Their texts reflect virtually no awareness of the way in which the problems and choices of the painting process bear upon the determination of the forms and colors that they interpret only iconographically. This entails faults ranging from a misleading overall conception of how Pollock painted to a number of specific misreadings of his imagery (some of them probably due to working from photographs and reproductions rather than the pictures themselves).

As the topic of my caveat is the limits and limitations of this Jungian criticism, I should say at the outset that beyond detailing an important aspect of the spiritual and cultural environment from which Pollock's art emerged, a few of these writers—Langhorne, in particular—have provided some valuable insights into the iconography of certain early pictures (which I cite in the monograph on Pollock I am now completing). Certainly a painter who was involved for the better part of four years (1939–42) in Jungian analysis and whose pictures of 1938–44 often deal with mythological or seemingly mythological subjects must have been at least indirectly influenced in his work by his analytic experience. And when this painter says "all of us [are] influenced by Freud, I guess, I have been a Jungian for a long time,"[16] and deploys a syncretistic mélange of primitive, archaic and mythic elements in his images, it is highly probable that his art

223

not only reflects a concern for Jung's central thesis of the "collective uncon-scious" but contains at least some references to particular images and symbols discussed in his analytic sessions. How much *more* than this we can say is the crucial point. How specifically we can identify and interpret these references, how much we can enter into the mind of the painter, how much we can attribute to this or that image—and especially to the whole series of images—the intervention of Jung's writings or Pollock's analytic sessions are the more prob-lematic questions raised by this new criticism.

In his catalogue essay for the exhibition of Pollock's "Psychoanalytic Draw-ings," Wysuph made use of an unpublished text by Dr. Henderson himself[17] (who had recently sold the 82 drawings and one gouache to the commercial gallery of which Wysuph was "curator"). Wysuph began with the mistaken assumption that the 83 works left in the hands of Henderson constitute a cate-gory of their own—i.e., "psychoanalytic drawings"—made specifically by Pollock for the purposes of his therapy. Greater familiarity with Pollock's work and less interest in a promotional public relations splash would have led Wysuph to the conclusion that the works in question, which ranged from very elaborate and finished pieces to random quick sketches, did not differ in character, style and/or iconography from other works of the same period (1939–40) not directly associ-ated with Pollock's analysis. While a few of the drawings might conceivably have been experiments done specifically for his analytic sessions, it is evident that Pollock simply brought Henderson examples of the work he was doing. As virtually all Pollock's work from the late '30s onward begins from "automatist" assumptions and involves an improvisational development of the image that subsumes ideas linked through free association *all* his work lent itself to being analyzed from a psychological point of view. As the painter no doubt recognized, there was no need to create pictures specifically for his analysis.

The observations of Wysuph—and through him, of Henderson—were often of an alarming naïveté, as much for some of their psychological generalizations as for their few interpretations of the drawings. Indeed, Wysuph's "minimal use" of the drawings themselves "confirms one's general impression"—the psychoan-alyst Eugene Glynn noted "of this whole, sad shabby enterprise."[18] Henderson reportedly diagnosed Pollock as schizophrenic.[19] The frequency of female figures in the drawings was interpreted as a quest for the "all-giving mother," a con-tention Wysuph supported by citing Henderson's banal observation that "Pollock's mother was central to his difficulties."[20]

When Wysuph and Henderson addressed the drawings themselves they drew conclusions that might or might not have had validity for the images of children or psychotics but certainly failed to take into account that Pollock was making *art*. The drawing reproduced here, for example [OT 501], was said by Henderson to indicate Pollock's "state of withdrawal"—thus exemplifying,

added Wysuph, the diagnosis of schizophrenia. Why?
- Because of the "ambiguity of line—that is, lines and shapes serving several functions."
- Because it shows a "claustrophobic compaction of forms within a specified area."
- Because "a thin white line surrounds an agitated rendering of confused human and animal forms."[21]

Most readers of this magazine will no doubt recognize every one of these "symptoms" as basic pictorial devices. A linear ambiguity that fosters multiple readings had been the stock-in-trade of Miró and Masson in making their hybrid *personnages* and had also occasionally been employed by Picasso, whose influence on Pollock was primary. Indeed, Rosalind Krauss was to focus on this ambiguity as a particular *virtue* of the Pollock drawings in question.[22] Moreover, the forms in this drawing, disposed in a familiar late Cubist manner, are no more "claustrophobically compacted" than those of many related Picassos or Surrealist works of the late '30s and far less so than many of the allover pictures characteristic of New York painting around 1950 (de Kooning's *Attic*, for example). Certainly these paintings were not all symptomatic of schizophrenic withdrawal. Finally, Pollock's addition of a little framing device (the "thin white line") around his hybrid "monster" was obviously done to make his image more taut and expressive by setting it in a defined limited space as distinguished from its more amorphous relation to the support as a whole. Later, he would frame many paintings in the same way—by determining the precise location of the edge of the field *after the execution of the image*. Some of the black pictures of 1951–52 gained in intensity in a manner analogous to the Wysuph example precisely by Pollock's having "closed down" on their images when determining the framing edge.

The tendency of Jungians to interpret unfamiliar configurations as symptoms of mental problems is perhaps most poignantly illustrated by Henderson's analysis of *Guardians of the Secret*. The central panel of this 1943 painting has long been recognized as adumbrating—in its loosely scattered quasi-allover calligraphy—Pollock's more abstract paintings of the following years. While not fully resolved, its prophetically disjoined and freewheeling articulation was a radical attempt to implement a more fluid and lyrical configuration than those suggested by received geometrical modes of composition (as exemplified by the schema of the *Guardians* as a whole). Henderson, however, recognized in the central panel only "the essential elements of [Pollock's] sickness," which were being "walled off" by a "scaffolding" that, while "seeming to 'guard' the secret, really exposed the *inner confusion* all the more clearly." Faced with a visual configuration that he could not grasp, that he could not see as anything other than "confusion," Henderson called for "a return to the world of"—you guessed it—"significant form."[23]

Wysuph's 1970 text, unlike those by the critics we will next consider, was only partially devoted to Jungian interpretation. Indeed, much of it consisted of a vulgarization of previously published ideas. He did, however, posit a notion that in one form or another was to remain central in the subsequent Jungian literature, namely that Pollock's pre-1947 symbol-making was occasioned by mental illness and constituted a form of self-analysis that conditioned his art as a whole. "Only during his 'classical' drip period," wrote Wysuph, "was Pollock free of his need to elicit unconscious experiences, and only then was his psychological stability sufficient to suspend his alcoholism and permit him to approach the canvas analytically, *without therapeutic directives.*"[24]

Judith Wolfe, the first of Pollock's serious Jungian critics to publish, cast this thesis in somewhat less clinical, more literary terms with the suggestion that Pollock's early-'40s work be seen as what Jung called the "descent into the unconscious" or "night sea journey." Here the protagonist, "reliving the psychic history of mankind" contends with the oppositions deriving from the "biopolarity of human nature" (to continue Jung's terminology) especially the struggle against "the all-devouring Terrible Mother." The emergence from this "Hades," the assumption of mental health, takes the form of a union or resolution of these opposites in a unity that eliminates the conflict and makes possible "the restoration of the whole man" (a process known as "individuation"). Wolfe sees the struggles of Pollock's "night sea journey" resolved by 1947, which henceforth permits him to make "magnificent 'outpourings.'"

This more specifically Jungian paradigm also underlies the text of Freke's "symbolic self-portrait" of Pollock, which, though it appeared a month after Wolfe's, was obviously developed independently. Freke argues, however, that Pollock's "unfolding narrative of the life, death, and rebirth of the Jungian archetypal hero" may be perceived in the iconography of the 1942–43 works alone and that "the one place where all [its] themes come together" is "the seventh chapter of Jung's book *Symbols of Transformation*. . . ." He sees *Pasiphaë*, painted late in 1943, as "the end of the cycle," after which Pollock "freed himself from the need of a consciously Jungian program." Langhorne, in her turn, grants that the picture on which much of Wolfe's and Freke's reasoning turns, *Moon Woman Cuts the Circle*, "can be seen as Pollock's self-birth as an artist" and, indeed, as the "psychological paradigm for the creative act in Pollock's work not only in 1943 but also throughout his career." But while she accepts this picture as representing "an important early step in [Pollock's] individuation," Langhorne argues that it is part of a more prolonged symbolic drama that reaches its climax only in late 1946, just before Pollock began his poured pictures. This paradigm—only loosely sketched in Wolfe's article—is the underlying concept of Langhorne's dissertation, in which its unfolding is presented in great detail. For Langhorne, it is not until *Shimmering Substance* of 1946, executed just prior

to the adoption of the pouring technique, that Pollock's "final rebirth"[25]—his "selfhood"—can be regarded as achieved. Henderson/Wysuph had attempted (naïvely, as we have seen) to "psychoanalyze" the stylistic data of some of the images with which they dealt, thus permitting Wysuph to carry his story into the purely abstract paintings. Subsequent Jungians have been almost entirely concerned with the identification and interpretation of *symbols*. Not surprisingly, therefore, even the most extended narrative—that of Langhorne—comes to a halt with the poured paintings.

The thesis of a disturbed Pollock beginning about 1938 to explore his unconscious in a "night sea journey," confronting deep-lying problems masked as animals, hybrid anthropomorphs and monsters, and emerging "cured" by late 1946 is certainly attractive. Anyone with the least sympathy for Pollock's work will grant that the symbol-making aspects of the 1938–46 pictures reflect a quest for self-knowledge and that certain problematic aspects of their imagery and formal structure—expressions of contradiction and antagonism—seem to disappear, resolve or at least realign themselves as Pollock confirms his allover poured style. It was, moreover, during the making of the poured pictures that the primary symptom of Pollock's problems, his chronic alcoholism, disappeared for an extended period.

To be sure, the suggestion of a self-analysis on Pollock's part was not entirely new. In 1964, Thomas Hess, after noting the "whiff of the shaman and of Jung" and the "primal hordes" of Freud "in the atmosphere of Pollock's 1942–46 images," added that "it was as if Pollock had undergone a pictorial analysis" which "released" his "instinct for painting."[26] There are important distinctions to be made here, however. Hess's "pictorial analysis" covers formal as well as imagistic aspects of the pictures, and he is careful to characterize the analysis-through-art as a simile—it was, he says, *as if*; the Jungian critics, on the contrary, see Pollock using the symbols in his paintings in actual self-analysis. Moreover, where Hess hints that art-making helped Pollock in the resolution of personal problems, the Jungian psychodynamic model envisions the system working conversely, so that "Pollock's Jungian psychotherapy" becomes "important. . . in [his] dealing with his art" (to which he is said to take a "therapeutic attitude").[27]

The Jungian model for Pollock's development has a certain ring of truth, and some symbols in the works of 1939–43 have an unquestionably Jungian flavor—although their meanings are often difficult if not impossible, as we shall see, to pin down or confirm. Yet the Jungian paradigm remains only a partial truth, only one of many ways of approaching a subject we can never know completely. This is never admitted by the Jungian critics, who not only often state their surmises as facts but seem largely oblivious to other interpretive approaches. Even among psychological models—and there are other criteria than psychology for characterizing Pollock's development—the Jungian one has

manifest limitations. It seeks out, for example, only those symbols that can be assimilated to a system of archetypes of the "collective unconscious" as defined in Jung's writings. Those aspects of the images that—while no less symbolic—are peculiar to Pollock, that belong to an aspect of his psychology and personal history not universally shared or easily mythologized, are of little interest to the Jungians. While, for example, they dwell on the animal imagery that lends itself to their purposes, they overlook, in the pictures of the same period, such motifs as chairs, mirrors, ladders, palettes and tables—which evoke other networks of associations, among them the painter's studio. Even though our lack of knowledge of Pollock's inner life and the details of his everyday existence makes it difficult to identify, not to say interpret, such personal references as were surely cast up in the development of his improvisational imagery, any balanced account of his psychology must also explore these more "Freudian" possibilities. Indeed, one has the impression that wittingly or no, the Jungian critics have inherited the antagonism to Freud's ideas that marked Jung's own writings. Not only is such *parti pris* alien to the art-historical approach, but it runs counter to Pollock's admiration for Freud, whom he recognized as the greatest of the explorers of the unconscious. To illustrate his insistence that painting confront the modern world, Pollock always said "it has to deal with Einstein and Freud," Lee Krasner Pollock recalls. "These two names—not that of Jung—" she observes, "were always coupled in his definition of modernity."[28]

It is not my purpose in this article to elaborate an alternative Freudian model for Pollock's psychological development, but a few observations will demonstrate that strong claims could be made for such a construct. In the Freudian paradigm, Pollock would not be seen primarily in conflict with the Terrible Mother, the Jungian *agon* that dominates the analyses of our writers, but in an Oedipal situation, struggling against symbolic father figures, one of whose crucial embodiments is easily identified in the paintings of 1938–46 as Picasso.

Among Picasso's familiar masks or alter egos important for Pollock is that of the Minotaur—a mythic being passed over in Jung's writings[29]—whose horns the Surrealists had characterized as symbols of Eros (libido) and Thanatos (the death-wish), the poles of the Freudian psychodynamic for the functioning of the unconscious. The anthropomorphic bull figures in Pollock's imagery in the Henderson drawings of 1939–40 and in the paintings of that period [*Mask*, c. 1941, and *Head*, c. 1938–41] clearly attest to his experience of Picasso's (and probably also Masson's) Minotaur images, many of which were exhibited in New York in the late '30s and early '40s and were, in any case, widely reproduced in *Cahiers d'art* and *Minotaure*. Indeed, the ubiquitousness of the Minotaur legend in Picasso and late Surrealism makes it a more immediate and likely candidate for absorption into Pollock's personal mythology than many of the references—some very obscure—which the Jungian critics adduce from books by Jung that

Pollock almost certainly never read. Even assuming (riskily) that the substance of such texts had been recounted to Pollock in his analytic sessions, one might still wonder whether words (Jung's) would influence a painter—especially of Pollock's makeup—as intensely as images (Picasso's).

The Minotaur leads us in turn to the image of the labyrinth, a mythological projection of the recesses of the mind that the Surrealists assimilated from Freud (and that was later to be evoked in relation to Pollock's poured pictures[30]). In the center of the labyrinth (the unconscious) resides the Minotaur, symbol of irrational impulses and undirected libido expressed by a bull's head "collaged" on a human body. Theseus' quest is an allegory of the conscious mind threading its way into its own unknown regions. Sought out in the heart of darkness, the Minotaur is slain, and Theseus finds his way back again by virtue of intelligence, that is, self-knowledge—Ariadne's thread symbolizing the tissue of revelations woven of free association and dreams (whose linkages are almost literally embodied as line in "automatic drawing").

It is easy to see why the myth of Theseus and the Minotaur was recognized as providing a paradigmatic schema for Surrealist theory, as indeed, for the whole process of psychoanalysis. Certainly it constitutes, in the symbolic imagery of Pollock, an alternative to various embodiments of the "night sea journey" described by Jung. An investigation of Pollock's taurine/equine imagery of 1938–44, extrapolated from the corrida/crucifixion iconography of *Guernica* and related images[31] would provide another. Jungian critics direct primary attention to American Indian and Pre-Columbian legends and art; these remained always of some interest to Pollock, and they surely provided symbols for certain of his images, especially in the late '30s. By the end of that decade, however, such "indigenous" sources had been joined by others derived from Picasso and late Surrealism under the sign of Freud. These more European sources—which accompanied Pollock's assimilation into the mainstream of avant-garde painting—came increasingly to influence his early-'40s imagery as they did his style. This new orientation is consistently underestimated, however, by the Jungian critics because it does not satisfy the needs of their *a priori* psychological construct.

The technique of automatism, for example, that underlies most of Pollock's early-'40s paintings and is exploited in unprecedented ways in the allover works, was a direct extrapolation into image-making of Freud's ideas of free association, the "undirected" hand supposedly recording mediumistically the messages of the unconscious. This procedure—with its concomitant invocation of chance and accident, both also dealt with by Freud—is marginal in Jungian theory and is thus virtually omitted from consideration by the writers before us.[32] With few exceptions, Pollock's works of 1942–46 began without preconceptions, symbolic or otherwise, in an improvisational, automatic manner. (Pollock called this "direct" painting and emphasized that he made no preliminary studies.) As in

Miró's approach or Masson's, the image was developed as the artist worked on it, his method becoming progressively more conscious and less automatic as the picture proceeded. Pollock's open-ended, exploratory procedures in the early '40s works thus reveal direct parallels to those of the "abstract" Surrealists. And while the pictures of both contain some of the type of symbolic references to primitivism and myth central in Jung, the unique and very *personal* kinds of images Pollock and the Surrealists produced in this radical manner were embodiments of free will and invention. They could not have been more different in character and esthetic form from the images of the Aztecs, Eskimos or American Indians, whose pictorial language and methods were traditional—that is, part of a received vocabulary, collective and ritually stylized.

This article is no more devoted to anatomizing a "pictorial paradigm" for Pollock's development than to elucidating a Freudian model. It should be observed, however, that the almost total inattention on the part of the Jungian critics to the plastic aspects of Pollock's formation must be accounted their greatest flaw. With the partial exception of Wolfe, they treat Pollock in purely iconographic terms so long as they can read in the paintings—or as is often the case, read *into* them—"usable" (i.e., mythic, storytelling) symbols. Only after 1946 does Pollock appear to them as something other than an *imagier*.

Apart from splitting Pollock's development between 1942 and 1950—a continuous progression despite false starts, tangents and slippages—into two utterly contrasting periods (1942–46 and 1947–50), this position involves a double blindness. First, it overlooks the fact that much of the content of the 1942–46 pictures depends not on imagistic symbols but on direct plastic expression (which was increasingly inventive and abstract in the three years *prior* to the poured paintings). And second, it fails to comprehend that the "classic" poured works—like all other paintings, figurative or not—are inherently symbolic because the language of painting is nothing if not symbolic. Every picture, especially those improvised directly, can be approached as what Meyer Schapiro calls a "mosaic of decisions," in the implementation of which the artist willy-nilly projects on to the support in symbolic fashion his deepest psychological and spiritual conflicts, and in the very act of structuring the configuration seeks their resolutions. The same, of course, can be said in an overarching sense of the drama revealed by any sequence of an artist's pictures. For the viewer, a picture is an isolated object, a closed, self-contained system of meanings and, to that extent, an end. For the painter, the making of it is part of a process of self-interrogation and self-discovery and is therefore also a means. I would not, however, extenuate the mystery of this process in the case of Pollock or any other serious artist by calling it "therapeutic." Freud would have agreed: "Before art," he admitted, "psychoanalysis lays down its arms."

Pollock intuited very early the analogy, the profound and mysterious inter-

connection, between giving order to one's pictures and to one's life. As an art student of 20 he had written his father: "the art of life is composition—the planning—the fitting in of masses—of activities. . . . I've got a long way to go yet toward my development—much that needs working on—doing everything with a definite purpose. Without purpose for each move, there's chaos."[33] A few months later, he wrote his mother: "Painting and sculpturing is life itself (that is for those who practice it) and one advances as one grows and experiences life. So then [my progress] is a matter of years—a life."[34] Equilibrium is a continuing dramatic factor in painting as it is in life, and must constantly be regained. For a painter such as Pollock, who realized that his growth as both man and artist meant rejecting yesterday's solutions, every new picture was a peril. Thus, risky as was Pollock's technique (especially after the mid-'40s), his attitude toward painting, like that of all great modern painters, was even riskier.

The pictorial paradigm for Pollock's growth that I outlined in 1967[35] is based, of course, on the assumption that *pictorial problems and their resolutions are not formal exercises or disembodied professional games but significant projections of psychic and spiritual states*, whether or not the esthetic structures involved accommodate images. Approached from that perspective, Pollock's work from 1940 to 1950 shows a progression involving a variety of dynamics:

1. Overarching, binding geometries (sometimes superimposed on passages of great freedom and inventiveness) in compositions of 1940–43 are gradually fragmented over the next three years and absorbed (through the discipline of Cubism) into what emerges in 1946 as Pollock's non-geometric, anti-hierarchical, allover configuration; this conception, in turn, engenders new problems that are solved over the following years in part through the implementation of the pouring technique.

2. Drawing becomes progressively more abstract. Line is used less and less to define "readable" images and increasingly to delimit abstract planes, ultimately becoming autonomous in the poured works by ceasing to define planes at all;[36] the autonomy of this abstract graphism, which unifies the composition through an allover rhythmic articulation, is already anticipated in the "scribble" of such pictures as *Stenographic Figure* of 1942 and in the poured passages of several paintings of 1943. It is further developed in the drawing of various works of 1945–46, notably in the prophetic *There Were Seven in Eight* (discussed in Part II).

3. Color moves from a context of juxtaposed panels (derived in part from Synthetic Cubism as prolonged into the '30s by Picasso) to a more fragmented context (reminiscent morphologically of Analytic Cubism) and is finally atomized by the crisscrossings of the poured webs (which thus reveal affinities to the Impressionist tradition). In the poured pictures, color has become largely "tonal"; we are aware of color rather than colors,[37] though the richness of the dominant hue—the green of *Full Fathom Five* or the raspberry of *No. 1, 1949*, for example—

231

depends upon the myriad accents of other colors infused into the web. (In a marvelous image, Pollock described this elaboration and enrichment of the canvas on the ground before him as "gardening" the picture.)[38] The color of the 1942–43 paintings (unlike those of the late '30s, which largely recall American Indian and Mexican art) is essentially "European." But this palette, indebted to Picasso and Miró among others, is gradually made more personal as the color tends to favor secondary and tertiary hues and begins to take on an almost disembodied luminescence (in *Gothic*, 1944, for example), final disengaging itself completely from "form" in the elusive optical molecularity of the poured works.

The above is but a rough summary of certain of the progressions that constitute a pictorial as opposed to psychological model for Pollock's development. It contains other parallel components I have also discussed in detail elsewhere, such as his increasing sensitization to and exploitation of the paint substance itself, and the progressive assimilation and elimination (by digesting and transforming them) of influences from other painters. All these interlocked changes show us a Pollock gradually finding his unique vision and becoming master of his means.

The paradigm they come together to form parallels more than it contradicts the psychological models (and has the advantage of components that are more easily verified in the pictures than are—as we shall see—the mythic references of the Jungians). The tension at the outset, for example, between the freely invented local passages and the diagrammatic binding geometries that often hold them in place suggests a conflict in the artist himself between his instinct for maximum liberty, for an improvisational freedom that just skirts chaos, and his contrary need for an absolute, sometimes *a priori* order. This can be likened to Jung's "conflict of opposites" in the "night sea journey," just as Pollock's resolution of these tendencies in the synoptic "oneness" of the poured compositions—a reconciliation of maximum freedom with structural density—could be called the "union of opposites" that makes possible his Jungian "selfhood." By the same token, Pollock's descent into past art, his confrontations with the work of Benton, Orozco, Picasso and Miró (to name a few) might be likened to the perils faced by the hero in the "night sea journey." His overcoming of these *monstres sacrés* by making their magic his own—a process in which his pictorial ontology recapitulates (a very particular slice of) the phylogeny of art history—would mark his "individuation" as a painter.

The most important contradiction between the psychological and pictorial models is in the role attributed by each to imagistic symbols in the work. For the Jungians, these symbols are the essence of Pollock's art through 1946. They believe Pollock to have assumed a "therapeutic" attitude toward his psychic malaise and to have projected it in the form of concrete symbols; the artist is described as able, via Jungian self-analysis, to overcome testings (e.g., shamanis-

tic initiation rites[39]) and to rout demons (e.g., the Terrible Mother), a process resulting in a series of "rebirths" of which the definitive one takes place in autumn 1946, with *Shimmering Substance.*

Shimmering Substance is an allover (non-poured) painting containing a suggestion of a vestigial circular motif—almost an "after-image"—not all of whose remnants were "painted out." Langhorne takes this hinted circle to be a Jungian mandala "superimposing a pattern of order on [the] psychic chaos" represented by the field of "raw scumbled pigment. . . [which is] the unchannelized libido of the dissolved [earlier] imagery." Thus, the circle, not the composition as a whole, is said to represent "the goal of a fully individuated self for which Pollock has striven at least since the beginning of his Jungian analysis in 1939 and more consciously since the birth of the hero in his paintings in 1943."[40] With Pollock's "selfhood" achieved in *Shimmering Substance*, "the continuing transformation in [his] work," Langhorne adds, "will be in the realm of the manipulation of abstract paint [sic] in the evolution of a new style, the drip style. . . ." "While one has become used to following psychological meaning in Pollock's images [up to *Shimmering Substance*] one must learn," she cautions, "to expect meaning in his abstraction."[41]

Nothing could more clearly distinguish my approach from that of the Jungians than the way we parse this painting and situate it in Pollock's development. Langhorne considers the surface of *Shimmering Substance* made up of "chaotic and unformed" pigment saved only, as it were, by the presence of the barely visible circular motif. I find the entire painting coherently articulated throughout, but in an unexpected, dispersed manner that makes the overpainted circle (or any other overarching geometrical structure) vestigial. This new allover configuration, which Pollock would soon elaborate through pouring, is not a configuration at all to Langhorne—not to say a new and challenging one. She sees the circle as the symbolic *conclusion* of Pollock's "night sea journey"; I see the work as a whole more as a *transition* leading to the poured paintings. Apart from the question of whether Pollock's "selfhood" or "individuation" is not more fully achieved in the great poured paintings than in this small work of 1946, one wonders why it is only thereafter that "meaning" can be sought for in abstraction as opposed to imagery. The false polarity on which such an assertion is based confirms one's suspicion, aroused by the writing of all the Jungian critics, that Pollock's impressive and often highly abstract *pictorial* accomplishments in the early and mid-'40s paintings they discuss are not being appreciated.

Wolfe and Langhorne see Pollock's "therapeutic" symbol-making procedure extending through 1946. I see Pollock's symbol-making diminishing radically as early as 1944 as his energies as a painter are increasingly taken up with the problems and possibilities of direct expression. As the only Jungian critic to deal extensively with this period, Langhorne notes a diminution of symbolic preci-

sion in the face of Pollock's new painterly concerns, but it never occurs to her (or her colleagues) that Pollock might well have experienced between 1944 and 1946 a crisis of belief in the potency—whether pictorial or "therapeutic"—of such symbols. I consider that what has been called the Expressionism of Pollock's early and mid-'40s works—the anxiety, conflict and, ultimately, violence reflected in many of their iconographies and expressed plastically in compositional discontinuities, convolutions, truncations, angularities and asperity of color—in part reflected an incongruity between the painter's extraordinary potentialities (and ambitions) and his inability, at that time, to forge a vehicle sufficient to their fullest, most personal realization.

Between 1944 and 1946 the inherent antagonism between Pollock's symbolic imagery and the plastic aspects of his enterprise became increasingly acute. He seemed to have wanted the imagery to carry a message, but only of a nonspecific, unverbalizable kind. As carriers of meaning, his early-'40s symbols appear frequently to have fallen short (he was always in a *Search for a Symbol*, as one of his titles has it[42]), and some of the pictorial exacerbation in his work derived from his plastic assaults on these images, in the form of repainting and painting out. His painterly "attack"—using even then sticks,[43] palette knife, and the tube itself in preference to the brush—seemed more and more aimed at forcing the recalcitrant symbols to carry the kind of content he was subsequently able to express in purely pictorial terms. It was above all this violence in Pollock's "attack" that led to the characterizations of his early-'40s pictures as Expressionist. Only with the poured pictures of 1947 (*pace* Langhorne), where Pollock eliminated simultaneously the last vestiges of symbolic imagery and the last manifest traces of borrowed pictorial ideas in a style that realized his full identity, did the Expressionist element as such disappear. The violence, frustration and asperity that partly informed the earlier works were now transmuted into a passionate lyricism—a subtly hued, choreographically rhythmic art capable of both Baroque drama and Rococo fragility and grace. The gap between an inherited language and a burgeoning new content, between instinct and self-awareness, in short between the potential and the actual, had been closed.

Reading and Misreading:
Moon Woman Cuts the Circle

It gives one something of a jolt to consider that the painting found by the Jungian critics to be the single most important work in Pollock's early development should have been omitted despite its availability from both of Pollock's American museum retrospectives.[44] This emphasis dramatizes, I think, the specialized character of what the Jungians seek and value. *Moon Woman Cuts the Circle*, of 1943, is an agitated, compact, smallish composition, more interesting

than good, which quite clearly owes its recent eminence to a unique combination of a recognizable American Indian in its imagery and a mythopoeic title that—until we look at the picture—appears frankly descriptive.[45] I doubt, nevertheless, that it would have received so much attention had not Sir Herbert Read written to Lawrence Alloway in 1961 remarking on its similarity to a Haida Indian tattoo of a woman in the moon published by Jung. Read added that there was a "reference on the same page to a Hottentot legend about 'cutting off a sizable piece' of the moon." Alloway excerpted this letter in his catalogue for the Marlborough Gallery (London) retrospective,[46] and when, more than a decade later, Wolfe initiated serious discussion of Jungian influences, Pollock's "borrowing of [this] specific Jungian motif" illustrated in *Symbols of Transformation* seemed to her the ultimate confirmation of her broader thesis regarding the artist's use of Jung's ideas and writings.

Wolfe noted, to be sure, that Sir Herbert had been wrong about Jung's discussion of the Hottentot legend; it referred to the sun and not the moon. Nevertheless, she accepted the Haida tattoo as the source of the "semicircular entity" on the upper left of *Moon Woman Cuts the Circle*, and added that in the chapter in which Jung reproduced the tattoo, he discussed at length the legend of Hiawatha, in which a woman who lives in the moon plays an important role. Only a month later, Freke, focusing on the same painting, pointed out that Pollock would not have seen the tattoo as no edition of Jung's *Symbols of Transformation* published before 1952 contained a reproduction of it.[47] Freke nevertheless considered Jung's discussion of the Hiawatha legend as the source of the picture, somewhat finessing the fact that what is cut in this tale is not a circle (or moon) but a vine—and that it is not the Moon Woman (Hiawatha's grandmother) but her jealous lover who does the cutting.

Langhorne, in a letter to the editor of *Artforum*, in which Wolfe's article had appeared, also made the point about the dates of the Haida illustration, concluding that the "tantalizing possibility of directly relating a work of Pollock to a Jungian illustration. . . is laid to rest."[48] Later she would confirm that "Jung as a visual source for Pollock's imagery is very largely a false assumption," but she observed nevertheless that the "possibility [of Jung] . . . as a literary source remains." Indeed, although Langhorne finds the Hiawatha legend "unlikely" as an influence on *Moon Woman Cuts the Circle*, she frequently points to Jung's writings as possible sources in other contexts. This, despite her own admission that "from the recollections of those who knew Pollock, it seems that he did not [read Jung]." In fact, though Pollock had long owned a copy of Freud's *Interpretation of Dreams*, he possessed neither of Jung's principal texts, *Symbols of Transformation* (earlier known as *The Psychology of the Unconscious*) or *The Integration of the Personality* (later retitled *Psychology and Alchemy*). Indeed, the only book by Jung in his library—*The Myth of the Divine Child and the Mysteries of Eleusis* (written in

collaboration with C. Kerenyi)—was first published in 1949, three years after Pollock had given up his symbolic imagery.

The constant recourse to Jung's texts alluded to by Pollock's Jungian critics seems to me as mistaken as the assumption that he borrowed from Jung's illustrative materials. This leaves us essentially with his analytic sessions, in which, we must presume, some of this material was discussed. They (the sessions) would be at the origin of the unquestionably Jungian spirit that inhabits much of Pollock's early imagery, especially that of 1939–42.[49] But as we have no knowledge of just *what* was discussed, the entire question takes on a speculative character quite opposite to the ambience of scholarly precision and verifiability that Pollock's Jungian critics are at pains to project. Such precision, in any case, presumes—as they both imply and on occasion declare—that Pollock "consciously" introduced Jungian references, indeed, a whole "program" of them. Given Pollock's working method, I find such *a priori* planning for the pictures inconceivable and alien to the nature of the painting. As Pollock himself said in 1944, doubtless referring to *Moon Woman Cuts the Circle* among other pictures: "Some people find references to American Indian art . . . in parts of my pictures. *That wasn't intentional*; [it] probably was the result of early memories and enthusiasms."[50] Note that Pollock refers here to his early interest in American Indian *art*, not to discussion of Indian lore or imagery in psychoanalytic sessions. If the influence of Indian art on an Indian motif in Pollock's work was at most "unintentional," how much more so would have been the use of any literary/psychoanalytic source?

Nothing more dramatically underlines the speculative character of Jungian interpretation than the differences between the critics themselves in identifying the iconography of given pictures, especially the pivotal *Moon Woman Cuts the Circle*. Wolfe, for example, considers the semi-circular creature in the upper left with the diamond patterned body to be the Moon Woman; the smaller black arc emerging near its "head" would be an arm whose extremity holds the dagger in the top center; Wolfe says nothing about any circle being cut. Langhorne, on the contrary, identifies the personage at right with headdress and facemarkings as the Moon Woman and, in a reading that truly strains credulity, describes the entire curvilinear figure on the left as the Moon Woman's "extended crescent arm," which, wielding the dagger, "cuts out [her] third eye" (to the right of the dagger's handle). Thus, "literally," Langhorne insists "the Moon Woman cuts the circle."

I find neither of these readings convincing. If Wolfe is correct, the left-hand figure would probably be a serpent-deity (which makes some iconographic sense of the Picasso-inspired diamond patterning)[51] and the circle being cut would by implication be the archetypal circle of the tail-eating snake, with which Pollock was familiar from images in American Indian and Pre-Columbian art[52] and which appears in at least one of his drawings of the early '40s. Of course, this

interpretation carries us quite a distance from Jung's Hiawatha/Moon Woman, but it is not inconsistent with the kind of syncretism—the fused and confused recollections of early imagery—that Pollock's automatist/associational method of the time often engendered. While Langhorne's reference to a "third eye" is provocative, her reading of the entire left-hand figure as an arm of the Indian on the right is inconsistent with the nature of all Pollock's other figuration in this period. Moreover, she still has the problem of reconciling the fact that the figure she calls the Moon Woman is wearing a headdress that Pollock, given his familiarity with Indian traditions, surely knew was a man's. Langhorne resolves this contradiction by the strained argument that the "creative act" of cutting out what she calls a third eye was made possible for the Moon Woman only by "differentiating into her male and female parts and actually enacting a union of opposites."

The attempt to reconcile Pollock's images with given ideas or texts of Jung—indeed, to precise them at all—seems to me to posit another kind of identity than really inhabits these pictures. Forcing a Jungian straitjacket on them less elucidates meaning than it diminishes poetic resonance. As Pollock said of his 1943 *She-Wolf:* "Any attempt on my part to say something about it, to attempt the explanation of *the inexplicable*, could only destroy it."[53] Pollock was, of course, here speaking only for himself. But his remark confirms that he did not program into the image any specific symbolic meaning; else how could it be "inexplicable" to its maker?

Forcing images so that one finds in them what one is looking for is, regrettably, characteristic of the Jungian interpretation of many of Pollock's most important early pictures. Take, for example, the Jungian reading of *Stenographic Figure*, 1942. Here, following O'Connor,[54] Langhorne reads the image as *two* figures—despite the singular noun of the title; the "big breasted woman" on the left is seen as "joined by reaching hands" to a male figure on the right.[55] What Langhorne reads as a "featherlike projection from the top of the [female] head" suggests "an Indian Woman"—which conveniently permits her to link the picture more readily with the main thread of her argument. I do not think there is any question but that *Stenographic Figure* presents us with only *one (reclining female) protagonist.*[56] Langhorne is prompted to see two figures by the desire to characterize the female personage as a Jungian "anima figure" of the hypothetical male on the right. She reinforces this vision of confrontation between the masculine and feminine components of Pollock's psyche with a Jungian interpretation of numbers scribbled on the surface (about which more in Part II). If, however, there is only *one* figure, then the theory is wrongly applied and the numerical symbolism misconstrued. And if the "figure" of the title is both woman and clawed animal, as I think is quite clearly the case, we are led to a series of psychological associations very different from those Langhorne describes.

What I take to be another characteristic Jungian misreading of an impor-

tant early work is the interpretation of the lone frontal eye of *Bird*, c. 1941. Whereas I see this eye as centered in the bird's head,[57] Wolfe sees it "hovering in the sky," which leads her—despite Miró's ubiquitous eye in the sky—to link it to Jung, for whom the "floating eye" was the "Eye of God." Langhorne, referring to a different passage in Jung, contrarily describes what she too takes for a celestial "floating eye" as an "archetypal symbol of the union of opposites, self on an elevated level." If, however, the eye is in fact situated in the center of the bird's head, then this Cyclopean eye in a winged protagonist would lead us not to Jung but via classical symbolism to a straightforward phallic interpretation (supported, moreover, by this painting's relation to the ithyphallic *Naked Man*).[58]

I want to make clear that while I think Pollock considered all his images to have psychological content, their *precise* definition or identification—given how little we know of the artist's intimate life and thought—is a chancy if not impossible (and most likely wrong-headed) task, even if we do not misread the forms. Symbols of this order are difficult to interpret even for the psychoanalyst who, in extended direct contact with the analysand, has infinitely more to go on than we. He develops a matrix of personal associations far more dense than any context we can reconstitute from the combination of Pollock's painted images and limited "logos." Pollock spoke very little about his pictures. So far as I know, he interpreted the psychological symbolism of an early image only once, when pressed by his wife to identify the animal at the bottom of *Guardians of the Secret*, 1943. Pollock described it as a dog, and added that it was "obviously a father figure."[59]

Now the dog of *Guardians* has a long history in the literature. O'Hara—probably quite independently of Jung—had already associated it to Anubis, the jackal-headed Egyptian god, who protects the treasure of the underworld.[60] Overlooking a possible model in Picasso,[61] Wolfe speculates that the dog is rightly placed at the bottom of the composition because it belongs to "the instinctual animal world." Reading the picture upwards, she identifies different levels of consciousness in the psyche as outlined by Jung. Thus, the dog guards the mysterious central panel—"casket, bed or altar"—which Wolfe, quite rightly, I believe, takes for a cryptogram of the unconscious, i.e., "the secret."[62] Wolfe, however, overlooked a number of interesting clues about such guard-dogs in *Symbols of Transformation*; Freke mentions some of these—the association to Anubis, for example—but omits others. In *Symbols of Transformation*, however, Jung not only notes that "snakes and dogs are guardians of the treasure" of the netherworld, he assimilates the "hound of hell" to Hecate, "Goddess of the underworld," who is "dog-headed, like Anubis" and serves as "guardian of the gate of Hades." Given that "her attributes are dogs," Jung sees this canine Goddess "as *deadly mother*"[63]—an embodiment of the archetype he calls the Terrible Mother. We therefore find, ironically, that on the lone occasion when Pollock identified the psychological significance of one of his early images, he

attributed to it precisely the opposite symbolism (i.e., "father figure") than we would be led to expect from Jung's references.[64]

One wonders, moreover, that the elucidation of the symbolic dog of *Guardians of the Secret* should be restricted solely to archetypal, "mythic" references. Would not a man who likes dogs, owns one, indeed, dreams about them, have associations to that animal which, though perhaps prosaic and certainly individual, might be equally revealing? The detail of a page from a notebook of 1950–56 [OT 897] records a dream Pollock had about his dog; its imagery serves well—despite its later date—to illustrate the principle involved.

At the top of the detail is an inverted U-shaped form of mixed sexual connotations that Pollock identifies as a "divining rod," about which he evidently dreamt "two nites."[65] Below it—either a suite to that image or the record of a new dream—is sketched a clearly phallic, almost Oldenburgian "vacuum sweeper." The latter, according to Pollock's annotation, "becomes my dog which attacks me." We immediately recognize here a superimposition of symbols derived from everyday reality. Vacuum cleaners and pet dogs find no place in Jungian commentary, but I warrant they could tell us as much as references to Anubis and Hecate about Pollock's psychology—in particular his feeling about the inhibitory dog of the *Guardians* that he called a "father figure." I don't want to engage in instant analysis, but it hardly takes a psychiatrist to recognize here that theme of male aggression against the dreamer endemic to the Oedipal situation. Indeed, a convincing argument could be made for a Freudian as against a Jungian interpretation of *Guardians of the Secret* as a whole: the secret would be the painter's inadmissible sexual desire for his mother, which is repressed into the unconscious (the central panel); the watch-dog which blocks access to that "treasure" would represent the painter's father; and the sentinel-like Guardians at the sides would embody the super-ego, Freud's "policeman" of the mind.

Happily we are not forced to choose between the Jungian and Freudian systems—neither of which, in any case, can be taken seriously today as an adequate picture of the complexities of the human spirit. Doubtless there is some truth in both these approaches to the *Guardians*. In my view, art history is properly an eclectic discipline: we should welcome insights derived from any and all critical approaches, while remembering that even taken collectively they illuminate little more than a corner of our experience of art. But we should always test the observations proffered with a skeptical eye against our experience of the work; this is the substance of the remainder of the present article below.

Titles

They play a central, indeed, primary role in Jungian interpretations of Pollock's early paintings. One can hardly imagine readings of *Moon Woman Cuts the Circle*

such as those discussed in Part II of this article had the picture's title been unknown.[66] Yet not one of Pollock's Jungian critics seriously explores the nature of his early titles or the ways in which they were engendered. Hardly mentioned, and for obvious reasons, is the pivotal fact that Pollock often titled his pictures only long after making the image. ("He hated titling and tended to put it off until the last moment, usually just before a show," according to Lee Krasner.[67]) Nor are false assumptions about titles—especially as regards their literalness— limited to the Jungians. David Rubin, for example, assumes that it is "often not too difficult" to "pinpoint the artist's subject matter with some specificity" in those instances "where the artist provided titles . . . or where recognizable figuration is clearly evident."[68]

Citing Pollock's celebrated statement that *She-Wolf* was "inexplicable," Lawrence Alloway had argued that "if paintings are 'inexplicable,' titles can serve only to evoke the kind of experience Pollock associated with the creative experience generally."[69] This generalization is too broad, however. Certain titles—*Something of the Past* or *Blue Unconscious*, for example—do correspond to Alloway's characterization. Other seemingly elliptical titles are more "associational"—in the manner of Surrealist titles—than evocative of the "creative experience." Thus, *Earth Worms* is certainly not a picture of worms, nor was it inspired by them—though Pollock surely associated the *matière* of painting in a general way with the earth. After making this picture, which contains numerous small curvilinear forms, Pollock gave to it a title no doubt provoked by the character of its surface but also in harmony with that of the nature-oriented series ("Sounds in the Grass") of which it is a part. *Portrait of H.M.* is certainly not a "portrait," abstract or otherwise of anybody, but H. M. (Helen Marot or Herbert Matter, both friends) was no doubt either recalled by something in the work or, more probably, was recollected or discussed at the time of the making of the image. Some titles, however, move in varying degrees toward literalness. A hand holds a key, for example, in the upper right of *The Key*—though this does not help us much with the rest of the image. And there is a totemic figure in *Totem Lesson I*, but the "lesson" remains speculative. On the other hand, titles such as *Wounded Animal*, *Stenographic Figure* and *Guardians of the Secret* seem roughly descriptive of the images to which they are attached.

Given this range and inconsistency in Pollock's use of titles, one should employ them with extreme caution in interpreting the images. Certainly literalness should not be presumed—as it is, for example, by Elizabeth Langhorne in her discussion of *Moon Woman Cuts the Circle*.[70] Literalness forces her into astonishing prolixities as she attempts to rationalize the "circle" of *Moon Woman Cuts the Circle* as a "third eye" of the figure on the right (as discussed above). I think it is clear that, as in Pollock's other titles, the notion of a moon woman cutting a circle represented *an ex post facto association to the artist's "inexplicable" depicted*

image rather than an a priori program for its iconography. Nor can we say here, any more than in the case of the *Moon Woman* of 1942, that the title necessarily "attests" to a Jungian derivation of the image, as Judith Wolfe declares.[71] The link between title and image is almost certainly a memory, association or private fantasy unknown to us. Given Pollock's youthful fascination with Indian art and lore, it is very likely that he knew of a Moon Woman legend—of which there are a number[72]—quite without the reference to chapter seven of Jung's *Symbols of Transformation* which Wolfe and David Freke[73] deem essential, and that *his* Moon Woman implied a different context than that of the Hiawatha legend.

If Alloway went too far in generalizing the significance of Pollock's assertion that *She-Wolf* (and presumably his other images of the time) were "inexplicable," Freke goes to the other extreme. In a tour de force of special pleading, he asserts that Pollock's statement "only means that [he] was not prepared to explain [*She-Wolf*], not that it had no meaning, or that the meaning is too vague." In fact, Freke adds, "it may indeed have been *too precise*" for Pollock's temperament, and he concludes that its meaning is, in any event, "given away" by the "particularity of the title. . . ." Now Pollock never said that his image "had no meaning," nor that it was "vague." "Inexplicable" means "incapable of being explained, interpreted or accounted for," as Webster has it, hence certainly unverbalizable. Great art is full of such ineffable content. A meaning capable of being precisely rendered would, I think, have been offensive to Pollock—all the more if it could be "given away" by a title. He would no doubt have considered a painted image that could give itself up in words as inherently inartistic.

If I press this question of Pollock's titles, it is in part because, as a graduate student, I fell myself—with the title of *Pasiphaë*, 1943—into just the trap of over-reading that has closed around the Jungian critics. Pasiphaë was the Queen of King Minos of Crete who, as a result of Poseidon's anger, was caused to become enamored of a bull. With the help of Daedalus, who created a cow "costume" for her, she consummated her love, and its issue was the Minotaur. As Pollock was familiar with the Minotaur, and as Pasiphaë was not an uncommon figure in the iconography of some of the Surrealist exiles then showing in New York (Masson showed a picture of that title in an exhibition Pollock probably saw), I interpreted the painting in the light of the legend. The central area of Pollock's *Pasiphaë* shows two figures in what could well be the sexual act. The lower one is somewhat animalistic, has full, rounded forms and (as I see it) is on its back; the one on top of it is an angular black stick figure. The frontal and symmetrical scene has a ritual character that implies a mythic ambience, and the sexual *agon* of the protagonists is enframed by priestly sentinels not unlike those of *Guardians of the Secret.*

Prof. Meyer Schapiro and the members of his doctoral seminar found my interpretation convincing, and I subsequently published it.[74] Later I discovered

241

that the picture had originally been called *Moby Dick* and that—with no changes in the painting—it had been retitled *Pasiphaë*. On a visit to Pollock's studio in the company of James Johnson Sweeney, Peggy Guggenheim expressed some dislike of the title *Moby Dick*, and Pollock said he was willing to change it. After some discussion, Sweeney—who had that morning come upon a reference to the Minoan Queen in some work he was doing on Pound and Eliot—suggested the title, *Pasiphaë*. According to his wife, Pollock said something to the effect of "Who the hell is Pasiphaë?" Sweeney recounted the tale, which Pollock found very interesting because it concerned the mother of the Minotaur and dealt with a combination of eros and bestiality. (He later jotted down an outline of the story, which survives among his papers.)

The ease with which Pollock made this switch, finding appropriate a title derived from a story unknown to him when he made the image, should not be generalized into an assertion that the artist cared little about titles. But neither can its implications for an *elliptical* relation between image and title be overlooked. Pollock would certainly have rejected a title that did not have some metaphoric significance in regard to the image. Obviously he found the Pasiphaë legend in accord with the underlying nature of his picture. Is there any reason to believe that the image's relationship to the original title, *Moby Dick*,[75] was more literal? The Melville novel was a favorite book of Pollock, and the *agon* of Ahab and the White Whale has epic proportions. But the central panel of *Pasiphaë* even less illustrates any scene in the novel than it does the myth of Minos' Queen. (Langhorne, in a passage as fanciful as it is unconvincing, sees the painting as depicting a Jungian "winged sun-hero riding on the back" of Melville's "Leviathan.")[76]

Had the caveat that should have been engendered by my error been properly appreciated by the Jungian critics (who are all aware of the change in title), they would have much less particularized their readings. Nor presumably would they have proceeded as if the titles of the paintings were necessarily Pollock's. Thus Wolfe's title-oriented disquisition on the alchemical symbolism of *Alchemy* would not have been undercut by the fact that the title is not Pollock's. Nor would Langhorne have found that the title of *Gothic*, in fact the contribution of Clement Greenberg, "conveyed Pollock's premonitions of a spiritual life."[77]

Alchemy: Color and Number Symbolism

Given Jung's involvement in alchemy, it is hardly surprising that the Jungian critics see it contributing to Pollock's iconography. Non-Jungians, however, will be troubled by the centrality as well as the nature of the role they attribute to it. "Alchemy," for Langhorne, was "more than an esoteric source"; her article and much of her dissertation are devoted to proving that Pollock used it to express

his "basic psychological desires." Jonathan Welch goes even further. In developing an idea implicit in Wolfe, he suggests that alchemy "may even be seen as a factor in Pollock's dramatic change of style in 1947," and that it "contributed materially to Pollock's drip technique."[78]

Pollock never mentioned alchemy in any recorded statement,[79] though the subject is consistent with his early interests in Krishnamurti, theosophy and Jung. The evidence produced by the Jungian critics for his involvement with alchemy is not profoundly convincing. Welch, for example, organizes his argument around a Pollock image of *personnages* in sexual confrontation called *The White Angel*, 1946. He proposes a tenuous connection between this painting and an article about alchemy by Kurt Seligmann which mentioned "fallen angels who mated with mortal women in antediluvian times." But nothing indicates these were "white angels," nor does Welch produce any reference to white angels in alchemical lore. For Wolfe, the touchstone is the title of the 1947 painting, *Alchemy*. But as observed above, *Alchemy* was not, in fact, named by Pollock. (The artist's East Hampton neighbor, Ralph Manheim, who titled the work, had translated a variety of texts concerning Surrealism as well as a book about Jung and was very interested in alchemy).[80]

Langhorne approaches the question of Pollock and alchemy more convincingly in terms of the artist's personal contacts and cultural environment. It is indeed likely, as she suggests, that Pollock would have heard about alchemy in 1941 from John Graham. And alchemy was also, of course, an important theme in late Surrealism—though Pollock could not have read the relevant untranslated texts by Breton and others. Langhorne singles out an article by Seligmann in *View*, which Pollock probably would have read, and also mentions Matta, who was, indeed, very interested in alchemy, astrology and tarot; Langhorne and Wolfe note that Pollock had some contact with Matta in 1942 through Motherwell and Baziotes (though Motherwell says that alchemy did not figure in their discussions.)[81]

Nevertheless, alchemy was "in the air." Many of the Surrealists were showing pictures with alchemical subjects or titles as were, indeed, some Americans (such as Gottlieb), and the analogy of the artist as alchemist, transmuting base material (pigment) into something precious (art), had wide appeal. Moreover, Pollock would surely have been fascinated by the more "abstract" alchemical symbols, which some of his own calligraphy resembles. It is almost certain, therefore, that Pollock had a passing knowledge of the subject; his Jungian analysts could hardly have avoided discussing it. But that Pollock had the profound commitment to alchemical theory suggested by some of the Jungian critics is pure speculation. It should not, therefore, have been treated as more than a hypothesis to be tested against alternative explanations.

Take, for example, Wolfe's theory of color symbolism in *Alchemy*. Even pre-

tend, for the sake of this discussion, that Pollock himself had really titled that picture. Wolfe begins by invoking the alchemical operational formula *solve et coagula* (dissolve and congeal) as an inspiration for Pollock's pouring technique, and then (citing Cirlot) explains: "The four stages of the [alchemical] process were signified by different colors, as follows: black (guilt, origin, latent forces) for prime matter (a symbol of the soul in its original condition); white (minor work, first transmutation, quicksilver); red (sulphur, passion); and finally, gold." "These," states Wolfe conclusively, "are the colors of Pollock's *Alchemy*." To be sure, she notes that yellow has been substituted for gold, but as Langhorne would point out, Jung reported that the "old painters" had "usually expressed" the "quaternity of alchemy" with "red, black, *yellow* and white. . . ."[82] Then Wolfe does the unexpected. Noting the additional presence in *Alchemy* of aluminum paint, she explains that it had been added "to mediate between light-dark contrasts." But does not this formal explanation for the aluminum constitute an inconsistency that weakens her thesis? Welch evidently thought so, for in his gloss of Wolfe's text he attempts to eliminate the contradiction by pointing out that this "silvery colored paint *may refer to quicksilver*" which, he adds (quoting Jung), is "sometimes identical with [the alchemist's] *materia prima*."[83] (This is presumably how Welch understands alchemy as having "contributed materially to Pollock's drip technique.")

Fine. We now have Pollock's palette in *Alchemy* all lined up with the color symbolism implied by the title. Of course, one might wonder whether Pollock would choose his colors in such a cerebral, "literary" way. And, indeed, Wolfe may herself have wondered, for she asks whether Pollock followed the motto *solve et coagula* and organized his color scheme on an alchemical basis, or whether he titled the work only after he noticed its "fire colors and melting forms." But what is left of *either* hypothesis if the "colors of Pollock's picture" *do not* conform to the alchemical palette? I can only assume that Wolfe and Welch were looking at a poor color reproduction, for the fact is that *Alchemy* contains, in addition to the colors cited by these two writers, liberal doses of orange and blue as well as some green and ocher. As for "melting forms," one should leave *solve et coagula* to the fluctuant morphologies of Matta. The forms in *Alchemy*—if, indeed, one can refer to lines as "forms"—can hardly be described as "melting."

Langhorne's treatment of color symbolism is somewhat more sophisticated. Following Jung, she begins building a case (through her analyses of certain of the 1939–40 "psychoanalytic drawings") for red (symbolic of Sol) as a "masculine" color and yellow (the "crescent moon," or "Luna") as a "feminine" one. (To be sure, a case could be made in Pollock's work for associating yellow with the sun and identifying it with the masculine principle.) A crucial confirmation, as she sees it, is that in an early drawing [OT 547], "the crescent moon, placed in the pelvic area of the composite image of woman, is yellow."[84] But is not the point

somewhat mitigated by the fact that most of the woman's left leg and right arm, as well as two other large if less defined areas of the image, are also yellow? And are there not numerous instances in which Pollock used yellow in connection with male figures?[85] Given the cast of Pollock's thinking in the late '30s and early '40s, it would have been surprising had he not speculated about a possible symbolism for color. But there are many schema for the latter, and the only real evidence we have is a little diagrammatic sketch for a *Crucifixion* of 1939–40, in which, as Eugene Thaw points out, Pollock equates yellow with "intuition"[86]—in a Jungian system different from the polarity Langhorne proposes.

How long during his subsequent development Pollock continued to think of color symbolically is difficult to say. But even if we were to pretend that he never ceased to think in this manner, would we not still have to confront the fact that this symbolism is only *one* aspect of the decision-making process of his enterprise? The Jungian critics are to be faulted not for speculating on color symbolism as such, but for isolating it from the pictorial considerations that functioned in tandem with it. Pollock was not simply—or even primarily—an "auto-analysand" or a symbolist poet. He was before all else a painter. Hence, while the decision to put yellow in the pelvic area of the woman in a 1930–49 untitled drawing [OT 547] *may* have been intended to convey femaleness, it may also—or even *rather*—have responded to an esthetic need Pollock felt for yellow in that area on the surface. Surely, that must have been his motivation in most instances where he applied yellow to his canvas. These two hypotheses—one psychologically and the other esthetically motivated—need not be in contention. On the contrary, a single artistic decision in good painting answers simultaneously to many more than the two considerations raised here. But by abstracting the *possible* symbolic motivation for using a particular color in a given instance from the *inevitable* formal questions that choice had to answer, the Jungian critics develop a very unreal model for Pollock's procedures.

Langhorne's interpretation of *Male and Female*, 1942, is an instance of what must be called the circular, self-fulfilling nature of the Jungian critics' propositions. While she admits that in this picture "it is difficult to distinguish" which figure is male and which is female, she nevertheless asserts that, based on what she takes to be Pollock's color symbolism in 1939–40, the *personnage* on the left, which has a red upper torso and what she chooses to interpret as a "curling limp phallus," also red, must be a male; the figure on the right has "a yellow triangle in the pubic area" and must therefore be the female.[87]

If, however, we approach the picture without this prejudice, we find a number of indications of just the opposite pairing. The head on the right, for example, is arguably more male for the violence of both its forms and execution;[88] that on the left is gentler and has eyes with huge lashes. The figure on the right is more angular, its more straight-edged forms incorporating a panel of seeming

mathematical equations (which even Jung, since he associated abstract thinking with the male principle, would surely have found curious inscribed on a female figure); the figure on the left has a more curvaceous silhouette, including what could be taken for (bulging) red breasts. A close look at the picture reveals, moreover, other seeming inconsistencies in Langhorne's argument: the crucial "yellow triangle" which is outlined in the "pubic area" of the right hand figure is, in fact, executed *in both red and yellow*; the white scumbling (below it and slightly to the left), which Langhorne takes to be the "ejaculation" from what she identifies as the penis of the left-hand figure,[89] would be an unlikely occurrence at a moment when his member were actually, as she says, "limp."

Since Pollock was here making a work of art in which the color scheme was roughly black, white, yellow and red against a blue ground, we should be surprised if (even as early as 1942) the colors had been distributed so cerebrally and mechanically that the two protagonists were, in effect, color coded. Apart from the fact that both are mostly black, the head of the right *personnage*, while containing a dominant yellow form, has also a good deal of red. And if the bust and neck of the other is red, its eyes and many parts of its silhouette are outlined in yellow.

It may even be, I suspect, that interpreting the title *Male and Female* to mean that there are two figures of distinctly identifiable sex is asking both more and less of the image than it contains.[90] Pollock was not, after all, making a codified picture of integral human beings, but imaging a pair of anthropomorphic constructs which, like the *personnages* of the Surrealists, contain only as much anatomical definition as the context required. This is one of Pollock's most reworked, overpainted images. Even if he started with a clear idea of a male on one side and a female on the other, it seems highly probable that changes along the way, prompted both esthetically and psychologically, got the sexes confused. If requiring that each figure give itself up as of a specific sex thus asks more than the picture contains, the same assumption demands less of the picture insofar as it preempts more interesting interpretations. The image as a whole might be seen, for example, as a metaphor for that loss of the sense of somatic discreteness and distinctness associated with the sexual act, a metaphor comparable, then, to that exchange or confusion of bodily parts which sexuality inspires in many of Picasso's pictures of the '20s and '30s. Or, as I think more likely, Pollock's image may express that awareness of bisexuality or of sexual unsureness present in all individuals and usually repressed to the lowest levels of the psyche.

It must be said, in fairness to Langhorne, that if she insists in the first instance on identifiable male and female figures making a "union of opposites" in *Male and Female*, she does admit, as a secondary association, to what she calls "hermaphroditic fusion." Regrettably Langhorne supports this multiple thesis by

reference to a very strained number symbolism drawn from Jung and his gloss-
es on alchemical lore. "Amid the many numbers scribbled on the adjacent[91]
black panel," she writes,

> 1, 2, 4, 1 and 6 are prominent at the top, underlined in red. Two, 4 and 6 were [also]
> found in *Stenographic Figure*. Now the bringing together of opposites, 2, in order to
> make the union of opposites, 4, even the hermaphroditic fusion of male and female,
> 6, seems to be actually occurring in the sexual activity.[92]

To say that Langhorne was guilty here of "selective" vision would be an
understatement. 9, a number of no interest to the Jungian critics, appears twice
and is far more prominent in the black panel than 4 (present only as a power
sign), as are 0 and the plus and minus signs, none of which Langhorne chooses
to interpret. If some profound symbolism was intended—consciously or not—in
the use of 2, 4, and 6, is it likely these integers would have been interspersed in
a panel of otherwise "meaningless" numbers and signs? More striking, perhaps,
is the fact that Langhorne *et al.* entirely overlook the resemblance of the black
panel of *Male and Female* to a blackboard with mathematical notations chalked
on it. After all, the numbers she selects for interpretation are not isolated or sus-
pended in air like apocalyptic symbols or Demuth's vision of William Carlos
Williams' "figures five in gold." They are written as mathematical sequences
(imaginary) in white on black and the clear allusion to a blackboard prompts
both art-historical and biographical associations at variance with the Jungian
interpretation.

As a possible source for Pollock's use of numbers Langhorne proposes illus-
trations" of a man in a cabalistic square filled with numbers[93] which illustrated
a 1942 article published by Seligmann in *View*. Pollock may have seen this, but
his "handwriting" in general, especially in *Stenographic Figure*, more resembles
the cryptic signs and diagrams in de Chirico's paintings [such as *The Evil Genius
of a King*, 1914–15] with which we know he was very familiar. The esoteric
Jungian/alchemical explanation for the numbers in *Male and Female* seems to me
less relevant than the memories we all retain of experiences in the classroom,
as they would, in Pollock's case have been reinforced by his exposure to de
Chirico's pictures. Is it too prosaic to suggest that in high school if not earlier,
Pollock would have been fascinated by the *esthetic* appearance of the blackboard
in math or physics class, however much he may or may not have been interest-
ed in these subjects? Indeed, the blackboard, with its retrospective psychological
allusions, its blackness evoking both the recesses of the mind and the "color" of
dreams, its wooden frame making it a "picture," its encouragement of rubbing
out and reworking, and its association with a linear graphism of seemingly
occult signs and symbols, could stand as an ideal metaphor for Pollock's picture-
making process in the '40s. (Who knows but that the earliest "allover" picture

he ever saw was not the blackboard at the end of a busy class—as the Pollock-influenced painter Cy Twombly suggested quite literally from his own experience.)

The containment of numbers in a separate panel as in *Male and Female* is exceptional for Pollock. When numbers occur, there are usually fewer of them and, mixed with letters and quasi-mathematical signs, they are more loosely distributed over the whole surface, often as part of a continuous "short-hand" calligraphy, as in *Stenographic Figure*. For the numbers in the latter picture, Langhorne again marshals Jungian theory, this time to reinforce her notion (discussed above) that *Stenographic Figure* represents *two* protagonists of opposite sexes. "Roughly in the middle of the canvas," she writes,

> One sees the numbers 3 and 4. Jung notes that 'four signifies the feminine, motherly, physical; three the masculine, fatherly, spiritual.' The Theosophical assignations are the same. The juxtaposition of the numbers 3 and 4 in the center of the canvas suggests either a joining of male and female or their conflict. That the desire is for a union of opposites is conveyed by an equation of numbers found on the red arm of the woman that reaches toward the man. The equation is 66 = 42. Jung notes that the number 6, with its even and uneven factors, two 3's and three 2's, traditionally represents the hermaphrodite, or the fusion of male and female. The number four, as well as traditionally representing the feminine, represents a fourfold totality, that incorporates the feminine principle with the masculine principle and so represents the totality of the self. For Pollock the totality of the self is to be achieved by the union of two. Thus the numerical formula 66 = 42 is yet another statement of Pollock's desire for the union of opposites.[94]

No doubt those who are really convinced by Jung's mystical numerology will find the above reasonable—until they look carefully at the picture. For if, as I observed in Part I, *Stenographic Figure* contains but one protagonist (female and animalistic), the above quotation becomes meaningless as a projection in terms of number symbolism of the picture's supposed "narrative." But even if we were to grant Langhorne her two figures, we would still have to find her interpretation selective and forced. To begin with, the supposedly "male" and "female" numbers, 3 and 4, are *not* "juxtaposed" in "the center of the canvas," as she claims. *What she takes there to be a 4 is an invented sign, something like an X with one "curly" bar*, as is even clearer in the repetition of that same motif not far above in the top center of the composition. Moreover, the 2, 3, 4 and 6 she cites are not the only numerals in the picture; also present are an 8 and a zero, to say nothing of plus and minus signs as well as a number of "mathematical" letter symbols (such as X and W). If 2, 3, 4 and 6 are impregnated with such symbolic meaning, are these other numbers and signs just decor?

The Jungian approach to Pollock's numbers completely overlooks the artist's improvisational scanning of a continuum from symbol to sign to mark in

his cursive writing. We get an excellent insight into the functioning of this process in a fascinating page from a late notebook [OT 887], where Pollock extrapolated a veritable allover composition from jottings that include phone numbers, reminders of appointments and a list of the month's expense checks (upper left).[95] The latter is instructive in providing still another characteristic model in everyday life for the panel of numbers in *Male and Female*; certainly a psychologist would have to say that in a confrontation of two such figures, an indirect allusion to the family accounts would not be out of place. The manner in which such a "piece of life" gets into Pollock's configurations is beautifully expressed in the notebook drawing by the literal absorption of the expense list into the abstract handwriting of the composition. The numbers in the list are symbols of domestic economy, but within the context of the picture they also become signs and ultimately marks. They are transformed by reason of their analogies to the motifs around them. In the scribble to the left of the list we can read such numbers as 1, 6, 7 and 10, but as these have been disengaged from a mathematical context, they may also be read simply as shapes; the numbers 1 and 0 become nothing more than straight lines and circles serving as "filler" for the allover composition.

It is especially interesting to observe how, in the upper part of the drawing, the O of "Oregon" is analogized to the circles around it, how the W of "Wednesday" is extrapolated as an abstract leitmotif, and how the notation near the page's bottom, the appointment reminder, "Sunday-six," is transmuted into an equation in which the hyphen becomes a minus sign: Sunday-six = W = IV. Here, as in *Stenographic Figure*, the functioning of Pollock's fantasy of science (recall his remark about the importance of confronting Einstein as well as Freud) becomes the graphic vehicle for absorbing notations common to our written language into the personal vocabulary of his drawing. Indeed, in the lower part of the image, the invented signs (such as 手) of his antic algebra bear a family resemblance to certain signs of the alchemical pseudo-science (such as 丰, the character for "inherent") as they do to all ideographic signs, the Chinese numeral "one," for example (壬).

The broader problem, however, of Langhorne's (and Wolfe's) number interpretations lies less in their selective and forced readings than in their seeming total unawareness that in such pictures as *Stenographic Figure*, Pollock undoubtedly chose his numbers as much, if not more, for their shape as for any symbolic connotations. Numbers, after all, have an esthetic of their own. 1, 4 and 7, for example, are entirely straight-edged; 2, 3 and 6 (as handwritten) are entirely curvilinear; 5 combines both elements.[96] 3 is the "right half" of 8; bottom-heavy 6 and top-heavy 9 are more or less the same figure inverted; 1 and 7 have potentially anthropomorphic associations as vertical "stick" figures, etc. Is it possible that a serious artist who draws numbers over his canvases should have failed to

choose them at least in part to meld analogically with his other forms (precisely, in fact, what Pollock seems to be doing in *Stenographic Figure*)? Can we not also be sure Pollock chose the shapes of his numbers as a function of the size, color, paint-thickness, etc., of the motif he felt his composition needed at the point where he used them? None of these considerations are ever mentioned by Langhorne or Wolfe.

Perhaps the most dubious of the number symbolisms proposed by the Jungians is in Wolfe's interpretation of *Alchemy*. Wolfe wants to find in this picture a 4 (which "represents completeness" and "the four elements of the [alchemist's] physical world") and a 6 (which, according to Jung, represented "the hermaphrodite or fusion of male and female"). "Laid on [the surface] in thick white paint" she sees "an asterisk-star, a numeral '4,' a space, and a numeral '6,' from left to right." A close look unguided by a priori expectations reveals that mediating Pollock's composition are not three but some 12 heavily painted white markings which, in the picture's hierarchy of size, paint-thickness and luminescence, function as big structural accents setting off the filigree web in a manner adumbrating the "elbow joints" of *Autumn Rhythm* and the "hooks" of *Mural on Indian Red Ground*. The linkage between these tube-drawn accents and the more diaphanous poured web is not always well worked out in *Alchemy*, which is hardly surprising as this was one of Pollock's earliest poured pictures. Some of the tube-drawn accents are simple straight-line fragments; others, such as the "X" with a horizontal line through it (Wolfe's "star") and the one resembling a "bass clef" or "volute," recall forms commonly found in Pollock's early '40s work. This more potentially "figurative" type of marking reflects the early position of *Alchemy* in the order of the poured pictures; signs of this sort disappear shortly afterward.

It may be—though I more than doubt it—that the volute or bass clef form was intended by Pollock to be a number 6, as Wolfe claims. (It would have to be almost upside down; to read it as a 9 would be, as the reader will recall, of no interest to the Jungians.) But the artist certainly didn't intend his titled V and the vertical to its right, from which it is quite separate to be read as a 4. Now Wolfe's desire here to see a 4 where there is none was partly motivated by a will to find a pairing of numbers that does, in fact, occur in a few of Pollock's figurative pictures. She notes that a 6 and a 4 are inscribed on the surface of *Wounded Animal*, 1943; she might have added that they are also to be found (inverted) in the lower right of *Direction*, 1945, where they seem to compose the number "46." After discussing the Jungian significance of 4 and 6, Wolfe observes—but without recognizing the obvious questions it raises—that 46 had been Pollock's address on Carmine Street in 1932 not long after coming to New York and that it was his lucky or "magic" number.[97] Even if 46 *had* been inscribed on *Alchemy*, as it is on a number of works both earlier and later, would we need to reach for

the arcane alchemical interpretation, which anyway breaks the number into separate integers, when we know that as an integral number it had immediate autobiographical connotations? Both Wolfe and Langhorne see Pollock's use of 46 as *confirming* the Jungian/alchemical thesis. I see it as just the reverse. To the extent—esthetic questions apart—that Pollock used this number because it was lucky *for him*, and had resulted from or been reinforced by the chance events of *his* personal history (such as an address), the choice would seem to militate for a Freudian (personal, specific) rather than a Jungian (collective, archetypal) interpretation. Thus, while the inspiration for Pollock's occasional use of 46 might have been either conscious or unconscious, it certainly would not have had to issue from what Jung postulated as the more remote "deep conscious," where the collective archetypical symbols of alchemical numerology are said to abide.

"Veiling the Image": An Excursus

Wolfe's search for figurative elements in a poured picture such as *Alchemy*, like Wysuph's reference to "obscure images lurking in the shallow webs of overpainting"[98] in Pollock's "classic" pictures, are characteristic of a tendency in recent criticism to annex Pollock's wholly abstract 1947–1950 pictures to the claims of figuration. The allover, poured paintings are said literally to contain "hidden presences"—Pollock's familiar totemistic personages—which supposedly constitutes the first phase of each picture's drawing; these are presumed to be overpainted as the pictures are realized. For Charles Stuckey, "veiling" even supports a bizarre thesis that Pollock thought of his classic paintings as two-sided. The painter's "choice to 'veil the imagery,'" he insists, "not only could 'repress' protectively something he had begun with; it supplied him with sides, behind and before."[99]

Actually, the suggestion that the classic pictures contain buried figuration was made as early as 1964 by Thomas Hess,[100] but it was seen at the time as representing Hess's confusion of Pollock's methods with those of de Kooning (whose most abstract paintings *do* begin from figurative premises). The reemergence of this idea in the 1970s has been supported with literary rather than pictorial "proofs"—remarks by Pollock and his wife, uprooted from context and often pruned to the purpose. Pollock, for example, is quoted to this end as saying that he was "very representational some of the time and a little all of the time."[101] But given the date of the interview in question (1956) and, above all, the context of the remark, it is clear that Pollock was referring to the work of his last years, about which his observation would have been apt. Lest we apply his 1956 remark to the work of 1947–50, let us remember that in 1950 he specifically referred to his painting as "non-objective"[102] and said he gave up titling pictures in order to "stop adding to the confusion." "Abstract painting, damn it,"

he added, "is abstract."[103] Quite without such citations, however, we would need only to *look* at the classic pictures—many of which are sufficiently open and transparent in their webbing to permit every stage of their evolution to be seen— to verify that there are no figures in them on the first layers of paint. (I except here a small minority of images from 1947–50 primarily on paper, in which *unveiled* figuration is evident.)[104] Now the reference to "veiling the image," which has become the standard manner of describing Pollock's overpainting or "painting out" of images, comes from an interview with Lee Krasner Pollock which, it must be said, lent itself readily to misinterpretation. "Many of [Pollock's] most abstract paintings," Krasner observed, "began with more or less recognizable imagery—heads, parts of the body, fantastic creatures."

> Once I asked Jackson why he didn't stop the painting when a given image was exposed. He said: "I choose to veil the imagery." Well, that was that painting.[105]

In my 1967 articles,[106] I described in some detail this overpainting process as it takes place in the abstract *transitional* works Pollock executed in late 1946 *before* he adopted the pouring method. There is only one poured canvas, *Galaxy*, 1947—one of the first Pollock painted—in which there is the unmistakable presence of figurative forms under the abstract web. Here, Pollock uses the poured paint to substantially the same ends he used the overlay of tube pigment several months earlier in *Eyes in the Heat* and *Shimmering Substance*. It may also be that a few of the more thickly painted works of spring 1947, such as *Sea Change*, contain overpainted *personnages*. But there is no positive evidence.

Galaxy and the transitional works of winter 1946–47 represent the final phase of a veiling procedure that actually begins over two years earlier in 1944–45; apart from its poetic purpose, this covering over of images was a function of a broader process (outlined above) of fragmenting large compositional units so that they could be more readily subsumed into an incipient allover rhythm and patterning. "Veiling the image" should thus be associated not with the fully developed classic pictures, but with the transition from late 1944 to mid-1947 during which Pollock moved from metaphoric imagery to full abstraction. This, as we shall see in a moment, is precisely the context in which Pollock himself spoke of veiling.

Now the contradiction between what has generally been taken to be the meaning of Krasner's statement and the absence of visual evidence of figuration in the many characteristic classic paintings where the lower layers are visible has not gone unnoticed. E. A. Carmean, in an article mentioned above, attempted to resolve it by arguing that Krasner's remarks constituted "a description of how *some* of the works *from 1951*, were made" rather than a formula for the 1947–50 pictures. "Furthermore," Carmean continued, "[that] description of Pollock 'veiling' in 1951 should cause no surprise, exactly because many works from that

year are figural and in the initial layer."[107] David Rubin disagrees with Carmean only to the extent that, for him, "veiling took place in the most abstract of the black-and-white paintings."[108]

Such theorizing might not have been needed, however, if closer attention had been given to one aspect of Krasner's remarks. After citing Pollock's statement about choosing to veil the image, she carefully added, "Well, that was that picture." Indeed, which was *"that picture"*? As it happens, Pollock was referring not to the classic poured works (the popular interpretation), nor to the black pictures of 1951 (Carmean's and D. Rubin's theory), but to a painting of 1945, a very large—and largely overlooked—canvas called *There Were Seven in Eight*. In this picture, there is an underlayer consisting of a "frieze" of totemic forms painted in black and white with accenting in yellow, green and blue. Some months after painting these *personnages*, Pollock went back to the canvas and added the web of arabesqued drawing which links the surface in a more taut and abstract manner even as it renders the imagery somewhat indistinct. Most of this overpainting, which prompted Pollock's reference to "veiling," was done directly from the tube and its linear patterns were "fleshed out" with some dripping, pouring and spattering of liquid enamels.

The structure, character and integration of *There Were Seven in Eight*, the largest easel painting Pollock was to make prior to the Museum of Modern Art's *Number 1, 1948*,[109] speak volumes for the nature of his endeavor, despite the fact that Pollock was not yet able fully to realize the ambitious possibilities it announced. And while this is not the place for a proper analysis of this extraordinary painting, it should be immediately clear how, in its allover linear surface linkage, it reaches at once back to *Stenographic Figure* of 1942 and forward to the earliest allover paintings of 1946 and even the first poured canvases of 1947.[110] The knowledge that Pollock's remark about "veiling the image" referred to this early transitional work in which he *literally* veiled his original figures, should do much to clarify Lee Krasner Pollock's remarks. Lest questions remain, however, I have asked her to make an explanatory statement, which I quote in full: "Pollock made the remark about 'veiling' in reference to *There Were Seven in Eight*, and it doesn't necessarily apply to other paintings—certainly not to such pictures as *Autumn Rhythm, One*, etc."[111]

The Naïve Poet

Schiller compared two types of poets, those who describe nature and those—the "naïve poets"—who *are* nature. When asked whether he painted from nature, Pollock replied: "I *am* nature."

Pollock made himself into a very knowing painter, but he remained ever the naïve poet, in Schiller's sense of the term. His poetry took the form of flash-

253

es of insight thrown off in the course of improvising; it was never brought into full consciousness nor conceived as a consistent imagistic system. By ascribing complex iconographic programs to Pollock, the Jungians turn him into a footnote-poet, endowing him with a psychological consciousness akin to Dali's. Dali had read widely in Freud and Krafft-Ebing and deliberately employed the symbols they discussed in systematic ways. Pollock's understanding of psychology was less cerebral, more intuitive; it was based upon his observation (no doubt assisted by analysis) of the working of his own psyche. But it hardly issued, particulars and all, from reading books by Jung, as our critics suggest.

The naïve poet, Schiller observes, not only identifies empathetically with the phenomenal world but finds himself in harmony with the biological order of existence, the underlying rhythm of nature, the cycle of the seasons. Pollock sensed a continuity between himself and the natural world and loved everything associated with the earth, whence his interest in the Navaho sand painters. Their method of ordering an art that was literally made from and upon the earth seemed to express the organic relation of the artist to the physical universe. In view of these attitudes, it is not surprising that of the various schools of psychology that proffered themselves in the '30s, Pollock was predisposed to the Jungian. His analytic experience surely enhanced—but just as surely did not engender—the particular poetry we find in his art. Pollock was Schiller's naïve poet long before he was a Jungian analysand.

For Pollock's images to have had the precise meanings insisted upon by the Jungian critics without the iconography having been introduced consciously, Jung's models for the configuration and the working of the mind would have had to be correct. Yet outside of a handful of Jungian analysts, nobody seriously believes that the mind works the way Jung said it did or is structured as he pictured it; as with Freud, but far more so, our interest in Jung has become primarily literary, historical. Not even Langhorne believes that the iconographies she proposes could have come about unconsciously. It is therefore inadequate to argue that it doesn't matter whether or not Jung was right so long as Pollock *thought* he was. Such a position requires that Pollock be seen as consciously and deliberately elaborating an iconographic scheme—and this was not his way of working, either as he describes it or as we see it operating. The propinquity of Pollock's poetry and Jung's psychomythology is less a matter of a common imagery than of a parallelism in character and spirit. Pollock's pictures are mythopoeic in the truly creative sense; he did not paint Jungian glosses or paradigms but created his own private myths whose elusive meanings are inseparable from the pictorial language he invented to recount them. To attribute their symbols to a study of Jung or even to the broader literature of mythology itself is to deprive them of their originality.

This is not to say that the Jungianism of Pollock's early work was a matter

of character and spirit alone. A few of the works on paper executed during the Henderson analysis (1939–40) have a specifically Jungian configuration and content—and not surprisingly so, inasmuch as Dr. Henderson actively exhorted the painter to produce symmetrical, mandala-like images.[112] ("I encountered the strongest possible resistance at first," Henderson reported. "As a true son of Picasso, [Pollock] felt bound to uphold the dogma of the contemporary art world of his time. . . . He fought me tooth and nail."[113]). Some of the Jungian-type imagery in the drawings of the analysis years seems to have found its way into the paintings of 1942–46, but only as slivers and fragments. This would have happened "unintentionally," to use Pollock's word, and these occasional symbols were clearly subsumed by the personal poetry of the painter's making. In any case, few such specific references—few symbols that cannot be associated with Pollock's anterior interest in American Indian art—have been convincingly identified.

What I described above as the various limitations of Jungian criticism should hardly come as a surprise insofar as they are built into the master's method. We need only consult Jung's 1932 essay on Picasso to see them at work.[114] First comes the artificial division between formal values and iconography. "I have nothing to say on Picasso's 'art' but only on its psychology," writes Jung; "I shall therefore leave the aesthetic problem to the art critics." Then follows the identification of unfamiliar configurations as symptoms of mental disease. Picasso's "so-called 'lines of fracture,'" Jung continues, are "a series of psychic 'faults'"; thus the artist belongs to "the schizophrenic group,"[115] whose pictures "immediately reveal their alienation from feeling." Important also is the suppression of symbols tainted directly or indirectly by Freudianism; hence, though the Minotaur had appeared in Picasso's art five years before Jung's essay, there is no reference to it.

Errors of commission, however, distort Jung's text more than his omissions. The interpretations he *does* propose wrench Picasso's imagery from both its art-historical and personal contexts. As with his followers, Jung is interested in symbolism only to the extent it can be related to the collective unconscious. In discussing Picasso's Harlequins, he says nothing about the *commedia dell'arte* or the world of ballet, not a word about Cézanne's Harlequins or the other images which make up the art-historical and autobiographical context of Picasso's figure.[116] Instead, Jung reaches directly for the mythological with the suggestion that Harlequin is "an ancient chthonic god"; even if true, this is hardly the sense of Harlequin in Picasso's work.

The second section of this essay concluded with a discussion of the imagery of *Guardians of the Secret* as interpreted by the Jungian critics. Let me conclude my text as a whole with their theories about the composition of that picture. It is characteristic that all three critics who discussed the composition of *Guardians*

should have sought a Jungian model for its symmetrical rectangle-within-a rectangle configuration, despite the fact that it is a basic art-school layout not without precedents in Pollock's own work. Freke invokes Jung's description of a sacred cave in the temple of Cos which had "a rectangular pit covered by a stone slab with a square hole in it"; but he cautions that *Guardians* does not "owe its format directly to that description." Rather we should seek its source in the "whole Middle Eastern mortuary cult"—which forces us to imagine Pollock leafing through books of reproductions in an architecture library. Wolfe would like to see the picture's "diagrammatic" composition deriving from Jung's illustrations of mandalas. But she is halted by the fact that the latter are almost all circular, and so concludes that "if Pollock's composition represents a Jungian scheme, it has been entirely remodeled." Langhorne, however, proposes as its source a "disturbed mandala" that Jung reproduced in connection with the analysis of one of his patient's dreams. In the center is an "eight-rayed star"; the circles in the smaller rectangles are bowls "containing red, yellow, green and colorless water." The "disquieting" question posed by the dream, according to Jung, "is whether there is enough water of life—*acqua nostra*, energy, libido—to reach the central star. . . ."[117] Apart from the fact that this diagram does not really conform to the configuration of *Guardians of the Secret* (which is not missing its corners and does not have a strong accent on the biaxial crossing), the dream illustrated by the diagram has no relation to the content of *Guardians*. Thus, even in the unlikely event that Pollock ever saw the diagram (he almost certainly did not read Jung), it is hardly likely that he would have recalled it while making *Guardians*. Moreover, art-school precedents apart, the configuration of *Guardians of the Secret* follows naturally enough from the fact that the much-discussed central rectangle—though perhaps alluding to a casket, bed, altar, table, or treasury, as different critics (myself included) have suggested—is without question *a picture-within-a-picture*. We might title it with Pollock's own words: *The Unconscious As The Source Of Art*.

 Guardians of the Secret speaks symbolically of the libido as the source of both creation and procreation within the cycle of nature. This is also the theme of Picasso's allegory *La Vie*, which appears a more likely influence on both the content and structure of *Guardians* than the references the Jungians propose.[118] In order for the spiritual and poetic identification suggested here to hold up, it is not necessary that Pollock have actually remembered this image, which he would have seen in the 1939 Picasso retrospective.[119] The striking similarities—both pictures contain hieratic figures that flank the composition, a picture-within-a-picture motif and, if we want to stretch a bit, a crouching figure in the bottom center—could reflect a less than conscious awareness of it. We know that in the original conception of *La Vie*, the male figure was a self-portrait of Picasso; *La Vie* must therefore have had for the Spanish painter the same immediate,

autobiographic implications as *Guardians of the Secret* had for Pollock.

"Painting . . . is life itself (that is, for those who practice it)," Pollock had written his mother at age 20. In his life as thus defined, the primary psychic *agon* would have had to have been with Picasso rather than with the Jungian Terrible Mother. More than once in the early '40s he said to his wife Lee, "Damn that Picasso. Just when I think I've gotten somewhere I discover that bastard got there first."[120] Picasso's own psychodrama was most frequently bodied forth through the image of the *corrida* (another theme overlooked in Jung's Picasso essay). By age 15, the precocity of this "matador of painting," as he would later be called, had "killed" his real father, a professional artist who at that time definitively laid down his brushes.[121] Many duels would follow, but such was Picasso's self-assurance that even his *mano a mano* with Cézanne did not have the overwhelming intensity, the involvement and risk, of Pollock's struggle *with him*. In calling his canvas an "arena," Pollock was probably remembering the scene where many of Picasso's greatest dramas were enacted, though he characteristically shifted the metaphor from "life" to the process of painting. (Pollock was appalled by Harold Rosenberg's literal-minded extrapolation of his use of the word arena in forming the theory of "action painting."[122])

Pollock's "triumph" in his contest with Picasso's art was a matter of the individuality and the abstractness of the allover poured pictures, and his sense of having gone beyond Picasso certainly had some role in triggering their quality of exhilaration and exaltation. When painter-critic Paul Brach asked him why he went into that style, Pollock replied, "to get rid of Picasso." He was only half joking. Looking now at *Guardians of the Secret* from the perspective of this titanic struggle, the canine "father figure" (to use Pollock's words) inhibiting access to the vatic picture-within-a-picture takes on a very particularized symbolic significance and a new poignancy. It also reinforces the suggestion I made above that somewhere in the background of *Guardians* is an association to Picasso's own dog, crouching and ears alert, at the bottom of *Three Musicians* in the presence of hieratic and strangely mysterious revelers. *La Vie* of 1903 and *Three Musicians* of 1921 are sources, however remote, of the imagery and layout of *Guardians of the Secret*; its style—to the extent that it is indebted—owes more to the Picassos of the decade that precedes its execution. Picasso's art served as a powerful lever in forcing Pollock's painting toward its own resolution. It was a measure of Pollock's ambition, and of his strong sense of individual identity, that he risked using that lever with such abandon.

Notes

1. Sometime in January 1937 Pollock began psychiatric treatment for alcoholism. This treatment—about which little is known—was apparently not Jungian; with the assistance of his psychiatrist, Pollock entered the Westchester Division of New York Hospital in June 1938 for treatment of acute alcoholism, remaining there until September.

Early in 1939 Pollock entered psychoanalysis with a Jungian, Dr. Joseph Henderson, with whom his treatment continued through the summer of 1940, when Dr. Henderson moved his practice to San Francisco. By the spring of 1941, Pollock was already in analysis with a second Jungian, Dr. Violet Staub de Laszlo: this treatment lasted through 1942 and probably some months of the following year. Pollock offered his works on paper to both doctors for use in his analysis.

2. *Jackson Pollock*, New York, Harry N. Abrams, 1960. pp. 72, 91, 139–40.

3. In an experiment, a group of staff members of The Museum of Modern Art, all of whom had been undergraduate majors in art history (some also graduate students) were shown a color reproduction of *Moon Woman Cuts the Circle* (staff familiar with the painting were not included). They were asked to explain what was taking place in the picture and to propose a title. All saw it as an image of conflict between two entities and their titles reflected this impression. Only one identified the figure on the right as female, the others identifying it as male or not specifying sex. None expressed, either in their descriptions or their proposed titles, any reference to a moon, a moon woman, or a circle.

4. *Jackson Pollock. Paintings, Drawings and Watercolors from the Collection of Lee Krasner Pollock*, London, Marlborough Fine Art Ltd., June 1961.

5. *The Genesis of Jackson Pollock: 1912 to 1943*, Ph.D. diss., Baltimore, Johns Hopkins University, 1965, p. 101. (Hereafter "O'Connor dissertation"). It may be that O'Connor no longer subscribes to the view cited here: his recent work—the superb *Catalogue Raisonné* apart—has been much involved with Jungian hermeneutics. I was unable to attend his lectures earlier this year in Washington, D.C.—"Jackson Pollock: Facts, Myths and Speculations" (Jan. 30) and "The Iconography of Jackson Pollock's *She-Wolf*" (Feb. 1)—on the occasion of the annual C.A.A. meetings. Summary notes taken by friends indicate that O'Connor now seems to be taking a position more consistent with

that of the Jungian critics. As, however, his texts are unpublished, and as he is not prepared to make their typescripts available, I cannot deal with them in the present article.

6. In Volume II of the *Catalogue Raisonné* (ed. by Francis V. O'Connor and Eugene V. Thaw, New Haven and London, Yale University Press, 1978, p. vii). O'Connor describes the problems of the term "drip" in relation to Pollock's technique and gives the impression of suggesting a new term: "Pollock's 'pouring technique'—as we choose to call it." As Hilton Kramer, in his review of these volumes in the *New York Times Book Review*, Dec. 3, 1978, p. 86, observed: ". . . now, we are advised, [the 'drip' paintings are] more properly described as 'poured' paintings." Mr. O'Connor should have pointed out (and footnoted) the fact that the present writer first used and developed that term. Although in my 1967 articles in the February through May issues of *Artforum*, "Jackson Pollock and the Modern Tradition," I made use of the conventional word, I also there described the technique as a "pouring" technique and stated flatly that "poured pictures is a more apposite term." By the early '70s I had eliminated the word "drip" from my writings completely and in a 1974 article ("Pollock was no Accident," *New York Times Magazine*, Jan. 27, 1974) pointedly indicated my preference for the use of the term *poured paintings*, "as I prefer to call them."

7. "Jackson Pollock and the Modern Tradition: Part I," *Artforum*, Feb. 1967, p. 19.

8. Alloway, op. cit. (unpaged), note no. 34.

9. In *Jackson Pollock*, catalogue of a retrospective exhibition, New York, Museum of Modern Art, 1967.

10. *Jackson Pollock/Psychoanalytic Drawings*, New York, Horizon Press, 1970.

11. "Jungian Aspects of Jackson Pollock's Imagery," *Artforum*, Nov. 1972, pp. 65–73. All references hereafter to Wolfe are from this article and will not be individually footnoted.

12. "Jackson Pollock: A Symbolic Self-Portrait," *Studio International*, Dec. 1973, pp. 217–221. All references hereafter to Freke are from this article and will not be individually footnoted.

13. "Jackson Pollock's *The Moon Woman Cuts the Circle*," *Arts*, March 1979, pp. 128–137. All references hereafter to Langhorne that are not individually footnoted are from this

article. References to "A Jungian Interpretation of Jackson Pollock's Art through 1946," Unpublished Ph.D. diss., University of Pennsylvania, 1977, (hereafter "Langhorne dissertation") will be separately indicated.

14. "Jackson Pollock's *The White Angel*, and the Origins of Alchemy," *Arts*, March 1979, pp. 138–141. All references hereafter to Welch are from this article and will not be individually footnoted.

15. "Jackson Pollock: Classic Paintings of 1950," in *American Art at Mid-Century: The Subjects of the Artist*, Washington, D.C., National Gallery of Art, 1978, pp. 127–153.

16. Cited in Selden Rodman, *Conversations with Artists*, New York, Devin-Adair, 1957, p. 82.

17. Quotations and paraphrases from this unpublished text make it clear that it is not the one published the following year in *Medical World News*, Feb. 5, 1971. No author is given for this article. "How a Disturbed Genius Talked to his Analyst with Art," and though it takes the form of an interview by a second party, it appears to have been written by Dr. Henderson himself. (I am obligated here to Langhorne's dissertation, in the notes which I came upon this reference).

18. Eugene Glynn, M.D., review of *Jackson Pollock: Psychoanalytic Drawings*, in *Print Collector's Newsletter*, New York, Nov.–Dec. 1970

19. Wysuph, op. cit., p. 14. At the time, Dr. Henderson took no exception to this characterization of Pollock as reported by Wysuph. This—among other aspects of the publication—led to wide-spread criticism, professional as well as private, and threats of a lawsuit from representatives of Pollock's family. In the "interview" of the following year cited in fn. 17, Henderson modified—or, as the case may be, corrected—the diagnosis: "I had said Pollock was not schizophrenic, but had at times been close to it."

20. Op. cit., p. 17.

21. Ibid., p. 15.

22. "Jackson Pollock's Drawings," *Artforum*, Jan. 1971, p. 60–61.

23. Quoted in "How a Disturbed Genius. . ." op. cit. (Italics mine).

24. Wysuph, op. cit., p. 29 (Italics mine).

25. Langhorne dissertation, p. 210.

26. "Pollock: The Art of a Myth," *Art News*, Jan. 1964, pp. 39–41, 62–65.

27. Langhorne dissertation, p. 19.

28. Interview with Lee Krasner Pollock, June 1979.

29. The Minotaur is not even men-

tioned in passing in any of Jung's three principal texts, *Symbols of Transformation* (earlier known as *The Psychology of the Unconscious*), *The Integration of the Personality* (later retitled *Psychology and Alchemy*) and *The Myth of the Divine Child and the Mysteries of Eleusis* (later known as *Essays on a Science of Mythology*). Though the Minotaur had appeared in Picasso's art five years before Jung's 1932 essay on the artist, Jung managed to overlook it even in that context.

30. Cf. especially Parker Tyler's "Jackson Pollock: The Infinite Labyrinth," *Magazine of Art*, March 1950, pp. 92–93.

31. Cf. Rubin, *Dada and Surrealist Art*, New York, Harry N. Abrams, 1968, pp. 290–309.

32. Automatism is mentioned once in passing by Freke and is briefly discussed in Langhorne's dissertation (pp. 16–18) as an important Surrealist device of no relevance to Pollock's work.

33. Cited in *Catalogue Raisonné*, IV, p. 212

34. Ibid., IV, p. 213.

35. "Jackson Pollock and the Modern Tradition," *Artforum*, Feb. through May 1967.

36. Cf. "Jackson Pollock and the Modern Tradition," *Artforum*, Feb. 1967, pp. 20–21 and Michael Fried, "Jackson Pollock," *Artforum*, Sept. 1965, pp. 14–17.

37. Cf. Robert Goodnough, "Pollock Paints a Picture," *Art News*, May 1951, pp. 38 ff.

38. Reported to the author by Tony Smith in conversations recorded in April 1967.

39. Langhorne dissertation, pp. 125 ff., 217–220.

40. Ibid., pp. 339–40, 346.

41. Ibid., p. 349.

42. This picture of 1943 was originally titled *Male and Female in Search of a Symbol*. In 1945, Pollock shortened it to *Search for a Symbol*.

43. Actually Pollock used paint brushes, the caked bristles of which had dried solid; thus they functioned as sticks rather than brushes.

44. At The Museum of Modern Art, Dec. 1956–Feb. 1957, selected by Sam Hunter, and again in Apr.–June 1967, selected by William S. Lieberman.

45. See above, fn. 3.

46. See above, fn. 8.

47. Freke identifies the German language revised edition of 1952 as the first to contain the Haida illustration.

48. Letter to the Editor, *Artforum*, Mar. 1973, p. 7.

49. It is possible that Pollock explored Jungian ideas prior to his first analysis as an outgrowth of his friendship with Helen Marot (cf. Langhorne dissertation, p. 13).

50. Interview with Jackson Pollock, *Arts and Architecture*, Feb. 1944, p. 14 (Italics mine).

51. Langhorne proposes a more remote explanation. Paraphrasing Jung to the effect that the diamond is a "common symbol for the alchemical philosopher's stone," she sees this "flow of diamonds, symbols of a union of opposites on the higher level of an individuated self" as occasioned by the putative cutting of the third eye by the Moon Woman.

52. As for example, the one illustrated in the Smithsonian volumes Pollock owned: Annual Report, Bureau of American Ethnology, vol. 17, part II (1895–96), fig. 266 (cited in Langhorne dissertation, p. 170, fn. 19). For Langhorne (dissertation, p. 165), the slaying of the tail-eating snake is only "implicit," since 1) the one motif identifiable with it (the semi-circular figure in the upper left) is considered to be the arm of its Moon Woman, and 2) the circle of the title is identified as an eye.

53. Statement prepared by Pollock for Sidney Janis' *Abstract and Surrealist Art In America*, New York, Reynal and Hitchcock, 1944, p. 112 (Italics mine).

54. O'Connor dissertation, p. 219.

55. Langhorne dissertation, p. 146.

56. Lee Krasner Pollock and E. V. Thaw (co-author of the *Catalogue Raisonné*) looked at this picture carefully last spring at my request. Both agreed with me that the image represents only one figure.

57. Lee Krasner Pollock and Eugene V. Thaw have looked carefully at the picture and are in accord with my reading.

58. The kinship of *Bird* and *Naked Man* (*Catalogue Raisonné* I, no. 86) was suggested to me by Lee Krasner Pollock who, in terms of her recollections of Pollock's and her own associations at the time, always considered the pictures related. *Naked Man* is a witch doctor-like figure, a male nude with a bird's head (or bird mask).

59. Recorded conversation with Lee Krasner Pollock, April 1967.

60. *Jackson Pollock*, New York, George Braziller, 1959, p. 21.

61. The Museum of Modern Art version of Picasso's *Three Musicians* contains, as does Pollock's picture, a dog with alert ears shown crouching and in profile in the bottom register. Both pictures are symmetrical and show frontal, hieratic figures who generate an air of mystery. The table in the Picasso is roughly comparable in location to the central panel of *Guardians*; Wolfe calls this a "casket, bed, or altar," but it might just as well be called a table, understood to be flipped up into the picture plane as in the Picasso. This said, I don't wish to insist on an influence here. But, given Picasso's role in Pollock's work and considering Pollock's known love of dogs, it seems to me that associations to the Picasso work, whether conscious or unconscious, may have played a role in Pollock's development of his picture. In any event it is a much more likely point of reference than Jung's scheme for the different levels of consciousness; Wolfe's proposed illustration of the latter imputes to Pollock's procedures an intellectual self-consciousness that had no place in his painting.

62. "Such a diagrammatic interpretation [of *Guardians*]," says Wolfe, "is consonant with the fact that Jungians diagram all aspects of the psyche. . . ." But Pollock's supposed use of such a diagram comes up against the problem, as Wolfe admits, that "Jungian diagrams are most frequently circular, radiating from the center. . . ." Thus, Wolfe concludes, "if Pollock's composition represents a Jungian scheme, it has been entirely remodelled."

Langhorne pursues the diagrammatic idea by suggesting as a possible source for the *Guardians* schema derived from a dream—two transecting rectangles with a common center—which had been illustrated in the 1939 edition of Jung's *Psychology and Alchemy*, then called the *Integration of the Personality* (cf. Langhorne dissertation, p. 193 and plate 160). Even in the very unlikely event that Pollock ever saw this diagram, and more than that, remembered it (it would not have been remembered for any relevance to the theme of the *Guardians*), we must finally observe that it doesn't really resemble the rectangle-within-a-rectangle organization of Pollock's picture, which is a straightforward geometrical subdivision of the picture surface. This compositional pattern can be found in Pollock's earlier work and by 1943 hardly needs to be "explained" by some outside visual precedent. Langhorne nevertheless pursues the diagram conception, ultimately concluding that "*Guardians of the Secret* is in effect a disturbed mandala."

It is hard to say whether the latter proposal for the manner in which Pollock arrived at the simple geometrical

arrangement of the *Guardians* is more far-fetched than Freke's notion that the picture "owes its format" to "the whole Middle Eastern mortuary cult" discussed by Jung in *Symbols of Transformation*—a suggestion which forces us to imagine Pollock in an architecture library scanning volumes on the Middle Eastern mortuary temples, none of which Jung has reproduced.

63. *Symbols of Transformation*, New York, Bollingen Foundation (Princeton University Press), Second Edition (with corrections), 1967, pp. 238 and 239 (italics mine).

64. Perhaps because Langhorne knew in advance of her writing (from Lee Krasner) that Pollock considered the dog a father figure, she elected not to deal with the Jungian references mentioned in fn. 63. She notes that for Jung "the semi-animal psyche with its regressive demands against which [the analysand] struggles so desperately is attributed to the mother, and the defense against it is seen in the father"; thus Jung is shown to "acknowledge" a possible "equation of the male animal with the father." Langhorne is not herself much convinced by this argument, however, and finally comes down on the side of what is, in any case, Jung's basic perception, namely that the treasure-guarding dog is a female symbol. She supports this thesis by citing not Jung himself but the Jungian Erich Neumann, who "insists that the male animal is still chiefly an attribute of the Terrible Mother." Langhorne views his analysis as "probably ultimately correct." (Langhorne dissertation, p. 186.)

65. The form of Pollock's "divining rod"—not at all the usual forked stick—suggests female sexuality insofar as it is shaped as what Freud calls a "receptor." Nevertheless, the image is primarily masculine, insofar as it is a "rod" impaled by the earth (universally understood as feminine in connotation). Taking the divining rod as the staff of a magus or shaman would permit translation of the image from a Freudian to a Jungian level.

66. See note 3.

67. Conversation with Lee Krasner Pollock, June 1979.

68. "A Case for Content: Jackson Pollock's Subject was the Automatic Gesture," *Arts*, March 1979, pp. 103–109.
The title of this article reflects the author's tendency to confuse the terms "subject" and "content," with deleterious effects on his exposition.

69. *Jackson Pollock. Paintings, Draw-*

ings and Watercolors from the Collection of Lee Krasner Pollock, London, Marlborough Fine Art, June 1961, unpaginated.

70. Langhorne dissertation, pp. 143–173 and *passim*.

71. Wolfe, op. cit., pp. 65–73.

72. Many American (and Pre-Columbian) Indian tribes had legends of a Moon Woman, often associated by mythographers with Luna. Called Atahensic by some of the American tribes, she was believed to reside in the moon. She was often considered a war goddess and identified with the Spirit of Death. (cf. Ellen Russell Emerson, *Indian Myths or Legends, Traditions and Symbols of the Aborigines of America*, Minneapolis, Ross and Haines, 1965, pp. 75, 119 ff.) An account of quite another type of Moon woman may be found in Katherine B. Judson, *Myths on Legends of British North America*, New York, 1917, pp. 68, 159 ff. While these references merely scratch the surface of the literature on Moon Women, they suffice to show that there were alternative sources to the Moon Woman of the Hiawatha legend as treated by Jung.

73. Freke, op. cit., pp. 217–221.

74. "Notes on Masson and Pollock," *Arts*, Nov. 1959, pp. 36–43.

75. James Johnson Sweeney's recollection of the original title of *Pasiphaë* is *The White Whale*, but Lee Krasner is sure it was *Moby Dick*.

76. Langhorne dissertation, pp. 203–205.

77. Ibid., p. 228.

78. See note 14.

79. At least as far as that can be judged by the material assembled in the *Catalogue Raisonné* .

80. In Wolfe's text, she states outright that Pollock "gave the title *Alchemy*" to the picture. In her notes, she admits that some doubt exists on this point, but reaffirms her position.

81. In conversation with this author, Sept. 1979.

82. Langhorne dissertation, p. 170, note 12. (Italics mine).

83. The reader may have noticed in the discussion of *Alchemy* above that Wolfe, citing Cirlot, had assigned quicksilver to the second stage (white) in the alchemical color hierarchy, while Welch, citing Jung, had identified it with the initial stage, or *materia prima*. So much differing information exists on alchemical lore that one can find texts to support any number of contradictory theses. In this, it is comparable to the Jungian literature as a whole. Take for example Langhorne's identification (based on Jung) of the sun with the male principle and the moon with

the female one (in any case, the common symbolic interpretation); all of Langhorne's demonstrations depend on this particular polarity. Now suppose she had wanted a text by Jung to support just the opposite contention. She could simply have cited, from *Symbols of Transformation*, the legend of the Hottentots (which Herbert Read had gotten wrong) where the sun, thought to consist of bacon fat, is identified as feminine. Were more proof needed, she could have quoted Jung's general statement to the effect that the "belief among the primitives that the sun is feminine and the moon masculine" is "widespread" (Princeton paperback edition, p. 318).

84. Langhorne dissertation, p. 149.

85. The ambivalent sexual identity of many of Pollock's figures permits Langhorne to make identifications based on the supposition that yellow indicates a female; this is her procedure in *Male and Female* (see below): The "female" figure thus identified is then cited elsewhere, in a classic example of circular reasoning, to "prove" the rightness of the contention that yellow signifies female.

86. *Catalogue Raisonné*, Vol. I, p. xiv.

87. Langhorne dissertation, p. 148.

88. The Jungians would probably argue that this observation reinforced their point, as the female would be the Terrible Mother. Nothing, however, forces that assumption on the non-Jungian critic who does not accept in advance that all Pollock's figures are archetypes.

89. Langhorne dissertation, p. 150.

90. This, I have recently discovered in conversation, is also the view of Lee Krasner Pollock, for whom the title means something akin to "*Maleness and Femaleness*."

91. The black panel is directly under the right-hand figure's head and should be considered an integral part of it. By relegating it to a position "adjacent" to it, Langhorne frees herself from accounting for its relationship to that particular figure.

92. Langhorne dissertation, p. 150.

93. Ibid., pp. 146–147.

94. Ibid., pp. 147–148.

95. The identification of the list of numbers as the monthly accounts is Lee Krasner Pollock's.

96. This esthetic varies according to whether the numbers are printed or handwritten. 9 as handwritten would share with 5 the combination of straight-edged and curvilinear forms.

97. Interview with Lee Krasner Pollock, June 1977. The Jungians refer to 46 exclusively as Pollock's "magic" number, since this suits

their purpose better than the more prosaic "lucky."

98. See note 10.

99. "Another Side of Jackson Pollock," *Art in America*, Nov.–Dec. 1977, pp. 81–91.

100. "The Art of a Myth," op. cit., pp. 39–41, 62–65.

101. Cited in Rodman, *Conversations with Artists*, op. c it., p. 82.

102. "Unframed Space," an interview with Jackson and Lee Krasner Pollock, *New Yorker*, Aug. 5, 1951, p. 16.

103. As recounted to the author by Lee Krasner Pollock. The same remark—shorn of the expletive—appears in the *New Yorker* interview cited.

104. Among the exceptions on canvas support are the "cut-out" paintings and those works in which Pollock attempted to use the pouring method against the grain, so to say, in a frankly representational way (see, for example, *Triad*, 1948). There are also a few works entirely unique in method, such as the painting with wood collage called *The Wooden Horse* (1948), which contain both abstract and figurative elements. All these pictures together constitute but a small fraction of Pollock's 1947–50 production.

105. Friedman, "Interview with Lee Krasner Pollock," op. cit.

106. Rubin, "Jackson Pollock and the Modern Tradition," op. cit.

107. "Jackson Pollock: Classic Paintings of 1950," op. cit., pp. 127–153.

The conclusion Carmean draws here is hardly novel insofar as it associates images with the black paintings of 1951. Four paragraphs earlier he quotes me to the effect that in 1951 imagery "surfaced again, as if the fearful presences in his work of the early '40s had remained as informing spirits beneath the fabric of the 'allover' pictures." Since Carmean here uses me, or rather misuses me, to make his point about the "myth" of "hidden images" in the classic pictures—in effect attributing to me the idea that these figures remained literally present underneath the poured skeins—I must point out that he overlooked the significance of my words "as if," to say nothing of a number of passages in which I described 1947–50 works as non-figurative from start to finish. I do believe the earlier images persisted during this period *in Pollock's unconscious*.

108. Op. cit.

109. The only larger format is that of the magnificent and highly prophetic mural of 1943 commissioned by

Peggy Guggenheim for the lobby wall of her townhouse.

110. An extended discussion of both the style and presumed iconography (the theories of O'Hara and Langhorne) in this picture will appear in the monograph on Pollock I am now completing.

111. Interview with Lee Krasner Pollock, June 1979.

112. According to Dr. Henderson's written but still unpublished account cited in Bernice Rose, *Jackson Pollock Works on Paper: Suggestions for a Chronology—An Annotated Worklist*, Qualifying Paper, New York University, 1967, notes, p. 10.

113. Ibid., p. 10.

114. "Picasso," trans. By R. F. C. Hull, *The Spirit in Man, Art and Literature*, Princeton University Press, 1966, pp. 135–41. (First published in the *Neue Zürcher Zeitung*, Zurich, Nov. 13, 1932.)

115. Jung's identification of Picasso with the "schizophrenic" group of his patients led to considerable controversy in the press. As a result, Jung added a clarifying note to the 1934 publication of the text. There he explained that he did not mean to say that Picasso was literally a schizophrenic, but merely that he had "a disposition" to that disease. Thus Picasso is not "psychotic"; he simply has a "habitus" which leads him "to react to a profound psychic disturbance not with an ordinary psychoneurosis but with a schizoid syndrome" (note 3, p. 137).

116. See Theodore Reff, "Love and Death in Picasso's Early Work," *Artforum*, May 1973, pp. 64–73, and "Harlequins, Saltimbanques, Clowns and Fools," *Artforum*, Oct. 1971, pp. 30–43.

117. *Psychology and Alchemy*, second edition, Princeton University Press, 1968, p. 192. If the small picture reproduced by O'Connor and Thaw (*Catalogue Raisonné*, Vol. I, p. xiv) in juxtaposition to *Guardians* is a study for it and not associated with a later picture, the absence in such an early state of what the Jungians call a mandalic configuration would be a further argument against Pollock's having used the diagram to which this note refers.

118. The painter-critic Paul Brach suggested that I explore a possible relationship between *Guardians of the Secret* and *La Vie* as we were looking together at the former work during the 1967 retrospective.

119. The picture was also reproduced in the catalogue of that exhibition—among the books in the inventory of Pollock's library—and was widely exhibited at the time. It entered the

collection of the Cleveland Museum in 1945.

120. Recorded conversation with Lee Krasner Pollock, April 1967.

121. There are minor differences in the various accounts of Picasso's father abandoning painting. His decision to limit his activities to teaching was probably confirmed by his son's *Science and Charity* (c. 1896), for which brilliant academic tour de force he posed as the doctor.

122. "Appalled" is Lee Krasner Pollock's word for Jackson's reaction to the famous Rosenberg text (recorded conversation, April 1967). Pollock believed that Rosenberg had developed his thesis from a conversation between the two on the train to East Hampton, but that Rosenberg had "got it wrong." Rosenberg denied that this conversation was the source of his thesis and, indeed, the latter depends heavily on ideas derived from Dada, Surrealism and Existentialism. Yet his conversation with Pollock, in which the latter no doubt used the word "arena," must certainly have played a role. Rosenberg "got it wrong" in the sense that Pollock's use of the word with reference to his canvas was metaphoric. Rosenberg treated it as if meant literally and saw the paintings as the result of a physical "enactment" of an ideational drama directly on the canvas surface (as is actually the case with some art that derives, not from Pollock, but from Rosenberg's theory, e.g., Yves Klein's "body art"); for Rosenberg "the canvas was not a picture but an event" which "broke down every distinction between art and life" and whose "value must be found apart form art." Barbara Rose (*Arts*, Mar. 1979, pp. 112–119) makes a convincing case for the importance of Hans Namuth's photographs in the inception of Rosenberg's theory. For an extended discussion of Action Painting in regard to Pollock in particular and Abstract Expressionism in general, see Part I of this author's "Jackson Pollock and the Modern Tradition," *Artforum*, Feb. 1967.

1993

William Rubin's critique of Jungian approaches to Pollock effectively discouraged other psychological interpretations as well. In the course of the 1980s, however, new theoretical models were imported into art criticism from gender theory, from Surrealism, and from French and English schools of psychoanalysis. These seemed to allow psychological and formal issues in Pollock's work to be addressed simultaneously. Such theoretical perspectives were supplemented, furthermore, by a new awareness of the crucial role that Pollock's wife, the painter Lee Krasner, had played in his development as an artist. Anna Chave's article represents a critical approach that assumed increasing importance in the 1990s.

Anna C. Chave. "Pollock and Krasner: Script and Postscript," *RES*
(CAMBRIDGE, MASS.) 24 (AUTUMN 1993): 95–111. © 1993 ANNA C. CHAVE.

The venerable legend of Jackson Pollock, that oft-told American tale, is the story of a taciturn, "'hard-drinkin'. . . farmer's son from Cody, Wyoming" who "rode out of the Mid-West to put citified art to rights" with his sweeping lariats of paint.[1] This tough "bronco-buster of the art world" has lately suffered some slights to his manhood, however.[2] With the closer scrutiny of Pollock afforded by a rash of recent biographies, the maker of the famed and defamed poured and dripped paintings (see *Autumn Rhythm: Number 30, 1950*) has unexpectedly emerged as a vulnerable and even sexually confused figure.[3] As for his spouse, Lee Krasner, her image also has been subject to revision. Once dismissed as an inconsequential figure, dwarfed by Pollock's formidable stature, she has since been touted both as a worthy artist and as the mastermind behind her husband's immense success. No less an authority than Clement Greenberg (who himself could have laid claim to engineering Pollock's rise) has declared that "for his art she was all-important, absolutely," while the dealer John Bernard Myers asserted, "There would never have been a Jackson Pollock without Lee Pollock and I put this on *every level.*"[4] Such assessments of Krasner's influence often carry a derisive edge, however, as when the painter Fritz Bultman referred to Pollock as Krasner's "creation, her Frankenstein," adding "Lee was in control toward the end and very manipulative."[5]

This matter of control—the fact that, by all accounts, Krasner was a deeply controlling person while Pollock was chronically veering out of control is a crucial factor in the work as in the lives of both these artists. The way Barbara Rose narrated the story of the couple's "working relationship" (as she was first to do), he was her creation from the outset: when Krasner and Pollock met in 1942, she was a smart, well-connected New Yorker whose intensive studies at Hans Hofmann's school had brought her au courant with events in the Paris vanguard, while he was a misfit hick who—having separated himself with difficulty from his mentor, that self-styled hillbilly painter and archenemy of modernism, Thomas

Hart Benton—was adrift and consumed by doubt. Pollock's engagement with the work of such comparatively marginal figures as Benton and the Mexican muralists had left him groping for a language to articulate the social content and the mythic dimension of art. Krasner's training had brought her, by contrast, a sure command of the idioms of cubism and the School of Paris. As Rose portrayed it, then, Krasner had to catechize Pollock in the dominant tenets of modernism.[6]

If Krasner enjoyed some initial advantage in the studio, it proved evanescent, for her encounter with Pollock caused her to question so severely what she knew about making art that between 1942 and 1945 she did not complete a single painting.[7] Subsequently, she developed a convincing facility with various New York School idioms, beginning with that of Pollock, as she created a group of her own poured and dripped "all over" pictures between 1946 and 1949. It followed that Krasner was reflexively identified as Pollock's wife and described by the press in solicitous but inaccurate terms as "an artist in her own right." In fact, she never could nor would decouple herself from Pollock. Whereas he prevailed in the studio, however, it appears that there were ways in which she prevailed at home: visitors describe how the more urbane and cultivated Krasner was forever "educating" or improving her spouse, the uncouth high school dropout.[8]

To hear his biographers tell it, the cause of Jackson Pollock's deep feelings of inadequacy was less his limited formal education than the immense difficulty he had in mastering his craft. The consensus about Pollock within his family is that he never really did learn how to draw—not like his eldest brother, Charles, a wondrously adept draughtsman. Classmates from the Art Students League likewise remember that no matter how diligently he applied himself to drawing, Pollock never really measured up. This trouble with drawing impeded his progress in painting and caused him terrible frustration. A psychoanalyst he consulted during his early years in New York related that "at first his main preoccupation and sorrow was not being able to paint and paint as he wanted to."[9]

Pollock did eventually learn to draw: his sketchbooks from the late 1930s, when he was engrossed with the art of Michelangelo and El Greco, then of the Mexican muralists, and then of the Picasso who painted *Guernica*, are often riveting. But what is of interest here is his peers' estimation; and even after Pollock emerged as a leader of the New York School, they remained skeptical of his basic abilities. Robert Motherwell reportedly "was always bragging that Pollock couldn't draw," and Franz Kline went around at the reception following Pollock's funeral (in 1956) telling anyone who would listen, "Say what you want, he couldn't paint."[10] According to his family and friends, Pollock was inept not only at drawing but at practically everything he undertook: he couldn't dance or play an instrument; he didn't read easily; he had great difficulty speaking, unless he had had too much to drink (in which case he wasn't always lucid); and he plainly couldn't hold his liquor. So pathetic was Pollock in the conduct of his daily affairs

that "he felt he couldn't go to the station and buy a ticket for himself," as Greenberg described it.[11]

What is at issue here is not Pollock's troubles at the ticket office but his difficult relation to languages, both visual and verbal: his perceived and self-perceived ineptitude with a pencil and brush and his no less remarked infacility with words. The small body of letters and writings that Pollock left behind is riddled with incomplete and ungrammatical sentences made up of misspelled and misformed words. "It is of the utmost difficulty that I am able to write—and then only miles from my want and feeling," a distressed Pollock once lamented to his mother.[12] And a psychoanalyst who treated the artist has revealed that she was hindered by his being an intractably "inarticulate personality."[13] Even his wife found him " . . . very closed mouth. I practically had to hit him to make him say anything at all."[14] This silence was to become an indelible part of the Pollock melodrama: "He left silent as he came," pronounced a friend, "It was phenomenal, that silence."[15]

If Pollock was as tongue-tied and as ham-fisted as legend has it, then the question must be asked: How did he succeed in making his presence felt at all, let alone to the remarkable extent that he did? What his biographers now tell us is that his wife contrived to speak for him, that she "became Jackson's voice, corresponding with his relatives, making his phone calls, even speaking his thoughts."[16] His close friend, the painter Alfonso Ossorio, observed "Someone had to speak," so she did the talking.[17] And while Krasner was busy putting words in Pollock's mouth, others reportedly helped him put words on paper, ghostwriting some of his few public statements.[18] Pollock once protested to his dealer, Sidney Janis, that "to attempt explanation" of his art "could only destroy it"; but Janis pressed him anyway to title rather than number his pictures.[19] Knowing that titles facilitated marketing his difficult paintings, Krasner and others regularly helped to title them.[20] Not only did Pollock resist naming his most radically abstract pictures, he also hesitated signing them. But signatures also aided picture sales, so Krasner not only urged the artist to sign his work but allegedly had his signature forged on some unsigned work after his death to enhance the value of the estate, of which she was the sole beneficiary.[21]

If Pollock was such a hapless figure and Krasner was such a crafty woman as one is led to believe, then another question begs to be asked: Why couldn't Krasner do for her own career what she evidently did for Pollock's; or what can account for the huge discrepancy in their reputations? Some feminist critics would argue that the best answers to this question lie with the discriminatory behavior of critics, dealers, and collectors toward women artists in general, and with the sexism rampant in the precincts of the New York School. Krasner's art probably would have been taken more seriously had she been a man. What undid Lee Krasner was perhaps not merely her sex but her success at painting like a

264

man—or rather like a succession of men, from Matisse and Picasso to Pollock and Motherwell. By contrast, what finally made Pollock such a compelling figure was in a sense his success at painting like a woman—or, more precisely, at assuming what might be called a "transsexuating" role as an artist. The contrast, in other words, is that between a female artist who, over the course of a long career, demonstrated her knowledge of a range of modernist languages, with their difficult, hermetic parts of speech, and a male artist who is persistently associated (as women more typically are) with a state of nonknowledge, wordlessness, and incoherence. To her feminist partisans, Krasner's command was all to her credit, but others reacted more skeptically to the specter of that oxymoronic being, a female master. Said Greenberg dismissively, "I don't think Lee was much of a painter—all brass and accomplishment"—as if accomplishment were some sort of liability; and Le Corbusier snidely adjudged of Pollock and Krasner: "This man is like a hunter who shoots without aiming. But his wife, she has talent—women always have too much talent."[22]

Whether Pollock aimed when he shot, the extent to which he exerted control, has always been a matter of some dispute. The painter was highly sensitive about this matter—sensitive in part, no doubt, because unloading a brush, like shooting a gun, has sexual connotations. That Pollock made his art through a series of "explosions" is a standard locution in descriptions of his technique, with all its sexual implications. The photographer Hans Namuth recalled "the flame of explosion when the paint hit the canvas;. . . the tension; then the explosion again."[23] The critic William Feaver less euphemistically envisioned the artist "casting paint like seed . . . onto the canvas spread at his feet. This was no sissy. . . . It was, demonstrably, the real thing . . . painting composed of . . . manly ejaculatory splat."[24] And Time magazine suggestively related that his friends had seen Pollock "emerge from the studio limp as a wet dishrag" with "a cigarette smoldering on his lip."[25]

Pollock's own account of his working process was likewise sexually imbued. When he began the poured paintings, he reported happily: "I'm just now getting into painting again, and the stuff is really beginning to flow. Grand feeling when it happens."[26] He talked also of experiencing a kind of ecstasy or loss of the boundaries of self when he worked: "I can . . . literally be in the painting. . . . When I am in my painting, I'm not aware of what I'm doing."[27] The image this evinces, of a painter ejaculating in the body of his picture, is suggested in a particularly graphic way by the painting called The Deep of 1953, with its abstractly vaginal slit; but a rhetoric of potency and virility is rife in discussions of all of Pollock's art—surely fostered in part by the famous film footage that shows the intensely rhythmic movements of his body, and of his flowing sticks and syringes, over the canvas spread beneath him on the floor.

That implements of painting, drawing, and writing are phallic symbols, one

may take, of course, from Freud, or from less exalted sources.[28] And the masculinist ideal of the great painter as one who, as Renoir is supposed to have coarsely put it, "paints with his prick" helped reinforce the legend of Jackson Pollock in a way it could never do for his wife: although Lee Krasner also poured paint for a time, the critics would never think to credit her with the potency to have ejaculated it. And what flows from a woman's body—with its lack of that putatively crucial, anatomical equivalent to the brush or pen—is tacitly understood to be less subject to control, more vulnerable to happenstance or accident, than the flows of the male body. The key question for critics in Pollock's case, then—a question that became tantamount to a test of manhood—was whether, or to what extent, he could control the flow of paint on the canvas, and so control the image. *Life* magazine sneered that Pollock "drools" and "dribbl[es]" paint, evoking the involuntary flows of the body of an infant or moron; and the association of his painting practice with basic bodily functions was underlined more recently by Steven Naifeh and Gregory White Smith, whose celebrated biography makes much of the artist's engrossment with urination.[29] For years, the most repeated anecdote about Pollock was of his urinating in a fireplace at a party. And some have described him as being chronically out of control of all that flowed into and out of his body: when Jackson got drunk, one friend remembered, "All he did was spit, drool, sneeze, cough, snot and piss. He was a mess, a real pain in the ass."[30]

The years when Pollock made most of his greatest paintings, from 1947 to 1950, are in fact the years when he had his alcoholism most in check; and he reportedly made it a rule not to paint when drunk in any case. But hostile critics have all along insinuated that Pollock's poured pictures are merely the damning evidence of his lawless behavior. Declared an Italian critic: "It is easy to detect the following things in all of [Pollock's] paintings: Chaos. Absolute lack of harmony. Complete lack of structural organization. Total absence of technique, however rudimentary. Once again, chaos."[31]

Not only Pollock's poured paintings but even his prior, technically more conventional work, such as *Stenographic Figure* of 1942, looked to critics like, to take a representative phrase, "a chaotic tangle of broad lines, wiry lines, threads and speckles. . . . What it means, or intends, I've no idea."[32] *Stenographic Figure* could be seen as bearing a loose relation to Picasso's *Painter and Model* of 1928, replete with its palette of primary colors, black, white, and gray. But while Picasso's rigidly outlined artist neatly limns a naturalistic profile of his sitter's face, Pollock's artist is like a comical clerk spewing a ream of numbers, letters, and cryptic marks that career off his paper and settle like flies all over the surface of the picture. Something about those garbled, frenzied marks began to attract a sensitive viewing public, however; and buoyed by the positive response to this picture—from such well-placed figures as Piet Mondrian, Peggy Guggenheim, and

the reviewer for the *New Yorker* magazine—Pollock kept on writing. After 1942, his pictures increasingly looked like tablets inscribed, in whole or in part, with obsessive jottings and marks, until he finally lifted his paintbrush from the canvas, unrolled the fabric on the floor, and let his script flow freely with the movements of his hand, arm, and body.

Jackson Pollock's classic poured and dripped paintings evince complex manuscripts or palimpsests covered by a snarled, alien script. That script also may recall the physicalized and sprawling scribbles of the preliterate child who tries to produce handwriting by furiously willing a legible text onto a page. For that matter, Pollock generally felt as small children often do: excluded from language and ill-served by speech. Although many critics read his vigorous script as a manly affirmation of potency, that same script could be read instead as an aggrieved and urgent admission of impotence. In Jacques Lacan's rewriting of Freud, where language is identified with the almighty phallus, feelings of inadequacy in relation to language are symptoms of castration—a state that men and women necessarily, although unequally, share insofar as we are all "inevitably bereft of any masterful understanding of language, and can only signify ourselves in a symbolic system that we do not command, that, rather, commands us."[33]

The notion that Pollock's distinctive scrawl was merely childlike and random was something that always rankled the artist. "I *can* control the flow of the paint," he insisted, "there is no accident."[34] When, in 1950, *Time* magazine headlined an article on Pollock "Chaos, Damn It," the painter testily cabled back: "NO CHAOS DAMN IT. DAMNED BUSY PAINTING."[35] Yet drips are an index of accidents in Western culture; and the space that Pollock unremittingly left between the end of his brush or stick and the surface of his canvas was ineluctably the space of accident, of a loss or surrender of control. (This space is what decisively separates Pollock from the Surrealists, moreover, whose concept of automatic writing and the controlled accident had helped encourage him to liberate his line, and what separates him also from artists like Mark Tobey, Cy Twombly—or Krasner, for the most part—who retained the role of, and the control of, the renderer in creating their calligraphic pictures.) To a significant extent, refusing control, as Pollock did, meant refusing the authority of craft—refusing mastery.

That the poured paintings are never purely random or chaotic, that they could never have been done blindfolded, for instance, is plain enough to an attentive viewer. What attests to the pictures' manipulated character is the range of gestures, from broad to tight, lilting to tense; the measured degree of density to the webs of lines; the varied ordering or layering of the (however limited) palette of colors; the nuances in the viscosity and refractive properties of the diverse types of paint; and, in many cases, the artist's attention to keeping the majority of his meandering paint skeins within the borders of the canvas. For Pollock, then, the pressing question was not whether he could maintain any

control but how much control he ought to exert, or whether the real test of his mettle might be the extent to which he permitted himself to let go in spite of the critics' taunts.

Jackson Pollock's radical painting practice might be said to represent a freedom, the taking of a freedom, which was practically political in its dimensions.[36] The lawlessness these pictures evince becomes especially pronounced, however, when we contrast Pollock's fullbodied and expansive script with the cramped and involuted script produced by Krasner in the late 1940s. Krasner produced her postscript to Pollock's script—the diminutive "Little Image" series—in the small upstairs bedroom of the couple's farmhouse while Pollock was making monumental pictures in the capacious barn in back.[37] Rose insists that "the decision to work small and retain maximum control was her own," but she adds that Krasner was not "psychologically free enough to let go."[38] What helped to keep her enchained was no doubt her self-appointed role of serving as Pollock's voice, a role that must have impeded her developing a distinct voice of her own. Commented Arthur Danto, "There is no recurrent touch, or whatever may be the pictorial equivalent of voice, in Krasner's canvases"; there is only "the echo of other voices"—chiefly, while he lived, that of Pollock.[39]

In endeavoring to empower Pollock, then, Krasner wound up disempowering herself. Presumably, she would not have endured that sacrifice for just anyone: there was something about Pollock's art that she deeply identified with, something that seemed to stymie and even to displace her own production, almost as if, while she was busy talking for Pollock, Pollock was painting for her. "I had a conviction, when I met Jackson, that he had something important to say," she explained after his death. "When we began going together, my own work became irrelevant. *He* was the important thing."[40] Naifeh and Smith detect an insidious pattern in the couple's relationship: as long as his work went well, hers tended to go badly, and vice versa—the exception being this moment between 1946 and 1949 when she succumbed to his influence and began to make something like "Pollocks."[41] But Krasner's Pollocks were Pollocks with a difference: where his script was free and fluid, hers was constricted, congested, obsessive. To deride a picture like *Continuum* of 1947–1949 as "derivative," in the usual way, then, is to ignore its distinct charge and to miss its intense affectivity. Although she was using Pollock's language, Krasner was making something other than Pollocks: an image less of rampant lawlessness than of rampant order—an order, like that of cancer cells, turned in on, replicating, and consuming itself.

Pollock liked to talk about how well a painting was going in terms of the ease of the "flow": "When I'm working, working right, I'm in my work so outside things don't matter—if they do, then I've lost it. That happens sometimes, I guess because things get in the way of the flow."[42] But if flow and freedom were what counted most to Pollock, "flow" is important to everyone else, too. "Human

beings live in, and on, flows," Klaus Theweleit observes. "They die when streams dry up."[43] In his pioneering study of *Male Fantasies*, Theweleit dwells on the significance of the flow; and although he focuses on a population remote from the New York School—namely, professional soldiers in Germany between the wars (including some who went on to help form the core of Hitler's *Schutzstaffe*)— many of the discursive and symbolic formations he describes plainly overreach their immediate context. Freud's writing was rife with the imagery of fluid mechanics. He visualized the libido, more specifically, as "a flow that must be reg- ulated"—so notes N. Katherine Hayles in her insightful study of gender encoding in the science of hydraulics with its paradigmatically "masculine channels and feminine flows" and its longstanding difficulty in accounting for the dynamics of turbulent flow.[44] In the population Theweleit studied, flows likewise were asso- ciated predominantly with the female body and, as such, considered repugnant and even dangerous; for what flows may escalate into a flood.[45] The dissident Lacanian theorist Luce Irigaray observed that the most dangerous floods identi- fied with women are those related to childbirth and the body of the mother: fluids "threaten to deform, propagate, evaporate, consume him [the male subject], to flow out of him and into another. . . . The 'subject'. . . finds every- thing flowing abhorrent. And even in the mother, it is the cohesion of a 'body' (subject) that he seeks. . . . Not those things in the mother that recall the woman—the flowing things."[46]

In the early 1930s, Pollock conjured a nightmarish image of a kind of devouring mother dominating a row of five cowering, emaciated men (*Woman*, 1935–38?; OT: c. 1930–33) This picture begs to be examined in a biographical light in view of the fact that Pollock, the fifth of five sons, had a dreadful birth, during which he was nearly strangled to death by his own umbilical cord.[47] As an adult, Pollock is said to have had a very disturbed relation to the forceful woman he occasionally referred to as "that old womb with a built-in tomb."[48] He told Krasner that he sometimes "had trouble working because the idea, or the image, of his mother came over him so strongly that he'd see her," and his pictorial flows became dammed.[49] Alluding to a productive period of painting he enjoyed in 1950, Pollock once told a friend: "Last year I thought at last I'm above water from now on in—but things don't work out that easily I guess."[50]

Critics typically associate Pollock's flows not with the engulfing floods of the female body but with masculine streams of urine and semen. Semen attests to the presence of desire; and the Freudian image of desire as a flow has lately been reshaped by Gilles Deleuze and Félix Guattari, for whom "the unconscious is a flow and a desiring machine."[51] Because sexuality and love "dream . . . of wide-open spaces and cause strange flows to circulate that do not let themselves be stocked within an established order," further, that machine is implicitly revolutionary.[52] Under patriarchy, "the work of domination has consisted in

subjugating, damming in . . . [while the] desiring-production of the unconscious has been encoded as the subjugated gender, or femaleness," Theweleit suggests. As he describes it, then, the subversive errand of Deleuze and Guattari is to take Freud's mandate for human development—"Where id was, there shall ego be"—and reverse it, demanding: "Where dams were, flowing shall be." Concludes Theweleit, rather than sublimation, "a different process is applauded here: dive right in, be dissolved, become nameless—and not just in a regressive sense. What is seen here is a breaking out, a crossing of boundaries to discover . . . new streams, . . . [and] deterritorializations."[53]

Jackson Pollock's impossible aim was to paint "out of [the] unconscious," as he famously put it.[54] Many critics have sensed that the artist's rawest feelings flowed through his streams of paint—the feelings of a man who confessed he sometimes felt as if he were "skinned alive"; felt like "a clam without its shell"[55] Pollock tried to assuage that pain with the "grand feeling" he got when "the stuff is really beginning to flow"; tried, in effect, to dissolve himself in his work—work he wished to leave unnamed and unsigned. Pollock had some dephallicizing impulses, in other words, toward abnegating the role of the author. (As for Krasner, she did not enjoy the prerogative of renouncing the position of authority that she was largely precluded from assuming in the first place, both due to her gender and because she was not the originator of the language she used.)[56] For Pollock, it followed that becoming a public name or figure, even *the* public face of contemporary art, proved a deeply troubling experience. After being featured in a story in *Life* magazine in 1949, he reflected that once *Life* had finished with one of its subjects, "You're not your own anymore—maybe more, maybe less. But whatever the hell you are after that, you're not your you." And as for the film of Pollock made by Namuth in 1950, it made him think that "maybe those natives who figure they're being robbed of their souls by having their images taken have something"[57]; and it also triggered his return to drink in a violent break from several years of sobriety.

Jackson Pollock hated being objectified, in short, and that aversion was in a meaningful way continuous with his distinctive mode of painting. What distinguishes Pollock's work from almost all other art before it is not merely that he poured paint on canvas but that he kept those streams of paint from forming pools or bodying shapes or objects, and so configuring a composition. Theweleit observes that "flows have no *specific* object. The first goal of flowing is simply that it happen (and only later that it seek something out)."[58] What Pollock's flows generated might be termed a kind of *de*composition, with streams of paint running more or less evenly all over the picture surface; there is no center in his paintings, no one area predominating over others. This refusal to allow discrete pictorial territories to develop on his complex road maps, a resistance to borders or outlines, might be said to render Pollock's pictures exercises in "deterritorialization," in a

process of destructuring and dehierarchization. This is, in a sense, what critics alluded to when they remarked on the "complete lack of structural organization" in Pollock's art and its "abnegation of all composition in the traditional sense."[59] Critics generally refer to this radical painting mode as "all-over painting," yet no one has noted that idiom's double meaning: "all over" means not only "everywhere" but "finished," which is precisely what Pollock's art would signify to many: that European modernism was finished—or even that painting itself was all over. As de Kooning bluntly put it: "Every so often a painter has to destroy painting. Cézanne did it. Picasso did it with cubism. Then Pollock did it. He busted our idea of a picture all to hell."[60]

Pollock created pictures that many viewers could not recognize as pictures at all; pictures substituting chaos—albeit a painstakingly manufactured chaos—for composition. Remarked the sculptor Constantine Nivola: "The French would say of de Kooning, 'As painting, we can recognize this.' Of Pollock, '*This* is not painting! Only in America could it happen.' "[61] Through the nonsensical graffiti with which he covered his pictures, Pollock perpetrated a kind of willful defacement or erasure of established pictorial languages. At first he had hoped to master those languages; but the established canon admitted no American masters, and Pollock wished to be a great American artist, the first to paint on, or to paint, the tabula rasa of American culture. Less drawn to the Metropolitan Museum than to the Cedar Bar, Pollock was "very mad at civilization," observed a friend who witnessed some of his drunken sieges;"[62] and that roiling anger finally placed him in a different relation to the canon from his wife, who would never shed the role of acolyte in the church of high culture. While Krasner endeavored from the first to insinuate both herself and Pollock into a high cultural frame, Pollock was toiling away in Krasner's own backyard at leveling that very frame and projecting in its stead an image of the unframed or the void.[63]

The effect of Pollock's classic poured and dripped paintings is often cosmic or oceanic, like the infinity of the universe as inscribed by the constellations and the seeming infinity of the ocean as marked by the repetitive patterns of the waves—an effect underscored by some of the titles he approved, such as *Galaxy, Comet, Reflection of the Big Dipper, Full Fathom Five,* and *Sea Change.* The extreme open-endedness of Pollock's paintings—not only the fact that the most impressive of them cover a relatively vast expanse but the way there seems to be no end to the patterns that form the pictures—was a feature that troubled some critics, but that the artist himself especially valued.[64] The sense that Pollock's predominantly horizontal paintings give, of going on and on while going nowhere in particular (as they lack any notable landmarks), may well relate to his intense feeling for the American landscape, especially the boundless, open spaces of the West—the memory of which he managed to recapture in the East in the presence of the ocean.[65] "There is in Pollock some fundamentally American quality,"

271

declared the cultural historian Leslie Fiedler, "so that I think of him along with Huckleberry Finn and Jay Gatsby; a 'heart-of-the-heart-of-the country' American. This is because of the contempt he had for boundaries."[66]

Pollock was often asked if, as an artist, he didn't need or want to go to Europe. He replied impudently, "Hell no. Those Europeans can come look at us,"[67] knowing full well that the proverbial New World was widely regarded by Europeans as a gaping cultural hole. Before World War II, "absolutely no one thought American painting could rival French painting, then or ever," recalled Lee Krasner."[68] If Europe represented the center of cultural authority and knowledge—the Father, metaphorically speaking—the New World represented the Mother, in all her nonknowledge and relative lack of authority or presence.[69] Pollock's painting, in its attempt to describe "unframed space" (as Krasner phrased it), and in its act of destructuring and decentering, may in a sense be seen as an attempt to visualize the void, the hole, the Mother.[70]

Alice Jardine has suggested that "we might say that what is generally referred to as modernity, is precisely the acutely interior, unabashedly incestuous exploration of these new female spaces: the . . . exploration of the female, differently maternal body. "[71] Further, "Over the past century, those master (European) narratives—history, philosophy, religion—which have determined our sense of legitimacy in the West have undergone a series of crises in legitimation"; and that crisis has propelled a radical rethinking, marked by a rejection of

> Anthropomorphism, Humanism, and Truth. . . . In France such rethinking has involved, above all, a reincorporation and reconceptualization of that which has been the master narratives' own "nonknowledge," what has eluded them, what has engulfed them. This other-than-themselves is almost always a "space" of some kind (over which the narrative has lost control) and this space has been coded as feminine, as woman.[72]

The task undertaken by some contemporary theorists, as Jardine describes it, then, is "the putting into discourse of 'woman'," that is, of the master narratives' absent term.[73] But feminist critics are not completely sanguine about these new roles that male theoreticians have been positing for women. Gayatri Spivak observes that throughout Jacques Derrida's critique of phallocentrism, he "asks us to notice that *all* human beings are irreducibly displaced although, in a discourse that privileges the center, women alone have been diagnosed as such; correspondingly, he attempts to displace all centrisms" while using woman as "the 'model' for deconstructive discourse." Spivak criticizes Derrida's "desire to usurp 'the place of displacement'" thereby, in effect, doubly displacing women; and she writes insinuatingly of "the male appropriation of woman's voice."[74]

Returning to Pollock: one might see how, in his tacit assumption of the position of the woman—the decentered and the voiceless, the one who flows uncon-

trollably, the one who figures the void and the unconscious—he remained, on some level, a man using his masculine authority to appropriate a feminine space.[75] In fact, one woman had tried to articulate that space before Pollock did, in a similar way—not Krasner but Janet Sobel, who made poured, all-over compositions that unmistakably made an impact on Pollock. Greenberg recalls that "Pollock (and I myself) admired [Sobel's] pictures rather furtively" at the Art of This Century gallery in 1944; "The effect—and it was the first really 'all-over' one that I had ever seen . . .—was strangely pleasing. Later on, Pollock admitted that these pictures had made an impression on him."[76] When Sobel is mentioned at all in accounts of Pollock's development, however, she is generally described and so discredited as a "housewife," or amateur, a stratagem that preserves Pollock's status as the legitimate and unique progenitor, both mother and father of his art, a figure overflowing not only with semen but with amniotic fluid.[77]

What separates Pollock's work definitively from Sobel's is the heroic scale his pictures sometimes assumed and the relatively free flow of his paint. As for Krasner's all-over pictures, her postscript to Pollock's script looked less like Pollock than like something else: like the compressed and chilling record of one woman's strangled speech. If, in some sense, Pollock and Krasner both were struggling to get "Out of the Web" (to take the title of a painting of 1949 by Pollock), he alone managed to leave his webs open enough on occasion to offer glimpses of escape. Krasner's sense of being bound or trapped emerged not only in her tightly closed webs, however, but in her career-long practice of obsessively reworking, cannibalizing, and demolishing her work: "Jackson never destroyed his work the way I do," she noted. "If he had things that didn't come off, he'd put them aside for later consideration."[78] Observed another artist and artist's wife, Elaine de Kooning, Krasner became "kind of the opposite of competitive with Jackson. She wiped herself out."[79]

Jackson Pollock's pictures are often described as exalting the freedom of individual action and expression and, by comparison with Krasner's constricted pictures, they surely appear to. Yet the freedom in question in Pollock's art was, in a sense, a freedom to express frustration. As the painter George McNeil put it, "The freedom with which Pollock painted then, that was great. Everybody was changed by his work . . . he was able to project his frustrations—his work came from this."[80] Pollock's script had better be read not simply as an affirmation of freedom, then, but also as an image of the frustration that triggered that affirmation. Observed a doctor friend of Pollock's: "I think Jackson was trying to utter something. . . . There's an utterance there, but it's a lot like trying to understand brain-damaged people or those with an autistic or dyslexic factor, or psychotics."[81] Although Pollock wrote and wrote in his art, his script was never lucid, never legible. But that Pollock's art would "stop making sense" may be construed not as the babbling of a helpless fool, but as an artist's ingenious way of testifying to the

failure of writing, or painting and drawing, to represent experience; or as a material protest against the poverty of received modes of communication.

"The threads of communication between artist and spectator are so very tenuous" in Pollock's work, one critic commented, that "there are times when communications break down entirely, and, with the best will in the world I can say of such pieces as 'Lucifer,' 'Reflection of the Big Dipper,' and 'Cathedral' only that they seem mere unorganized explosions of random energy, and therefore meaningless."[82] The significance of Pollock's tangled script lay elsewhere, however—not in its communicativeness but in the act of writing itself. "What is at stake in writing," the critic Barbara Johnson observes, "is the very structure of authority itself," as writing is a form of control. And whereas the graphocentric, logocentric logic of Western society "has been coded as 'male', the 'other' logics of spacing, ambiguity, figuration, and indirection are often coded as 'female'," such that a critique of graphocentrism and logocentrism "can enable a critique of 'phallocentrism' as well." In the history of modern literature, the writer who is credited with introducing space or spacing into reading is Stéphane Mallarmé, who gave "a signifying function to the materiality—the blanks, the typefaces, the placement on the page, the punctuation—of writing."[83] In the history of art, Jackson Pollock, the vaunted "action painter," achieved something comparable, not only in forgoing the representational function of drawing but in letting the action of and the spacing of lines on canvas alone be his image.

"To act . . . to produce upon many a movement that gives you back the feeling that *you* originated it, and therefore exist: something no one is sure of," wrote Mallarmé in a text called "Action Restrained":

> . . . to send a force in some direction, any direction, which, when countered, gives you immunity from having no result. . . .
>
> Your act is always applied to paper; for meditating without a trace is evanescent, nor is the exalting of an instinct in some vehement, lost gesture what you were seeking.
>
> To write—
>
> The inkwell, crystalline like consciousness. . .
>
> You noted, one does not write, luminously, on a dark field; the alphabet of stars alone does that, sketched or interrupted; man pursues black upon white.
>
> This fold of dark lace, which retains the infinite, woven by thousands, each according to the thread or extension unknowing a secret, assembles distant spacing in which riches yet to be inventoried sleep.[84]

Remarks Johnson, "Mallarmé is here suggesting that action cannot be defined otherwise than as the capacity to leave a trace—a written trace, a trace not of clarity but of darkness. It is with his obscurity, his nonknowledge, that man writes,

and the poet's duty is to stand as guardian of an ignorance that does not know itself, an ignorance that would otherwise be lost."[85]

If Pollock's unraveling script is still mesmerizing more than forty years after he wrote it, it may be for a related reason: because Pollock's writing is writing that unwrites itself, that deauthorizes language, where language is identified with the phallus, the word of God the Father, and the constraints of law. Johnson observes that "what enslaves is not writing per se but *control* of writing, and writing as control."[86] Pollock offers a spectacle of writing that does not control or order but *dis*-orders; writing degenerated into lawlessness, anarchy, chaos. Critics described his art in terms of "the absurdity of sheer scribble"; as "formless, repetitious, empty"; and as "a loose, shapeless mess of paint without any apparent will to form."[87] But the primal chaos suggested by Pollock's art—an art of deterritorialization, full of lines, but no boundaries or borders; an art of dedifferentiation, spilling with flows, neither and both male and female—spells a perversion or a reversal of values, of the logic of the biblical universe that moves purposively from chaos or "indistinctness to separation and demarcation"; division, order and control.[88] In a world where order is, ipso facto, patriarchal order—the world as we know it—Pollock's perverse spectacles of chaos and formlessness may serve as a vision of a reality, a material reality, other than that of the paternal universe.

Notes

This essay derives from a lecture commissioned in 1990 by the Fundacio Antoni Tàpies, Barcelona. I thank Michael Leja and Lisa Saltzman for their criticisms of its earlier versions.
1. William Feaver, "The Kid from Cody," review of the *Jackson Pollock: Drawing into Painting* exhibition in its Oxford, England, Museum of Modern Art venue, 1979. A copy of this review is in the artist's file on Pollock at the library of the Museum of Modern Art, New York.
2. Dorothy Seiberling, "Baffling U.S. Art: What It Is About," pt. 1, *Life* (9 Nov. 1959): 79.
3. The biography that focuses most on Pollock's sexual instability, going so far as to make, to my mind, unconvincing insinuations about his engaging (willingly or otherwise) in homosexual activity, is Steven Naifeh and Gregory White Smith, *Jackson Pollock: An American Saga* (New York: Clarkson N. Potter, 1989).
4. Jeffrey Potter, *To a Violent Grave: An Oral Biography of Jackson Pollock* (Wainscott, N.Y.: Pushcart, 1987) p.139. Also, in a lecture in 1980, Greenberg described Krasner as the "greatest influence" on Pollock (Ellen G. Landau, *Jackson Pollock* [New York: Harry N. Abrams, 1989], p. 253, n. 10). Myers made his statement in an undated, unpublished interview with Barbara Rose (ibid., p. 253, n. 2).
5. Potter, *To a Violent Grave*, p. 115. And in the words of Isamu Noguchi, "Jackson was guided by a definite apparition, meaning Lee. She was the agent, be it angel or witch" (ibid., p. 79).
6. Barbara Rose, *Lee Krasner/Jackson Pollock: A Working Relationship* (East Hampton, N.Y.: Guild Hall Museum, 1981), p. 8. Rose's account exaggerated the degree of Pollock's ingenuousness in 1942 and diminished the role John Graham played in his formation before he even met Krasner, as Naifeh and Smith point out (*Jackson Pollock*, p. 406).
7. "Later, she would refer to this as her 'blackout' period" (ibid., p. 402). "The effect of Pollock's art on Krasner was to cause her to question everything she was doing," noted Rose in a slightly later account (Barbara Rose, *Lee Krasner: A Retrospective* [New York: Museum of Modern Art, 1983], p. 50).
8. Potter, *To a Violent Grave*, p. 174. For comparable observations by Fritz Bultman and B. H. Friedman, see ibid., pp. 65, 78. Further: "'She was much brighter than he was and she ran his career,' says Lionel Abel. 'She carried the ball for the enterprise. She thought the whole thing out from the beginning: how to put him over

and make him a big success. How to attack rival painters and rival movements'" (Naifeh and Smith, *Jackson Pollock*, p. 404).
9. Violet Staub de Laszlo, cited in Potter, *To a Violent Grave*, p. 66.
10. Ibid., pp. 127, 260.
11. Ibid., p. 102. For Pollock's self-description of his sense of helplessness, see *Jackson Pollock: A Catalogue Raisonné of Paintings Drawings and Other Works*, ed. Francis V. O'Connor and Eugene Victor Thaw [hereafter cited as "OT"] (New Haven: Yale Univ. Press, 1978), vol. 4, doc. 6, p. 208, and doc. 12, p. 212.
12. Ibid., vol. 4, doc. 19, p. 216. What prompted the poignant phrase cited was the news of his father's death, news that might make anyone feel at a loss for words; but Pollock expressed comparable feelings on other, less momentous occasions: "I'm usually in such a turmoil that I haven't any thing to write about and when I do after I've written it—it looks like all bunk," he wrote to his father in 1932 (ibid., vol. 4, doc. 12, p. 212). Thomas Hart Benton recalled how the young artist developed some kind of language problem and became almost completely inarticulate. "I have sometimes seen him struggle, to red-faced embarrassment, while trying to formulate ideas boiling up in his disturbed consciousness, ideas he could never get beyond a 'God damn, Tom, you know what I mean!' I rarely did know." Naifeh and Smith, *Jackson Pollock*, p. 167. For additional testimonies to Pollock's inarticulateness, see Potter, *To a Violent Grave*, pp. 45, 65, 93.
13. The phrase is Violet Staub de Laszlo's, cited in Landau, *Jackson Pollock*, p. 254, n. 12. The same source is cited in Potter, *To a Violent Grave*, p. 67.
14. Flora Lewis, "Two Paris Shows à la Pollock," *New York Times* (3 Oct. 1979), p. C21 (bylined Paris). In an earlier interview, Krasner used more decorous phrasing: "Jackson had a mistrust of the word," she explained. "Words were never his thing. They made him uncomfortable" (John Gruen, "A Turbulent Life With Jackson Pollock," *New York/World Journal Tribune Magazine* [26 March 1967]: 15).
15. Douglass M. Howell, cited in Potter, *To a Violent Grave*, p. 179. Pollock's parents are also invariably described as exceedingly laconic people: "There was no conversation at all around the Pollock family dinner table," remembered Marie Pollock. "Our parents. . . didn't need talk in the house," recalled Charles Pollock

(ibid., pp. 43, 168).
16. Naifeh and Smith, *Jackson Pollock*, p. 402. The painter Cora Cohen pointed out, in conversation, that there was a cultural factor in Krasner's taking charge of Pollock's career and daily affairs: it is customary in Orthodox Jewish homes for the wife to assume as many as possible of the mundane responsibilities to leave the husband free to pursue religious study—a pattern that fits the household where Krasner was raised, according to Naifeh and Smith, *Jackson Pollock*, p. 373.
17. Landau, *Jackson Pollock*, p. 253, n. 2. On Krasner's role as Pollock's mouthpiece, see also Potter, *To a Violent Grave*, p. 78, and Naifeh and Smith, *Jackson Pollock*, p. 612.
18. According to Krasner, Howard Putzel helped Pollock answer the questionnaire that formed the basis for his first full-length interview, published in *Arts and Architecture* in Feb. 1944 (Francis V. O'Connor, *Jackson Pollock* [New York: Museum of Modern Art, 1967], p. 31). Other accounts have Motherwell helping to answer those questions instead (Deborah Solomon, *Jackson Pollock: A Biography* [New York: Simon and Schuster, 1987], p. 146, and Naifeh and Smith, *Jackson Pollock*, p. 472). Naifeh and Smith detect Krasner's hand in many of Pollock's letters (see, for instance, *Jackson Pollock*, p. 467, although the authors err in part in their analysis of the letter in question by misreading "he" as "we," as can be seen from careful study of the facsimile of the letter published in OT, vol. 4, doc. 60, fig. 25; O'Connor and Thaw made the same error in transcribing the letter in their doc. 50, ibid.).
19. Ibid., vol. 4, doc. 60, p. 234. The statement in question was made in 1944 with reference to *She-Wolf*, but that Janis urged Pollock to title his mature paintings emerges in Potter, *To a Violent Grave*, p. 187, although the dealer there insists that Pollock readily agreed to do so.
20. Among the many accounts of this practice, see ibid., pp.187–188, and Landau, *Jackson Pollock*, p. 172.
21. The allegation is made by Nicholas Carone in Potter, *To a Violent Grave*, p. 268. (Regarding Pollock's will, see Naifeh and Smith, *Jackson Pollock*, p. 661.) For Krasner's account of Pollock's chronic difficulties with signing his work, see OT, vol. 4, doc. 102d, p. 264. Pollock himself is cited on this subject in Potter, *To a Violent Grave*, p. 187.
22. Ibid., pp. 139, 200.
23. B. H. Friedman, *Jackson Pollock:*

Energy Made Visible (New York: McGraw-Hill, 1972), p. 162.

24. Feaver, "The Kid." Today, such descriptive phrases evoke Andres Serrano's *Ejaculate in Trajectory* photographs of 1989, as Michael Leja pointed out to me.

25. "Beyond the Pasteboard Mask," *Time* (17 Jan. 1964): 69.

26. Letter to Louis Bunce, 29 Aug. 1947, cited in Landau, *Jackson Pollock*, p. 166.

27. This statement continues: "It is only after a sort of 'get acquainted' period that I see what I have been about. . . . It is only when I lose contact with the painting that the result is a mess"—a description of a kind of coitus interruptus—"Otherwise there is pure harmony, an easy give and take, and the painting comes out well" (OT, vol. 4, doc. 71, p. 241).

28. See Sigmund Freud, *The Psychopathology of Everyday Life*, trans. Alan Tyson (New York: W. W. Norton, 1960), p. 197, and Freud, *Introductory Lectures on Psychoanalysis*, trans. James Strachey (New York: W. W. Norton, 1966), p. 155. Also, "Jacques Derrida describes the literary process in terms of the identification of the pen with the penis, the hymen with the page. . . . This model of the pen-penis writing on the virgin page participates in a long tradition identifying the author as a male who is primary and the female as his passive creation" (Sandra Gubar, "'The Blank Page' and the Issues of Female Creativity," in *New Feminist Criticism*, ed. Elaine Showalter [New York: Pantheon, 1985], p. 295).

29. "Jackson Pollock: Is he the greatest living painter in the United States?" *Life* (8 Aug. 1949): 44; and "The Metropolitan and Modern Art," *Life* (15 Jan. 1951): 34. Naifeh and Smith twice tell of Pollock's relating his method of painting to a childhood memory of watching his father urinate on a rock (*Jackson Pollock*, pp. 101, 541), and they describe repeatedly his making a public spectacle of his urination, and his wetting his own and others' beds as an adult (ibid., pp. 491, 760, 770, 541, 612, 671, 762).

30. John Cole, cited in Potter, *To a Violent Grave*, pp. 166–167. Nor was it only bodily fluids Pollock reportedly lost control of: de Kooning gleefully related a story told him by Franz Kline of Pollock pouring wine at a restaurant and becoming "so involved in watching the wine pour out of the bottle that he emptied the whole bottle. It covered the food, the table, everything. . . . Like a child he thought it was a terrific idea—all that

wine going all over" (James T. Valliere, "De Kooning on Pollock: An Interview," *Partisan Review* vol. 34, no. 4 [Fall 1967]; repr. in *Abstract Expressionism: A Critical Record*, ed. David Shapiro and Cecile Shapiro [Cambridge: Cambridge Univ. Press, 1990], p. 374).

31. As cited in O'Connor, *Jackson Pollock*, p. 55. Also, Harold Rosenberg reportedly taunted Pollock that "you paint like that monkey," referring to a laboratory animal that had been set to work making paintings for reasons that are now obscure (Potter, *To a Violent Grave*, p. 182).

32. Maude Riley, "Review," *Art Digest* (1 April 1945): 59.

33. Jane Gallop, *Reading Lacan* (Ithaca, N.Y. : Cornell Univ. Press, 1985), p. 20.

34. OT, vol. 4, doc. 100, p. 262; see also ibid., doc. 87, p. 251 ("I deny the accident"). Krasner, too, affirmed: "His control was amazing" (ibid., doc. 102d, p. 264).

35. "Chaos, Damn It," *Time* (20 Nov. 1950): 70–71 (the headline referred to Alfieri's description of Pollock's work as total "chaos"); Pollock, "Letters to the Editor," *Time* (11 Dec. 1950): 10. In a letter written to his father in 1932, Pollock spoke of "doing every thing with a definite purpose—with out a purpose for each move—thers chaos [sic]" (OT, vol. 4, doc. 12, p. 212).

36. Of interest in this regard is the impression that Pollock's work made on the painter Gerhard Richter when he encountered it at the Documenta exhibition in Kassel in 1958 and determined that it was "not a Formalist gag, but rather the bitter truth, liberation." Mused Richter, "I might almost say that these pictures were the real reason for my leaving East Germany" (Benjamin H. D. Buchloh, "Interview with Gerhard Richter," trans. Stephen P. Duffy, in Roald Nasgaard, *Gerhard Richter: Paintings* [London: Thames and Hudson, 1988], p. 15).

37. Pollock made small paintings, too, of course: in fact, the preponderance of his work was relatively modest in scale, but the pictures his heroic reputation was built on were those heroic in scale.

38. Rose, *Lee Krasner*, p. 56. Although Rose argued that the difference in their studios was not a determining factor in their work, pointing out that Pollock had made a large canvas in the same bedroom before he converted the barn into his workspace, Krasner told Lawrence Alloway in bitter terms that she resented the discrepancy in the scale of their studios

(Naifeh and Smith, *Jackson Pollock*, p. 638).

39. Added Danto, "The whole [Krasner retrospective] exhibition is a series of surrenders to artistic personalities stronger than her own, and those surrenders are what enabled her to paint. Even though huge and bold, Krasner's work has something of the art school exercise about it" (Arthur Danto, "Lee Krasner: A Retrospective," in *The State of the Art* [New York: Prentice-Hall, 1987], p. 36).

40. Gruen, "A Turbulent Life," p. 14. Pollock's work "opened a new channel, a new avenue for me," Krasner also recalled. "I started to break away from what I had learned" (Grace Glueck, "Scenes from a Marriage: Krasner and Pollock," *Art News* [Dec. 1981]: 59).

41. Regarding the couple's destructive symbiosis (which Rose was the first to remark), se Naifeh and Smith, *Jackson Pollock*, pp. 483, 571, 672. Of the "Little Image" paintings, Pollock reportedly said, "Lee keeps copying me and I wish she'd stop" (ibid., p. 640). His attitude toward Krasner's painting is said to have been mildly encouraging, at best; brutally dismissive, at worst (ibid., pp. 571, 751).

42. Potter, *To a Violent Grave*, p. 129.

43. Klaus Theweleit, *Male Fantasies, Volume One: Women, Floods, Bodies, History*, trans. Stephen Conway (Minneapolis: Univ. of Minnesota Press, 1987), pp. 266–267.

44. N. Katherine Hayles, "Gender Encoding in Fluid Mechanics: Masculine Channels and Feminine Flows," *Differences*, 4, no. 2 (summer 1992): 30. "In hydraulics as in Freudian psychology, intuitions about flow come together with laws of conservation to posit equivalence between regulating fluids and regulating behavior," adds Hayles; and "It is significant . . . that Freud chose 'sublimation' to describe the process of converting libido into a socially constructive force, for in its technical meaning sublimation denotes the transformation of a solid into a gas without going through the liquid phase. Better to bypass liquidity altogether than to risk being caught up in the vagaries of turbulent flows" (ibid., pp. 31, 32).

45. Theweleit acknowledges that male bodies also generate flows, but in the fantasies of the population he studied, those flows remained deeply associated with the fearsome floods of the female body: "Fear of the flood has a decided effect. . . on the structuring of their [the soldiers'] bodily feelings," as they suffered from sus-

tained erections they could not or would not relieve; also, in the military, "Fluid fell under the heading of dirt . . . [and] unmanliness" (Theweleit, *Male Fantasies*, pp. 249, 410).
46. Luce Irigaray, *Speculum of the Other Woman*, trans. Gillian C. Gill (Ithaca, N.Y.: Cornell Univ. Press, 1985), p. 237. In Irigaray's analysis, as Hayles notes, "The privileging of solid over fluid mechanics, and indeed the inability of science to deal with turbulent flow at all," is attributed to "the association of fluidity with femininity. Whereas men have sex organs that protrude and become rigid, women have openings that leak menstrual blood and vaginal fluids. Although men, too, flow on occasion. . . this aspect of their sexuality is not emphasized. It is the rigidity of the male organ that counts, not its complicity in fluid flow" (Hayles, "Gender Encoding," p. 17).
47. The brush with mortality that Stella and Jackson Pollock both suffered during his birth was evidently a subject of family discussion and family lore (see OT, vol. 4, doc. 1, p. 203). Following the birth, Stella was told she could have no more children and, interestingly and atypically, Jackson grew up knowing that his parents had both desperately wanted their fifth son and final child to be a girl (Naifeh and Smith, *Jackson Pollock*, pp. 42–43, 69). That Pollock's reading and developmental difficulties may well have stemmed in part from his traumatic birth has been suggested to me by numerous interlocutors.
48. Potter, *To a Violent Grave*, p. 203. Stella Pollock and Lee Krasner both are habitually assigned the role of the "terrible mother" to Pollock's "bad son" in their friends' reminiscences and in the literature (see, for instance, ibid., pp. 209, 275). Tellingly, Pollock's father, LeRoy, who all but abandoned the family when Jackson was a child, and whose youngest son believed that his father "thinks I'm a bum" (letter of 1931, OT, vol. 4, doc. 11, p. 211), generally gets portrayed as a pitiable, not a censurable, figure—and never as an important source of Pollock's problems.
49. As related by Cile Downs, in Potter, *To a Violent Grave*, p. 204.
50. Letter to Alfonso Ossorio (OT, vol. 4, doc. 94, p. 257).
51. Theweleit, *Male Fantasies*, vol. 1, p. 255.
52. Deleuze and Guattari, *Anti-Oedipus*, as cited in Theweleit, *Male Fantasies*, vol. 1, pp. 269–270. Within the capitalist system, "under

no circumstances could desires be allowed to flow in their inherently *undirected* manner . . . desires had to be channelled. . . [to] bolster the flow of currency. Streams of desire were encoded as streams of money" (ibid., pp. 270–271).
53. Ibid., pp. 432, 270.
54. OT, vol. 4, doc. 113, p. 275. See also ibid., vol. 4, doc. 72, p. 241 ("The source of my painting is the unconscious").
55. Ibid., vol. 4, doc. 103, p. 267 (misspelled as "skined" in the original); and Potter, *To a Violent Grave*, p. 156.
56. "The female subject can participate in this fantasy of sexual and discursive divestiture only in a displaced and mediated way. She can assist the male subject in removing his mantle of privileges, but she herself has nothing to take off" (Kaja Silverman, "The Female Authorial Voice," in *The Acoustic Mirror: The Female Voice in Psychoanalysis and Cinema* [Bloomington: Indiana Univ. Press, 1988], p. 192).
57. Potter, *To a Violent Grave*, pp. 114, 129. Pollock said he allowed Namuth to film him because Krasner "kept at me" (ibid., p. 129).
58. Theweleit, *Male Fantasies*, vol. 1, p. 268.
59. Alfieri, cited in O'Connor, *Jackson Pollock*, p. 55; and Edith Hoffman, "Current and Forthcoming Exhibitions," *Burlington* (Feb. 1957): 68. Pollock did have to reckon with the actual, physical borders of his canvases, of course, and sometimes he looped most of the paint skeins back at the pictures' edges, tacitly acknowledging the limitations of the space, whereas at other times he poured paint on a canvas and then cropped a picture out of it after the fact, in which case the trajectories of the paint skeins were necessarily interrupted by the picture's edge.
60. Rudi Blesh, *Modern Art U.S.A.: Men, Rebellion, Conquest, 1900–56* (New York: Knopf, 1956), pp. 253–254. De Kooning usually is described as Pollock's chief rival for leadership of the New York School; but de Kooning was unquestionably the figure most emulated by other painters in the circle because, as Al Held aptly remarked, "de Kooning provided a language you could write your own sentences with. Pollock didn't do that" (Naifeh and Smith, *Jackson Pollock*, p. 714).
61. Potter, *To a Violent Grave*, p. 221.
62. Manuel Tolegian, cited in ibid., p. 47. Tolegian recalled Pollock's having smashed a Catholic altar in a church, ripped his (Tolegian's) paintings off the wall of a gallery, and

smashed the windows in a building (ibid., pp. 47–48, 57).
63. It bears noting, as an aside, that Lenore Krassner deliberately took the "Krass" out of Krassner (besides adopting the gender-neutral name "Lee" in preference to her given first name).
64. In 1948, Aldous Huxley said of Pollock's work: "It raises a question of why it stops when it does. The artist could go on forever. I don't know. It seems to me like a panel for a wallpaper which is repeated indefinitely around the wall" (from a roundtable discussion on modern art in *Life* [18 Oct. 1948], as cited in Landau, *Jackson Pollock*, p. 179). Recalled Pollock some time later: "There was a reviewer who wrote that my pictures didn't have any beginning or end. He didn't mean it as a compliment, but it was. It was a fine compliment" (Berton Roueché, "Unframed Space," *New Yorker* [5 Aug. 1950]: 16). And "there is no accident, just as there is no beginning and no end," Pollock once declared (OT, vol. 4, doc. 100, p. 262).
65. "I have a definite feeling for the West: the vast horizontality of the land, for instance; here only the Atlantic ocean gives you that," observed Pollock (ibid., vol. 4, doc. 52, p. 232). "'Jackson's art is full of the West', [Krasner] said. 'That's what gives it that feeling of spaciousness. It's what makes it so American'" (Roueché, "Unframed Space," p. 16). Horizontality is conventionally coded feminine, verticality masculine, the former connoting passivity or inertia, the latter activity and erectness. It bears noting in this context that Krasner explicitly stressed the predominant verticality of her own work (Cindy Nemser, *Art Talk: Conversations with Twelve Women Artists* [New York: Charles Scribner's Sons, 1975], p. 94).
66. Leslie Fiedler, "Was Jackson Pollock Any Good?" *Art and Antiques* (Oct. 1984): 85. Contended the dealer Holly Solomon, "Pollock invented a new language for us, for Americans. . . . He taught us how to breathe" (ibid., p. 85).
67. Landau, *Jackson Pollock*, p. 266.
68. Naifeh and Smith, *Jackson Pollock*, p. 341. This situation was not entirely altered after the war. To Hilton Kramer, Pollock's art would be "dim indeed" compared to that of the European masters: "It is only the poverty of our own artistic values that has elevated his accomplishment into something higher" (Kramer, "Art: Looking Back at Jackson Pollock," *New York Times* [5 April 1967]: 44).

278

69. In a sense, the United States had, like Pollock, only a distant or remote father—Europe, that is—with whom it maintained strained relations, longing for approval, but bent on independence.

70. Interestingly enough, Pollock was named for Jackson Hole in his birthplace of Wyoming (Naifeh and Smith, *Jackson Pollock*, p. 43), and was subject to being teased about "Jackson's Hole" when he mused aloud philosophically, as he sometimes was prone to do, on the subject of the "hole" or the "void" (Potter, *To a Violent Grave*, pp. 203, 192).

71. Alice A. Jardine, *Gynesis: Configurations of Woman and Modernity* (Ithaca, N.Y.: Cornell Univ. Press, 1985), pp. 33–34.

72. Ibid., pp. 24–25.

73. Ibid., p. 25.

74. Gayatri Chakravorty Spivak, "Displacement and the Discourse of Woman," in *Displacement, Derrida and After*, ed. Mark Krupnick (Bloomington: Indiana Univ. Press, 1983), pp. 170, 173, 190.

75. "It has also become clear that the imaginary femininity of male authors, which often grounds their oppositional stance vis-à-vis bourgeois society, can easily go hand in hand with the misogyny of bourgeois patriarchy itself" (Andreas Huyssen, *After the Great Divide. Modernism, Mass Culture, Postmodernism* [Bloomington: Indiana Univ. Press, 1986], p. 45). "Society often tolerates and even encourages the femininity of male artists," observes Mira Schor; "Catherine Elwes . . . writes that 'their role is often to provide the opportunity for other men vicariously to experience their buried femininity. The power and prestige of the artist's biological masculinity is *reinforced* rather than undermined by artistic forays into the feminine. His status as an artist partly depends on this poetic femininity'" (Schor, "Representations of the Penis," *M/E/A/N/I/N/G* [Nov. 1988]: 8).

76. Greenberg's next sentence quickly retreats from the suggestion that Sobel—whom he describes as "a 'primitive' painter. . . who was, and still is, a housewife living in Brooklyn"—may have been a significant source for Pollock: "But he had really anticipated his own 'all-overness' in a mural he did for Peggy Guggenheim at the beginning of 1944" (Clement Greenberg, "'American-Type' Painting," in *Art and Culture: Critical Essays* [Boston: Beacon, 1961], p. 218.

77. Luce Irigaray has suggested that men have conspired to keep naming, representing, and cultural production

generally a masculine prerogative, thus in a compensatory way usurping the biological status of women as the site of reproduction or procreation (in *Speculum*, pp. 23, 33, 41–43). As for Sobel, her work is nowhere to be seen, on a regular basis, in any major museum (although the Museum of Modern Art owns two paintings), nor is there any monograph on her.

78. Glueck, "Scenes from a Marriage," p. 61. In the years after she first met Pollock, Krasner painted what she called her "gray slabs": canvases (eventually thrown out) that she covered over and over with paint "until they'd get like stone and it was always just a gray mess" (Nemser, *Art Talk*, p. 87). In 1953 she began a series of collages made up of her own old drawings, torn into shreds; many of those drawings came from her years in Hans Hofmann's school, where, interestingly, she once suffered the insult of having Hofmann tear up and rearrange a newly completed (and admired) drawing in front of the class (Naifeh and Smith, *Jackson Pollock*, p. 386). Krasner proceeded to "slashing" and collaging her own old oil paintings: "it is dangerous for me to have any of my early work around because I tend to always want to go back into it . . .—so the less around the better," she told an interviewer, while explicitly expressing feelings of hatred for her own old work (Nemser, *Art Talk*, pp. 93–94).

79. In Potter, *To a Violent Grave*, p. 175. "Lee was his victim in the end," pronounced Greenberg (ibid., p. 174). Observed Potter, Krasner was "trading on the trajectory of his fame, although not admitting to herself how much she was putting her own work and self aside from his" (ibid., p. 226). The increased visibility Krasner's art found in the decades following her husband's death was tacitly viewed more as an insidious index of Pollock's stature than as a positive measure of her own, as it was known that she controlled the holdings of the Pollock estate and so was a figure to be indulged.

80. Ibid., p. 100.

81. Ibid., p. 177.

82. Robert M. Coates, review, *New Yorker* (17 Jan. 1948): 57.

83. Barbara Johnson, "Writing," in *Critical Terms for Literary Study*, ed. Frank Lentricchia and Thomas McLaughlin (Chicago: Univ. of Chicago Press, 1990) pp. 46–48.

84. As cited in Barbara Johnson, "Is Writerliness Conservative?" in *A World of Difference* (Baltimore: The Johns Hopkins Univ. Press, 1987), pp. 29–30.

85. Ibid., p. 30.

86. Johnson, "Writing," p. 48.

87. "Beyond the Pasteboard," p. 69; Emily Genauer, "Sad Art of Pollock in Museum Show," *Herald Tribune Book Review* (23 Dec. 1956); Victor Willing, "Thoughts After a Car Crash," *Encounter* (Oct. 1956): 66.

88. Not only the specific phrase cited but this notion of chaos and perversion generally is taken from Janine Chasseguet-Smergil, "Perversion and the Universal Law," in *Creativity and Perversion* (New York: W. W. Norton, 1984), p. 10 and passim. It bears noting that science since Pollock's day has come to evaluate chaos in more positive terms, reconceptualizing it as "the progenitor of order rather than its opposite," but in her analysis of contemporary chaos theory, Hayles has shown that the feminineness or "otherness that chaos represents, while immensely attractive, is also always a threat, arousing the desire to control it, or even more extremely to annihilate it" (Hayles, "Gender Encoding," pp. 32, 33; see also Hayles, *Chaos Bound: Orderly Disorder in Contemporary Literature and Science* [Ithaca, N.Y.: Cornell Univ. Press, 1990]).

Acknowledgments

As curators for The Museum of Modern Art's 1998 retrospective *Jackson Pollock*, Kirk Varnedoe and I had intended from the beginning that our catalogue would be accompanied by a volume of critical essays documenting the varied ways that scholars approach Pollock's work today. In the course of researching the exhibition, it became apparent that there was also a wealth of first-rate older criticism that had fallen more or less into obscurity. I therefore proposed that we publish an anthology making the most important older texts easily available to contemporary scholars, critics, and artists. The two resulting books are appearing concurrently as *Jackson Pollock: New Approaches* and this volume, *Jackson Pollock: Interviews, Articles, and Reviews*.

I am extremely grateful for the enthusiastic support this project has received from Kirk Varnedoe, Chief Curator of the Department of Painting and Sculpture, and from Michael Maegraith, Publisher, Department of Publications. I am especially indebted to The David Geffen Foundation, which has generously underwritten all three of the publications associated with the Pollock exhibition.

The texts gathered in this book are merely the tip of an enormous iceberg of writings on Pollock. In assembling and selecting them, I have depended on the herculean labors of an exceptional team headed by Anna Indych, Research Assistant. Much of the hard work of gathering, verifying, and classifying bibliographic information has been done by Delphine Dannaud, assisted at various moments by Kristin Erickson and by Danielle Jankow. Other assistants, including Robert Beier, Alejandra Munizaga, and Tom Ormond, fanned out to libraries and made innumerable photocopies for our files. Their task was facilitated by the staff of the Museum's library, especially Daniel Starr, Jennifer Tobias, and Karen Mainenti. Unfortunately, the comprehensive Pollock bibliography and exhibition history compiled by these researchers is too large and unwieldy to include in this volume. It is, however, being made available on the Museum's Web site at www.moma.org (see instructions for accessing the bibliography on page 14).

The production of this anthology has also depended on the efforts of a second team of assistants. Elisa Gerber retyped the material in the book from the

original documents. Tiffany Barnard Davidson, Kathleen Mrachek, and Maria Elena Buszek helped contact the authors and the original publishers to clear rights to the texts that appear here. We have tried diligently to contact all appropriate parties and are sorry if there have been any omissions. The retyped texts were expertly proofed against the originals by Susan Richmond. I have reviewed them as well and should be held responsible for any remaining errors.

The book as a whole was sensitively edited by Jasmine Moorhead, Assistant Editor, Department of Publications. Steven Schoenfelder has handled the complex design problems inherent in a project of this type with his usual brilliance and efficiency, and Christina Grillo, Senior Production Assistant, Department of Publications, has worked miracles to bring it in on budget and produce an elegant volume.

Pepe Karmel